New Trends In Argentine and Brazilian Cinema

Edited by Cacilda Rêgo and Carolina Rocha

intellect Bristol, UK / Chicago, USA

First published in the UK in 2011 by Intellect,
The Mill, Parnall Road, Fishponds, Bristol, BS16 3JG, UK

First published in the USA in 2011 by Intellect, The University of Chicago Press,
1427 E. 60th Street, Chicago, IL 60637, USA

A catalogue record for this book is available from the British Library.

Front cover image: *Casa de Areia* by Vantoen Pereira Jr. Courtesy of Divulgação
Conspiração Filmes

Cover design: Holly Rose
Copy-editor: Heather Owen
Typesetting: John Teehan

ISBN 978-1-84150-375-2

Printed and bound in Great Britain by 4edge Ltd, Hockley. www.4edge.co.uk

Contents

IV. Gender

To Alexandre Andreas

To my parents, Carlos and Paulina, who encourage me to learn

ACKNOWLEDGEMENTS

We would like to thank a number of people who have helped in the preparation of this book. We are very much indebted to the contributors for the various drafts they supplied and the many deadlines they met. We are, of course, grateful to them. This book quite simply would not be possible without them. Mary Bartsh, Gerard Dapena, Regina Félix, Ana Forcinito, Pedro Lapera, Rebecca Lee, Pablo Piedras, Rielle Navitski, Isis Sadek and Fernanda Zullo-Ruiz provided valuable suggestions at different stages of the project. We would also like to thank Alexis Torres and Devan Faulkenberg for their valuable assistance. We are also grateful to Carolyn Hutchinson for her careful editing. Special thanks go to Kevin Johnson, Assistant Dean for Research in the College of Liberal Arts at Southern Illinois University Edwardsville (SIUE) and Venessa Brown, Assistant Provost for Institutional Diversity and Inclusion for their ongoing support. We would particularly like to thank Yolanda Flores-Niemann, former Dean of the College of Humanities, Arts and Social Sciences, Utah State University (USU), and Brad J. Hall, Chair of USU's Department of Languages, Philosophy and Speech Communication for their support of the project. We thank Jorge Gaggero as well as Divulgação Conspiração Filmes and Vantoen Pereira Jr. for granting us permission to use the still photographs which appear in the book. Previous versions of some of the chapters were published in the journals *New Cinemas, Hispania* and *Cuaderno Internacional de Estudios Humanísticos y Literatura/International Journal for Humanistic and Literary Studies* as well as in M.J. Moore and P. Wolkowicz (eds.), *Cines al margen: Nuevos modos de representación en el cine argentino contemporáneo;* we are also grateful for the permission to reprint them. Last, but not least, our thanks also go to May Yao, Associate Publisher and Director at Intellect Books for her supportive encouragement at all stages of the project, Holly Rose for her cover design, and the comments of an anonymous referee.

C.R. AND C.R.

Abstract

This volume provides a variety of critical perspectives on the realities of contemporary film-making practices in both countries by shedding light on the aesthetic and thematic concerns that have inspired local film-makers to make successful and widely acclaimed films as well as the general conditions of production and consumption of national films since roughly 1995. The interest in the topic was spurred by the profound changes in Argentine and Brazilian societies and their respective cinemas following the implementation of neoliberal policies by Fernando Collor de Mello (1990–1992) in Brazil and Carlos Menem (1989–1999) in Argentina.

Introduction

In a recent study of Brazilian cinema, Lisa Shaw and Stephanie Dennison state that the Portuguese language 'sets Brazilian cinema apart from film production elsewhere in Latin America, despite (mostly Euro-American) academics' insistence on lumping all Latin American cinemas together in one' (2007: 1). While it is true that language and a strong filmic tradition make Brazilian cinema unique, during the 1990s both Brazil and Argentina experienced similar processes of losing state support for their film industries—as a result of the inception of neoliberalism in South America—and then later benefited from laws that supported film production. Departing from the existent body of literature that focuses on either Brazilian or Argentine cinema, this volume addresses the cultural policies that provided incentives for film-making and its effects on Argentine and Brazilian film production after the early 1990s, as well as films that thematize the impact of neoliberalism and globalization in Argentina and Brazil. This collection focuses, then, less on a comparative approach of both film industries and more on how the cinematography of these countries reacted to similar and subsequent processes of diminishing state support and state-sponsored subsidies and incentives. As such, this constitutes the first study linking the cinematographic developments in both countries from the mid-1990s on. Consequently, the goal of the editors is to examine the trends that emerged as a result of changes in funding for cinematic production in the early 1990s and how they have influenced the portrayal of social and cultural phenomena in South America's two largest film industries.

In the early 1990s, both Brazil and Argentina underwent a crisis in film production as a result of the neoliberal economic policies implemented by Fernando Collor de Mello (1990–1992) in Brazil and Carlos Saúl Menem (1989–1999) in Argentina. Robert Stam, João Luiz Vieira and Ismail Xavier note, for instance, that Collor de Mello's neoliberal measures were as swift as they were controversial: he not only closed down Embrafilme (the state production and distribution company created in 1969) and Concine (the legal agency regulating film activities since 1976) but also suspended Law 7,505 of 1986, known as 'Sarney Law,' which provided a tax benefit for cultural projects, thus abolishing almost overnight all state support for the Brazilian film industry (Stam et al. 1995: 389–90). In

Argentina, the consequences of Menem's early policies of slashing funding for cinema resulted in an uncertainty that dramatically affected the funds for film productions. This situation has been euphemistically summarized by film scholar Gonzalo Aguilar: 'During the 1990s making a movie was an adventure' (Aguilar 2008: 8).

Although these policies were deplored by film critics and professionals alike, Argentina and Brazil, as Paul Drake (2006) explains,

> had little choice but to heed the demands of international economic elites by curtailing independent policy making, restraining fiscal and monetary practices, deregulating domestic markets, and liberalizing foreign trade and investment rules. As neoliberal reforms accelerated, they became cumulative. The more ground these governments ceded to the marketplace, the less able they were to resist making further concessions to the increasingly powerful domestic and international market forces. (Drake 2006: 36)

Accelerating the crisis in both countries were innumerous other factors, such as high inflation, devalued currency, soaring production costs, the shrinking of the internal market, the closing of movie theatres, the impoverishment of the middle-class audience, the growing popularity of television and home video, the power of Hollywood distributors and pro-Hollywood exhibitors and, consequently, the massive presence of Hollywood films in the national market (Johnson 1991; Stam, Vieira & Xavier 1995; García-Canclini 1997; Caetano, Valente, Melo & Oliveria Jr. 2005; Alvaray 2008).

The implications of changes in consumption and production negatively impacted on Argentine and Brazilian cinema. Not only did the state in these two countries eliminate traditional protection for national film production but national film producers and film-makers also faced steep competition from foreign films that contributed to decreasing the consumption of national films. With few exceptions, notably Walter Salles, Hector Babenco, Sérgio Toledo and Walter Hugo Khouri, who all turned to English-language co-productions, Brazilian film-makers found it difficult to make films in the absence of public investment. Private investment in film production was almost non-existent at the time, and films already in production were halted with the closing of Embrafilme. Thus, the Brazilian film industry only produced nine films in 1993 (Silva Neto 2002: 36–7). Without a screen quota, or any other protectionist measure, Brazilian cinema faced 'the most severe crisis of its history' (Johnson 1991: 98). For its part, Argentina's national cinema production, which had been reinvigorated during the transition from dictatorship to democracy, came to a halt as the 'new wave' crashed against a ruined economy in the early 1990s (Alvaray 2008: 49–50). As a result, the production of Argentine films fell to only four in 1994 (Getino 1998: 117).

To offset the dire effects of the legislation that did away with state support, new funding laws were passed in both countries. In Brazil, Law 8,313 of 1991, known as 'Rouanet Law', and Law 8,586 of 1993, known as the 'Audio-Visual Law', permitted the Brazilian

film industry to devise new funding strategies which, in turn, allowed a remarkable resurgence of production known as the *Retomada*. Still in force today, the two laws, which are considered the main pillars of the country's tax incentive system, have allowed individuals and national and foreign corporations alike to receive tax exemptions for sponsoring national cultural productions, including films. As a result, US distributors such as Sony and Warner Bros. have increasingly invested in Brazilian national film production, as have public and private domestic corporations such as the National Bank of Economic and Social Development (BNDS) and the media conglomerate Globo TV Network, which, in December 1997, created Globo Filmes with the goal of 'strengthening the Brazilian audio-visual industry and increasing the synergy between cinema and TV' (Globo Filmes website 2009; see Rêgo 2008).

In Argentina, Law 24,377 of 1994, which sought to reinvigorate domestic film production, was also approved. This law, implemented in 1995, has served not only to regulate but also to encourage film production and exhibition (Rocha 2009). For instance, this law made possible the creation of a national public agency to regulate the industry, the National Institute of Cinematography and Audio-visual Arts (INCAA). In addition, Law 24,377 mandated several measures to develop local film-making, such as opening credit lines, providing subsidies and setting screen quotas for national films. Ten percent of the box-office income makes up a fund that is, in turn, redistributed among local film producers and directors. These subsidies make possible films that are deemed agents that 'contribute to the development of national cinematography through their cultural, artistic, technical or industrial qualities, except those that are based on or related to sex and drugs, and those that do not offer a positive influence for the community' (Law 24,377 Article 30). In addition, two committees within the INCAA sought to expand film-makers' access to the new credit lines and supervise the institution's budget (Falicov 2007: 89).

For both Argentina and Brazil, the second half of the 1990s marked a period of expansion for cinematic production (Alvaray 2008: 50). In Argentina, film production began to re-emerge from the ashes during President Menem's second term in office (1995–2000). The new system of financing gave small credits to first-time film-makers (Falicov 2007: 115–18). In 1998, a film made with a modest budget, *Pizza, birra y faso/ Pizza, Beer and Cigarettes* (Adrián Caetano & Bruno Stagnaro), generated widespread enthusiasm among local and international film critics who hailed it as representative of a new aesthetic, the New Argentine Cinema or the New Independent Argentine Cinema (Falicov 2007). Indeed, during this time, recent graduates from several film schools made their *operas primas* [directorial debuts] which attracted significant critical attention. According to Argentine film critic David Oubiña:

> For the moment, we cannot consider these new movies as part of a movement: they don't share a collective project or a homogeneous aesthetic. Their liveliness comes, precisely, from their variety and

their differences. In any event, they agree about the same independent modes of production, the absence of empty rhetoric, a strong sense of authorship, a certain generational spirit and, above all, they inherit the same Argentine history after the horrors of the military dictatorship. (Oubiña 2004: n.p.)

Parallel to the emergence of the New Argentine Cinema, there were several films that performed well with domestic audiences (Falicov 2000). Marcelo Pineyro's *Caballos salvajes/Wild Horses* (1995) and *Cenizas del paraíso/Ashes from Paradise* (1997), the first blockbusters of this period, were followed by *Comodines/Cops* (Jorge Nisco & Daniel Barone, 1997), *La furia/Fury* (Juan Bautista Stagnaro, 1997), *Nueve reinas/Nine Queens* (Fabián Bielinsky, 2000) and *El hijo de la novia/Son of the Bride* (Juan José Campanella, 2001) (Rocha 2006; 2009). The strong domestic performance of these films generated a renewed optimism among film-makers, film critics and local and international audiences.

Within this context of recovery of Argentine and Brazilian film-making in the late 1990s, *New Trends in Argentine and Brazilian Cinema* not only looks into some of the commercially- or critically-successful films produced after 1995, that is to say after legislation to revitalize the film industry passed in both countries, but also examines the developments and challenges for both industries in light of sweeping neoliberalism and globalization. Thus, the purpose of this volume does not lie in comparing the post-1995 cinematography of these countries. Rather, the essays in this collection analyse the new modes of production and distribution of Argentine and Brazilian films during a period (1995–2006) in which both countries implemented a new economic doctrine that changed national economy, society, culture and media. These trends are related to the way in which the state in both countries redefined itself to adjust to market demands and renegotiated its role with its constituencies. First, both countries sought to lower barriers and expand markets for their own goods, forging regional alliances. In 1991, Mercosul/Mercosur (Southern Common Market) was established to promote free trade and the free movement of goods, people and currency between Argentina, Brazil, Paraguay and Uruguay (see the Mercosul/Mercosur website). As the largest and most influential full members of this regional trading bloc, Argentina and Brazil have engaged in unprecedented levels of cooperation and mutual exchange which transcend traditional business practices. For instance, in March 2010 an agreement was signed between the Foro Entre Fronteras [Forum Among Borders] and the INCAA to sponsor four documentaries for a TV series called *Parcerías entre fronteras* [Collaborations Among Borders]. This agreement realizes the goals set forth in Colonia, Uruguay, in November 2009 by representatives from Foro Entre Fronteras, the INCAA, the Audio-Visual Division of the Ministry of Culture of Brazil and the Office of Promotion of Cultural Industries of Paraguay. The idea originated in November 2008 when officials of the Ministry of Culture of the Mercosur agreed upon the creation of a fund dedicated to promote cultural projects from the region. The documentaries to be produced under the

agreement were selected by a jury composed of film-makers from Argentina, Brazil and Paraguay at the Santa Maria Cinema and Video Festival.

Representatives from INCAA and Ancine, along with the Paraguayan Director of Cultural Industries and the Uruguayan Institute of Cinema and Audio-Visual in the RECAM (Reunión Especializada de Autoridades Cinematográficas de Cine y Audiovisuales del Mercosur/Reunião Especializada de Autoridades Cinematográficas de Cine e Audiovisuais do Mercosul) attended a meeting of the Ministers of Culture of the member countries that took place in February 2010 to discuss the circulation of the cultural industries (Recam).

The second trend revolves around the emergence of a new generation of film-makers as well as the diversification of forms of production. Traditionally, São Paulo, Rio de Janeiro and Buenos Aires had been the sites where production decisions were made by predominantly male film-makers. Although these cities continue to be the preferred location of production companies and the setting of many contemporary Argentine and Brazilian films, the peripheries have experienced a resurgence which, albeit modest, may be of greater significance in future years. In addition, the perspective, interests and techniques of film-makers have all been expanded by both the active participation of female film-makers, such as Argentina's Lucrecia Martel and Brazilian Tata Amaral, and female characters leading in *Cama adentro/Live-in Maid*; *Eu, Tu, Eles/Me, You, Them*; and *Casa de Areia/ House of Sand*.

The third group of trends is related to the presentation of social phenomena in both countries brought about by high unemployment, economic crisis and socioeconomic inequality. In this regard, scholar Gastón Lillo has noted that both the cinematic aesthetic and the system of production prevailing since the 1960s and 1970s have had to adapt to the dominant global neoliberalism (Lillo 2007: 7). Indeed, referring to Argentine cinema, Oubiña has judiciously asserted that

> [i]f politics are not in the forefront as a theme or as a conflict, that's because they pervade all personal relationships: an omnipresence of the political that extends across (and produces) habits and forms of behaviour. In this sense, the characters of these films are privileged sensors, making it possible to understand the relationship between the forces of a perverse socio-economic system. (Oubiña 2004: n.p.)

Thus, though Argentine films produced after 1995 might not have political agendas, they still remain firmly influenced by Argentina's political context and the socioeconomic implications of a new social order whose most conspicuous feature is adapting to the push of globalization. This tension between the local and the global, the national and the post-national, does not imply the demise of the nation as a site of representation and a topic to be addressed. Indeed, most films thematize national problems and concerns. A similar trend is noticeable in Brazilian cinema, where the depiction of social violence in

contemporary Rio or the portrayal of disenfranchisement in marginal areas, such as the *sertão* and the *favela*, point to the efficacy or lack thereof of national projects that seek to modernize and shape Brazilian society and culture. Indeed, given this context, Brazilian anthropologist Gabriel Lins Ribeiro has stressed the prevalence of the nation-state as a suitable entity to analyse issues of territory, population and culture (2002: 240).

If the nation continues to be an organizing axis for the cinematic production of Argentina and Brazil, it is appropriate to refer to them as examples of national cinema. Defining national cinema, Paul Willemen highlights the importance of cultural specificity

> established by governmental actions [and] implemented through institutions such as a legal framework of censorship, industrial and financial measures on the economic level, the gearing of training institutions towards employment in national media structures, systems of licensing governed by aspects of corporate law, and so on. (Willemen 2006: 33)

Taking Willemen's perspective into account, it might be argued that discussions of national cinema should not be limited to a body of 'films produced by and within a particular nation station' (Higson 1989; see also Higson 2000; Crofts 2006), but should also encompass a discussion of modes of co-production, distribution, exhibition, audience and critical and cultural discourses, alongside state policies and legislation which, as Willemen points out, ultimately (and substantially) regulate and control film production by establishing subsidies, screen quotas, tariff constraints, censorship, regulations and training institutions.

Since the late 1990s there has been a renewed interest in contemporary Argentine and Brazilian film-making, as attested by the number of critical publications in Spanish, Portuguese and English. Regarding contemporary Argentine cinema, these include the bilingual *New Argentine Cinema* (2002) by Horacio Bernades, Diego Lerer and Sergio Wolf and Gonzalo Aguilar's *Other Worlds: New Argentine Film* (2008), which, along with Fernando Martín Peña's *Generaciones 60/90 cine argentino independiente* (2003), trace the evolution of the New Argentine Cinema—that is to say, independent films that have attained national and international critical acclaim, but lukewarm success at the box office. *New Trends in Argentine and Brazilian Cinema* deals with both independent and popular film directors from Argentina. While Tamara Falicov's *The Cinematic Tango: Contemporary Argentine Film* (2007) provides an overview of Argentine cinema in the twentieth century, *New Trends in Argentine and Brazilian Cinema* focuses only on films produced after the passage of laws that regulate contemporary film production. Gabriela Copertari's *Desintegración y justicia en el cine argentino contemporáneo* [Desintegration and Justice in Contemporary Argentine Cinema] (2009) and Joanna Page's *Crisis and Capitalism in Contemporary Argentine Cinema* (2009) touch upon questions of class, nation and identity politics, which also inform some of the essays about Argentine cinema included in this volume, albeit analysing different films.

Key publications on contemporary Brazilian cinema include Lúcia Nagib's *The New Brazilian Cinema* (2003), Luiz Zanin Oricchio's *Cinema de Novo: Um Balanço Crítico da Retomada* [Cinema de Novo: A Critical Survey of the *Retomada*] (2003) and the edited collection by Daniel Caetano (2005), *Cinema Brasileiro 1995–2005: Ensaios sobre uma década* [Brazilian Cinema 1995–2005: Essays on a Decade], which focuses on the themes and stylistic approaches of the films produced since the *Retomada*. No less important are Pedro Butcher's *Cinema Brasileiro Hoje* [Brazilian Cinema Today] (2005), which discusses the complex relationship that has developed between Brazilian cinema and television since the creation of Globo Filmes in 1997, and Lúcia Nagib's *A Utopia do Cinema Brasileiro* (2006), later released in English as *Brazil on Screen: Cinema Novo, New Cinema, Utopia* (2007), which offers an in-depth analysis of well-known films of the 1990s which rework some of the themes, aesthetics and 'clichés' of the 1960s' cinematic movement called Cinema Novo. Taking one step further from these earlier works, the essays about Brazilian cinema included in this volume are interested not only in the themes and stylistic approaches of contemporary films but also in the cinematic and cultural policies that shaped the industry during a particular historical moment. In diverse ways, then, the focus of the essays here is on trends resulting from legislative changes and the emergence of new funding institutions which have fostered Brazilian cinema since the early 1990s.

More recently, two volumes brought contemporary Argentine and Brazilian cinema together for the first time: Denise da Mota da Silva's *Vizinhos Distantes: Circulação cinematográfica no Mercosul* [Distant Neighbors: Cinematic Circulation in Mercosur Countries] (2007) examines the cultural, political, historical and economic determinants of film initiatives, including those made under the Mercosur and Ibermedia Treaties, in Uruguay, Paraguay, Argentina and Brazil, and the collection of essays in Gastón Lillo and Walter Moser's bilingual compilation *Cine, historia y sociedad: Cine argentino y brasileño desde los años 80/Cinema, History and Society: Argentinian and Brazilian Cinema since the 80s* (2007), which further displays a concern with the history and discussion of both Argentine and Brazilian cinema while focusing specifically on sociopolitical, cultural and economic issues as well as the state practices which have impacted the production of films. *New Trends in Argentine and Brazilian Cinema* complements these existing critical studies on Argentine and Brazilian cinematography by presenting original essays which tackle, though not always directly, key issues resulting from new developments in Argentine and Brazilian cinema from 1995 on. *New Trends in Argentine and Brazilian Cinema* benefits from, and contributes to, the variety of approaches that inform these works.

The questions that the essays in this collection seek to address revolve around how new socio-economic policies affected Argentine and Brazilian cinema: To what extent did the new financing system influence the thematic and stylistic forms of films? How did new notions of individual and social identity relate to developments in film in both countries? What role has cinematic production played in concepts of national identity? How have

films attempted to represent the changing roles of the state and civil society? What are the lines of continuity and change visible in contemporary Argentine and Brazilian cinematography? The essays are organized around three nuclei. The first deals with the production of films—from the metropolises of São Paulo, Rio and Buenos Aires, as well as from the southern part of Argentina. It also surveys the distribution of national films in Argentina and Brazil and between both countries. Carolina Rocha's 'Contemporay Argentine Cinema during Neoliberalism' explores the resurgence of Argentine cinema since the passing of Law 24,377. By looking at film production and consumption, the emergence of young film-makers and the performance of both commercial films and those belonging to the so-called New Argentine Cinema, she makes the case for the success of Law 24,377 regarding an increased national production, but not necessarily in higher film consumption of national cinema by local audiences. In 'The Fall and Rise of Brazilian Cinema,' Cacilda Rêgo offers a glimpse into how legislation for audio-visual investment played a crucial role in the revival of Brazilian national film production in the 1990s and what subsequent steps were taken by the state to strengthen and protect the cinematic sector. Rêgo shows that public policy towards the Brazilian film industry has been important, but limited, and chronic structural problems remained during the 1995–2005 period. Conversing with Rêgo's essay, Courtney Brannon Donoghue's 'Globo Filmes, Sony and Franchise Film-making: Transnational Industry in the Brazilian *Pós-retomada*' discusses the rise of Globo Filmes as the dominant producer and distributor in the *Pós-retomada* period (1995–1998) as well as the importance of private corporate funding and co-productions with transnational corporations, particularly Sony's subsidiary Columbia, to the Brazilian film industry. Her analysis underscores Globo TV's domination of the national film market and how Brazilian television has shaped Brazilian cinema since the late 1990s. Marina Moguillansky's 'Close Strangers: The Role of Regional Cultural Policies in Brazilian and Argentine New Cinemas' discusses the background of New Brazilian and Argentine Cinemas in the context of Mercosur's institutional framework and cultural policies. The creation of Mercosur as a common market in 1995 coincided with the passing of legislation to protect Argentine and Brazilian film production. Moguillansky addresses the fact that, over time, the political context changed, leading to a new model of regional integration in which cultural issues became more central. In 'New Visions of Patagonia: Video Collectives and the Creation of a Regional Video Movement in Argentina's South', Tamara L. Falicov deals with new organizations that present different aesthetic agendas emerging from a marginal area of film production. Traditionally, the Argentine South has been the site of utopian projects, as recorded by well-established film-makers (Stites Mor 2009). Within this context, Falicov analyses the ways in which Patagonian videomakers are testing the boundaries of what it means to make independent video and film in Argentina. She concludes that groups such as ARAN (Asociación de Realizadores Audiovisuales de Neuquén/Association of Audio-visual Film-makers of Neuquén) and RIPA (Realizadores Independientes de la

Patagonia Agrupados/Independent Film-makers of Patagonia) are not only creating their own narratives and images of Patagonia—thus challenging the predominant film narratives and images in which this region is represented as a tourist landscape—but also providing alternative access to them via regional, national and Ibero-American film festivals, as well as via the internet.

The second nucleus concerns itself with the analysis of films that deal with the impact of neoliberal policies on unemployment, inequality, poverty and, ultimately, personal relationships. Hence, as these essays show, even if not explicitly dealing with politics as the films made in the 1970s and 1980s did, the films made from 1995 on have not given up on showing the political, economic and cultural dimensions of a perverse socio-economic system and how they have helped to shape public institutions, social relationships and individual and collective identities. One evident concern of the films analysed here and produced in both Argentina and Brazil after the mid 1990s is the impact of globalization on these societies. If, as demonstrated in the first section, globalization has shaped the financing, production and distribution of Argentine and Brazilian films due to technological advancements and the flow of information and capital, there is another side that needs to be considered. Discussing the globalizing processes of neoliberalism since the 1970s, Jane Schneider and Ida Susser hold that 'neo-liberal economic restructuring has also marginalized poor residents, increased or concretized ethnic and racial divisions, increased the subordination of women in new ways, and opened the door to a burgeoning criminal economy resting heavily on drug traffic' (Schneider & Susser 2003: 4). All of these problems inform the scripts of the films examined in this section, not just in describing social reality but also in presenting an aesthetic representation of the phenomena created by globalization.

In addition, the films studied in this part can be grouped together because of their concern with the ways in which space in neoliberal times redefines social relations. In this regard it is pertinent that they all consider, albeit in different degrees, what globalization scholar John Tomlinson calls 'complex connectivity'; that is to say, the multifaceted network of interconnections and interdependencies that characterize modern social life (1999: 2). Given that connectivity allows people to feel close, even when they are separated, Tomlinson argues that the concept has significant value in understanding the use of spaces. Moreover, it affects the localities which he defines as 'the places where people live their everyday lives: the day-to-day environments of 'home'' (Tomlinson 1999: 7). The fact that the Argentine and Brazilian films included in this section focus on these localities certainly constitutes a new trend that represents the interconnection between social reality, art and representation. The first essay in this section belongs to Ana Ros. In 'Leaving and Letting Go as Possible Ways of Living Together in Jorge Gaggero's *Cama adentro/Live-in Maid*' Ros examines the downward mobility of the Argentine middle class as fundamental in developing collaboration with other classes. She argues that by engaging in solidarity over defending their private interests (which the author calls 'social

class transference phenomenon'), the film questions the traditional contacts between social classes, revealing them to be obstacles to forging new kinds of relationships and unimagined ways of dealing with the implications of neoliberalism. Ana Laura Lusnich's 'Electoral Normality, Social Abnormality' centres on *Nueve reinas/Nine Queens* (Fabián Bielinsky, 2000), a paradigmatic film that condenses several themes which characterized Argentina's political, economic and social life between 1989 and 2001. This essay examines the film as a cultural text from two different points of view: the recovery and reformulation of two dominant trends in earlier Argentine cinema, costumbrist realism (characterized as the elevation of daily behaviours and colloquial forms of speech) and the metaphorical film noir, developed mainly between 1976 and 1983. Lusnich's emphasis is on the original features of the film which underscore the immediate consequences of the neoliberal policies of the democratically-elected presidents Carlos Menem and Fernando de la Rúa: social disintegration and the concept of honourable work as a negative value, mercantilism and the consolidation of an individual identity, and the disarticulation of the state as an instrument of social unity and mediation.

The tensions posited by neoliberalism in the 1990s are also felt in areas that have been scarcely depicted in Argentine cinema, such as the North. Amanda Holmes' 'Landscape and the Artist's Frame in Lucrecia Martel's *La ciénaga/The Swamp* and *La niña santa/The Holy Girl*' interprets spatial representation in two of Lucrecia Martel's films: *La ciénaga* (2001) and *La niña santa* (2004). A reflection of the disquieting political and economic atmosphere of the era, these films exemplify new perspectives on spatial categorization and construction: *La ciénaga* responds to cultural antecedents that portrayed the New World as an exoticized landscape, while *La niña santa* defies hegemonic aesthetics for the framing and definition of interior space. Holmes argues that the filmic construction of space generates questions about the formation of social and personal order in the complexity of contemporary Argentine society.

As the Argentine state withdraws from public life, who imposes order and law? What are the mechanisms to regulate violence? In 'Transactional Fiction: (Sub)urban Realism in the Films of Trapera and Caetano,' Beatriz Urraca explores how filmic production engages the process of (sub)urban identity formation and its sociocultural frameworks in its portrayal of modern Buenos Aires. In *Mundo grúa/Crane World* (Pablo Trapero, 1999), *El bonaerense/The Policeman* (Trapero, 2002), *Bolivia* (Adrián Caetano, 2001) and *Un oso rojo/A Red Bear* (Caetano, 2002), social and artistic concerns are linked to the events surrounding the 2001 collapse of the Argentine economy. The essay argues that the human relationships portrayed in these films are determined by spaces that tend to be transitional and public, alienating and chaotic, populated by irreparably broken objects. The films' dominant discourse contributes to reflecting modes of social interaction defined by the precarious and the temporary, the transactional and the contractual. For his part, James Scorer explores in his essay 'Trigger-Happy: Police, Violence and the State in *El bonaerense/The Policeman*' the cinematic perspectives on

police and policing in Argentine society since the 1990s. With the neoliberal philosophy of Carlos Menem's administration came the withering of state protection, resulting in what Javier Trímboli has called a country 'a la intemperie' [left out in the open] (Trímboli 2003: 188). Scorer argues that there is a striking shift in the depiction of the police in a body of films released between 2000 and 2002, such as *Plata quemada/ Burnt Money* (Marcelo Piñeyro, 2000), *La fuga/The Flight* (Eduardo Mignogna, 2001), *Un oso rojo/A Red Bear* and *Tumberos* (TV) (both Adrián Caetano, 2002). He asserts that Pablo Trapero's film *El bonaerense* strikes at the dark heart of the ties between state and city assemblage at the turn of the millennium.

Contemporary Brazilian cinema has captured the crux of the social crisis in blockbuster films such as *Cidade de Deus/City of God* (Fernando Meireles & Kátia Lund, 2002), *Ônibus 174/Bus 174* (José Padilha & Felipe Lacerda, 2002), *O Homem do Ano/ The Man of the Year* (José Henrique Fonseca, 2003) and *Tropa de Elite/Elite Squad* (José Padilha, 2007). Piers Armstrong's essay 'The Socially Productive Web of Brazil's Urban Über-dramas' examines the predominant genre of 'urban über-dramas,' which are large-scale, graphic films dealing with social dysfunction. He holds that the genre draws on real-life dramas and integrates documental aspects, and yet often has recourse to stylistic techniques usually not associated with realism, including MTV style and cyber-culture touches. Documental style, meanwhile, can actually undermine the suspension of disbelief and the realist illusion to which its sense of authenticity contributes. Overall, however, the psychological compact at the heart of realism is sustained, largely because of the concern for social mimesis. For her part, Vanessa Fitzgibbon in 'Fernando Meirelles' *Cidade de Deus/City of God:* The Representation of Racial Resentment and Violence in the New Brazilian Social Cinema' focuses on Fernando Meirelles' *Cidade de Deus:* the most significant work of the Brazilian Social Cinema since Cinema Novo. Departing from Mikhail Bahktin's concept of heteroglossia, Fitzgibbon examines the role of racial resentment and marginality in the escalation of social violence in Brazilian society.

The nucleus of the third and final set of essays deals with the representation of gender. The cinematic revivals which emerged in Argentina and Brazil during the 1990s have both been marked by the increased participation of female directors. Not only did a record number of female directors release films in the year 2005 in Argentina— constituting approximately 20 percent of national releases for that year—, but it is also estimated that in Brazil 20 percent of the productions released from the mid- to late 1990s were directed by women. This section covers the work of female film-makers as well as films that represent the plight of women predominantly, but not exclusively, in Brazilian society. Taking into account that 'globalizing processes are of course gendered' (Schneider & Susser 2003: 8), this section begins with Ana Peluffo's essay, 'Staging Class, Gender and Ethnicity in Lucrecia Martel's *La ciénaga/The Swamp.*' Peluffo reads Martel's film as a visual *exposé* of the contradictions of the ideology of racism in Argentina—a country that has traditionally portrayed itself as more 'European' or 'civilized' than its

Latin American neighbours. Although much has been written about *La ciénaga/The Swamp* (2001), a film that has in recent years achieved an almost iconic status in New Argentine Cinema, Peluffo tackles the yet-unexplored question of domestic service and its semantic relationship to class and ethnicity and makes a case for the ideological tension between word and image, textuality and visuality, that positions the viewer in a critical stance with the ideology of racism in the Andean region of Argentina. In 'The Dystopian City: Gendered Interpretations of the Urban in *Um céu de estrelas/A Starry Sky* (Tata Amaral, 1996) and *Vagón fumador/Smokers Only* (Verónica Chen, 2001)' Charlotte Gleghorn offers detailed analyses of these films, suggesting how the representation of the body in them is inextricably linked to the violent histories of dictatorship and neoliberalism in both countries.

In 'Reimagining Rosinha with Andrucha Waddington and Elena Soarez: Nature, Woman and Sexuality in the Brazilian Northeast, from Popular Music to Cinema' Jack Draper frames director Andrucha Waddington and screenwriter Elena Soarez's work in *Eu, Tu, Eles/Me, You, Them* (2000) and *Casa de Areia/House of Sand* (2005) as an updating of the union between woman and nature prevalent in regional popular culture, particularly in country music. As Draper shows, these films develop psychologically-complex studies of Northeastern women in the heartland of traditional rural culture. Thus, he concludes, this film-maker/screenwriter partnership has yielded a remarkable, delicate balancing act, combining an appreciation of regional popular culture and history with a rethinking of women's agency in the face of patriarchal ideology and geographic isolation. The last essay, Leslie Marsh's 'Taking Initiatives: Brazilian Women's Film-making Before and After the *Retomada*' offers a reflection on how and to what degree Brazilian women film-makers have been able to negotiate with state and private agencies over the course of their careers to secure production funds and find distribution for their films. This essay is based on interviews conducted in 2001, 2002 and 2005 with directors Norma Bengell, Eunice Gutman, Tizuka Yamasaki, Lúcia Murat, Ana Carolina Teixeira Soares, Helena Solberg, Ana Maria Magalhães and Suzana Amaral.

The editors hope that the essays in this volume—which identify tensions between production and distribution, the impact of globalization in Argentina and Brazil and the significant production of female film-makers—will provoke thought, stimulate discussion and encourage debate amongst its readers.

References

Aguilar, G. (2008) *Other Worlds: New Argentine Film*, New York: Palgrave Macmillan.

Alvaray, L. (2008) 'New Waves of Latin American Cinema', *Cinema Journal* 43.3: 48–65.

Bernades, H., Lerer, D. and Wolf, S. (2002) *New Argentine Cinema*, Buenos Aires: Tatanka.

Butcher, P. (2005) *Cinema Brasileiro Hoje*, São Paulo: Publifolha.

Caetano, D. (ed.) (2005) *Cinema Brasileiro 1995-2005: Ensaios sobre uma década*, Rio de Janeiro: Azougue.

Caetano, D., Valente, E., Melo, L.A.R. and Oliveira Jr., L.C. (2005) '1995–2005: Histórico de uma década' in D. Caetano (ed.) *Cinema Brasileiro 1995–2005: Ensaios sobre uma década*, Rio de Janeiro: Azougue, pp. 11–47.

Copertari, G. (2009) *Desintegración y justicia en el cine contemporáneo argentino*, Rochester: Támesis.

Crofts, S. (2006) 'Reconceptualizing National Cinema/s' in V. Vitali and P. Willemen (eds.) *Theorizing National Cinema*, London: BFI, pp. 44–58.

Drake, P. (2006) 'The Hegemony of US Economic Doctrines in Latin America' in E. Hershberger and F. Rosen (eds.) *Latin America After Neoliberalism. Turning The Tide in the 21ˢᵗ Century?* New York: NACLA, pp. 26–48.

Falicov. T. (2007) *The Cinematic Tango: Contemporary Argentine Film*, London: Wallflower.

Falicov. T. (2000) 'Argentina's Blockbuster Movies and the Politics of Culture under Neoliberalism 1989–1998,' *Media, Culture and Society* 5.22: 327–42.

García-Canclini, N. (1997) 'Will There Be Latin American Cinema in the Year 2000? Visual Culture in a Postnational Era' in A.M. Stock (ed.) *Framing Latin American Cinema*, Minneapolis: University of Minnesota Press, pp. 246–258.

Getino, O. (1998) *Cine argentino entre lo posible y lo deseable,* Buenos Aires: Ediciones Ciccus.

Globo Filmes (2009) website, http://globofilmes.globo.com/GloboFilmes/0,,5367,00.html. Accessed on December 22, 2009.

Higson, A. (2000) 'The Limiting of Imagination of National Cinema' in M. Hjort and S. Mackensie (eds.) *Cinema and Nation,* New York: Routledge, pp. 63–74.

Higson, A. (1989) 'The Concept of National Cinema,' *Screen* 30.4: 36–47.

Johnson, R. (1991) 'The Rise and Fall of Brazilian Cinema, 1960–1990,' *Iris* 13: 97–124.

Law 24,377. http://www.cinelatinoamericano.org/assets/docs/Ley%20de%20Cine%20 24.377%20Argentina.pdf . Accessed August 1, 2010.

Lillo, G. (2007) 'Presentación' in G. Lillo and W. Moser (eds.) *Cine, historia y sociedad: Cine argentino y brasileño desde los años 80/Cinema, History and Society: Argentinian and Brazilian Cinema since the 80s*, New York: Legas, pp. 7-8.

Lillo, G. and Moser, W. (eds.) (2007) *Cine, historia y sociedad: Cine argentino y brasileño desde los años 80/Cinema, History and Society: Argentinian and Brazilian Cinema since the 80s*, New York: Legas.

Lins Ribeiro, G. (2002) 'Tropicalismo e Europeísmo. Modos de representar o Brasil e a Argentina' in A. Frigeiro and G. Lins Ribeiro (eds.) *Argentinos e Brasileiros. Encontros, Imagens e Estereótipos*, Petrópolis: Vozes, pp. 237-52.

Mercosul/Mercosur (n.d) website, http://www.mercosur.int/msweb/Portal%20Intermediario/. Accessed August 1, 2010.

Mota da Silva, D. (2007) *Vizinhos Distantes: Circulação cinematográfica no Mercosul*, São Paulo: Annablume.

Nagib, L. (2007) *Brazil on Screen: Cinema Novo, New Cinema, Utopia*, New York: I.B. Tauris.

Nagib, L. (2006) *A Utopia do Cinema Brasileiro*, São Paulo: Cosacnaify.

Nagib, L. (ed.) (2003) *The New Brazilian Cinema*, New York: IB Tauris.

Oubiña, D. (2004) 'Between Breakup and Tradition: Recent Argentinean Cinema,' *Senses of Cinema* (online), http://archive.sensesofcinema.com/contents/04/31/recent_ argentinean_cinema.html. Accessed December 12, 2009.

Oricchio, L. Z. (2003) *Cinema de Novo: Um Balanço Crítico da Retomada*, São Paulo: Estação Liberdade.

Page, J. (2009) *Crisis and Capitalism in Contemporary Argentine Cinema*, Durham: Duke University Press.

Peña, F. M. (2003) *Generaciones 60/90: cine argentino independiente*, Buenos Aires: Malba.

RECAM (n.d.) website, http://www.recam.org/?do=news&id=9135a07a5ac8d34d6a099 e5a2ed3d8e7. Accessed June 6, 2010.

Rêgo, C. (2008) 'Rede Globo: A TV que virou estrela de cinema,' *Studies in Latin American Popular Culture* 27: 182–90.

Rocha, C. (2009) 'Contemporary Argentine Cinema during Neoliberalism,' *Hispania* 93.3: 824–34.

Rocha, C. (2006) 'Idealismo en tiempos del mercado? La cinematografía de Piñeyro en los noventa,' *Nuestra América. Revista de Estudios sobre la Cultura Latinoamericana* [Portugal] 2: 211–26.

Shaw, L. and Dennison, S. (2007) *Brazilian National Cinema*, New York: Routledge.

Schneider, J. and Susser, I. (2003) *Wounded Cities: Deconstruction and Reconstruction in a Globalized World*, New York/Oxford: Berg.

Silva Neto, A. L. (2002) *Dicionário de Filmes Brasileiros*, São Paulo: n.p.

Stam, R., Vieira, J. L. and Xavier, I. (1995) 'The Shape of Brazilian Cinema in the Postmodern Age' in R. Johnson and R. Stam (eds.) *Brazilian Cinema*, New York: Columbia University Press, pp. 389–472.

Stites Mor, J. (2009) 'Imágenes de un sur desplazado: Fernando Solanas y el imaginario cultural de la transición' in C. Feld and J. Stites Mor (eds.) *El pasado que miramos, Memoria e imagen ante la historia reciente*, Buenos Aires: Paidos, pp. 221–54.

Tomlinson, J. (1999) *Globalization and Culture*, Cambridge: Polity Press.

Trimboli, J. (2003) 'Una lectura de las imágenes de los noventa' in A. Birgin and J. Trimboli (eds.) *Imágenes de los noventa*, Buenos Aires: Libros del Zorzal, pp. 187-203.

Willemen, P. (2006) 'The National Revisited' in V. Vitali and P. Willemen (eds.) *Theorising National Cinema*, London: BFI, pp. 29–43.

Contemporary Argentine Cinema During Neoliberalism

Carolina Rocha
Southern Illinois University Edwardsville

In the early 1990s, Argentine cinema production and consumption reached historically low records with twelve films released in 1990, seventeen in 1991, ten in 1992 and thirteen in 1993. A host of reasons contributed to this decline. First, Argentine President Carlos Menem (term of office 1989–1994) cancelled state funds for the National Institute Cinematography (INC) as part of a larger plan of reducing governmental expenditure. This measure constituted a harsh blow to Argentine film-making for, unlike American mainstream cinema that is solely financed by private investors, national cinemas around the world require state funds as primary sources for production. The inability of the Argentine state to sponsor film production resulted in a decrease of national films released. In addition, given this elimination of state support, even Argentine studio companies reduced their investments in film production (Getino 1998: 117). For instance, in 1994, only four movies were released in Argentina, a record low for a country that had traditionally had one of the three major Latin American film industries.

Another factor that impacted film consumption around the world, and also in Argentina, revolved around new access to visual products, thanks to the widespread availability of VCRs in the 1980s. Anthropologist Néstor García Canclini noted in the early 1990s in Latin America 'the displacement of cinema from the public arena to the home, [a trend that] involves not only changes in pattern of consumption but also changes in the production and financing of the offering' (García Canclini 1997: 248). In the case of Argentina, not only did audiences choose to consume films through new technology but also, and more importantly, an economic crisis made the price of a cinema ticket a

luxury for middle-class audiences and an unaffordable expense for the working class. It soon became evident that audience loyalty towards domestic cinema—something that was noticeable in the 1980s when some Argentine films generated good box-office returns and one Argentine film, *La historia oficial/The Official Story* (Luis Puenzo, 1986), won an Oscar for Best Foreign Film—was fast disappearing among Argentine cinemagoers. This, in turn, produced less demand for national movies.

What further complicated the situation of Argentine cinema was its lack of appeal to domestic audiences. According to Argentine film-maker Octavio Getino, Argentine films accounted for only 3.5 per cent of the released films in 1994. Thus, as Getino judiciously asserts, referring to the early 1990s, 'Argentine cinema has lost the interest of the public' (Getino 1998: 121). The virtual disappearance of Argentine cinema led the state to backtrack from its initial denial of state funds. Taking into consideration that film is part of the so-called cultural industries and that culture needs to be protected, Law 24,377, which sought to reinvigorate domestic film production, was passed in 1994. This law, which was implemented in 1995 and is still in effect, not only regulates but also encourages film production and exhibition in Argentina. This law dictates the creation of a national public entity to regulate cinematography: the National Institute of Cinematography and Audio-visual Arts (INCAA). In addition, Law 24,377 mandates several measures to develop local film-making, such as opening credit lines, subsidies, and screen quotas for national films. Specifically, 10 per cent of the box office income generated by both national and foreign films makes up a fund that, in turn, is redistributed among local film producers and directors. These subsidies are earmarked for films that are deemed to 'contribute to the development of national cinematography being by their cultural, artistic, technical or industrial qualities, except those that are based on or related to sex and drugs, and that do not present a positive influence for the community' (Law 24,377 Article 26).

Since the implementation of Law 24,377 in 1995, Argentine film production has dramatically increased. However, the deregulation of the national economy as a result of neo-liberal measures implemented in the early 1990s facilitated the entrance of foreign companies that invested heavily in the entertainment sector, particularly film exhibition.

The presence of foreign companies constituted a new challenge to domestic production as the exhibition of Hollywood productions attracts larger audiences and, thus, generates more revenue. How did Argentine cinema fare since the passing of a protectionist law designed to mitigate the impact of the growing trans-nationalization of visual products? In this chapter, I will assess Argentine film production from 1996 to 2006—which corresponds to the period between the implementation of Law 24,377 and the most recent year of complete statistical data compiled by the Argentine Union of Argentine Cinematography (SICA). By taking into account Argentine film's domestic box office performance as well as its international reception, I will look into Argentine

cinematography after the passing of Law 24,377. This will allow me to evaluate whether this law successfully contributed to the development of a national cinema in times of increased global interactions (Appadurai 1997: 46). I will also compare the success of Argentine films by seasoned film-makers to the performance, both domestic and international, of the New Argentine Cinema film directors in order to explore the ways in which this national cinematography has appealed to different audiences.

General considerations about the period

Argentine film production and consumption between 1996 and 2006 has been punctuated by the impact of economic recessions triggered by Argentina's neo-liberal economic model. For instance, in 1996, when the national unemployment index reached 18.8 per cent (Svampa 2005: 35), the overall number of national spectators amounted to 21 million, the lowest number in the period under study (DEISICA 1996: 6). The financial crisis that took place in the last months of 2001 and resulted in the resignation of President Fernando De la Rúa also influenced the number of Argentine cinemagoers. In 2001 and 2002, there was a significant decrease in the number of spectators: from 33 million in 2000 to 31 million both in 2001 and in 2002 (DEISICA 2000, 2001 & 2002: 10–12). The secretary of the Argentine Union of Argentine Cinematographic Industry, Mario López Barreiro in his annual summary of the sector forecasted reduced budgets with the following words: 'esta contracción, que se trasladará a la recaudación impositiva, sin duda tendrá una incidencia negativa sobre el fondo de fomento y producción para el año 2002.' [this contraction, that will be reflected in the tax revenue, will undoubtedly have a negative impact upon the fund of promotion and production of the year 2002] (DEISICA 2002: 11, 1). Indeed, the decrease in consumption negatively impacted on the funds collected in box offices and, thus, the money that the INCAA has been able to distribute for new film productions. Consequently, in a country where film production heavily depends on box-office revenues, it is important to take into account the implications of recessive economic cycles as well as financial booms.

Another issue that has to be considered is the price of a movie ticket for local audiences, which, during the 1990s, was similar to that in the United States. When President Eduardo Duhalde was sworn as president in January 2002, he ended the pegging of the Argentine peso to the US dollar—a trademark feature of the Menem years (1989–1999) and the De la Rúa administration (1999–2001). This measure impacted on the price of movie tickets, which was reduced to 30 per cent of its previous value, making cinema-going more accessible to domestic consumers, even in a recessive economy.

Argentine films, audiences and market

After the implementation of Law 24,377, Argentine film production increased significantly when compared to the number of films from the early 1990s. In eleven years, some 489 domestic films were released: the highest number ever among similar periods in Argentine film production. This fact also attests to the positive stimulus derived from a renewed interest in this industry, particularly among young film-makers.[1]

Table 1: Argentine film production and consumption, 1996–2006.

Year	National films released	National films produced	Theatres
1996	38	25	480
1997	28	36	608
1998	35	23	830
1999	38	N/A	920
2000	45	39	956
2001	45	39	852
2002	37	30	334
2003	46	67	1003
2004	54	28	290*
2005	65	41	290
2006	58	58	297

Source: DEISICA

What is apparent from the data shown in Table 1 is that the crisis of 2001 negatively impacted on the film industry in 2002 but, since then, film productions have rebounded in the 2003–2006 period, and even considerably surpassed the number of releases of the year prior to the crisis. This fact highlights the positive influence for the film industry of ending the convertibility of the peso and the dollar, since production costs visibly decreased for national films. In addition, except for the year 1997 when there were only 28 films released, national production has remained strong, reaching a peak in 2005 when 65 films were made.

A number of reasons have contributed to this solid production. First, undoubtedly, the beneficial clauses of Law 24,377 that provide financial incentives for local productions have jumpstarted Argentine cinematography. Second, the emergence of new directors trained in both international and domestic film schools has contributed to the diversification of themes, styles and genres. Third, several films, with nationally-recognized stars, have been very successful among cinemagoers, probably because they provide an opportunity for cultural heterogenization in the otherwise homogeneous film

consumption (Appadurai 1997: 32). I will touch more on each of these reasons, but I will now analyse the distribution and exhibition of national films.

Film exhibition during the period under study experienced some changes as independently-owned movie theatres were replaced by foreign-managed multiplexes. Indeed, when taking into account the number of movies theatres, it is evident that the tendency of the early 1990s to reduce the number of traditional theatres in favour of multiplexes with several small rooms continued during the 1996–2006 period. For instance, the annual report of the first trimester of 1999 and 2000 noted that, 'continuó por tercer año consecutivo la tendencia de inaugurar complejos cinematográficos iniciada en diciembre del [19]96 con el aterrizaje de empresas norteamericanas y australianas' [the tendency of opening cinematographic complexes that began in December [19]96 with the arrival of American and Australian companies continued.) (DEISICA 1997: 9, 4].[2] These multiplexes located in shopping centres were the main outlets of exhibition in Argentina, particularly those of the international chains Hoyts General Cinema and Village Roadshow and Cinemas.[3] Hoyts General Cinema is a transnational exhibitor and a distribution company that owns multiplexes in Argentina, Brazil, Chile and Uruguay and is based in the Cayman Islands. As a profit-making company, Hoyts not only advertises the high quality equipment and technology of its multiplexes, it is also the main exhibitor of foreign films, which dominate the Argentine market. As the following table shows, the Argentine market was unevenly divided between Argentine and American films.

Table 2: Argentine and American Film Consumption in Argentina, 1996–2006.

Year	Domestic market share	US market share	Number of spectators(thousands)
1996	38 (7.96%)	78.73%	21,348
1997	28 (15%)	61 %	25,623
1998	35 (13 %)	78 %	32,400
1999	38 (15 %)	67.7 %	31,800
2000	45 (17.71 %)	73.3 %	33,500
2001	45 (12 %)	74.2 %	31,300
2002	37 (10.21%)	80.32%	31,800
2003	46 (9.2 %)	82 %	33,300
2004	54 (10.15 %)	74.53 %	44,500
2005	65 (11.82 %)	75.18 %	37,600
2006	58 (10.76%)	78.13 %	35,700

Source: DEISICA

In spite of a sustained and significant local production, Argentine films have irregular success with the local audiences. On the one hand, in 1997, three Argentine movies attracted close to 3.5 million local cinemagoers, eroding the market share of American films, which in that year accounted for its lowest point of the period under study at 61 per cent. A similar situation occurred in 1999 when three other Argentine movies had almost 3 million spectators, and thus, the American share was 67 per cent. On the other hand, the commercial success of local films was ascribed to a small number of blockbusters. For instance, if we compare the domestic market share in 2000 and 2005, in 2000 fewer Argentine films were watched by more people than when the offer of national films increased in 2005.

Argentine audiences strongly favoured American films over domestic movies, a trend that is also visible in the other two major Latin American film producers: Brazil and Mexico. For instance, for every four films screened in Argentina in 2004, only one was Argentine and the remaining three were American. One of the most significant conclusions that can be drawn from Table 1 is that American films prevailed despite the strong national cinematic production since 2001. For example, the market share of the 65 domestic films released in 2005 did not negatively impact on the consumption of American films, which was, in fact, slightly higher for that year than in 2004. In addition, in 2006 when 58 Argentine films were released—the second-highest year of local production—American movies performed better than local productions. Thus, it is evident that Argentine films faced the competition of other domestic films without significantly affecting the consumption of foreign entertainment.[4]

The fact that Argentine films competed among themselves for a market share is noteworthy, particularly if the protectionist measures that were introduced during this period are examined. Known as screen quotas, this measure was spelled out in Resolution 2016 and implemented for the first time on July 1, 2004. Screen quotas stipulate the showing of one Argentine film per movie theatre every trimester. Another measure, the median continuity—which sets different numbers of spectators per theatre to allow the uninterrupted screening of a national film[5]—was also introduced in 2004 to support domestic productions (Steinmann 2005: 25). This resolution has been strongly resented by exhibitors, who feel that showing Argentine films deprives them of the higher income that could be obtained by showing foreign films. This brings me to analyse the Argentine movies that resonated with local audiences.

During the 1996–2006 period, twelve top-grossing national movies surpassed the one-million-spectators mark. Of particular importance was the year 1997, with three blockbuster movies: *Comodines/Cops* (Nisco, 1997), *La furia/ Fury* (Stagnaro, 1997) and *Dibu, la película/Dibu, The Movie* (Olivieri & Stoessel, 1997). Other films with more than a million spectators were: *Un argentino en Nueva York/An Argentine in New York* (Jusid, 1998), *Papá es un ídolo/Dad is an Idol* (Jusid, 2000), *Nueve reinas/Nine Queens* (Bielinsky, 2000), *Corazón, las alegrías de Pantriste/Corazon, the Joys of Pantriste* (García Ferré, 2000), *El hijo de la novia/Son of the Bride* (Campanella, 2001)—the only one to be

nominated for an Oscar for Best Foreign Film—*Apasionados/Passionate* (Jusid, 2002), *Luna de Avellaneda/Moon of Avellaneda* (Campanella, 2004), *Papa se volvió loco/Dad Went Crazy* (Ledo, 2005) and *Bañeros III, Todopoderosos/Lifeguards III, Almighty* (Ledo, 2006). Most of these films were produced by Argentina Sono Film S.A.C.I.—*La furia/ Fury, Un argentino en Nueva York/An Argentine in New York, Papá es un ídolo/Dad is an Idol, Papa se volvió loco/Dad Went Crazy, Bañeros III, Todopoderosos/ Lifeguards III, Almighty* —and Artear (*Comodines/ Cops*) and Patagonik, (*Nueve reinas/Nine Queens, El hijo de la novia/ Son of the Bride* and *Apasionados/Passionate*). These films mainly pertain to three genres: comedies, dramas and thrillers. Another genre that has consistently performed well at the box office during this period is the animated movie: *Dibu, The Movie* (Oliveri & Stoessel, 1997) was the second-top-grossing film in 1997. *Manuelita* (García Ferré, 1999) was the top-grossing film of 1999 with a share of 42 per cent of the national audience, an achievement replicated by *Patoruzito* (Massa, 2004), which also had over two million domestic spectators, followed by *El ratón Pérez/Pérez, The Mouse* (Buscarini, 2006) which was second in the top-ten box office successes of 2006.

While top-grossing films should not necessarily be equated with meaningful cultural productions—in fact, most of them are produced for the entertainment and consumption of local audiences—some of these top-grossing films such as *Nine Queens, Son of the Bride* and *Moon of Avellaneda* have effectively captured the *zeitgeist* of Argentine culture at the beginning of the twenty-first century and have been rightfully recognized for this achievement, both nationally and internationally. A case in point is Bielinsky's *Nine Queens*, which was very successful among local cinemagoers. In addition, it garnered seven Condors—the most prestigious Argentine awards—and two awards at the International Film Festival of Mar del Plata. It won 21 of the 28 national nominations it received. It also did well among international audiences and garnered critical acclaim in film festivals worldwide.[6] Most of these recognitions were awarded in the European film festivals of Biarritz (France), Trieste (Italy), Lleida (Spain) and Norway. *Nine Queens* was remade for American audiences as *Criminal* (Jacobs, 2004) and even reached India, with a remake entitled *Bluffmaster* (Sippy, 2005). For his part, Juan José Campanella's *Son of the Bride,* besides its Oscar nomination for Best Foreign Film, also received numerous awards both in Argentina (nine Condors) and abroad at the film festivals of Gramado, Brazil (three), Havana (two), Montreal (two), Sant Jordi, Spain (two) and one award each in Cartagena in Colombia, Lima, Oslo, São Paulo, and Valladolid in Spain.

In the 1996–2006 period, fourteen films were commercially successful but had less than a million spectators. Among these, in 1999, two comedies, *Esa maldita costilla/That Damned Rib* (Jusid, 1999), *Alma mía/My Soul* (Barone, 1999), and one action-thriller, *La venganza/The Vengeance* (Desanzo, 1999), attracted more than two million spectators. By casting popular TV actors, these three films targeted local audiences and, hence, did not receive international recognition. For their part, Marcelo Piñeyro's *Plata quemada/ Burnt Money,* which is a rendition of Argentine writer Ricardo Piglia's novel of the same

name, and Bielinsky's *El aura/The Aura*, a noir thriller, deserve particular attention as they attracted both cinemagoers and international critical acclaim. *Burnt Money* received one of the seven Condors for which it was nominated, the prestigious Goya award given by Spain, two awards at the Havana Festival and one award in the United States. *The Aura* won six Silver Condors out of the ten for which it was nominated, as well as foreign awards at the festivals of Cartagena and Havana.

Other films with important box-office numbers are listed in Table 3.

Table 3: Argentine films which had between 100,000 and 500,000 spectators.

Film	Director	Spectators
Tiempo de valientes (2005)	Damián Szifron	461,734
Cleopatra (2003)	Eduardo Mignona	450,446
El faro (1998)	Eduardo Mignona	445,008
La edad del sol (1999)	Ariel Piluso	440,610
Martín Hache (1997)	Adolfo Aristarain	380,000
Kamchatka (2002)	Marcelo Piñeyro	372,006
Patoruzito, la gran aventura (2006)	José Luis Massa	356,742
Erreway 4 caminos (2004)	Ezequiel Crupnicoff	342,904
Iluminados por el fuego (2003)	Tristán Bauer	328, 107
Despabilate amor (1996)	Eliseo Subiela	321,225
Sol de otoño (1996)	Eduardo Mignona	312,597
Rodrigo, la película (2001)	Juan Pablo Laplace	299,845
Valentín (2003)	Alejandro Agresti	297,110
Un día en el paraiso (2003)	Juan Bautista Stagnaro	279,927
Una noche con Sabrina Love (2000)	Alejandro Agresti	240,148
Dibu 3 (2002)	Raul Rodriguez Peila	234,121
Eva Perón (1996)	Juan Carlos Desanzo	222,130
Las manos (2006)	A. Doria, J. B. Stagnaro	219,029
Lugares comunes (2002)	Adolfo Aristarain	218,249
El bonaerense (2002)	Pablo Trapero	215,784
Crónica de una fuga (2006)	Adrián Caetano	194,059
Whisky, Romeo, Zulu (2005)	Enrique Piñeyro	184,484
Derecho de familia (2006)	Daniel Burman	184,281
El perro (2004)	Carlos Sorín	178,432
No sos vos, soy yo (2004)	Juan Taratuto	175,288
Un oso rojo (2002)	Adrián Caetano	169,356
El abrazo partido (2004)	Daniel Burman	159,855
El dedo en la llaga (1996)	Alberto Lecchi	149,421
El mundo contra mí (1996)	Beda Docampo Feijóo	138,546

Historias mínimas (2002)	Carlos Sorín	138,105
Ay, Juancito (2004)	Héctor Olivera	134,609
Roma (2004)	Adolfo Aristarain	134,416
Los Pitin al rescate (2000)	Franco Bittolo	133,767
El mismo amor, la misma lluvia (1999)	J.J. Campanella	127,317
Fuerza Aerea, SA (2006)	Enrique Piñeyro	113,848
La ciénaga (2001)	Lucrecia Martel	110,321
Un hijo genial (2003)	José Luis Massa	109,149
El desvío (1998)	Horacio Maldonado	108,964
No debes estar aquí (2003)	Jacobo Rispa	105,423
En el fondo del mar (2003)	Damián Szifron	103,764
Cama adentro (2005)	Jorge Gaggero	102,503
Pizza, birra y faso (1998)	B. Stagnaro, I A. Caetano	101,709
Hasta la victoria siempre (1997)	Juan Carlos Desanzo	100,000

Source: DEISICA

These 36 films make up a heterogeneous group ranging from popular to more art-house productions. Among the films that were produced for domestic consumption with nationally-recognized TV stars and singers are *Erreway 4 caminos/Erreway 4 Roads* (Crupnicoff, 2004), *Rodrigo, la película/Rodrigo The Movie* (Laplace, 2001), *Un hijo genial/A Wonderful Son* (Massa, 2003), *Un día en el paraíso/A Day in Paradise* (Stagnaro, 2003) and *El mismo amor, la misma lluvia/The Same Love, The Same Rain* (Campanella, 1999), films that addressed topics relevant to domestic audiences include the whistleblower films of Enrique Piñeyro: *Whisky, Romeo, Zulu* (Piñeyro, 2005) and *Fuerza Aerea, SA/Air Force* (Piñeyro, 2006). Another group is made up of films based on popular American genres such as the buddy movies (*Tiempo de valientes/Time of the Courageous* (Szifron, 2005), comedies with broad appeal *(No sos vos, soy yo/It is Not You, It's Me* (Taratuto, 2004) and *Valentín* (Agresti, 2003), a feminist road movie *Cleopatra* (Mignona, 2003) and a war film (*Iluminados por el fuego/Blessed by the Fire,* Bauer, 2003). There are also films that have attracted considerable national and international critical acclaim and were made by veteran directors such as Eduardo Mignona, whose *El faro/The Lighthouse* (1998) received several awards including the Goya for Best Foreign Film in Spanish as well as other awards in Montreal, Oslo and Argentina. Carlos Sorín directed *Historias mínimas/Intimate Stories* (2002), which received 22 awards, including a Goya, and also prizes at the Havana, Los Angeles and San Sebastian film festivals. His most recent film, *El perro/Bombón: The Dog* (2004) was awarded best director in Guadalajara and won the FIPRESCI award at the San Sebastian and was, surprisingly, viewed by more spectators than the much-awarded *Intimate Stories*. Two other experienced film-makers, Alejandro Doria and Juan Bautista Stagnaro, directed *Las manos/The Hands* (2006), which received a Goya and other awards

at the Cartagena (Colombia) and Huelva (Spain) film festivals. It is important to point out that besides the credit lines and subsidies stipulated by Law 24, 377, many of the film-makers mentioned above participated in co-production and/or received financial support from the Hubert Hals fund, thus transcending local audiences and state sponsorship.

The final group is composed of film-makers who directed *operas primas*, belong to the same age group (under 40) and/or are usually grouped under the umbrella term New Argentine Cinema. Argentine film critics Horacio Bernades, Diego Lerer, Sergio Wolf, Gonzalo Aguilar and Fernando Martín Peña have hailed the arrival of the New Argentine Cinema, particularly after the release of *Pizza, birra, faso/Pizza, Beer, Cigarettes* (Caetano & Stagnaro, 1998). For Gonzalo Aguilar, in the 1990s there was a renewal in Argentine film production thanks to the New Argentine Cinema (Aguilar 2006: 13). However, a precise definition of what the NAC entails has eluded these critics. For her part, film scholar Tamara Falicov provides a persuasive explanation to group this generation based on the facts that film directors in this group belong to the same generation (most of them were born after 1965), were trained in film schools and received funding from the INCAA after a 1994 controversy that pitted seasoned directors against young ones as they vied for funding (Falicov 2007: 115–17). The discussion led to the creation of a new category, the *operas primas*, with funding available to first-time film-makers. This category has thus contributed to a democratization of cinema providing more access to young directors. For instance, in 1997, *Historias breves I y II/ Short Stories I and II,* a collection of 16 shorts made by young film-makers, was seen by 6,419 spectators. This screening has been hailed as a promising beginning for those seeking to gain exposure in the field. Nonetheless, the circulation among the public was minimal as illustrated by the number of spectators. In the following, I analyse the reception of the NAC.

The New Argentine Cinema: national and international reception

The thirteen most-watched films listed in Table 4, and that belong to the New Argentine Cinema, have collectively attracted 1.5 million spectators. A considerable number, yet one that lags behind the box-office revenues of more commercial films. This data leads me to question Joanna Page's assertion that New Argentina Cinema films 'are consciously produced as much for an international market as a domestic one' (Page 2009: 56). As I will discuss shortly, the domestic consumption of New Argentine Cinema is a point of contention among some film critics and directors.

Only four directors have been able to sustain production during the last eight years: Burman, Caetano, Trapero and Martel. Burman and Caetano have steadily captured bigger audiences, despite Burman's *Todas las azafatas van al cielo/All Stewardesses Go to Heaven* (2002) and Caetano's *Bolivia,* which did poorly at the box office. What is interesting about *Bolivia* is the fact that it has generated considerable scholarly interest

(Gundermann 2002; Page 2005) for its treatment of urban violence and racism as well as it neo-realist cinematic techniques.

Table 4: Ranking of the most-watched films of the NAC, 1996–2006.

Year	Film	Arg Spectators/ Ranking
1998	*Pizza, birra y faso* (B. Stagnaro, I A. Caetano)	101,709 (6)
1999	*Mundo Grúa* (Pablo Trapero)	68,544 (8)
2000	*Esperando al mesías* (Daniel Burman)	39,579 (N/A)
2001	*La Cienága* (Lucrecia Martel)	110,321 (N/A)
2002	*Bolivia* (Adrian Caetano)	52,272 (11)
	El Bonaerense (Pablo Trapero)	215,784 (5)
	Un oso rojo (Adrian Caetano)	169,356 (6)
2004	*El abrazo partido* (Daniel Burman)	159,855 (7)
	La niña santa (Lucrecia Martel)	104,860 (N/A)
	*Familia rodante (*Pablo Trapero)	57,000 (N/A)
2006	*Crónica de una fuga* (Adrián Cateano)	194,059 (5)
	Derecho de familia (Daniel Burman)	184,281 (6)
	Nacido y criado (Pablo Trapero)	29,882 (16)

Source DEISICA

Of the four most-watched directors, both Burman and Martel were well received in Germany. Burman received two Silver Bears at the festival of Berlin for *El abrazo partido/ The Lost Embrace*. His fourth feature film, *Derecho de familia/Family Law* (2006), has performed well at the box office and was immediately released on DVD. Lucrecia Martel, whose feature-length *La cienága/The Swamp* was recognized with the Alfred Bauer Award in Berlin, also gained four awards in Havana and two awards at the Toulouse film festival (Martín Morán 2003; Gómez 2005; Forcinito 2006; Martins 2007; & several essays in Rangil 2007).

In general, Argentine film reviewers of *La Nación, Clarín, Pagina 12* and *Ambito Financiero*, the most important and widely circulated newspapers in Argentina, have strongly supported the production of these directors, particularly the *Clarín,* which awards film prizes.[7] From the data in Table 5, which provides information about awards, it is evident that the aesthetic of the NAC has generated substantial interest at international film festivals, both in Latin America—Lima, Havana, São Paulo and Uruguay—and also in Europe—Lleida and San Sebastian (Spain), Toulouse (France), Rotterdam (Holland), and Berlin (Germany). European film festivals have celebrated particularly the stark tone of Argentine film productions from these NAC directors. This attempt to raise awareness of the socioeconomic conditions of everyday life in Argentina has been a developing

strategy through obtaining awards at European film festivals and, thus, reaching foreign investors.

Yet, as is shown in Table 4, local audiences have only cautiously supported the techniques and themes of the New Argentine Cinema. Indeed, the lack of a sizable national audience seems to be the weakness of the NAC. In 2001, film critic Jorge Carnevale wrote with great lucidity that,

> most of the films that returned to Argentina with awards and merits fall within a week into the tomb of Argentine cinema, which is the Tita Merello Complex or slowly languish at the Gaumont. With its minimalism, commonplace settings and boring dialogues, people run away from these films or do not even become aware of them. (Carnevale 2001: n.p.)[8]

Part of the alienation of local spectators may lie in the fact that, with some exceptions such as Graciela Borges in *The Swamp* (Martel, 2001), Enrique Liporace in *Bolivia* (Caetano, 2004) and Mercedes Morán in *The Holy Girl* (Martel, 2004), most of the New Argentine Cinema directors use non-professional actors in their films. They also use cinematic techniques such as a handheld camera, unusual lighting, and real sound that lacks the glossy touch of Hollywood film productions to which local audiences are accustomed. Another reason for the low public support is that most of the funding goes to cover production costs and few copies of each film are released, making its exhibition in different movie theatres difficult. Finally, when these movies are screened under the benefits of the screen quotas that I mentioned at the beginning of this chapter, low attendance motivates exhibitors to informally 'encourage' cinemagoers to watch more mainstream films. The fact that Argentine films have smaller audiences means that exhibitors can substitute a film that produces low box-office earnings by one that generates profit.

Concluding remarks

In this chapter, I have shown that Argentine cinematic production post-Law 24,377 has been strong compared to that of the early 1990s. In addition, some films have received important national and international awards, a fact that has given visibility to this national cinema. However, the support of the local public has, at best, been irregular.

While some films have enjoyed excellent box-office performances, others have failed to attract significant numbers of spectators and others have struggled to be shown, despite protectionist measures designed to ensure their circulation. The failure to interest domestic audiences and be shown has been particularly true of the productions of young directors grouped under the term of New Argentine Cinema. While the arrival of a new generation of directors was, at first, a reason for optimism and renewal, lately it has generated new

tensions and calls for accountability, since many of these films are financed to promote Argentine cinema and yet are only watched by small audiences. The experimentation and subsequent proposal of a cinematography that considerably departs from the formulas associated with Hollywood productions have not gained the massive support hoped for from either Argentine or international spectators. In spite of this, many films have been recognized for their originality at both national and international film festivals. It seems that at the moment, despite some well-made films such as *Nine Queens* and *Son of the Bride*, the Argentine cinematic industry is atomized into low-budget *operas primas* and art-house productions that fail to appeal to national and international spectators alike, thus, posing a yet-to-be resolved problem pertaining circulation of Argentine productions.

Acknowledgments

I would like to thank my colleagues David Desser and Cacilda Rêgo for their careful reading of previous versions of this chapter and their insightful suggestions. I also appreciate the invaluable help of Marcela Carreira at the Argentine Union of Argentine Cinematography (SICA).

This chapter was originally published in *Hispania* 93:3 (2009), pp. 824–34.

Notes

* For the first time, the DEISICA data tabulates information, dividing it into *salas* [movie theatres] and *screen*s [pantallas].

1. Other periods of high national film production were 1937–1947, when 426 films were released and 1947–1957 when 453 were made (Getino 1998: 337). Part of this boom is due to the interest that film-making generates among young people. Fernando Martín Peña mentions that there were 10,000 film students who attended ENERC (Escuela Nacional de Experimentación y Realización Cinematográfica) and Manuel Antín's FUC (Universidad del Cine) (Martín Peña 2003: 268–9).

2. The report of the first three months of 1999 and 2000 also mentioned that the national Cinecenter opened 19 screens in the provinces (7 in Bahia Blanca, 7 in San Luis and 5 in Tucuman) while Nai/Paramount and Village Readshow opened the most theatres in two upscale neighbourhoods of Buenos Aires: 16 in Recoleta and 16 in Olivos. Finally Hoyts General Cinemas opened 16 new theatres in Córdoba. (DEISICA 9: 4). The report of 2001 acknowledged the opening of new multiplexes but at a slower pace (DEISICA 11: 6).

3. The Australian-based Village Roadshow and Cinemas left the Argentine market in the year 2000.

4. This data seems to contradict Horacio Bernades, Diego Lerer and Sergio Wolf's assertion that 'since 1999, Argentine cinema has recovered almost 20% of its domestic audience' (Blejman 2004: 9).

5. The median continuity classifies films according to the number of copies that are used during the initial screening. 'A' films have more than 20 copies, 'B' films are released with 10 to 20 copies and 'C' films are premiered with less than 10 copies. During high season (April 1 to September 30), this classification is used to determine a minimum of spectators per movie theatre. 'A' films have to have a median of 25% of movie theatres with a capacity of 250 and 20% in movie theatres of 250–500 spectators and 10 % in movie theatres with a capacity of more than 500 spectators, 'B' films should maintain a median of 22% of spectators in movie theatres with a capacity of 250–500 spectators and 18% in movie theatres, 9% in movie theatres of more than 500 spectators. 'C' films need to have a median of 20% of movie theatres with a capacity of 250 and 16% in movie theatres of 250–500 spectators and 8% in movie theatres with a capacity of more than 500 spectators. These percentages decrease during low season (October 1 –March 3) (Blejman 2004).

6. For specific numbers in foreign box office, see Deborah Shaw's (2007) article 'Playing Hollywood at its Own Game? Bielinski's *Nueve reinas*'.

7. *Clarín* newspaper is part of the Clarín Group, one of the largest multimedia holdings in Latin America with participation in TV, radio and production companies such as Patagonik and Pol-ka.

8. My translation. The original reads: 'la mayoría de estas películas que arriban con estatuillas y diplomas sucumben a la semana en esa tumba del cine argentino que es el Complejo Tita Merello o languidecen en la sala del Gaumont. Con su suma de minimalismo, lugares comunes y diálogos para el bostezo, la gente huye o ni se entera.' Agreeing with Carnevale, one of the key players of the Argentine cinematographic industry, the Argentine Union of the Cinematographic Industry (SICA) which represents technicians, musicians, camera operators, costume designers and directors, the Argentine Union of Musicians (SADEM), Argentine Cinematographic Directors (DAC) and the Only Union of Workers of Public Spectacles (SUTEP) published a petition on December 2, 2007 in the most popular newspaper in Argentina, *Clarín*. I transcribe it in its entirety because of its relevance:

'Given the depth of the crisis that Argentine cinematography is undergoing, a result of the negligent management of public funds earmarked for cinematographic creation and production, we require that national authorities undertake the following:

- the immediate implementation of active policies aimed at recapturing the lost Argentine audience as a natural spectator of our national cinema.
- the urgent institutional normalization of the INCAA (National Institute of Cinematography and Audio-visual Arts) through the constitution of an Advisory Board, the only industry group that has control over the distribution of public funds and which was disbanded six years ago.
- the imperative appointment of well-qualified and respected officials to be in charge of the executive direction of the INCAA, particularly those with a recognized reputation, knowledge and background in the Argentine cinematographic industry.
- the effective enforcement of the screen quota law for movies as well as a screen quota also for television.
- the updating of the Law of Cinematographic promotion, adapted to new audio-visual technologies, encouraging the development of new formats of production, distribution and exhibition.
- the creation of a Strategic Five-Year Audio-visual Plan—as policy of State—that, with efficient, rational and legal guarantees, would pave the way for a new impetus for our cinematographic industry.
- the creation of a national Cinemateca that would guarantee the conservation and audio-visual memory of the Argentines.

With the hope that the national authorities understand the urgent need of a change, by which we will work on behalf of our National Cinema as we have done historically for over fifty years.'

References

Aguilar, G. (2006) *Otros mundos: ensayos sobre el nuevo cine argentino*, Buenos Aires: Santiago Arcos.

Appadurai, A. (1997) *Modernity at large. Cultural Dimensions of Globalization*, Calcutta: Oxford University Press.

Bernades, H., Lerer, D. and Wolf, S. (2002) *New Argentine Cinema*, Buenos Aires: Tatanka.

Blejman, M. (2004) 'El cine argentino ya puede enfrentar a ogros y magos,' *Página 12* http://www.pagina12.com.ar/diario/espectaculos/subnotas/37368-13078-2004-06-29.html. Accessed November 26, 2008.

Carnevale, J. (2001) 'El cine argentino de hoy,' *Jornada Semanal*, December 16.

Departmento de Estudio e Investigación del Sindicato de la Industria Cinematográfica. (DEISICA) Annual reports from 1991(vol.1) to 2006 (vol 16).

Falicov, T. (2007) *The Cinematic Tango. Contemporary Argentine Film*, London: Wallflower.

Forcinito, A. (2006) 'Mirada cinematográfica y género sexual: Mímica, erotismo y ambigüedad en Lucrecia Martel,' *Chasqui* 35.2: 109–30.

García Canclini, N. (1997) 'Will There Be Latin American Cinema in the Year 2000? Visual Culture in a Postnational Era' in A. M. Stock (ed) *Framing Latin American Cinema. Contemporary Critical Perspectives*, Minneapolis: University of Minnesota Press, pp. 246–58.

Getino, O. (1998) *Cine argentino entre lo posible y lo deseable*, Buenos Aires: Ediciones Ciccus.

Gómez, L. (2005) 'El cine de Lucrecia Martel: La Medusa en lo recóndito,' *Ciberletras* 13.

Gundermann, C. (2005) 'The Stark Gaze of the New Argentine Cinema: Restoring Strangeness to the Object in the Perverse Age of Commodity Fetishism', *Journal of Latin American Cultural Studies* 14.3: 241–61.

Martín Morán, A. (2003) 'La Ciénaga/The Swamp' in A. Elena and M. D. López (eds.) *The Cinema of Latin America*, London: Wallflower, pp. 231–39.

Martín Peña, F. (2003) *Generaciones 60/90 cine argentino independiente*, Buenos Aires: Malba.

Martins, L. (2007) 'Bodies at Risk: On the State of Exception (Lucrecia Martel's *La Cienaga*' [The Swamp]) in H. Hortiguera and C. Rocha (eds.) *Argentinean Cultural Production During the Neoliberal Years (1989–2001)*, Lewiston: Edwin Mellen Press, pp. 205–16.

Page, J. (2009) *Crisis and Capitalism in Contemporary Argentine Cinema*, Durham: Duke University Press.

Page, J. (2005) 'The Nation as the Mise-En-Scene of Film-Making in Argentina', *Journal of Latin American Cultural Studies* 14.3: 305–24.

Rangil, V. (2007) *El cine argentino de hoy: entre el arte y la política*, Buenos Aires: Biblos.

Shaw, D. (2007) 'Playing Hollywood at its Own Game? Bielinski's *Nueve reinas*' in D. Shaw (ed.) *Contemporary Latin American Cinema. Breaking into the Global Market*, Plymouth: Rowan & Littlefield, pp. 67–86.

Steinmann, P. (2005) 'De los otros', *Haciendo Cine* 9.49: 25–7.

Svampa, M. (2005) *La sociedad excluyente. La Argentina bajo el signo del neoliberalismo*, Buenos Aires: Alfaguara.

SICA (n.d.) website, www.sicacine.com.ar. Accessed August 1, 2010.

Universidad del cine (n.d.) website, www.ucine.edu.ar. Accessed August 1, 2010.

Additional texts

Foster, D. W. (2007) 'Family Romance and Pathetic Rhetoric in Marcelo Piñeyro's *Kamchatka*' in D. Shaw (ed.) *Contemporary Latin American Cinema. Breaking into the Global Market*, Plymouth: Rowan & Littlefield, pp. 105–16.

Gutiérrez, M. (2004) 'Bountiful Rebound of Argentine Cinema', *Americas* 56.3.

Hines, D. (2007) '*Nueve reinas*: A Sign of Times (to come)', *Studies in Latin American Popular Culture* 26: 113–26.

Konstantarakos, M. (2006) 'New Argentine Cinema' in L. Badley, R. Barton Palmer and S.J. Schneider (eds) *Traditions in World Cinema*, New Brunswick/New Jersey: Rutgers University Press, pp. 130–40.

Remedi, G. (2006) 'De *Juan Moreira* a *Un oso rojo*: crisis del modelo neoliberal y estética neogauchesca' in M. Moraña and J. Campos (eds.) *Ideologías y Literatura. Homenaje a Hernán Vidal*, Pittsburgh: IILI, pp. 147–66.

Rocha, C. (2008) 'Cine despolitizado de principio de siglo: *Bar El Chino* y *El abrazo partido*,' *Bulletin of Spanish Studies* 85.3: 335–49.

Rocha, C. (2007) 'Identidad masculina y judía en la trilogía de Daniel Burman,' *Letras Hispanas* 4.2, http://letrashispanas.unlv.edu/. Accessed August 25, 2010.

THE FALL AND RISE OF BRAZILIAN CINEMA

Cacilda Rêgo
Utah State University

A salient feature of Brazilian cinema is that 'it undergoes periodical births and rebirths and, after brief peaks, it is afflicted by sudden deaths and prolonged silences'. (Nagib 2003: 157)

The fall

As the above quotation suggests, the history of Brazilian cinema has a sadly consistent pattern of birth, death, and silence. In 'The Rise and Fall of Brazilian Cinema, 1960–1990' Randal Johnson retraced that history from the Cinema Novo years (1960s–1970s) to the subsequent months after the dismantling of the state film enterprise—Embrafilme—by President Fernando Collor de Mello in 1990, recalling the moment in which the Brazilian film community watched the main pillar of Brazilian cinema abruptly collapse before its eyes (Johnson 1991: 97–124).

Contrary to what was expected, Brazilian cinema did not die. The consequences for the film industry, however, were immediate and grim. With a few exceptions, notably Sérgio Toledo, Walter Hugo Khouri, Walter Salles Jr, and Hector Babenco, who turned to English-language co-productions, Brazilian film-makers found it difficult, if not impossible, to make films in the absence of investments in production. Private participation in film production was almost nonexistent at the time, and films in production were halted with the dismantling of Embrafilme. As a result, production declined from 74 films in 1989 to 58 in 1990 and nine in 1993, when it reached its lowest level (Silva Neto 2002: 936-37). Such a drastic fall in production ultimately left a huge vacuum in the national market that was filled by foreign films, most of which were North American. Not surprisingly,

then, of the 1,186 films released in Brazil between 1990 and 1994, only 29 were Brazilian (*Brazil* 2002: 132)

With a creatively- and financially-moribund industry, the outlook for Brazilian cinema was anything but bright. However, in 1995 the industry made its phoenix-like rebirth, rising stronger on the heels of new tax incentive laws, and it has since matured and solidified into a 'new' national cinema with a freedom of expression and level of artistry which previously was only a dream. Between 1995 and 2005, the industry turned out some 300 new films featuring an assortment of genres, budgets, themes and styles.

In time, a new generation of Brazilian film-makers emerged in that period. These included several female directors like Monique Gardenberg, Ana Muylaert, Tânia Lamarca, Laís Bodansky and Eliana Caffé. Considered the clarion of the 'films of the revival' is Carla Camurati's first feature, *Carlota Joaquina* (1995), which was the first in a series of films of this period to attract over one million viewers to movie theatres.

Another developing trend during this period was the internationalization of the Brazilian film industry. This trend was, in part, generated by a growing awareness among industry professionals and government officials of both the necessity and the potential of international dealings such as treaty co-productions and co-ventures, and the importance of foreign investors and foreign markets for the industry's survival (Moisés 2003: 20). The result has been a boom in international co-productions, of the like Brazil has not experienced before (Silva Neto 2002: 936–39).

Another important development was the entrance of the giant conglomerate Globo Network—the nation's largest television producer—into the film arena. Today, Globo Filmes (Globo's film production arm) is the most important national film producer in the country. In this capacity, Globo has co-produced some landmark films such as *Cidade de Deus/City of God* (Fernando Meirelles & Kátia Lund, 2002), which received Oscar nominations for Best Film Editing, Best Cinematography, Best Adapted Screenplay and Best Director.

Significantly (though not surprisingly), Globo's films are released on the video market by Globo Video (Globo's distribution arm) and shown on television by TV Globo, Brazil's main commercial television channel. However, with the obvious exception of these films, it is rare for a Brazilian film to be shown on Brazilian commercial television. As contradictory as it may seem, Globo remains a stumbling block to Brazilian cinema's entrance into the 'open' (non-cable) national television market. What is significant in the case of Globo is that while cashing in on the booming market for local films, it has not hesitated to conspire against the interests of the film industry when its own interests are at stake. In both 2001 and 2004 it lobbied against film quotas for television, where competition for audiences among a substantial number of satellite, cable, and commercial television channels has led to an ever-increasing flood of foreign imports in recent years (Rêgo 2003: 165–80; 2008: 223–43). And yet, for all its faults, in 1998 Globo was more than happy to launch Canal Brasil [Brazil Channel], which became the

first and only satellite channel dedicated to showing local products. Within a year, Globo took this a step further when Globosat (Globo's satellite programmer) began to facilitate co-productions of documentary features, mini-series and films for television.

In this chapter, I offer an analysis of the current moment in Brazilian cinema history. My approach differs from much of the current work on Brazilian cinema, which prioritizes an analysis of the visual and cinematic qualities of the 'films of the revival' (see Labaki 1998; Johnson 1999; Salem 1999; Nagib 2001, 2002, 2003; Dennison and Shaw 2004; Oricchio 2003; Shaw and Dennison 2007). Rather, my primary concern is to analyse how the state acted—and continues to act—to help cinema maintain its presence and continuity in Brazil after the dismantling of Embrafilme. My approach complements the less-common treatments of the topic (see Diegues 2003; Moisés 2003) by offering a more detailed examination of the industry's financial performance during the period of revival. Such an examination entails a discussion of how legislation for audio-visual investment played a crucial role in the revival of national film production in the mid-1990s, and what subsequent steps were taken by the state to strengthen and protect the sector. This chapter shows that state protection for the industry has been important but limited, and that chronic structural problems have remained throughout this period. Brazilian cinema, which by 2003 was stronger than it had been for many years, is still overshadowed by the dominance of foreign films on national screens, not least because Brazil does not have effective control of its film industry. Today, Brazilian cinema remains at the mercy of foreign distributors and exhibitors, above all those with strong links to North American cinema. My analysis provides an understanding of the current developments in the Brazilian film industry, and the challenges for Brazilian film-making in the face of US domination of the domestic market. This essay argues that however important the existence of Canal Brasil, local films are still a long way from catching up with the foreign imports that flood Brazil's non-theatrical market (satellites, cable and commercial broadcast channels and video stores), where the statutory quota legislation for theatrical exhibition does not apply. This chapter also discusses why Brazilian film-makers are increasingly entering into co-production deals with foreign distributors, their 'traditional enemies' (Johnson 1991: 116), and what the implications of this are for the industry.

The state came to the rescue

If Brazilian cinema was reborn in the 1990s, the spark that gave it life was the Brazilian Cinema Rescue Award, which was given to 90 projects between 1993 and 1994. Implemented by Itamar Franco (who succeeded Fernando Collor to the presidency in 1992), this award came to rescue Brazilian cinema from almost total paralysis, and opened new doors to a young generation of new film-makers (and a few of the veterans)

who were confident that, as the title of a film by Cinema Novo veteran director Carlos Diegues prophetically announced, better days would come (*Melhores Dias Virão/Better Days Will Come,* 1989). They did not have to wait long.

Between 1991 and 1993, two things occurred that radically changed the nature of the Brazilian film industry. The first was the introduction of the Rouanet Law (No. 8,313) in late 1991. In the same spirit as the Sarney Law (No. 7,505) of 1986, which was abolished in 1990, this new law gave corporations and individuals a tax credit for investments in cultural projects, thereby making private participation in Brazilian cinema more attractive. Implemented in late 1992, the Rouanet Law stimulated in a short period of time (1993–1994) a rebirth of interest in Brazilian cultural production in general and in Brazilian film production in particular. Thanks to this new law, private investments in local cultural production and especially in cinema increased significantly in the following years (*Brazil* 2002: 132). Second, and of far greater importance, was the enactment of the Audio-Visual Law (No. 8,586) of 1993, which allowed producers to float individual projects on the Brazilian stock market, and allowed corporations to receive tax credits for investing in local productions. Moreover, the law also allowed foreign distributors with local subsidiaries to invest up to 70 per cent of their income tax on profits in Brazil in local film projects; this is an area in which Sony and its affiliate, Columbia—and to a lesser extent, Warner Bros., Fox, and Miramax—have become increasingly active. It is up to producers-turned-entrepreneurs to find individuals and corporations willing to invest in their projects. Additionally, they have to make their own deals with distributors and exhibitors (Oricchio 2003: 26–8). Virtually all Brazilian films made since 1993 have taken advantage of these laws.[1]

While these new laws have allowed Brazilian film-makers to make new films, they still face one other hurdle: that of exhibiting their films in Brazil. The most interesting example is that of *O Que é Isso Companheiro/Four Days in September* (Bruno Barreto, 1997) which, even after being nominated for a Best Foreign Film award by the Academy of Motion Picture Arts and Sciences in 1998, continued to face obstacles to exhibition in Brazil. The indignant reaction of its Brazilian producer, Cinema Novo veteran Luiz Carlos Barreto, was published in several major Brazilian newspapers and the film was finally exhibited. However, the incident made clear that, despite creating a more propitious atmosphere for national film production, the Audio-Visual Law had not affected prevailing distribution and exhibition practices or the hegemonic presence of foreign films in Brazil (Almeida 1998: 7). It also made it apparent that Brazilian cinema could not be rescued only by decrees or, for that matter, quotas of any kind, simply because the state lacked the mechanisms to enforce them. The statistics demonstrate this: of the 1,247 films released in cinema theatres in Brazil between 1995 and 2000, only 137 were Brazilian (*Brazil* 2002: 133).

The situation of Brazilian cinema in the late 1990s led Johnson to conclude that, despite major strides taken by the industry since 1993, not all was well. He wrote:

The structural problems long affecting Brazilian cinema have not yet been effectively addressed, and the current level of activity may in fact be rather tenuous. Brazilian cinema remains, to a very large extent, ghettoized within the domestic film market. Fewer than 10 films produced in the 1990s have attracted more than one million spectators. Most draw less than 100,000 and continue to be restricted to art houses and cultural centers. Brazilian film must compete against the almost total dominance of American cinema in the domestic market, but also against home video, cable, and satellite television, which have strengthened the presence of American audio-visual images in the country. (Johnson 1999: n.p.)

While regulatory measures and incentive programmes that were nonexistent in the 1990s have since been implemented, foreign domination of the national market has remained unchanged. Between 2000 and 2003, for example, 72.3 per cent of the films released in cinema theatres in Brazil came from abroad, despite the fact that national film production continued to grow consistently in that period (ANCINE 2009).

Whether Brazilian cinema will ever fulfill its full potential on the strength of its domestic market alone is questionable, given the history of the industry. However, not all developments in the 2000–2003 period were as bleak. An encouraging development was the reorganization and expansion of the state protectionist system, which resulted in the creation of the National Film Agency (ANCINE) in 2001. It replaced the National Film Council (CONCINE), which was closed along with Embrafilme in 1990. Although ostensibly created to implement, expand, and enforce current legislation for the film industry, the agency's primary efforts went into stimulating national film production, expanding the domestic market and projecting Brazilian products into Latin American and other foreign markets, thus performing much the same function that Embrafilme once had.

After the introduction of the Audio-Visual Law of 1993, the creation of ANCINE was the most important expression of state support for the industry since the dissolution of Embrafilme. The agency aims at integrating the audio-visual industries, with the goal of garnering further financial resources and a larger market for Brazilian cinema. In spite of ANCINE's limited ability to offset the chronic structural conditions that make Brazilian cinema vulnerable vis-à-vis foreign competition in the national market, there are hopeful signs that Brazilian film-making at some time in the future might be put on a more sound basis as a result of policies implemented during the last two years of the presidency (2001–2002) of Fernando Henrique Cardoso (who succeeded Itamar Franco in 1995) and continued by his successor, Luiz Inácio 'Lula' da Silva, who took office in 2003. To appreciate fully the analysis that makes up the remainder of this chapter requires an understanding of the crisis experienced by Brazilian cinema in the 1980s that culminated with the closing of Embrafilme in 1990.

Brazilian cinema strikes back

Several factors converged during the 1970s and 1980s to trigger the collapse of the Brazilian film industry in the 1990s: the crisis within the Brazilian state precipitated by the end of the 'economic miracle' in the late 1970s, but which continued into the 1980s; the rising production costs due to soaring inflation rates; the importing of foreign films in unprecedented numbers resulting from the introduction of new technologies like videocassettes, cable and satellite networks; the closing of movie theatres throughout the country; and the loss of the mass audience to commercial television (Johnson 1991: 98–9). The films commonly produced by Embrafilme—e.g. *porno-chanchandas* [low-budget, titillating comedies]—in the last years were emblematic of a cinema at the end of its tether.

In the last instance, the crisis in Brazilian film-making in the 1980s coincided with the breakdown of a model of state intervention in film production that had become the norm since the early 1970s. The fact that Embrafilme had become the major source of production financing, ultimately created, as Johnson pointed out:

> a situation of dependence between the state and so-called 'independent' film-makers, and in itself became a marketplace where film-makers competed against each other for the right to make films. This, in turn, exacerbated tensions within the industry and created a situation in which the play of influences was often more important than the talent of the film-maker or the quality of the final product. As a consequence, public sector investments in the cinema lost social legitimacy. (Johnson 1993: 211–12)

Seen from this perspective, the demise of Embrafilme was a mixed blessing. While the immediate results were devastating, it prodded film-making into a new era in which private investment in national film production emerged as a dominant trend in the industry. Far surpassing initial expectations, US$184 million went toward film production via the Audio-Visual Law in the 1994–1999 period, a feast for a cash-hungry industry. As a result, employment in the sector steadily rose in this period, as did overall film production, distribution, and box-office receipts (Nagib 2002: 16–8).

As in the past, Brazilian films began to attract commercial and critical acclaim as well as a host of awards, both from Brazilian and international film festivals. It is worth noting that besides *O que é Isso Companheiro?*, two other films of this period received Oscar nominations for Best Foreign Film: *O Quatrilho* (Fábio Barreto, 1995) and *Central do Brasil/Central Station* (Walter Salles, 1998), for which Fernanda Montenegro also received a nomination for Best Actress (she and the film received the 1998 Golden Bear in Berlin for each category). This latter film in particular has received wide acclaim and

earned significant box-office receipts in the United States and Europe. However, the most telling index of the internationalization of the Brazilian film industry is the increasing number of co-productions undertaken in recent years, mainly with English-, French-, Spanish- and Portuguese-speaking nations with whom Brazil has ongoing production/ business arrangements, such as Argentina (Mercosul Treaty) and Spain and Portugal (Ibermedia Programme and Brazil-Portugal Treaty).

Another important development of this period was the emergence of Globo Filmes as a major player in the field. While tapping into the sensibilities of the national television audiences who are hooked on its telenovelas, Globo has helped Brazilian cinema, however slightly, to increase its share in the domestic market. Whether due to the hype of television marketing campaigns or their so-called 'standard of quality' (a trademark of the network), Globo's films have attracted the closest thing to a 'mass audience' for national products in recent years. Illustrative of this current trend within Brazilian cinema are, for example, *Carandiru* (Hector Babenco, 2003; 4.6 million spectators) and *Dois Filhos de Francisco/Two Sons of Francisco* (Breno Silveira, 2005; 5.2 million spectators), among others (ANCINE 2009).

If these figures can be trusted as an indicator, then Brazilian cinema is speaking to the national public in increasingly sophisticated and appealing ways. According to data published by Filme B, a local marketing agency, attendance for Brazilian films rose from 45,000 in 1993 to 2.9 million in 1995 and to 5.1 million in 1999. In the year 2000, the figure rose to 7.2 million and surpassed 22 million in 2003. In 2003, the film industry performed at levels not seen since 1989. In that year, the attendance figure for Brazilian films was 20 million (Cajueiro 2004: n.p.). During the first six months of 2003, the industry generated a gross of US$115.65 million in box-office revenue, for which national production contributed US$18 million—more than three times the amount Brazilian films grossed during the first half of 2002 (Cajueiro 2003: n.p.).

Yet, whatever successes Brazilian cinema has enjoyed in recent years, national exhibitors have not been in a rush to show local films, nor have foreign distributors been too anxious to pay for them. In 2002, for example, Warner Bros. was so incensed by a tax levied by the state on all foreign movies, television films, and video cassettes as a means of subsidizing national film production that it filed a lawsuit against ANCINE. Paramount, Fox, Universal, MGM, UIP, Viacom, Buena Vista International and Orion Pictures soon followed suit. The resulting judicial ruling against Fox in 2003 brought new momentum to the agency. While ANCINE's victory was applauded by independent producers (the main beneficiaries of the new tax), the attempt to restrict the flow of foreign films through a quota system (under which theatres showing foreign films are required to exhibit domestic films for 35 to 49 days per year) has been less satisfactory.

The law and the 'outlaws'

In 1988, Cinema Novo veteran director Roberto Farias declared in an interview that, although mandated by law, the screen quota was commonly ignored by a 'privileged group' of exhibitors who gave priority, preference and better treatment to foreign films (Farias 1988: 18–19). A decade later, the screen quota continued to be ignored, most blatantly by the National Exhibitors Federation (FENEEC), on the basis that the market, not the government, should determine which type of film is most in demand. Working from this premise, exhibitors have justified their blocking of national products by appealing to the public's right to choose what films it wishes to see. In the words of Arturo Neto, director of Severiano Ribeiro (the largest Brazilian exhibition group), 'The public is the one who determines when a film is exhibited. None of us is so insensitive as to stop showing a movie that is getting a good audience' (Dalevi 1998: n.p.). What this perspective conveniently ignores, however, is that for a public to choose a film, it must first be exhibited, which generally does not happen with Brazilian films, or does so only under conditions imposed by exhibitors (Nagib 2002:18).

This ploy has been aggravated, in part, by the fact that cinema in Brazil still lacks an effective distribution system (Dahl 2000; Leão 2000). As we have seen, the Audio-Visual Law has unfortunately contributed to the problem by stopping far short of securing distribution and exhibition provisions for the films it has helped to produce. For example, while US$184 million went toward production over its first five years, only US$12.5 million was destined for marketing and distribution during the same period (Butcher 2000: n.p.)—a tiny sum in a market dominated by foreign distributors-turned-national exhibitors with vested interests in screening their own films. Not long after the Severiano Ribeiro group joined United Cinema International (UCI, a Paramount and Universal venture) in 1997, in the acquisition of several multiplex cinemas nationwide, it became clear that the Audio-Visual Law had created, in Carlos Diegues' words, 'the biggest industry in the world of unreleased films' (Diegues 2003: 26).

For this reason, and because the System of Information and Control of the Commercialization of Audio-Visual Work (SICOA)—one of the several measures taken by the state to curb exhibitors' underreporting of box office revenues—was slow to be implemented (its creation was established by the Audio-Visual Law of 1992), it was unclear in which cinema theatres Brazilian films had been shown by the decade's end. Meanwhile, the state, ill-equipped to retrieve this information otherwise, could not enforce the screen quota legislation. The bad news for the 'outlaws' was that President Cardoso declared in late 2001 that, beginning in early 2002, he would enforce the current screen quota for Brazilian films and that he would penalize those who did not feel obliged to fulfill it. As a stimulus, he instituted the Additional Revenue Premium, designed to reward exhibitors that complied with the quota.

The mixed signals from television

Although figures indicate that the theatrical market is actually declining for foreign films, the non-theatrical market has become the prime target market for these films in recent years (*Brazil* 2002: 133). By the end of the 1990s, for example, all indications pointed to the fact that video stores, foreign-language television channels, and cable networks were increasingly providing upper- and middle-class Brazilians with alternative ways to view foreign (mainly North American) films and, as some critics argue, another reason not to see the local ones. The rising number of satellite dishes in Brazil in the last few years has only exacerbated the trend, one originally spurred by Brazilian commercial television in the 1960s (Johnson 1987: 173–6; Rebouças 1999: 70–80). In the 2000–2003 period, as some observers concluded, North American films continued to dominate Brazilian screens and, with the emergence of these new communication technologies, they also continued to dominate the airwaves (Diegues 2003: 25–8; Moisés 2003: 11–13).

Meanwhile, in an effort to compete with US dominance in the non-theatrical outlets, Globo made a start towards providing more visibility to Brazilian films on television by launching, in partnership with a group of prominent film professionals (GCB or Grupo Brasil), the Canal Brasil channel in 1998. Broadcasting simultaneously to Brazil and Portugal, it is the first and only television channel dedicated to showing Brazilian films. Moreover, in an effort to retain and further widen its lucrative non-theatrical marketshare, Globo also established a production division for Globosat, which started co-producing feature and documentary films for television as well as TV serials.

While widely welcomed at first, Globo's entrance into the film business has yielded deep resentment among some film professionals. One obvious reason for this is a built-in feature of Globo's productions, namely the self-styled 'standard of quality' that only Globo can afford, which makes other local productions pale in comparison. Given Globo's financial and technological resources, it is no surprise that it is able to churn out big-budget extravaganzas (by Brazilian standards) like *Carandiru* (which cost US$4.1 million), and spend more money on stars, sets, special effects, and publicity (around US$1 million in the case of the latter film) than any other independent producer in the country (Pires 2003; Rêgo 2008). In order to take advantage of Globo's resources, local production companies, like Casa de Cinema, Video Filmes, and 02 Filmes, have established co-production partnerships with Globo Filmes, turning out films and television serials which they could not have afforded to produce on their own.

The show of reconciliation

During Cardoso's administration, state policy towards the film industry changed drastically from that seen in the Collor years, reflecting some important changes in other

areas of economic, social and cultural policy that took place from 1993 onwards. Cardoso, who considered Collor's term a disaster for both the country and for the film industry, undertook a series of reconciliatory steps, thus reassuring the Brazilian film community that the state would continue to meet its responsibility to support national cinema (Cardoso 2001: 9–11). Such support was more pronounced in Cardoso's second term of office (1999–2002), however, when several measures were introduced to provide a more solid protectionist structure for the film industry. For example, in addition to ratifying Law 8,401 (First Audio-Visual Law of 1992) and enforcing the mandatory exhibition for Brazilian films, Cardoso issued a temporary measure (PM No. 2,118–1 of 2001), dubbed the 'Cinema Law', which marked the culmination of state support for the industry.

In addition, several public initiatives were implemented, such as the Grand Prize for Brazilian Cinema, the national equivalent of the Academy Awards. Also worth mentioning is the Petrobras Film Programme, implemented by the giant state-owned oil enterprise Petrobras in 2000 to support production, distribution, and exhibition of short films. By 2003 some 100 films had benefited from this programme (Cajueiro 2004), and BR Distribuidora (Petrobras' distribution arm) took charge of marketing and distributing these films.

These programmes accompanied earlier initiatives—such as the Cinema Brazil Programme, the 1999–2000 More Cinema Programme, and the programme of Support for Film Marketing—aimed at boosting, through a mix of public and private funds, film production financing, as well as enhancing the distribution, commercialization, and exhibition of Brazilian films. In the 1999–2000 period, some 52 films benefitted from these programmes. Another important initiative, created in 1999, was the so-called Rediscovery of National Cinema, a programme aimed at awakening interest in national films, especially among young people (Brazil 2002: 134-35).

After some delay, and following considerable pressure from members of the industry, the state created a film advisory committee (GEDIC) in 2000, with the responsibility of defining general guidelines for the reorganization of the film industry. Acting on its suggestion, Cardoso issued the temporary measure, which became known as the 'Cinema Law'. In addition to establishing a set of General Guidelines for a National Film and Audio-visual Policy, this measure created the Executive Film and Audio-visual Council (which replaced the defunct National Film Foundation) and ANCINE, thereby providing a new institutional and regulatory framework for the sector.

Additionally, this measure gave new leverage mechanisms for the industry by expanding and diversifying the state's financing capacity. It created, for example, the National Cinema Industry Development Programme (PRODECINE) and authorized the creation (which only occurred in late 2003) of the Funds for Cinematographic Development (FUNCINES). The measure further allowed foreign and national investor companies that are not part of media conglomerates to receive a tax credit equal to twice their investment in the funds. The money raised by PRODECINE and FUNCINES are invested in production and distribution of local films, as well as theatre construction and renovation projects.

Article 32 of the 'Cinema Law', which altered an outdated 'profit remittance' law (No. 1,990 of 1981), established a new tax on imports, including films, TV programmes, advertisements, and home videos. ANCINE, which took charge of collecting this additional revenue—euphemistically called Contribution to the Development of the National Film Industry (CONDECINE)—had the job of investing it in local film production, distribution, and exhibition. This measure gave foreign distributors and programmers the option of paying the new tax (11 per cent on remittances) or investing that same amount in projects by local independent producers. Investments could be recouped at the box office, a good enough incentive for foreign distributors-turned-national producers to see that these films are exhibited (Cajueiro 2003).

The reaction among the diverse constituencies in the film and television industries was, predictably, mixed. On the one hand, several film professionals applauded the measure; they believed it would further stimulate production. On the other hand, Pay-TV programmers, foreign distributors and commercial television broadcasters staunchly opposed it, and initiated legal actions against CONDECINE. After long negotiations, the measure was formalized into a law (No. 10,454) in 2002 with several modifications. One such modification allowed foreign distributors and programmers to invest a mere three percent of their remittances in local production. However grudgingly, virtually all of them have opted to invest in local products.

Moreover, while quotas on domestic titles for home video distributors are not currently enforced, efforts to regulate the flow of foreign films by commercial television broadcasters have thus far failed. The lobbying of major national broadcasters, especially TV Globo, has become a continuous feature of negotiations whenever the state includes the television sector in audio-visual legislation favouring the cinema. Not surprisingly, they were left out of the 'Cinema Law', despite protests from those included in it as well as from prominent members of the film industry. This, more than any other single factor, accounts for the fact that the domestic television market remains virtually closed to local productions to this day.

Concluding remarks

Perhaps this is the time to emphasize that, although problems of distribution and exhibition have persisted, the financial health of the film industry in Brazil seems to have improved since 1995. A reading of Cardoso's Presidential Report (Brazil 2002) underscores the extent to which private and public investments have contributed to this situation. The report boasted that the fastest-growing sector was exhibition—a trend fuelled by the creation of some 190 new movie theatres throughout Brazil since 1999 (by 2002 there were about 1, 500 screens in Brazil). When compared to the 1990–1994 period, releases of Brazilian films showed exceptional growth of 472 per cent in the 1995–2000 period, with figures for local production rising from 29 in 1990–1994 to 137 in 1995–2000. As a result,

the market share for Brazilian cinema increased from 3.7 per cent in 1995 to 7.8 per cent in 1999, and to 10.6 per cent in 2000, an increase of 10.5 per cent since 1993. (There was a slight decline in 2001 to 9.3 per cent, reaching 8 per cent in 2002, when national films attracted a total of 7.2 million viewers.) Further improvement in the industry's financial ledger was achieved by protectionist measures that were introduced in the 2001–2002 period by the outgoing president Cardoso.

Whether the Brazilian film industry will hold on to its gains is difficult to predict. Only one thing is certain: Brazilian cinema, to paraphrase the old samba composer Nelson Sargento, suffers but never dies; somebody always rescues it before its last sigh. By the time Collor, charged with fraud and corruption, was ousted from the presidency in 1992, Brazilian films had virtually disappeared from cinema screens. A year later President Itamar Franco threw Brazilian film-makers a lifeline: the Rescue Award. Hailed as 'a first step' in the reconciliation between the state and the film industry since the dismantling of Embrafilme, the award helped Brazilian cinema re-emerge in the 1990s. As we have seen, the Rescue Award was soon followed by the Audio-Visual Law of 1993 which, together with the Rouanet Law, further stimulated film production. The new wave of production from 1993 onwards represents a significant achievement for a cinema which, although known for giving rise to films of lasting quality, produced hundreds of low quality *porno-chanchadas* under the aegis of Embrafilme.

This should not, of course, obscure the fact that Brazilian cinema has been unable to recapture the 35 per cent market share that it had during Embrafilme's peak period (Moisés 2003: 6). In current circumstances, its survival is linked in a decisive way to the solutions which must be provided to the problems of distribution and exhibition of Brazilian films in the domestic market. Although current state protectionism has led to increased production and the industry is enjoying an economic recovery, it has also led US majors, which already distribute foreign films and own movie theatres in Brazil, to enter national film production on a large scale at no real cost for them.

Meanwhile, the increased screen quota and higher importation costs, while slightly reducing the space for foreign products in the theatrical market, have not diminished the domination and popularity of US films and television programmes in Brazil. Thus, by the end of 2003 Brazilian films still appeared in insufficient numbers when compared to the foreign films shown on commercial television and cable/satellite channels, with the exception of Canal Brasil.

One question that arises is the extent to which state protection has ensured the survival of cinema in Brazil. If, as former Secretary for National Audio-Visual José Álvaro Moisés observed, approximately 90 per cent of the films shown in both the theatrical and non-theatrical markets are foreign (Moisés 2003: 3), one cannot expect Brazilian films to catch up with them without having a vertically-integrated production and distribution system, plus exhibition windows such as theatre, video, pay-per-view, and commercial television to back them up. Will the trend towards making foreign distributors and exhibitors into national

producers reverse the current situation? Or have foreign majors become more powerful and, hence, able to decide not only which films are distributed and exhibited but also which projects are made and how they are made?[2] Who benefits most from this sort of integration? What are the trade-offs involved? What are the cultural and economic implications for Brazil? While the success of future public policy initiatives depends on the answers to these questions, more historical distance will be needed before the role of state protection toward the Brazilian film industry under President Lula (2003–2011) can be fully assessed.

Notes

* This chapter was originally published in *New Cinemas* (2005) 3.2: 85–100.

1. See http://www.aptc.org.br/lei-8685.htm and http://www.aptc.org.br/lei-8313.htm for the full texts of these laws. Accessed on August 27, 2004 (no longer available).

2. There seems to have been increasing pressure on independent producers and directors to tailor their projects to satisfy investors. See, for instance, the collection of interviews by film-makers in Lúcia Nagib (2002), as they underscore the extent to which film-making has become hostage to private funding and the aesthetic tastes of marketing CEOS of corporations that currently invest in Brazil's cinema.

References

Almeida, P. S. (1998) 'Entrevista', *Idéia na Cabeça* 2: 7.

ANCINE (2009) website, http://ancine.gov.br/media/SAM/informes/2009/InformeAnual2009. pdf. Accessed on June 21, 2009.

'Balanço do site Filme B' (2005), http://kinoforum.org/guia-numeros.htm. Accessed on January 25, 2005.

Brazil 1994-2002: The Era of the Real (2002), Brasília: SECOM.

Butcher, P. (2000) 'Brazil: Revival at Risk', *Courier*, http://www/unesco.org/courier/200-10/uk/doss27.htm. Accessed on May 18, 2004.

Cajueiro, M. (2004) 'Brazilian B.O. could backslide', *Variety.Com,* http://www.variety. com/articles/asp. Accessed on May 18, 2004.

Cajueiro, M. (2003) 'Carandiru leads Brazil's boffo B.O.', *Variety.Com*, http://www. variety.com/articles/asp. Accessed on June 12, 2004.

Cardoso, F. H. (2001) 'Uma idéia na cabeça, uma indústria por criar' in F. Welffort (ed.) *Cinema Brasileiro*, Rio de Janeiro: Fundo Nacional de Cultura, pp. 9–11.

Dahl, G. (2000) 'Cinema: Produzir Para Não Distribuir' in C.J.M. de Almeida (ed.) *Cultura Brasileira ao Vivo*, Rio de Janeiro: Imago, pp. 53–8.

Dalevi, A. (1998) 'Coming Soon to a Theater Near You', *Brazil-Brazzil*, http://brazzil. com/cvrmar98.htm. Accessed on March 13, 2002.

Dennison, S. and Shaw, L. (2004) *Popular Cinema in Brazil*, New York: Manchester University Press.

Diegues, C. (2003) 'The cinema that Brazil deserves' in L. Nagib (ed.) *The New Brazilian Cinema*, New York: I.B. Taurus, pp. 23–35.

Farias, R. (1988) 'Os fora da lei', *Cisco* 11: 18–19.

Johnson, R. (1999) 'Departing from Central Station: Notes on the Reermergence of Brazilian Cinema', *Brazilian Embassy Ejournal*, http://brasilemb.org/br-ejournal/ cnebras.htm. Accessed on November 20, 2003.

Johnson, R. (1993) 'In the Belly of the Ogre: Cinema and State in Latin America' in J. King, A. López, and M. Alvarado (eds.) *Mediating Two Worlds*, London: BFI Publishing, pp. 204–13.

Johnson, R. (1991) 'The Rise and Fall of Brazilian Cinema, 1960–1990', *Iris* 13: 97–124.

Johnson, R. (1987) *Film Industry in Brazil: Culture and the State*, Pittsburgh: University of Pittsburgh Press.

Labaki, A. (ed.) (1998) *O Cinema Brasileiro: de O Pagador de Promessas a Central do Brasil*, São Paulo: Publifolha.

Leão, M. (2000) 'Cinema: Produzir Para Não Distribuir' in C.J.M. de Almeida (ed.) *Cultura Brasileira ao Vivo*, Rio de Janeiro: Imago, pp. 47–51.

Moisés, J. A. (2003) 'A New Policy for Brazilian Cinema' in L. Nagib (ed.) *The New Brazilian Cinema*, New York: I.B. Taurus, pp. 3–22.

Nagib, L. (ed.) (2003) *The New Brazilian Cinema*, New York: I.B. Taurus.

Nagib, L. (2001) 'The New Cinema Meets Cinema Novo: New Trends in Brazilian Cinema,' *Framework* 42, http://www.frameworkonline.com/42ln/htm. Accessed on February 22, 2002.

Nagib, L. (ed.) (2002) *O cinema da Retomada*, São Paulo: Editora 34.

'O cinema brasileiro no mercado de salas' (2004), http://www.kinoforum.org/guia/2004/guia-numeros-01.htm. Accessed on March 13, 2005.

Oricchio, L. Z. (2003) *Cinema de Novo: Um Balanço Crítico da Reomada*, São Paulo: Estação Liberdade.

Pires, L. R. (2003) 'Cinema brasileiro agora é notícia: Por quê?', *Digestivo Cultural*, http://www.digetivocultural.com/arquivo/tema.asp. Accessed on March 14, 2004.

Rebouças, E. (1999) 'Desafios da televisão brasileira na era da diversificação' in S. Mattos (ed.) *A TV na Era da Globalização*, Salvador: Intercom, pp. 61–82.

Rêgo, C.M. (2008) 'Rede Globo: A TV que virou estrela de cinema', *Studies in Latin American Popular Culture* 27: 223–43.

Rêgo, C.M. (2003) 'Era uma vez…a Rede Globo de Televisão', *Studies in Latin American Popular Culture* 22: 165–80.

Salem, S. (ed.) (1999) *Cinema Brasileiro: um balanço dos cinco anos da retomada do cinema nacional*, Rio de Janeiro: Secretaria do Audiovisual do Ministério da Cultura.

Shaw, L. and Dennison, S. (2007) *Brazilian National Cinema*, New York: Routledge.

Silva Neto, A. L. (2002) *Dicionário de Filmes Brasileiros*, São Paulo: n.p.

Globo Filmes, Sony, and Franchise Film-making: Transnational Industry in the Brazilian *Pós-retomada*

Courtney Brannon Donoghue
University of Texas, Austin

In the past two decades, the Brazilian film industry has managed to rejuvenate and reinvent itself. With the weakening of the commercial industry in the 1980s and the dismantling of the state-run film enterprise Embrafilme in 1990, film production declined to almost zero in the early part of that decade known as *o colapso* [the collapse].[1] Due to the lack of domestic productions and distributions, importations of Hollywood films increased (Moisés 2001: 7). However, a tax incentive system provided by Law No 8,313/1991, known as Rouanet Law, encouraged corporate investment in local productions thus helping to revitalize the waning industry in the mid-1990s and ushering in a period known as *retomada* [revival]. At this same time, a wave of neoliberal measures such as privatization, liberalization and deregulation emerged from the US and transnational organizations pushing towards self-sustainable and privatized national industries including state-sponsored media (Waisbord & Morris 2001; Harvey 2005).

The process of privatizing state enterprises, a goal behind Brazil's audio-visual tax incentives, involved major changes in the media landscape. The initial revival brought about a new surge of film-making, and the government and industry players restructured policies to forge partnerships, increase funding to produce movies and ways to entice audiences to see them (Rêgo 2005). Beginning circa 1998, the *pós-retomada* period signalled a structural and practical shift in the Brazilian film industry. The Brazilian film industry witnessed a new period of growth and change distinct from the initial revival characterized by global patterns such as concentration of ownership, franchising and co-productions between transnational partners. This is evident particularly with the entry of Rede Globo, also known as TV Globo, into the film arena. In turn, the

introduction of these incentives and industrial restructuring, specifically the impact of the private investors entering the national market, has created a new market-driven cinema dominated by Globo Filmes.

This chapter will examine the *pós-retomada* period and the rise of the film subsidiary of the media conglomerate, Rede Globo. Earlier accounts of this period in Brazilian cinema have either focused on the aesthetic and narrative qualities of the films released during the rebirth (1994–1998) through a focus on a new group of film-makers emerging within the international film festival circuit or a industrial analysis of the restructured funding policies and government agencies.[2] Here, I am less interested in area studies or national-cinema-model approaches than understanding the transformation of the global media industry through a transnational and culturally specific case study. The objectives of this chapter speak to the overall volume's concern by interrogating the connectedness between key industrial developments in relation to neo-liberal policies and themes of globalization, particularly with a focus on commercially-successful films and the impact of current co-productions on the overall industry.

My theoretical framework is situated within current debates regarding film globalization that do not rely on earlier models of media imperialism and one-way flows. Instead, I am interested in how major political, economic, technological and cultural shifts have altered the way films are produced and consumed through transnational networks. This is forcing scholars such as Michael Curtin to consider the traditional national framework as reflected by current transnational media industries practices (Curtin 2009: 108). Furthermore, Charles Acland suggests that

> the globalization of film must not be mistaken as another case of unidirectional flow of cultural commodities and ideologies from the United States to the rest of the world… even at the level of participation in an economic machine, we do not find a single nationally bound organizational or ownership structure but rather an intricate international concentration. (Acland 2005: 132)

It is the intricate international concentration of media ownerships and transnational practices that will be the focus of this chapter.

Following this, I propose a different multi-layered approach in order to understand the transnational commercial forces driving the contemporary mainstream Brazilian film industry. This approach combines top-down political economic perspective with a close case-study approach to media industry analysis characteristic of contemporary film and television studies. My project builds on previous scholarship by Randal Johnson (1987, 2005) and Cacilda Rêgo (2005, 2008) that examines the policy, financing, and institutional shifts of this period. However, my approach utilizes a closer internal examination of Globo Filmes from a media-industry-studies perspective by examining how certain players or

individuals, transnational partnerships and production practices operate in relationship to the company's dominant domestic position.

I divide the bulk of my discussion into three sections, moving from a large structural analysis to a closer examination of industry discourse and production practices. My methodological approach combines discursive and political economic analysis borrowed from John Thornton Caldwell's 'integrated cultural-industrial methods'. While I do not utilize Caldwell's intensive 'on the ground' ethnographic approach, I consider institutional history, what management level individuals are involved and the institutional strategies implemented after the initial *retomada* (Caldwell 2008: 4). By combining these two approaches, this chapter will be able to consider Globo Filmes within the changing landscape of a commercialized national cinema as well as a globalized media business. I begin my examination of Globo Filmes with an institutional history, the company's structure and the impact on the local industry. The second section follows two director/producers working within the film subsidiary. The final part outlines how the acceleration of certain global economic shifts such as media convergence has led Globo Filmes to incorporate and rely on production practices, such as the pre-sold premise and franchising. Globo Filmes represents a major national media conglomerate that, through certain government policies, transnational partnerships and adoption of global business strategies, has emerged as the dominant force within contemporary Brazilian cinema. Prior to the analysis of my case study, the following section will outline some of the issues that arose after the restructuring of the film industry, which Globo was able to overcome.

Industrial climate after the initial *retomada*

Even after the introduction of new audio-visual laws, the industry was plagued by an unstable and unreliable film financing, systematic dependence on the state financing, foreign dominance of the market, lack of exhibition spaces and congested lines of films waiting for distribution and exhibition (Johnson 2005: 12). Few local production companies had the resources or networks to overcome the lack of a distribution network and the struggle against a saturation of films waiting to be released. Cinema Novo and commercial film-maker Carlos Diegues criticises the situation as

> the biggest industry in the world of unreleased films…since there is a bottleneck of films in each cinema theater, each awaiting its opening night, films are not shown for long enough to attain their expected box office receipts or to realise their income potential. But because, with this system, the general box office income increases, this commercial distortion is perpetuated in a vicious cycle. (Diegues 2003: 26–8)

When asked about the nature of the Brazilian film industry in 2002, Fernando Meirelles, who has emerged as a transnational film-maker with films such as *Cidade de Deus/City of God* (2003; co-directed with Kátia Lund), *The Constant Gardener* (2005) and *Blindness* (2008), emphasized the importance of powerful corporate partnerships. Meirelles suggested Brazilian cinema's 'good scripts and good films were not enough to compete in the global market. [Brazilian films and film-makers] need good international negotiators... otherwise we will continue selling films only to television with poor conditions for disgraceful prices' (Meirelles in Leal 2002: 16).

In order to compete within the global film industry, state policies and industry agencies have pushed for incentives to encourage private partnerships with other major production companies and distributors. Large transnational conglomerates have stepped into position to capitalize on the situation, whereas the number of transnational co-productions has drastically increased in the past decade and parallel larger economic and cultural changes worldwide. Toby Miller et al. (2005: 209) argue that 'the co-production marks an important axis of socio-spatial transformation in the audio-visual industries, a space where border-erasing free-trade economies meet border-defining cultural incentives under the unstable sign of the nation.' The tax incentives, currency imbalances and labour bargains that lure Hollywood to foreign soil provide financial incentives that far exceed treaty co-production, subsidy and quota provisions in support of Brazilian audio-visual expression. The co-production has been a major part of the commercialization and transnationalization of Brazilian cinema. In order to sustain film-making in recent years, state and industry professionals have realized the increased importance and possibilities for international relationships through varying degrees of co-productions and foreign investment (Rêgo 2005: 86). Created to open up opportunities, these financing schemes have been overshadowed by the entrance of Globo in the national market. Certain powerful national and transnational media firms have entered the industry since the *retomada* in order to co-finance and distribute Brazilian films locally, particularly media conglomerates with central operations in the US and Europe. Globo has had long and beneficial relationships with transnational media companies such as Time-Life and, more recently, Fox, Universal and Sony.

Many of the political and economic measures introduced in the early 1990s towards a more neoliberal model of private, commercial enterprises greatly impacted on the industrial structuring and practices of Brazilian cinema. In addition to the international attention and cultural cachet that followed the *retomada*, the funding policies and production practices introduced a shift in perspective from an internal and nationally-focused structure to one that is more externally-driven, open and encouraging of foreign partnerships. The following three sections will examine the Globo case study and how it utilized this structural shift in Brazilian cinema to adapt its production strategies and garner a powerful position alongside its transnational partners within the industry.

Globo Filmes

The 1980s' and 1990s' influence of a neoliberal, political economic perspective in Brazil has led to vast changes within the global media structure and, in turn, helped to reinforce and produce a newly commercialized Brazilian cinema. This privatization and maturation within the industry is distinguished by the rise of transnational players alongside a local media conglomerate. Globo, one of the biggest players to enter film industry in the 1990s, has become more and more identified with Brazilian cinema. Media mogul Roberto Marinho founded a television network, which flourished under a brief but fruitful partnership (1962–1968) with Time-Life. From this relationship on Globo benefitted from financing and areas management strategies from American commercial television (Sinclair et al. 1996: 40). The finance allowed Globo a competitive advantage over other television networks, especially considering the high level of entry barriers such as finance and distribution against anyone trying to create a new network. The network eventually became a powerful media player, what media scholar John Sinclair calls an 'economic, political and ideological institution,' which for decades has dominated the share national audiences and expanded successfully through international exports of their products (Sinclair et al. 1996: 43).

Rede Globo is arguably the fourth-largest commercial network in the world, lagging behind the three US networks ABC, CBS and NBC (Straubhaar 1984). According to US media scholar Joseph Straubhaar, dominating both the audience and the development of television programming, Globo typically captured a 60 to 80 per cent share of the market in the major Brazilian cities (Straubhaar 2007: 91). By the early 1990s, the network produced close to 80 per cent of its own programming and earned a reputation for its *padrão de qualidade* [standard of quality], which is the aesthetic and production quality associated with the corporate brand (Simpson 1993: 61–2). Particularly, Globo's telenovelas have come to represent a brand categorized for their high technical quality and large pool of contracted actors. With its audience share, production quality and solid economic infrastructure, Globo continues to dominate the Brazilian television industry.

In an age of deregulation and mergers, transnational media giants have absorbed and formed diverse media divisions, notably Sony and NewsCorps' acquisition of Columbia Pictures and 20th Century Fox, respectively. In 1998, Globo followed suit in forming a film division. Producing three to four pictures a year initially, the media giant began pumping resources into film-making and cross-advertising of films on its TV networks, newspaper and radio station (Cajueiro 2001). The Globo Filmes' structure began with executive director Carlos Eduardo Rodrigues and director, writer and producer Daniel Filho as artistic director (Cajueiro 1998; 1999). The film division's objective as stated on the company's website is 'to contribute to the strengthening of the Brazilian audio-visual industry and to increase the synergy between cinema and TV' (Globofilmes.com 2000).

According to Rodrigues,

> the image that we want to construct is to be a producer that develops quality projects that can reach the most number of people, contributing to the increased participation of national cinema in international and Brazilian markets, and stimulating of the development national audio-visual industry. (Rodrigues in Fonseca 2003: 26)

One of Globo's strategies has been to create partnerships with members of the Motion Picture Association such as Sony, Fox and Warner Bros. as producing partners and distributors (Johnson 2005: 24). Although Hollywood companies have had a longtime presence in Brazil through distribution and exhibition, there has been a significant increase in partnerships since the introduction of the new incentives. For example, since the late-1990s, Sony and its film division Columbia have partnered with Globo Filmes. Under the terms of the 1993 Audio-Visual Law (No. 8685), Globo is not considered an 'independent' producer and, therefore, is unable to participate directly in the tax incentive programmes for financing films. However, Globo developed *parcerias* [partnerships] with production companies such as the foreign-owned Columbia who are allowed to raise funds under the law. Taking advantage of the Audio-Visual Law's tax incentive programme, Sony has made low-risk investments through co-producing and distributing local productions. Teaming up with a local superpower guarantees their signature production quality as well as their knowledge of local audiences and a traditional stronghold within local markets. In turn, Globo receives the production capital and distribution resources needed to catapult its new film production branch and secure a strong place within Brazilian popular cinema. Participating in local co-productions has greatly increased the economic and cultural power for both global and local firms and reinforced dominant global media patterns discussed at the beginning of this chapter. For the Brazilian side, in order to achieve market success the objectives of the incentives were to promote not only lucrative relationships between private industries and the film industry, but also to eventually achieve a self-sustaining system (Rêgo 2005: 20). The question remains what kind of sustainability has been achieved, since film-makers depend on Hollywood distributors and Globo's resources.

Globo Filmes website proudly displays their 'grande sucessos com a alma do Brasil' [great successes with the soul of Brazil] and claims that '9 out of the 10 box office successful Brazilian films of the last ten years are Globo Filmes co-productions' (Globofilmes.com 2000). The numbers back these claims: Globo Filmes co-produced and/or distributed *all* of the top 20 grossing films between 1995 and 2007. Of these films, Columbia co-produced and/or distributed close to half (Filme B 2001; ANCINE 2008). Yet, this recent monopoly of the box office by one company creates a complicated

situation in a supposedly openly-commercial market. An independent commercial film-maker working outside the Globo sphere, Aluízio Abranches, states that

> one of the obstacles facing Brazilian cinema is the Globo-Columbia duo. If you are not connected with this duo, then you have few chances for success. So, the biggest problem is the exhibition and distribution. The public is only going where Globo Filmes is involved. [The 2002 film] *As Três Marias* was seen more in Italy than here. (Abranches 2003: 33)

One of Globo Filmes' strongest advantages are the telenovela stars under contract with its sister organization, TV Globo. In Brazil, the star system is associated more with the television industry, and particularly with the Globo network and its major product, telenovelas, than with cinema. Traditionally, the film has been positioned as an inferior medium in relation to television. Since the 1970s, many film-makers have utilized television production to gain a commercial and competitive edge in these cultural economies (Johnson 2005: 27). In order to put together viable film projects, Globo's film production branch has found an efficient way to utilize a major asset of the television network—the brand name stars. Reportedly, at one point, the company has even imposed restrictions on actors under contract with Globo to participate in films made by other production companies. The company also has the privilege of buying these 'independent' films starring their telenovela actors before they are offered on the market. While this creates an obvious and unfair advantage in the national film marketplace, director Daniel Filho defends these business strategies by claiming 'what Globo is doing is legal' (Daniel Filho in Leal 2001: 33).

Yet, it is also important to acknowledge that the incorporation of Globo stars does not guarantee success for a mainstream film project. A number of scholars argue that Globo relies less on their star system and more on their convergence with television or the actual film concept, as will be discussed below. Particularly since 2005, films starring the popular television personality Xuxa have not earned the box office gross of her earlier films between the late 1990s and 2003. More and more films 'sem Globo' [made outside of the Globo system] are seen by over one million spectators (Caetano et al. 2005; Simis 2005; Rêgo 2008).

In the *Revista de Cinema* article, 'The Power of Globo Filmes in Brazilian Cinema', film writer and critic Rodrigo Fonseca addresses various reactions within the film community. Through their films *Auto da Compadecida/A Dog's Will* (2000) and *Lisbela e o prisoneiro/Lisbela and the Prisoner* (2003), director Guel Arraes and his co-producer Paula Lavigne have had a fruitful collaboration with Globo Filmes, where they have been able to 'make films that speak to the [Brazilian] public' (Fonseca 2003: 27). The established mainstream producer, Luiz Carlos Barreto, argues that a fear of success is unjustifiable and

the films promoted by Globo Filmes help to raise the market for all. The producer has adopted a diversified policy in association to the more different films by independent producers. It is necessary to demobilise the paranoia of the 'Globo quality of production.' Brazilian cinema has its own specific parameters for a quality of production. (Barreto in Fonseca 2003: 28)

While Barreto openly supports the position of Globo Filmes, many in the Brazilian film community are critical of this free market, 'trickle down effect' mentality, and the dependence on Globo to get films made and distributed locally. Carlos Diegues calls for opening up more opportunities:

[T]he partnership with television, as a general model, is indispensable to Brazilian cinema… Globo Filmes is a very welcome pioneer initiative, but it is necessary that mechanisms are created that favor the entrance of all networks and Brazilian broadcasters (emissoras) in partnership with Brazilian cinema, and that these mechanisms permit all tendencies and formats of Brazilian cinema to improve from this partnership. (Diegues 2003: 27)

In response to the concern over a Globo monopoly, artistic director Daniel Filho claims that Rede Globo and its film production branch are separate entities that treat their own films as they would other independent films. Specifically, he claims they pay for commercials and advertising on the Globo television channel—'We pay what others pay. Nothing different' (Daniel Filho in Leal 2001: 16–17). However, it is important to note, Filho, Barreto and Diegues have been all established within the industry for over three decades and have benefitted greatly from their association with Globo Filmes since its inception.

The formation and ascent of Globo Filmes as a major film partner in the late 1990s can be credited to its positioning as a transnational media conglomerate as well as the company's strategic partnerships. This aggressive strategy and access to resources led to their films achieving unprecedented commercial success as well as criticism within the industry. The following section will examine key individuals and their roles within Globo Filmes' success.

Individual film-makers/players

Guel Arraes and Daniel Filho's recent film-making careers parallel the rise of Globo Filmes. Both began directing for TV Globo series early in their careers. Born in the Northeast and son of the former governor, Arraes began his career with Rede Globo in

1981, co-directing the telenovela *Jogo da vida/Life's Game* by Sílvio de Abreu. Later, he created and directed the sketch comedy show *TV Pirata* and other comedy programmes, becoming known for his signature style that introduced humour and more agile direction.

Arraes adapted Ariano Suassuna's play *Auto da Compadecida* into a 1999 four-part mini-series that aired on Globo to high ratings and critical acclaim, and Filho encouraged the film-maker to edit the original two hours and 40 minutes into a 104-minute theatrical version (Cajueiro 2001). Featuring Globo stars Matheus Nachtergaele (João Grilo), Selton Mello (Chicó) and Fernanda Montenegro (Compadecida), the story follows two young, poor *nordestinos* [men of the Northeast] in the impoverished 1930s *sertão* [backlands] through a satirical lens that examines race, class, religion and corruption in Brazil (Cannito 2000: 32–3). Upon its theatrical release, the Columbia distributed film brought in an audience of over 2 million, and ranked within the top national grossing films from 1995 to 2007 (Filme B 2001). The box office success led Arraes to directing, writing and producing a number of television and film projects for Globo such as the 2003 film *Lisbela e o prisoneiro* and its strong ancillary run through musical soundtracks, videos and on DVD (both legal and illegal versions) (Leal 2001: 13). Arraes personifies the characteristics of a 'new' type of Brazilian director who moves seamlessly between producing television and film and develops mutually beneficial relationships co-producing films with Globo Filmes and its international partners. This convergence between media industries has been the key strategy of both Globo and its most financially successful and active film-makers, producers and executives in the past decade.

Daniel Filho has emerged as a driving creative force behind this transition of Globo into films on both a creative and institutional level. Filho began his career as an actor in television and film in the 1950s and 1960s, respectively. In addition to his acting career, Filho began directing film and television, working mostly with Globo series from the 1970s to the early 1990s. According to Filho, for 25 years he and Globo's former owner Roberto Marinho (1904–2003), did talk about film-making and Globo investing in production: 'Our dream in this period was to make films' (Daniel Filho in Leal 2001: 13). After a period away from Globo, coincidentally during *o colapso* of Brazilian cinema, he returned in order to create a film production branch of the company.

Daniel Filho contends that 'because the cinema was beginning to be rebuilt, we began to articulate the possibilities that existed for Rede Globo to make films and in turn we created Globo Filmes [in 1998]… My project is Globo Filmes. I am Globo Filmes' (Daniel Filho in Leal 2001: 13). This statement summarizes Filho's multi-faceted involvement in the artistic and financial elements of the production company. Besides his role as co-creator, as the artistic director he approves projects and serves as acting producer, via his company Lereby Produções, to a number of Globo films. These productions include some of the most financial and popular successes in Brazilian film history: *O Auto da Compadecida*, *Cidade de Deus*, *Carandiru* (Hector Babenco, 2003), *Cazuza—O Tempo*

Não Pára/Cazuza—The Time Will Not End (Sandra Werneck & Walter Carvalho, 2004), and *2 Filhos de Francisco/Two Sons of Franciso* (Breno Silveira, 2005). Additionally, Daniel Filho began directing, producing and writing his own films, again through the company. Since 2001, Daniel Filho directed many of the annual top-grossing films co-produced with Globo, including *Se Eu Fosse Você/If I Were You* (2006) and the huge commercially successful sequel (2009) as well serving as producer of many of the films listed above (Globofilmes.com).

Both Arraes and Daniel Filho are deeply entrenched within both the television and film-making divisions of Globo. They represent a new variety of commercial film-making that has emerged since the *retomada*. Their work, which blurs the traditional lines between these two media industries, exhibits the shifting nature of Brazilian film-making towards more transnational, market-driven and cross-media practices combined with culturally specific themes and narratives. As will be discussed in the next section, media convergence extends beyond these two film-makers and has become the foundation of Globo's strategy in the past decade. Examining the production practices of the company's top grossing films reveals how Globo Filmes has utilized similar strategies with its co-partner Sony and other Hollywood conglomerates to gain a stronghold over the Brazilian and other marketplaces.

Globo Filmes production practices

As a result of deregulation, privatization, conglomeration and the development of digital technology, transnational media conglomerates with key film divisions globally have a tighter control over their media products, the distribution outlets and the movements between creating products with multiple applications across multiple platforms. Henry Jenkins describes this strategy of media convergence as 'the flow of content across multiple media platforms, the cooperation between multiple media industries and the migratory behavior of media audiences' (Jenkins 2006: 2). He suggests 'extension, synergy and franchising are pushing media industries to embrace convergence' (Ibid: 19). Building film and television brands into lucrative franchises spawning sequels, spin-offs and reboots become beneficial to integrated companies who can strategically guide products from production, distribution and into profitable ancillary markets. As will be explored in this section, many of these franchises are based on easily marketable and familiar narratives, what Justin Wyatt calls the 'pre-sold premise', which is a remake or adaptation of a best-selling novel as well as a concept that taps into national trend, sentiment or major historical or media event (Wyatt 2003: 376). In the Brazilian context, Globo has been able to adapt high concept film-making towards specifically Brazilian history, popular culture and local audience taste.

Furthermore, media convergence is understood as having a unique cultural logic blurring earlier distinctions between media economics and cultural meaning, particularly

production/consumption and active/passive spectatorship (Deuze 2009: 148). Not only does this age of accelerated media convergence change the way film and television is produced but also how spectators negotiate and interact with it. While the remainder of this chapter will focus primarily on the Globo's concentrated production strategies, it is important to note how this has altered the relationship between Brazilian cinema and the audience—where, what and how they consume media has been impacted by emerging technologies such as satellite, DVD, Internet, cell phones and so on. Many individuals who may not have had prior access to Brazilian film shown only in the theatres are now watching Globo films via different platforms and technologies. While much has been written on transnational media conglomerates such as Time Warner and News Corp., how have convergence strategies been implemented and understood in another translocal and culturally specific media industry?

Executive director Carlos Eduardo Rodrigues divides the first decade of the film division into three phases according to project type:

> [T]he first three years were learning, working with three or four features per year. Most of them were great brand names associated with TV, such as Xuxa and Renato Argão, or adaptations of some of Globo's TV series, such as *O Auto da Compadecida*. Our second phase was marked by a strong development period and a greater participation of Globo Filmes in movies not associated with TV... Finally, in our third period, from 2005 to date, we are trying to put to use those long years of experience to improve our actions, always looking for new ways to support and invest into Brazilian cinema. (Rodrigues in Bezerra 2008: 22)

At least a third of the top-grossing Brazilian films between 1998 and 2007 fall under the already established and widely popular Xuxa or Aragão franchises, aimed at a built-in family audience. These character-driven franchises may function as part of decade-long franchises that already had a strong foundation in film and television and a relationship to Globo. While I do not have the adequate space to examine these earlier Globo Filmes franchises, suffice is to say they rely heavily on pre-sold characters that were spun off into a lucrative, multi-annual film franchise at the beginning of the Globo Filmes.

Rodrigues suggests Globo Filmes relied heavily on the marketability of TV Globo stars and popular series merely at the beginning, yet I argue the company has continued to utilize this strategy, especially in its comedy series. Two film adaptations scored well among local audiences in recent years: *Os Normais—O Filme/So Normal* (José Alvarenga Jr., 2003) and *A grande família/A Great Family* (Luiz Fernando Carvalho, 2007). The latter was a television comedy series from the early 1970s that Globo remade in 2001 to become one of network's most popular shows (Cajueiro 2005). *A grande família* follows the dysfunctional homelife of two parents, their grown children and children-in-law

under one roof and features notable Globo actors who star in both versions. The film garnered an audience of over two million and a domestic gross of R$15 million, making it one of the top earning films of the decade (Filme B 2001).

In addition to adapting popular Globo television series, part of the trend among the pre-sold-premise strategy has been to focus on historical nonfiction, primarily via two subgenres—the bio-pic (based on the life of a famous figure) and adaptation of the personal memoir (adapted from a nonfiction novel). Globo has produced a number of bio-pics, primarily based on popular musical figures in Brazil including *Cazuza* and *2 Filhos de Francisco*. Columbia co-produced and distributed both films, which were seen by 3 and 5.5 million spectators, respectively (Filme B 2001). Globo capitalized on a built-in music fanbase and utilized the music soundtrack from both films as effective marketing tools.

A number of Globo Filmes also focus on adapting personal memoirs tracing individual's lives in the *favelas* [shantytowns] by constructing an image of the everyday experience of poverty, drugs and government corruption. Katia Maciel classifies films such as *Cidade de Deus, Cidade dos Homens/City of Men* (both the 2002–2005 television series and 2007 film directed by Paulo Morelli) and *Tropa de Elite/Elite Squad* (José Padilha, 2007) as Globo's 'franchised favela' (Maciel 2008). Adapted from published memoirs popular throughout the country, Maciel argues the series functions as a cross-media franchise similar to a Disney movie or Warner Brothers' *Harry Potter*. A sense of realism, aura of first-person authenticity, fantasy and marketable music soundtracks offer the *favela* as a spectacle through flashy handycam and editing, whereas the films function as a commodity or what many label as 'poverty porn' to be consumed by Brazilian and global audiences alike.

Globo Filmes is able to rely on the parent company resources and other media divisions in order to build strong ancillary markets. After national and sometimes international theatrical distribution, many films extend their shelf life through modest DVD distribution, premiere on Globo's satellite channels, particularly Canal Brasil which shows domestic features, and eventually Globo television network (Fonseca 2003; Rêgo 2005).[3] Globo's network of print and broadcasting divisions and resources allow the films unprecedented shelf life and marketing power among Brazilian and Latin American producers. Through the mobilization of established television franchises, stars and pre-sold premises, Globo has utilized the strategy of media convergence in increasingly global and culturally specific ways.

Conclusion

This chapter surveyed Globo Filmes' rise to a dominant *pós-retomada* position and argues how this clearly parallels larger changes within global media economy—a shift to a more concentrated, privatized and transnational business model. While a number of

media scholarship still focuses on national cinema models or sweeping macro industrial trends, my objective was to examine how a local media conglomerate within a particular national context formulates practices and capitalizes on co-partnerships, cross-media convergence and ancillary markets.

The star system, cross-media resources and mobilization of ancillary markets and advertising have redefined Globo's so-called 'standard of quality' to include film and, in turn, transformed contemporary, commercial Brazilian cinema. Transnational networks, resources and talent—*this* is the real Globo advantage. If, as Rêgo suggests 'Brazilian cinema is speaking to the national public in increasingly sophisticated and appealing ways' (2005: 92), Globo Filmes has managed to be the loudest and most persuasive orator in the room.

The growing power of Globo within the film industry needs to be further examined and problematized. This presence is a double-edged sword, bringing more money to productions and greater audiences to the theatre but also blocking the way for other production companies and films to form lucrative partnerships. Helvécio Ratton, a feature and documentary film-maker who has worked inside and outside mainstream cinema for the past few decades, sees Globo's power as a 'dangerous seesaw'. Ratton argues that 'Globo Filmes benefits from the hegemonic position of TV Globo... this creates a situation in the market of absolute inequality of competition and a new form of exclusion... an important film is from either Globo Filmes or not' (Ratton in Fonseca 2003: 28). The great inequality and barriers existing against anyone on the outside of Globo system has only been exacerbated by the relationship with Hollywood conglomerates like Columbia.

However, after a domestic audience share peak of 21 per cent in 2003, overall ticket sales have dwindled, despite the occasional box office breakthroughs (Nagib 2003; Cajueiro 2004, 2006; de la Fuente 2005). Further research is necessary to examine how changing government policies and the global recession affect the Globo business model and its hold over the local film market. Since cyclical booms and busts in financing and production characterize Brazilian cinema, the big question is whether shifting political, economic and cultural conditions will open up space for other large local producers and will Globo be able to adapt?

Notes

1. Unless otherwise stated, all translations are by the author.

2. For a more extensive discussion of Brazilian film policies, see Randal Johnson. *The Film Industry in Brazil: Culture and the State*. Pittsburgh: University of Pittsburgh Press, 1987; Lúcia Nagib, Ed. *The New Brazilian Cinema*. Oxford: I.B. Tauris, 2003; Cacilda Rêgo. 'Brazilian cinema: its fall, rise and renewal (1990-2003),' *New Cinemas: Journal of Contemporary Film*. 3.2 (2005).

3. This is a notable transformation for a national cinema without funding, albeit the ability to consistently distribute Brazilian films through multiple windows. Yet, due to the high costs of DVDs and pay-TV channels within Brazil, how accessible are these films to the Brazilian population? The audience for these markets is most likely a small urban percentage of the upper socio-economic mobile who can afford theatre tickets and legitimate DVDs.

References

Abranches, A. (2003) '3 anos de *Revista de Cinema*,' *Revista de Cinema*: 33.

Acland, C. (2005) *Screen Traffic: Movies, Multiplexes and Global Culture*, Durham: Duke University Press.

ANCINE (2008) website, http://www.ancine.gov.br. Accessed April 1, 2006 and May 1, 2009.

Bezerra, J. C. (2008) 'A decade of work and success,' *Revista de Cinema*: 22–3.

Caetano, D. V., Melo, L. A. R., and Oliveira Jr., L. C. (2005) '1995–2005: Histórico de uma década' in D. Caetano (ed.) *Cinema Brasileiro 1995–2005: Ensaios sobre uma década*, Rio de Janeiro: Azogue, pp. 11-50.

Cajueiro, M. (2006) 'Hit can't raise Brazil,' Variety.

Cajueiro, M. (2005) 'TV Globo turns skeins to features,' *Variety*.

Cajueiro, M. (2004) 'Domestic strife: Weak fare, higher ticket prices take toll on local B.O.,' *Variety*.

Cajueiro, M. (2001) 'Globo *Auto* in high gear to top B.O.,' *Variety*.

Cajueiro, M. (1999) 'Globo eyeing U.S. distribs,' *Variety*.

Cajueiro, M. (1998) 'TV giant Globo gears up in pic prod'n,' *Variety*.

Caldwell, J. T. (2008) *Production Culture: Industrial Reflexivity and Critical Practice in Film and Television*, Durham: Duke University Press.

Cannito, N. (2000) 'A TV encontra o cinema em O *Auto da Compadecida*', *Revista de Cinema*: 32–3.

Curtin, M. (2009) 'Thinking Globally: From Media Imperialism to Media Capital' in J. Holt and A. Perren (eds.) *Media Industries: History, Theory and Method*, Malden: Blackwell, pp. 108–19.

De la Fuente, A. M. (2005) 'Latin Americans debate tax perk,' *Variety*.

Deuze, M. (2009) 'Convergence Culture and Media Work' in J. Holt and A. Perren (eds.) *Media Industries: History, Theory and Method*, Malden, MA: Blackwell, pp.144–56.

Diegues, C. (2003) 'The cinema that Brazil deserves' in L. Nagib (ed) *The New Brazilian Cinema*, London: I.B. Taurus, pp. 25–35.

Filme B (2001) website, http://www.filmeb.com.br/portal/html/portal.php. Accessed June 1, 2009.

Fonseca, R. (2003) 'O poder da Globo: Filmes no cinema brasileiro,' *Revista de Cinema*: 26–8.

Globo Filmes (2000) website, http://globofilmes.globo.com. Accessed February 15, 2006.

Harvey, D. (2005) *A brief history of neoliberalism*, New York: Oxford University Press.

Jenkins, H. (2006) *Convergence culture: where old and new media collide*, New York: New York University Press.

Johnson, R. (2005) 'TV Globo, the MPA and Contemporary Brazilian Cinema' in L. Shaw and S. Dennison (eds.) *Latin American Cinema: Essays on Modernity, Gender and National Identity*, Jefferson, NC: McFarland, pp. 11–38.

Johnson, R. (1987) *Film Industry in Brazil: Culture and the State*, Pittsburgh: University of Pittsburgh Press.

Leal, H. (2002) 'F. Meirelles: Chegou a sua vez', *Revista de Cinema*: 12–18.

Leal, H. (2001) 'Filho: O diretor de TV estréia *A Partilha* e pretende colocar um filme por semana na Rede Globo', *Revista de Cinema*: 10–17.

Maciel, K. (2008) 'The Franchised Favela in Recent Brazilian Cinema' in *Proceedings of the Conference Transnational Cinema in Globalising Societies*, Puebla: Mexico.

Miller, T., Govil, N., McMurria, J., Wang, T. and Maxwell, R. (2005) *Global Hollywood 2*, London: FBI Publishing.

Moisés, J. A. (2001) 'Uma nova política para o cinema brasileiro', *Cinema Brasileiro Cadernos do nosso tempo, nova série*, Rio de Janeiro: Edições Fundo Nacional de Cultura, pp. 3–22.

Nagib, L. (2003) 'Introduction' in L. Nagib (ed.) *The New Brazilian Cinema*, London: I.B. Taurus, pp. xvii-xxvi.

Nagib, L. (ed.) (2003) *The New Brazilian Cinema*, London: I.B. Taurus.

Rêgo, C. (2008) 'Rede Globo: A TV que virou estrela de cinema', *Studies in Latin American Popular Culture* 27: 268–9.

Rêgo, C. (2005) 'Brazilian cinema: its fall, rise and renewal (1990-2003)', *New Cinemas: Journal of Contemporary Film* 3: 85–100.

Simis, A. (2005) 'A Globo entra no cinema' in V. C. Brittos, C. R. S. Bolaño (eds.) *Rede Globo: 40 anos de poder e hegemonia*, São Paulo: Paulus, pp. 341-57.

Simpson, A. (1993) *Xuxa: The Mega-marketing of gender, race and modernity*, Philadelphia: Temple University Press.

Sinclair, J., Jacka, E. and Cunningham, S. (1996) *New Patterns in Global Television: Peripheral Vision*, Oxford: Oxford University Press.

Straubhaar, J. (1984) 'Brazilian television: The decline of American influence', *Communication Research* 11: 221–40.

Straubhaar, J. (2007) *World Television: From Global to Local*, Los Angeles: Sage.

Waisbord, S. and Morris, N. (2001) 'Introduction: Rethinking Media Globalization and State Power' in S. Waisbord and N. Morris (eds.) *Media and Communication: Why the state matters*, Lanham: Rowman & Littlefield, pp. vii-xvi.

Wyatt, J. (2003) *High Concept: Movies and Marketing in Hollywood*, Austin: UT Press.

CLOSE STRANGERS: THE ROLE OF REGIONAL CULTURAL POLICIES IN BRAZILIAN AND ARGENTINE NEW CINEMAS

Marina Moguillansky
University of Buenos Aires

> Much more has been agreed upon, signed and confirmed on the topic of regional, sub-regional and even bilateral integration, than has actually been carried out.
>
> (Octavio Getino 2006)

Introduction

The beginnings of contemporary Brazilian '*Retomada*' and 'New Argentine cinema' coincide with the creation of Mercosur in 1995 as a regional customs union, the first step towards a process of regional integration. Both Argentine and Brazilian cinemas—as well as most of the world's cinemas, excluding Hollywood and India—depend on public funding and regulation to subsist. The role of national protectionist policies in these countries has been studied by Anita Simis (1999), Tamara Falicov (2000), Daniel Caetano (2005) and Octavio Getino (2007) among others. Nevertheless, there has been insufficient attention paid to regional cinematographic policies being developed by Mercosur.[1] This chapter describes policy initiatives at the regional level from the creation of Mercosur to the present. It explores the limits of these policies as a result of both competing interests between the field's main actors and the lack of institution of Mercosur as a legitimate space for cultural policies. The questions that this chapter seeks to address are: What tasks has Mercosur accomplished in constructing a common cinematographic policy? To what extent has it increased collaboration, cooperation in

joint ventures, exchange of productions, and mobility of technicians and professionals? What kinds of obstacles are faced by cultural policies aimed at a regional level?

Other studies about cultural industries in regional integration processes have established that cinematographic policies in regional blocs face a tension between, on the one hand, economic interests linked to the integration process in the sector (i.e. media corporations, multiplexes, international distributors) and, on the other, the issue of cultural diversity. The European Union (EU), the North American Free Trade Agreement (NAFTA) and Mercosur show three different traditions with respect to the treatment of audio-visual industries. According to Hernán Galperín (1999), the way that regional blocs deal with the audio-visual industry and the results they accomplish are conditioned by the industrial structure of each country, domestic policies for the sector, and the existence of significant cultural differences. The author considers that Mercosur had optimal chances to develop regional policies for cultural industries since their members were culturally close. However, it is possible to argue that relevant cultural differences do exist between the Mercosur members, as many recent studies have shown (Martini 2000; Lins Ribeiro & Frigerio 2002; Grimson 2007).

We begin by analysing the role played by the cultural and cinematographic industries in the project of integration in the Mercosur. We describe the shift in regional cultural policies around 2003 when cinema managed to establish an institutional space for the discussion and elaboration of projects for the sector: the creation of the Special Conference of Cinema and Audio-Visual Authorities of Mercosur (RECAM). We analyse the main discussions and programmes that have been implemented by this organization and conclude by exploring the topic of other policies that were not brought into existence. As we will demonstrate, the conflicting interests of those involved and the difficulties in establishing a regional space as a horizon in decision-making have been significant obstacles in the process of defining cinematographic policies for Mercosur. Therefore, assistance to the region's cinema was addressed mainly because of its usefulness to obtain greater markets for a particular country's own production.

Space for cinematographic policies in Mercosur

Well before the creation of Mercosur, there were several attempts at improving communication and exchange between the fragmented cinematographic industries of Latin America. These initiatives, however, developed between groups of countries that did not include Brazil and Argentina together, given that language was considered an important factor in mapping out the integration. Octavio Getino explains that 'the incompatibility of language complicated the existence of exchange projects with Brazil and the latter was further exacerbated by the relative self sufficiency of Brazil's market to finance its own industry's products' (Getino 2006: 2). The collaboration and exchange projects took place

between Spanish-speaking countries, particularly Argentina, Cuba, Mexico and Spain. The first step towards cooperation across the language frontiers was taken in 1989, when a group of Latin American and Caribbean countries, Spain and Portugal, signed the Ibero-American Agreement on Cinematographic Integration. This agreement founded the Conference of Iberian-American Film Organizations (CACI), one of the first instances of cooperation and integration that incorporated Brazil and Argentina into the same space.[2]

Under the auspices of Mercosur, Brazil and Argentina sat down, almost for the first time, at the negotiation table to establish a relationship of cooperation with respect to cinematography. During the regional bloc's first decade of existence, the topic of the cinematographic industry was included in general resolutions on culture or cultural industries. However, spaces for interaction also began to be created independently of the official Mercosur, such as the Mercosur Audio-Visual Producers Association (APAM) in 2000, film festivals such as the Florianópolis Audio-Visual del Mercosur (FAM) and other forums which marked the beginning of discussions on sector policies. Cinema then went on to form a specific space to focus on sectorial policies based on the combination of several factors. On the one hand, there was the already sustained recuperation of the cinematographic industries in Brazil and Argentina with important recognition at international festivals, while, on the other, was the importance given to the audio-visual industry in the foreign policy of Luis Ignácio Lula da Silva's government. In 2003, the creation in Brazil of a state organization for cinematographic policy, the Agencia Nacional do Cinema (ANCINE), led to a boost in regional cooperation.

Special Conference of Cinema and Audio-Visual Authorities of Mercosur (RECAM)

The Special Conference of Cinema and Audio-Visual Authorities of Mercosur (RECAM) was created near the end of 2003 with the goal of constructing a space for the promotion of the production and distribution of goods, services and personnel in the regional cinematographic industry. RECAM is an advisory body composed of the highest authorities on cinematography from the Mercosur countries, both full and associate members, with a temporary presidency rotating among full members. It has a Technical Secretary who coordinates meetings and carries out follow up on work related issues and, since September 2004, also oversees the Mercosur Audio-Visual Observatory (OMA), which produces and systematizes information on regional audio-visual industries.[3]

The main task of RECAM is the discussion and development of proposals for the improvement in the integration of the regional cinematographic industries. Major topics presented for analysis at meetings have included the reduction of disparities, access to national markets, free intra-Mercosur circulation, and creation of a regional screen quota and education of audiences. With respect to concrete initiatives, several starting points were established for projects, the majority of which are still at the stage of preliminary

studies. One of the main concerns raised by the various participants in RECAM has been the difficulty in circulating cinematographic works among Mercosur countries. Regarding this issue, the obstacles facing circulation were studied and an attempt was made to implement the Mercosur Cultural stamp, and finally the Mercosur Certificate of Cinematographic Work was created in 2006.[4] Despite this, according to distributors, bureaucratic setbacks continue to exist because the resolutions either did not reach or were not recognized by the corresponding Customs agencies.

Cinematographic integration also faces the problem of disparities between the institutions and laws that regulate the sector in each country. For example, Argentina and Brazil have specific organizations (INCAA and ANCINE, respectively) and laws that regulate and foster the cinematographic industry (Law no. 24,377 in Argentina, and Law no. 8,685 —known as the Audio-Visual Law—in Brazil). On the other hand, Paraguay and Uruguay had neither institutions nor specific legislation when RECAM began functioning. It is for this reason that the RECAM promoted the drafting of film laws in Paraguay and Uruguay. In the case of the former, the law is currently under study and with respect to the latter, the film law has recently been approved leading to the creation of the Instituto Cinematográfico y Audiovisual del Uruguay [the Film and Audio-visual Institute of Uruguay, ICAU].[5] RECAM has also encouraged the realization of Mercosur film festivals and discussion seminars in order to increase the possibility of exchange and mutual understanding among actors in this industry. The projects recognized by RECAM as its greatest achievements are the co-distribution agreement between Brazil and Argentina, the creation of a Competitivity Forum for the cinematographic sector and the initiation of bonds of cooperation with the European Union. These policies will be analysed in more detail below.

The Co-distribution Agreement between Argentina and Brazil

Based on a study that underscored the low circulation of films in the respective markets of Mercosur countries caused by 'existing distortions in the world cinematographic and audio-visual market' (RECAM 2004), the officials close to RECAM began to formulate a policy that would foment the circulation of non-national Mercosur cinema on the screens of regional countries. As a starting point, Brazil and Argentina were selected for the first co-distribution agreement, given that they were the largest producers and, at the same time, had the most significant markets. The main premise was that there was an unsatisfied demand for Latin American cinema that could be exploited and increased through supplemental public policies.

A co-distribution agreement between Argentina and Brazil (hereafter referred to as ACD) was signed in 2003.[6] The objective of the agreement was 'to give support, financial or otherwise, to projects aimed at the distribution of Brazilian full-length cinematographic works in the Argentine movie theatre market' and vice versa for Argentine films in Brazil

(Clause 1). Financial support would be earmarked for covering part of the costs involved in copying, subtitling and transporting copies as well as part of the costs of promotion and publicity. Moreover, the respective organizations governing film in each country were to send a list of possible films to be distributed in the neighbouring market. Copies of films would be allowed temporary entry into countries, contradicting national legislation; however the problem of the circulation of copies between Mercosur countries was not resolved in a conclusive manner.[7] As we will explain, this posed a serious obstacle for the implementation of the project in Argentina. According to the text of the agreement, 'INCAA and ANCINE are committed to seeking out ways to facilitate the transportation of copies and inter-negatives between the two countries' (ACD, Clause 21) (INCAA/ANCINE 2004).

The agreement, first implemented in 2004, generated a considerable increase in cross-releases in both countries. However, the results were quite different in the two countries. In Brazil there were no serious problems, while in Argentina the implementation of the agreement was much more complicated. The first public call was held in 2004 by both INCAA and ANCINE. In both cases, distributors were invited to present proposals to release films in the neighbouring country, choosing from a list tailored to these ends. The following table shows the eight Brazilian films selected in this first competition.

Table 1. Brazilian films selected in the first competition of the Co-Distribution Agreement for Argentina (2004)

Release Date	Film	Distributor	Audience	Box Office Receipts (US$)
2004	*Madame Satã*	Artkino	20,330	26,656.59
2004	*Dois perdidos numa noite suja*	Americine	250	348.00
2004	*O caminho das nuvens*	Disney	9,207	16,653.49
2004	*Separações*	Primer Plano	3,273	16,849.96
2005	*Amarelo Manga*	Artkino	828	1,435.43
2005	*Cristina quer casar*	Forever Films	467	542.50
–	*O casamento de Louise*	Forever Films	–	–
–	*Deus é Brasileiro*	Columbia	–	–

Source: Based on data from the OMA, INCAA, national newspapers and interviews with distributors.

According to the distributors participating in the first competition, this event worked relatively well despite showing some serious problems. Two out of eight Brazilian movies selected to receive subsidies ran into difficulties and could not be released (Betse de Paula's *O casamento de Louise/Louise's Wedding* and Carlos Diegues' *Deus é Brasileiro/ God is Brazilian*).

The implementation of the agreement in Argentina faced several issues which exacerbated the problem and detracted from any potentially positive outcome. In the first place, there were complications in bringing the Brazilian films into Argentina. Argentina has a legislation designed to protect local laboratories, prohibiting the importation of positive copies of films. In other words, the inter-negative must be imported to produce copies in Argentina. But the co-distribution agreement, foreseeing that the costs of this process might be high, established an exception which authorized the copying and subtitling of films in either Brazil or Argentina.[8] These instructions, however, never made it to Argentine Customs, where several films were delayed. According to distributors, this was a rather frequent problem. This was further complicated by the fact that the majority of Brazilian films that were designated for release in Argentina had previously been sold to HBO-Olé, a *premium* movie channel on cable television. This meant reduced times for theatrical release of the titles. Finally, a third complication was that INCAA delayed communicating the results and paying out the subsidies. The release of Karim Ainouz's *Madame Satā* experienced several setbacks that produced disastrous results. The film was delayed at the Argentine Customs, and when it finally got to the cinemas a cable channel was already about to broadcast it. As a result, the film was given no screen space in the most important movie theatres in Buenos Aires.[9] The remaining five films released under the agreement fared poorly in the box office although, according to distributors, the subsidy compensated their losses.[10]

The situation for the second competition in 2005 was even more complicated. The majority of independent distributors, at whom the competition was directed, decided not to participate, given the problems they had had in the previous year. One of the distributors that did enter the competition was Americine, specializing in Ibero-American cinema with a subsidiary in Brazil. However, despite their favourable position, not even they were able to benefit from the programme. The implementation problems were even more severe. Because the INCAA did not guarantee the payment of subsidies, the distributor decided not to release one of the films that had been selected. In an interview conducted by the author, the distributor summarized the process

> They didn't pay anything, saying 'you release the film and we'll pay afterwards'. Since I'm committed to Brazil, we have a commercial office there, and I'm internationally recognized, for all these reasons we went ahead with the release of the first film and, following that, the second. To date we haven't received any payment... I didn't bring the second. (Interview with an independent distributor, October 2008)

In the second edition of the competition, the issues that had not been resolved, such as the problem of copies, deadlines for payments and the sales of the films to television, worsened. The conflict between independent distributors and the INCAA authorities reached such an extreme that the decision was taken to suspend the implementation of the agreement in Argentina. The distributors who were consulted decided to no longer participate.[11] One final problem that affected and limited the experience of the co-distribution agreement was the absence of a circuit of commercial movie theatres for the exhibition of art cinema in Argentina. This was perhaps one of the key factors that explained why the agreement worked successfully in Brazil, where ANCINE carried out three editions of the competition for the distribution of Argentine films. Brazil has an important circuit of commercial theatres dedicated to art film: around 160 movie theatres dedicated to art film, representing 8 per cent of the total, distributed throughout the states, with a higher number in São Paulo and Rio de Janeiro (Filme B 2005).

The Film Competitiveness Forum

The second main policy promoted by the RECAM was the creation of a Competitiveness Forum to the film industry, designed to promote interconnectedness between producers, distributors and exhibitors across the region. In 2007 the Forum on Competitiveness in the Cinematographic Sector, the second of its kind in Mercosur, was created.[12] The first meeting, which took place in 2008, included representatives of respective governments, the production sector, commercialization (distribution and exhibition), and professional and technical unions. The anticipated objectives for the Forum included issues of production, distribution, exhibition and infrastructure (see Table 2). Due to its relatively recent creation, the results and progress of the Forum have yet to be evaluated.

Cooperation with the European Union

After about four years of difficult negotiations that saw both advances and setbacks, RECAM, through the creation of the Technical Secretary, managed to articulate the interests of both Mercosur and the European Union in a joint project of interregional cooperation.[13] This project was innovative given that 'international co-operation had always taken place between States' (Bayardo 2004: 3). In early 2007 the 'Strategic Regional Document 2007–2013 on Cooperation European Union-Mercosur', which established medium-term common objectives and included issues related to the cinematographic industry, was signed. The agreement also saw the creation of the Project to Support the Cinematographic and Audio-visual Sector which stipulated that the European Union would provide 1.5 million euro dedicated to strengthening the sector in Mercosur.

Table 2. Mercosur Film Competitiveness Forum

Sector	Objectives
Production	Strengthen the long-term association and complementation among regional producers in order to increase regional co-productions;
	Stimulate the exchange of production experiences with the objective of reducing costs, reinforcing technical and artistic quality and expanding the market for professionals in the sector.
Distribution	Promote the association of independent distributors, developing mechanisms of complementation and exchange for the co-distribution of national films and regional co-productions;
	Promote the creation of regional distribution pools that broaden the regional distributors' capacity for participation on an international level;
	Generate activity for joint commercial promotion abroad.
Exhibition	Encourage the association of regional businesses and national cinematographic exhibition chains, facilitating access to diverse national markets;
	Expand the cinematographic exhibition territory of the bloc's countries;
	Generate ties between independent distributors and MERCOSUR exhibitors;
	Generate mechanisms that encourage regional television stations and programmers, both open and subscription, to broadcast MERCOSUR cinematographic and audio-visual works.
Infrastructure	Plan on a regional level the various regional providers of infrastructure and cinematographic and audio-visual services for the whole value chain;
	Identify measures that facilitate the circulation of works in progress;
	Integrate new digital technologies into the regional cinematographic production, distribution and exhibition processes.

Source: Mercosur/X RECAM/DI No. 01/07

Cooperation with the European Union could be significant with respect to the transferral of experiences towards Mercosur, even if the amount of resources earmarked for that purpose is not. The European Union has typically had very active regional policies in the audio-visual sector, for instance, the development of financing programmes for production and especially co-production [*Eurimages*], policies of regional distribution [MEDIA], guidelines for cinematographic and television screen quotas [*Televisión sin fronteras*], an audio-visual observatory, and support for training sector professionals. The majority of these programmes were initiated in the early 1990s and today benefits from accumulated experience and significant evaluations of the results of these policies.[14]

The omissions of cinematographic policies

Cinematographic policies developed in the Mercosur region can be evaluated according to the results and limitations of programmes implemented, such as the Co-Distribution Agreement between Brazil and Argentina. We can go one step further and explore which initiatives and policies have been obstructed during these years as well. Keeping in mind the series of debates and proposals that were developed under RECAM and never converted into public policy, or were deliberately postponed, we will analyse the array of conflicting interests in the field of cinematography that effectively prevent the implementation of these projects. In order to take a closer look at the obstacles in the development of cultural policies in Mercosur, we will examine two representative cases of projects which were cancelled: the regional screen quota and the joint funds for cinematographic production.[15]

Regional screen quota

There are screen quotas for national production in Brazil and Argentina that do not include films from the other Mercosur countries. In the third meeting that took place in Brasilia in September of 2004, RECAM agreed to support the implementation of a regional screen quota. This project, however, has not come into fruition nor does it seem likely to in the short term, given the opposition expressed by some actors in the cinematographic industry. Some are opposed to the screen quota in general, whether for national or regional production, and look unfavourably upon any increase in exhibition regulation. Distributors and exhibitors see state intervention in this area as authoritative and detrimental: For example, in an interview with an independent distributor, he indicated,

> I'm not a strong believer in the screen quota. I agree that it's important to protect film but the thing is that we can't tell the public what they should or shouldn't see. (Interview with an independent distributor, Argentina)

According to distributors, the screen quota does not resolve the real problem, which is a lack of interest on the part of the viewers with respect to Mercosur's production and their own national production. Exhibitors represent the main opposition to policies on sector regulation with the same arguments as the distributors, both centred on viewers' preferences.[16] Much criticism has been levelled against the screen quota regulations. The majority of the questioning was along the lines of that expressed by distributors and exhibitors, again centering on the free choice of the viewer and business interests.[17] A minority supported the screen quota but warned that protective measures aimed exclusively at Argentine cinema would not protect film diversity. The critics of the magazine *El Amante* along with other independents, expressed their reservations not with respect to the screen quota itself, but rather with respect to its design in that it took spaces away from other cinemas, mainly the European industry.

Opposition from distributors and exhibitors to the screen quota is strong even when it is only a question of protecting national production, but the quota does count on emphatic support from Argentine directors and producers associations, the Sindicato de la Industria del Cine (the Film Industry Union, SICA) and INCAA authorities. On the other hand, when the possibility emerged that this quota could also be applied to production in other Mercosur countries, there was no significant show of support by any sector in the cinematographic field.[18] It is for this reason that the round of consultations among member countries initiated by RECAM to study a regional screen quota made no progress. Even with respect to the state, the extension of Mercosur cultural policies looks unlikely as is evident in the following passage:

> Argentine cinema is incumbent on the cultural policies of the Argentine State. French cinema is incumbent on the cultural policies of the French State. The Argentine State pays me to defend Argentine cinema. (Interview with Jorge Coscia, *El Amante*, no. 149, September 2004)

For actors in the field of cinematography, for both businessmen and officials, State protection of national cinema is a possibility that, though questioned by some, was finally accepted to varying degrees according to the interests in play. The inclusion of regional cinema in these protective mechanisms, on the other hand, either does not appear on the agenda for discussion or is automatically discredited as an impossible or absurd alternative. It is notable that despite Mercosur having been in existence for over ten years, the public discourse of state officials (directors of INCAA, for instance) still has not included it as a relevant space in the determination of cultural policies.

Regional financing funds

Although from the beginning RECAM set about to confront the tremendous inequalities that existed between the cinematographic industries of Mercosur countries (in terms of market size, public funding, industry density, legislation, among others), the concrete projects to carry out these objectives have seen practically no development, nor could they establish themselves as problems needing to be addressed. The smaller countries, Uruguay and Paraguay, presented several proposals to overcome their chronic lack of funds in developing a cinematographic industry. These were concerns that trace back almost to the beginnings of Mercosur. Paraguay, for instance, had proposed the creation of a Bank of Cultural Projects with lines of credit available to regional producers during the meetings of the Mercosur Cultural Parliament. Later on, in various RECAM meetings, both countries explained their situations, requesting more access to Brazilian and Argentine funds.

The proposals were focused on the idea of developing regional funds dedicated to financing cinematographic production and encouraging co-productions, practically the only option for the cinematographic industries of smaller countries. Taking into account that the state investments of Brazil and Argentina represent 99 per cent of the regional funds, it would be feasible to consider crossed investment mechanisms to assist in development of the industries of neighbouring countries.

The most ambitious initiatives did not even make it onto the agenda for discussion at RECAM. Access to joint financing for smaller countries was dealt with only with respect to the alternative of co-production agreements. In this regard, in 2005 and 2006, the possibility of developing a Mercosur agreement on cinematographic co-production was discussed but made no headway. In any case, there is a possibility that the issues of interregional inequalities and access to resources for film financing will make it onto the RECAM agenda in the near future. The coming into force of the Cooperation Agreement with the European Union could provide a suitable occasion.

Where are cinematographic policies defined?

Regional cultural policies have seen very little development under Mercosur. While it is true that in recent years some political initiatives have been established regarding the audio-visual sector, there has been little implemented beyond the rhetoric of statements, pacts and agreements. There are inconsistencies (as we saw in relation to the circulation of copies and Customs) and conflicts of interest (on the regional screen quota, for instance) that have emerged between Mercosur's regulations for cultural integration and the cultural transactions that actually take place between the regions' countries. The proposed cultural policies address neither existing asymmetries between Mercosur countries nor the serious problems in the film distribution and exhibition circuits. It is

clear that the most controversial issues such as 'the concentration of the industry, content diversity, and the growing social stratification of access to cultural goods' (Galperín 1999) have gone unaddressed. We must concede, however, that the silences of cultural policies are generalized and can be found in much more developed blocs with greater financial resources such as the European Union. It is therefore evident that there is a necessity, in this respect, for a significant advance in cultural policies related to the 'focal point of cultural diversity and social justice, not simply as a necessary instrument to put a stop to the mega corporations that complicated them, but rather as a creative work on the senses, that allows for the imagination and construction of pluralist worlds' (Bayardo 2008: 12).

Mercosur's definition of cinematographic policies continues to belong almost exclusively to nation states. The most relevant decisions regarding issues such as the general regulation of the sector, production financing, exhibition screen quotas and the policies regarding education of the public, are taken up by each national state with regards to their own cinematographic industry. Public investment in each sector is administered by each country and is conceived as limited to the space within their particular borders. To date, there are no regional funds to support cinematographic policies. Nor have regional regulations been developed to manage or intervene in cinematographic industries and markets.

To sum up, although there have been initiatives and political will to strengthen integration in the area of cinematography, these have faced a series of difficulties. The first being Mercosur's own configuration, with a bias toward commercial ends and based on an intergovernmental model that was not designed to make important concessions with respect to sovereignty. Second, the little importance that culture has had for the Latin American states and the traditional matrix of their cultural politics meant that they tended to centre on the administration of events and the protection of arts and folklore. Third, there are the significant asymmetries that exist between Mercosur countries with respect to the size of their industries and cinematographic markets as well as legislation, institutions, and public policies dedicated to the sector.

Finally, the main obstacle, in part dependent on the previous ones, is the difficulty involved in establishing the regional space as a field of reference in the definition of public policy. As previous research has indicated, 'even among those who have a very positive vision of regional integration, national interests and sentiments take precedence over regional ones' (Grimson 2007: 585). The nation continues to be the natural recipient of state action in the conception of investors and private actors in the field of cinematography. The design of the co-distribution agreement between Brazil and Argentina is symptomatic in this respect. The States set out a development framework for cinema in the corresponding neighbouring country only when reciprocity guaranteed benefits for their own cinematographic industry. Assistance to the region's cinema was addressed thanks to its usefulness as an indirect tool to obtain greater markets for a particular country's own production.

Notes

1. Denise Mota da Silva (2007) has studied the cinematographic Mercosur reconstructing the views from the main actors in the industry: producers, directors, actors and others, reaching the conclusion that the main interest behind cinematographic integration is to broaden markets. Therefore, nowadays the cinematographic integration in Latin America does not have the political meaning that it had decades before.

2. This is a significant landmark in regional cinematographic policy since it was under the same framework that the Latin American Agreement on Cinematographic Co-Production and the Agreement for the Creation of a Latin American Cinematographic Market were also signed. It was these agreements which, years later, allowed many Latin American and Caribbean countries to seek shelter from the liberalization of services in the GATS rounds (Sandoval Peña 2000:11). Furthermore, it was under CACI that the signing of bilateral agreements on co-production were instigated. Brazil and Argentina signed theirs in 1995.

3. Between 2004 and 2007, the OMA was directed by Octavio Getino and undertook a series of valuable studies that constitute the only source of systematized information on the audio-visual industries of Mercosur countries. Near the end of 2007, after its director resigned, the majority of projected research activities were cancelled.

4. Mercosur/GMC/Res. no. 27/06.

5. Law no. 18,284 of May 16, 2008.

6. This agreement was prepared by Eva Piwowarsky, Technical Secretary of RECAM from the time of its creation, and by Alberto Flaksman, official from the Agencia Nacional do Cinema (ANCINE) in Brazil.

7. Both Argentina and Brazil have protectionist legislations that forbid the entrance of positive copies of films. According to the law, the distributors must import internegatives and get the copies produced in the country by national laboratories.

8. 'The copying and subtitling of the Brazilian films deemed winners of the competition associated with the aforementioned Agreement, irrespective of whether in Brazil or Argentina, is hereby authorized under the exceptional terms of this agreement' (Article 10, Competition Terms and Conditions, INCAA).

9. Even so, this film obtained the best overall results with respect to audience numbers and box office receipts. According to the distributor, it was thanks to word of mouth that it managed to recover from a very complicated première.

10. 'The first competition went off well because the person in charge was responsible and there were no problems. Not all of the films made money but because of the subsidies there weren't any problems.' (Interview with an independent distributor, 2007)

11. 'You can see that on the one hand, the diplomatic party had no intention of supporting any of this and that politically in Argentina there weren't intentions of supporting any of this either. I got out of the agreement and I don't want to have anything else to do with it, with any week or anything like that. I don't like being used.' (Interview with an independent distributor, 2007)

12. Mercosur Forums are created under the auspices of the Programme of Competitiveness Forums of Mercosur Production Chains by Common Market Council (CMC), to take advantage of the comparative benefits of member countries and to improve global competitivity.

13. At the moment of writing, the agreement has yet to be signed (Interview with Eva Piwowarski, Technical Secretary of RECAM).

14. The *Eurimages* programme was created in 1989 as a subsidy fund for European co-productions and has continued functioning regularly since its creation. Although 90 per cent of its funds are intended for cinematographic production, it has also developed plans to foster the distribution and exhibition of European films. Its annual budget is approximately 20 million euro. *Televisión sin fronteras* [Television Without Borders] was implemented in 1991 and underwent a series of modifications. It establishes minimum broadcasting times to be dedicated to European material on the television channels of member States. With respect to the regional screen quota, the Management Report of RECAM's Technical Secretary (2006–2007) states that the issue will be addressed at a later date.

15. With respect to the regional screen quota, the Management Report of RECAM's Technical Secretary (2006–2007) states that the issue will be addressed at a later date.

16. According to Leonardo Racauchi, Secretary of the Cámara Argentina de Exhibidores Multipantalla (CAEM): 'The screen quota doesn't work nor does the audience average. It's the viewers who will decide what to see' (Blejman 2004).

17. 'Argentine cinema has been converted into a product manipulated by the State. They have nationalized it. Like during the dictatorships. The State is not creative, it acts very little, provides according to its criteria and is not concerned with failure. The State pays everything and fills the shelves with lifeless rolls of celluloid, forgetting that it is the moviegoing public that supports those lifeless rolls with ten percent of the admission price.' (Claudio España, *Perfil*, 12/31/2006).

18. Such as the Asociación Argentina de Directores de Cine (AADC), Directores Argentinos Cinematográficos (DAC), Directores Independientes de Cine (DIC) and Proyecto de Cine Independiente (PIC) Asociación General de Productores Cinematográficos de la Argentina (AGPCA) and the Federación Argentina de Productores Cinematográficos y Audiovisuales (FAPCA). In this respect, film directors and producers have generally employed a nationalist discourse which claims the State's exclusive attention: 'The function and purpose of INCAA is to foment and protect Argentine cinema. It is important to remember this given that there were objections to the regulations by those who alleged to conspire against the exhibition of any type of production that isn't Hollywood.' (Juan José Campanella and Juan Vera, in *La Nación*, 08/06/2004).

References

Bayardo, R. (2008) '¿Hacia dónde van las políticas públicas culturales?,' 1º Simposio de Políticas Públicas Culturales en Iberoamérica, Universidad Nacional de Córdoba, October 22-23.

Bayardo, R. (2004) 'Consideraciones para la cooperación euroamerica en investigación cultural desde una perspectiva latinoamerica,' *Pensar Iberamérica: Revista de Cultura* 7, September-December, OEI.

Blejman, M. (2002) 'Un acuerdo muy difícil de consensuar,' *Página 12*, http://www.pagina12. com.ar/diario/espectaculos/6-36453-2004-06-09.html. Accessed August 25, 2010.

Caetano, D. (ed.) (2005) *Cinema Brasileiro 1995–2005. Ensaios de uma década*, Rio de Janeiro: Azougue.

Campanella, J. J. and Vera, J. (August 6, 2004) 'Víctimas de la ley del más fuerte,' *La Nación*.

España, C. (December 31, 2006) 'La industria del cine argentino pierde peso,' *Diario Perfil*.

Falicov, T. (2000) 'Argentina's blockbuster movies and the politics of culture under neoliberalism, 1989–98', *Media, Culture & Society* 22.3: 327–42.

Filme B (2005) Film database, http://www.filmeb.com.br. Accessed August 25, 2010.

Galperín, H. (1999) 'Cultural Industries Policy in Regional Trade Agreements: the case of NAFTA, the E.U. and MERCOSUR', *Media Culture & Society* 21.5: 627-48.

Getino, O. (2006) 'Negociación e integración en el sector cinematográfico y audiovisual en los países del Mercosur. Antecedentes y experiencias' in C. J. Moneta (ed.) *El jardín de los senderos que se encuentran: Políticas públicas y diversidad cultural en el MERCOSUR*. Oficina de UNESCO en Montevideo, Representación de la UNESCO ante el MERCOSUR. Montevideo.

Getino, O. (2007) *Cine iberoamericano. Los desafíos del nuevo siglo*, Buenos Aires: CICCUS.

Grimson, A. (2007) *Pasiones nacionales. Política y cultura en Brasil y Argentina*, Buenos Aires: EDHASA.

INCAA/ANCINE (2004). Acuerdo entre Brasil y Argentina para el fomento a la distribución de películas de largometraje, http://www.recam.org/_files/documents/arg_bra_codistribucion_04_05.pdf. Accessed January 1, 2009.

Lins Ribeiro, G. and Frigerio, A. (2002) (eds.) *Argentinos e brasileiros. Encontros, imagens e estéreotipos*, Petrópolis: Vozes.

Martini, S. (2000) 'Los relatos periodísticos sobre el Mercosur o la (des) integración imaginada', V Jornadas Nacionales de Investigadores en Comunicación, UNER.

Mota da Silva, D. (2007) *Vizinhos Distantes: Circulação Cinematográfica no MERCOSUL*, São Paulo: Annablume

RECAM/MERCOSUR/ACTA N° (2004) II Reunión Especializada de Autoridades Cinematográficas y Audiovisuales, http://www.recam.org/_files/documents/acta_ii_reunionordinariarecam.pdf. Accessed January 1, 2009.

Sandoval Peña, N. (2000) 'Las industrias culturales en América Latina en el marco de las negociaciones de la OMC y el ALCA', *Pensar Iberoamérica*, Lima.

Simis, A. (1999) *Estado e cinema no Brasil*, São Paulo: Annablume.

NEW VISIONS OF PATAGONIA: VIDEO COLLECTIVES AND THE CREATION OF A REGIONAL VIDEO MOVEMENT IN ARGENTINA'S SOUTH

Tamara L. Falicov
University of Kansas

The history of cinematic images of the Patagonian region began in 1922 with the silent film titled ¡*Patagonia*! Since then, there have been a series of Argentine films made every few years that feature Patagonia as a backdrop. Film-makers who have directed feature films in Buenos Aires with Patagonian themes include Carlos Sorín, Jorge Víctor Ruiz, Nicolas Sárquis, and Ciro Capellari. Autochthonous film-making encompasses a small canon of principally documentary film-makers from the Patagonian region: Lorenzo Eduardo Kelly, Carlos Procopuik, and finally, Jorge Prelorán. Argentina's most celebrated documentary film-maker Prelorán was born in Buenos Aires, but made some of his most famous films in Patagonia, documenting indigenous and other rural people in their natural surroundings. While Argentine cinema as a whole has been well documented (relatively speaking), there has been little research on Patagonian regional cinema apart from Juan Carlos Portas' *Patagonia: Cinefilia del extremo austral del mundo* [Patagonia: Cinephilia from the Extreme South of the World] a landmark book from 2001.[1] Portas studies Patagonian films that were produced by locals, as well as national and international productions that have been filmed in the region.

In 2000, some young cineastes from Patagonia—through two video collectives based in Neuquén—tried to challenge the singular view of the uncharted, wild, and exotic landscape with the hope of expanding the production and circulation of the region's image. In an interview by Lisandro Listorti and Ezequiel Luka of the Argentine online magazine *Film*, the Patagonian videographer Martín Ferrari of the video collective RIPA,

Realizadores Independientes de la Patagonia Agrupados [Independent Film-makers of Patagonia], stated the objectives for the founding of the collective:

> Lisandro and Luka: Why did RIPA emerge?
>
> Martín Ferrari: Because there was a need to develop and disseminate our stories. We thought that the ways in which we used Patagonia differed from the others that use the land as scenery to shoot their films. We thought that there was a regional perspective [visión] that differentiated us from other productions.
>
> Lisandro and Luka: What is this perspective?
>
> Martín Ferrari: Patagonia is not just a landscape: there are people who live there with their stories and their problems; it isn't just a trip for newly graduated high school or college students. In many films, like *La nave de los locos/Ship of Fools*, they use Patagonia as a pretty backdrop. There isn't a concerted effort to research the history [or stories] of the region. (Listorti and Luka 2002: n.p.)

Patagonia is composed of a southern set of provinces (Neuquén, Río Negro, Santa Cruz, Chubut, Tierra del Fuego) that is less populated than other parts of the country. It has an abundance of scenic locations (lakes, glaciers, mountains, tundra, etc.) and thus has been considered an esteemed destination for international tourists and residents of major Argentine cities. Gabriela Nouzeilles documents how, as early as 1914, the Argentine state envisioned ways of transforming parts of Patagonia, such as the city of Bariloche (next to the National Park Nahuel Huapi), into a desirable tourist destination (Nouzeilles 1999: 41).[2] This romantic vision of the region may have promoted the long-standing tourist image of the Argentine South. However, it has also obscured the possibility of a diverse portrait of the region cinematically.

In contrast to these conventional representations, as Martín Ferrari suggests above, the aim of these new videographers is to depict what it means to grow up and live in Patagonia from a resident's perspective. In opposition to films that typically tell stories from a *porteño* perspective—a protagonist from Buenos Aires who visits the area and experiences adventure (see Argentine films *La vida según Muriel/The World According to Muriel*, Eduardo Milewicz, 1999; *La nave de los locos/Ship of Fools*, Ricardo Wullricher, 1995; or *Caballos salvajes/Wild Horses*, Marcelo Piñeyro, 1995), these videographers are moving away from what I argue is the *'porteño'* gaze, to a version of local history that may or may not include the landscape as the main focus. Interestingly, the emblematic 'New Argentine' film, *Mundo grúa/Crane World* (Pablo Trapero, 1999) has the working

class protagonist from the province of Buenos Aires migrate to Patagonia in search of work but, as Elina Tranchini points out, it is a 'desolate landscape: Illegal Chilean workers, overcrowded spaces, work and isolation in the middle of the desert where the promised meals and pay do not appear, and any attempt at redress renders one powerless' (Tranchini 2007: 123). Perhaps the difference in perspective is due to Rulo's space and place in Buenos Aires province rather than the Southern 'metropole.'

In their 2001 compilation tape, Patagonian collective ARAN (Asociación de Realizadores Audiovisuales de Neuquén) has created images of the region without focusing on the trademark outdoor landscape. Interestingly enough, many short pieces made by these collectives are shot completely in interior spaces, suggesting the isolation of being trapped inside during inclement weather. Other pieces are shot indoors and focus on personal relationships. This gives the viewer a sensation that the characters could live in any other part of Argentina because there are personal and humanistic attributes to these storylines. It is an issue that the videographers themselves were not aware of—the issue being that the majority of their videos did not focus as much as the land of Patagonia, so much as on the *habitus*, or lived space of the people. This strategy, whether conscious or not, might have been done as a way to struggle against the oft-framed depictions of life in Patagonia, always about the landscape, rather than about the mindscape of the people and their choices about how to tell stories in their rural region. A few exceptions exist; there are one or two documentaries made about the native people of Patagonia, the Mapuche Indians and their relation to the land, as well as the effect of factory closures on workers living in the area.

This chapter will examine, first, how and for what purpose two video collectives in the rural Southern provinces of Argentina, ARAN and RIPA (as aforementioned) were formed; it will then explore how their presence has impacted on the ways in which regional cultural production has changed in Argentina. In particular, these young videographers are helping to redefine how film and video production is produced and distributed in rural Argentina. While they are confronting many obstacles, such as ones related to funding and the dissemination of their work, they have both helped to focus on how images of Patagonia have traditionally been represented and have rethought how more localized and quotidian stories about the region might be envisioned.

ARAN

Both groups, ARAN and RIPA, are composed primarily of twenty-something women and men, many who have come back to their hometowns after graduating from film schools in various parts of the country. In ARAN's case, some studied at the *Escuela Nacional de Experimentación y Realización Cinematográfica* [ENERC—The National School for Experimentation and Production of Cinema] that is affiliated with the National Film Institute (*Instituto Nacional de Cine y Artes Audiovisuales*—INCAA—or,

National Film and Audio-visual Arts Institute) in Buenos Aires. Other schools include the Film School in the Buenos Aires suburb of Avellaneda, *Instituto Municipal de Arte Cinematográfico de Avellaneda* and a film school in the southern province of Río Negro, the *Escuela de Cine y Nuevos Medios de General Roca* [The General Roca School of Film and New Media].

Both groups typically work in digital video format because of the relatively high production values that digital technology brings. In addition, the low cost of digital format (Mini DV and digital Hi 8) allows the group to produce work at a reasonable cost (typically, the cost of film stock is prohibitively expensive) and edit on home computers. Projects range from narrative fiction, documentary and experimental forms, to other genres such as horror and that of the musical. The great majority of projects are *cortometrajes* [short films] or *mediometrajes* [medium-length films]. Each group assists individuals in completing their projects by working as a crew, and very few of them work professionally in film or video.[3]

ARAN was founded in 2001 (paradoxically at the height of the national economic crisis) as a non-profit organization. Now, comprised of roughly 20 people, the organization holds weekly meetings, the main objective being to disseminate their work and the work of other Patagonians through an annual regional film festival titled *Imágenes de la Patagonia* [Images of Patagonia], which began the same year of the organization's founding. In its first year, the festival played in Neuquén, San Martín de los Andes, and in the Recoleta Cultural Centre of Buenos Aires. In 2002, the festival expanded to theatres in the Southern provinces including the cities of Comodoro Rivadavia and Bariloche. In October 2005, a selection of the best projects toured Ibero-American countries including Spain, Mexico, Colombia, Peru, and Chile. As the only regional film and video festival in the country,[4] the festival's initial aim was to screen movies made exclusively by Patagonian film-makers or those which were filmed in Patagonia. However, the popularity of the festival grew and, beginning in 2006, donations were collected to give a cash prize to the top film selected by a panel of three invited judges. Other awards were given based on the region of Argentina the film came from, thus encouraging participation from all provinces of the country.

Currently, the 8th edition of *Imágenes de la Patagonia* (called IDLP 8) took place in May 2009, with films screening from all over the country. In this way, ARAN strives to create places for Patagonian videographers to exhibit their work and dialogue with others because they are faced with 'the reality that these objectives are practically impossible to achieve in a province so far away from all of the important production and distribution companies in the country.'[5] In 2006, ARAN's film festival founders teamed up with other film festival organizers in Latin America to create a network of Latin American film festivals. This meeting included representatives from Colombia, Peru, Bolivia, Venezuela and Argentina. Their goal was to help create an integration of Latin American countries through the dissemination of short films, thus calling for entries in these film festivals in the network.

In addition, the collectives have helped create a forum in which to discuss and troubleshoot regional production in Argentina; in Buenos Aires in 2002, two roundtable discussions accompanied the screenings. One specific topic was 'The Politics of Promoting a Regional Audio-visual Sector,' in which discussion centred on the processes for promoting and protecting provincial, regional, and national film sectors. The other roundtable was to explore 'Audio-visual Patagonia from various viewpoints: local, national, and international' (Anon. 2002: 1).

Currently, although it is only eight years old, the collective has already made its mark in terms of creating alternative circuits of exhibition and spaces for production in Neuquén. Ultimately, their long term objective is to help promulgate regional film legislation, called the *Ley Provincial de Cine* [The Cinema Law of the Provinces]. This law is to be implemented through the National Film Institute (INCAA). ARAN hopes that such legislation will encourage and support film production in the province of Neuquén, including the establishment of a film office for the region replete with a database of technicians, location scouts, actors, and equipment rental. One article would require that if a production were to shoot on location in Neuquén, a percentage of workers would have to be from the province itself (i.e., transportation, catering, equipment rental, etc.) (Tello interview 2003). Argentine provinces including San Luis and Mendoza have such laws on their books already.

In addition to video production, ARAN has branched out to television and internet distribution. In 2006, for almost the whole year, members of ARAN created a television programme called *Escena 10—La Patagonia muestra su Cine/Scene 10—Patagonia Screens its Cinema*, broadcast on Channel 10 out of the city of General Roca, Rio Negro province, wherein 45 one-hour programmes on local film culture included 40 guest interviews, and more than 150 short films made both in Patagonia and internationally were broadcast. ARAN has utilized the internet to transcend the geographical barriers of their region. Their website offers a few video clips to view online and descriptions of their short films. In the 2001 compilation, some of the pieces are genre films such as *Caja chica /Safety Deposit Box* by Iván Sánchez: a chase film and thriller, set in a parking lot, that hinges on a case of mistaken identity. There is also a very interesting experimental four-minute piece entitled *En memoria de Bioy /In Memory of Bioy* which was created by Verónica Tello and is about a boy robot who stumbles upon a Super 8 home movie of his mother and uses it to come to terms with his past.

Of all the short films in the compilation, however, the film *Rutina /Routine*, a six-minute video by Andrés Funes, is an especially poignant portrait of isolation and loneliness living in Patagonia. It explores the long-standing relationship between a couple that has been together for six years and the daily routine that permeates their lives. The interior of the house that they share is rustic: framed pictures of horses adorn the walls and a lodge-like aesthetic, characteristic of a rural setting. All of the interiors are very conventional, middle-class spaces. There is no sense of deprivation in the region but, rather, that they are disconnected from the world.

In the movie, the husband arrives home and, in stereotypical fashion, sits in a comfortable chair in the living room, reads the paper and watches the soccer game on television. The wife becomes angry and frustrated when he refuses to take her out to dinner. She complains that she is bored and unhappy due to their lack of intimacy and communication. The television news interrupts the soccer game with an emergency broadcast announcing that, due to the melting polar ice cap, Patagonia is losing communication with the United States and Europe (also, on a side note, throughout the piece there are complaints that there is a strange hot climate change in the dead of winter). The image then goes black and the husband is left in the dark. The geographical isolation that is already experienced by those people living in Patagonia is underlined in this piece by this threat of further physical separation.

Another film in the video compilation, *Un paseo en coche/A Car Ride* by Gladis Krumrick, is based on a short story by Argentine author Julio Cortázar. A woman is hitch-hiking on a desolate road on her way to visit friends in a small, tranquil village. A man pulls over and offers to give her a ride, but seems rather serious and acts strange. The camera pans down, revealing that he has a gun. Also, he alludes to the fact that he picked up another young woman earlier but that she 'didn't get far'. Finally, the car swerves off the two lane highway to a dirt road. The man jumps out and grabs the young woman out of the car. He pushes her against a tree so that she is trapped by his body and it is obvious that no one can hear her scream. The camera quickly cuts to a shot of the woman's purse flying in the air and a gunshot is heard. In the next scene, we see someone driving off and a man's wallet flies out of the car. The car pulls alongside a distressed man who is working on his stalled car on the side of the road. It is the young woman, who obviously took control of the situation. She smiles wickedly and asks, ominously: 'Do you need any help?' This piece alludes to the inherent danger that can occur in desolate, isolated areas. Cortázar's story is a tale that illustrates what dangers the Patagonian roads can portend, but that are not immediately visible.

Next in the compilation is a short piece titled *Mala Compra /Bad Purchase* by José Luis Gutiérrez which deals with the adage, 'pueblo chico, infierno grande' [literal translation: 'Small town, big hell'] when a couple videotapes a message to their friend in Spain and spoofs a guerilla organization by donning black ski masks (à la Subcommandante Marcos) and holding up a banner with the double entendre 'Partido por la Mitad' [Half a Political Party/Cut in Half]. In their diatribe, which at first gives the sensation to viewers that it could be real, the couple denounces the political situation in Argentina and states that it is 'going to hell'. Meanwhile, in the background outside, a woman sweeps and, through the window, sees the couple with their ski masks talking to the camera, causing her to call the police with her cell phone. Near the end of the piece, we see the couple relaying to the camera (and ultimately to their friend) that it was all a joke. Seconds later, the front door is kicked in and the police assault and arrest the couple. The epilogue of the film shows various headlines in Patagonian newspapers which all state that a 'terrorist cell' was captured in the area. Clearly it is a case of mistaken identity that raises the spectre of the fear and general distrust that

still exists in the society that causes neighbours to spy on each other and inspires fear of the police and of underground or illicit organizations in the South.

In addition to *Rutina*'s specific depiction of a Patagonian mindset, in 2002 ARAN produced pieces set in rural settings, such as *Mujeres/Women* by Iván Sánchez. This film examines the life of a Mapuche woman, who deals with the contamination of the earth, and her spiritual source of strength. However, in contrast to these natural pieces, the majority of directors have chosen scripts not specific to the land or the history; instead dealing with larger, more universal issues such as monogamy, infidelity and mistrust (such as Mario Tondato's six-minute *Cuestionario/Questionnaire*).

In a short survey sent to the Association's members, I asked them to comment on these projects that are devoid of the Patagonian landscape. All of the videos on the compilation, save one, were filmed indoors in homes and other interiors rather than outdoors. All were fictional pieces. The following question is raised: In their urge to do something else within the image of Neuquén, why did they feel the need to separate themselves from the land of which only outsiders took note? The responses I received were varied, from the financial constraints (Luis Rey) to the disadvantageous weather (Verónica Tello, who thought that the freezing conditions during wintertime necessitated filming indoors) to a more lucid suggestion from Virginia Capitano (who is from the city of Rosario and has lived in Neuquén for fifteen years):

> Patagonian video in my mind does not mean that the desert or the wind needs to be depicted. Rather, it is an issue of creating work within the region from a particular vantage point that is from the region itself.

Finally, Andrés Funes observed that 'perhaps people had an interest in showing other sides of life here'. [7]

RIPA

The group RIPA (*Realizadores Independientes de la Patagonia*) was founded in 2000. Five members of the group (of which three are also active in ARAN) come from the cities of Esquel, Río Negro and Neuquén while others reside in Neuquén and in Buenos Aires. In addition to helping to organize the film festival with ARAN, they aspire to create spaces in Neuquén to screen recent independent work from Buenos Aires. Ultimately, along with ARAN, they are attempting to construct an alternative cinema in the region (Fernández Irusta 2002: 1).

One of the video projects made by RIPA is Martín Ferrari's *Cinco siglos igual/Five Centuries of Sameness,* a twenty-minute video that examines the history of the eviction of the Mapuche Indians from their land and presents the hypothetical scenario of what would

happen if they were to be displaced again. However, this time they have been displaced by the secret police of Neuquén (a clear reference to the military dictatorship from 1976–1983 when military police would kidnap and 'permanently displace' its citizenry). Another director, Guillermo Glass, studied image and sound design at the University of Buenos Aires. He made a twenty-minute documentary called *El color del viento/The Colour of the Wind*, which depicts an impressive voyage over the continental ice floes.

When asked if there was such a thing as a Southern Argentine or Patagonian aesthetic, RIPA member Martín Ferrari answered affirmatively:

> When you study film you want to tell stories that you experience. I am tied to Neuquén, to that place, to that spirit… for this reason, although I live in Buenos Aires, all of my films are shot in Neuquén. (in Fernández Irusta 2002: 1)

As journalist Diana Fernández Irusta (2002: 1) observes, the Patagonian video-makers make the distinction between various cinematic views of that region: some directors who see it as 'beautiful scenery' or those who consider it a place with its own histories that can only be told by those who know it intimately. Film and video production in Argentina has historically been dominated by residents of Buenos Aires, the nation's capital. It was here that the film studio system was created in the 1930s and remains the locus of film and television production today. Composed of approximately one third of the population of Argentina, this metropolis has been called 'the Head of Goliath' by writer Ezequiel Martínez Estrada because of the way that it subsumes vast resources and its draining effect on the rest of the nation in terms of pulling professionals, students, and other workers to the city in search of opportunities. It is also the media hub of the country, where cultural industries are based and educational institutions (film schools included) abound. The National Film Institute (INCAA), the film union, and many other professional film organizations are also located here. Given the centralization of power in the cinema industry, the question remains: how did these Patagonian video collectives come to be? I argue that it was a confluence of factors: changes in film legislation, the rise of film schools, and recognition that regional film production was a viable site for not only locals but also foreign producers to be lured by affordable locations. These together encouraged the rise of these young Patagonian videomakers to create, circulate, and disseminate their visions of the rural south of the country.

Buenos Aires saw a trend in the establishment of a multitude of film schools in Buenos Aires during the mid-1990s. Two film schools were founded by established film-makers and public figures such as Manuel Antín (an Argentine director from the Argentine New Wave [*Nueva ola*] cinema movement in the 1960s and the head of the National Film Institute from 1983 to 1989 during President Alfonsín's administration) and well-known director Eliseo Subiela (*Hombre mirando al sudeste/Man Facing Southeast*, 1986 and *El lado oscuro del corazón/Dark Side of the Heart*, 1992). The prestigious film schools such

as Antín's *Universidad de Cine* [University of the Cinema], FUC, and Subiela's *Escuela Profesional de Cine* [Professional Cinema School] led others to follow suit. There are varying statistics as to how many students attend film schools nationwide, but the figures range from 4,000 students to 10,000 students.[8] Antín claims that in the decade that his film school has been in existence, his students have made over 500 short films and more than one thousand videos (in Zadoff 2003: 271).

The rise of independent non-union productions has also opened a space for more student participation than in previous years. In addition to the schools being an avenue to create and screen work, there also exists a Student Film Festival that takes place during the annual film festival in Mar del Plata, Argentina, each November. The student film festival is sponsored by the University of the Cinema and is a world-wide competition. In past years, student films have been screened and given awards bestowed by well-known Argentine actors and directors such as veteran documentary film-maker Fernando Birri and Spanish actor Eusebio Poncela.

Along with the changes in film legislation in 1994 emerged a proposal to decentralize the concentration of power away from Buenos Aires to the other provinces. While very little action was actually implemented to rectify the disparities from urban to rural, there were some policy changes regarding the creation of quotas for provincial students to attend the National Film School so that more of the trained film-makers from various provinces were represented. In addition, the decision was made to fund scholarships for talented provincial film students to study at the National Film School, the *Escuela de Experimentación y Realización Cinematográfica* [School of Experimentation and Cinematographic Production] (ENERC). With more rural film training, the hope was that eventually additional films would be produced with a more diverse rendering of the Argentine landscape. These films would include the rural spaces that could be depicted in non-stereotypical ways, unlike past films. Also, for the first time, the pieces would be shot from the residents' point of view.

The push to better represent the culture of the provinces went hand in hand with the hope that more pluralism and democratic decision making could be structurally built into the bylaws of the National Film Institute. The most sweeping changes to the administrative structure of the institute were made in terms of budget allocation, film funding decisions, planning regional film festivals, and film loan competitions. One of the key changes was to organize a federal assembly composed of a secretary of culture from each province to take part in decision-making about funding and support for the film industry throughout Argentina.

The idea of a 'federalization' of the film institute originated from efforts put forth by the Film Institute leadership (René Mugica and Octavio Getino) in 1989–1990 to create more spaces for regional representation. The aim was to encourage projects filmed in rural parts of the country, to renovate provincial movie theatres, to create regional film schools/cultural centres, and to fund regional film festivals. The logic was that the urban regions of the country had more representation in the selection of films for funding

and production, thus creating a bias toward depicting Argentina as a metropolis.[9] By including representatives from lesser represented regions in Argentina, it was hoped that a broader, more diverse portrait of the nation would be painted in the future.

National culture has been dominated by *porteño* culture for most of history, but now, through changes in national consciousness (especially of a populist nature), a call for more regional diversity was put forth. In theory, the institute was to assist with the production of films made by film-makers in the provinces. However, because of a lack of infrastructure (i.e., film equipment, technical expertise, etc.), national films in the provinces were rarely made by the residents themselves. One of the few films released in theatres was *Sapucay, mi pueblo/ Sapucay, My Town* (1995), directed by Fernando Siro, a veteran actor and director. This film deals with life in a small town in the provinces. In short, little production activity has sprouted from this legislation. However, one corrective measure, adopted in 1997, came up with enough funds to allow film directors and technicians from the capital to lead production seminars in the provinces. This effort to impart the necessary knowledge for film-making may yield more promising results.

Beginning in 1995, the Federal Assembly met and discussed the possibility of regional film festivals, such as one in each of the provinces of Chaco and La Pampa. The hope was that more films would be made with regional themes in mind and that film commissions could be set up in the provinces to encourage outside film-makers to shoot feature-length films there. For example, the province of Mendoza organized a film commission and worked hard to bring French director Jean-Jacques Annand's US film *Seven Years in Tibet* (1998) to the province for part of its filming. The fact that this film crew brought close to $5 million to Mendoza shows that this is a lucrative business for any province in need of foreign capital (Tomaselli interview 1998).

Another effort put forth by the INCAA to reach more remote areas of the country was the use of *cines móviles* [mobile cinemas].[10] Starting in 1997, the film institute adopted a form of film exhibition used by the Russians and the Cubans during the fervent years of their respective revolutions to democratize the art of cinema in all parts of the country.

The intention behind the Federal Assembly meetings was to encourage greater pluralism but, according to the film-makers and critics that I corresponded with in 1997 (a few years after the passage of these initiatives), they felt that the meetings were largely symbolic and nothing much came of them. Several film critics stated that each secretary was content to receive a 'small portion of the pie', and that they did not really make the efforts necessary to establish a true regional film centre outside of Buenos Aires. However, it is obvious that regional film centres are inherently at a disadvantage compared to large cities such as Buenos Aires in terms of the economies of scale that come with a base of film equipment, such as pools of technicians and actors. And, while the inequity between the metropolis (Buenos Aires) and the provinces is far from being resolved, it is commendable that, compared to previous years, more efforts were made under Film Institute head Getino's administration to promote cinematic activity in the provinces.

To keep things in perspective though, while this push to provide access to provincial film students has helped foment a small movement in Patagonia, it represents a small step in a much larger battle to extend the networks of exhibition, distribution and production to areas outside of Buenos Aires. Some of the difficulties in overcoming these more structural problems are discussed below.

The first obstacle in disseminating Patagonian videos to viewers via television is the way in which television channels in Argentina are structured. Unlike the United States, where national networks have regional or municipal affiliates, Argentine television, which is based in Buenos Aires, does not have a national network but, rather, a few main stations that churn out nationally-distributed local and foreign productions to independently-owned stations throughout the country (Waisbord 2000: 55). This clearly has an impact on local production, according to Mario Tonato of ARAN and Martín Ferrari from RIPA:

> Mario Tonato: For a Patagonian film to be shown in the province of Santa Fé, for example, we have to get it shown via transmission in Buenos Aires. It is the reality: we can't screen it on a Santa Fé television channel. We came to Buenos Aires and we were fortunate to find a venue to show our work to people in Jujuy (a Northern province). These people can turn on their television sets and learn about a story that took place in Neuquén or on the continental ice floes. That is really wonderful.

> Martín Ferrari: You have to go to Buenos Aires for people to recognize you. The first time that people began to mention us in the regional press was when we showed a short film, *El delator/The Informer*, that was aired on the cable channel News Network during the programme 'Lights, Camera, Network.' The film was broadcast throughout Latin America and they published articles about us... the best way for us to get some airplay in Buenos Aires is for us to get together as group, because each person on their own does not succeed. We call attention to the fact that we are from Patagonia (Listorti and Luka 2002: n.p.).

Conclusion

During the mid- to late 1990s, a group of motivated young people in the Argentine Patagonia region of the country bore their own costs of production to foment a low-budget form of collective video production and a film festival platform to exhibit their work. With the appearance of more affordable video technologies and accessibility to computer editing equipment, as well use of the internet to connect with other film-makers throughout the

region, they were able to not only create a regional video movement, but also in 2006 create a regional television programme to screen *cortometrajes* [short films].

Videomakers such as the members of ARAN and RIPA are testing the boundaries of what it means to make independent video and film in Argentina. They are working to create a regional cinema in Patagonia; this cinema aims to both replace the tourist image sold through its landscape with a 'regional perspective that research[es] the history [or stories] of the region' (Listorti and Luka 2002: n.p.). Members of ARAN and RIPA are not afraid to create video narratives that do not conform to stereotypical or dominant imaginings of what Patagonia is supposed to represent. They tell stories that reflect everyday life without resorting to what has become a reified image of the Southern Argentine landscape. The predominant image of the Argentine landscape that has been created to attract tourism and perpetuated by film-makers from Buenos Aires has been challenged by stories that reflect everyday life (whether this means an exterior or interior landscape) as the central point of reference. These Patagonian groups are creating their own images but also providing access to them through their circulation in regional, national, and Ibero-American film festivals, as well as on the internet.

Acknowledgments

I would like to thank Laura Podalsky for her initial advice on this project, and Ariadna Capasso, Stephen Steigman, and Celia J. Falicov for their keen eyes and helpful editing skills. I would also like to acknowledge ARAN member Verónica Tello for her very valuable and thoughtful email correspondence. Unless otherwise stated, all translations are the author's.

A version of this chapter was previously published under the title 'Desde nuestro puento de vista. Jóvenes videastas de la Patagonia re-crean el sur Argentino' in M.J. Moore and P. Wolkowicz (eds.) *Cines al margen. Nuevos modos de representación en el cine argentino contemporâneo,* 2007, Buenos Aires: Libraria, pp. 109–121.

Notes

1. Portas, J. C. *Patagonia: Cinefilia del extremo austral del mundo.* San Juan Bosco: Editorial Universitaria de la Patagonia and Ameghino Publishers, 2001.

2. See Nouzeilles' (1999) fascinating study of turn-of-the-century Argentine travel writings on the Patagonian region, and how the discourses on nature and the land changed over time and how the State appropriated those discourses to its own ends.

3. This information came from Virginia Capitano, email dated June 12, 2003.

4. See ARAN's website at http://www.aran.org.ar. Accessed August 20, 2010.

5. On their website under 'Que es ARAN?' at http://www.aran.org.ar. Accessed August 20, 2010.

6. On their website under 'Objetivos' at http://www.aran.org.ar. Accessed August 20, 2010.

7. An email survey was sent to Verónica Tello who distributed it to the ARAN members at a meeting. Four people responded. Luis Rey, email dated June 21, 2003, Verónica Tello, email dated June 12, 2003, Virginia Capitano, email dated June 12, 2003, and Andrés Funes, email dated June 16, 2003.

8. Patricia Moro, the director of the INCAA-run school in the mid-1990s estimated that in 1997 over 10,000 students were studying film production in Argentina. Fernando Martín Peña, film critic, estimates the figure at closer to 4,000 during the same year. In either case, these numbers represent a large increase over previous years. See Falicov, 'Los hijos de Menem: The New Independent Argentine Cinema, 1995–1999' in *Framework*, 2003, Vol. 44: 51.

9. In a study by the National Film Institute in 1988, it was shown that of 112 films produced nationally, 82 of them (72%) had Buenos Aires as their principal setting. 25 films were shot in the province of Buenos Aires and in the provinces of the country. Seven feature films were shot outside of the country. Cited in Octavio Getino, *Las industrias culturales*, Buenos Aires: Ediciones Colihue, 1995, pp. 265–6.

10. In the Mar del Plata film festival catalogue for 1998 there was a two-page advertisement from the National Film Institute (INCAA) about: 'A plan that permits Argentine cinema to be screened in the most remote areas of the country.' The advertisement describes how 24 mobile cinemas were purchased to 'take film to the most remote and inhospitable places of the country to show the most outstanding expressions of national culture, the cinema'. The 14th Annual Mar del Plata Film Festival Catalogue, 1998.

References

Anonymous (2002) 'Patagonia Audiovisual' November 29. *La Maga* (online version), www.lamaga.com.ar/www/area1/pg_cinevideo_nota.asp. Accessed June 24, 2003 (no longer available).

Falicov, T. L. (2003) 'Los hijos de Menem: The New Independent Argentine Cinema, 1995–1999', *Framework* 44.1: 49–63.

Fernández Irusta, D. F. (2002) 'Imágenes desde el Sur' May 6. *La Nación* Online, http://www.lanacion.com.ar/nota.asp?nota_id=394258. Accessed May 6, 2002.

Getino, O. (1995) *Las industrias culturales*, Buenos Aires: Ediciones Colihue.

Listorti, L. and Luka E. (2002) 'Cine independiente argentino: Realizadores independientes de la Patagonia,' *Film Online*, www.filmonline.com.ar. Accessed July 4, 2002 (no longer available).

Moore, M. J. and Wolkowicz, P. (eds.) (2007) *Cines al margen. Nuevos modos de representación en el cine argentino contemporáneo*, Buenos Aires: Libraria, pp. 109-21.

Nouzeilles, G. (1999) 'Patagonia as Borderland: Nature, Culture, and the Idea of the State', *Journal of Latin American Cultural Studies* 8.1: 35–48.

Portas, J. C. (2001) *Patagonia: Cinefilia del extremo austral del mundo*, San Juan Bosco: Editorial Universitaria de la Patagonia and Ameghino Publishers.

Tello, V. (2003) Email correspondence with author, June 28.

Tomaselli, V. (1998) Personal interview with author, March 29.

Tranchini, E. (2007) 'Tensión y globalización en las formas de representación del cine argentino contemporáneo' in V. Rangil (ed.) *El cine argentino hoy: Entre el arte y la política*, Buenos Aires: Editorial Biblos, pp. 119–36.

Waisbord, S. (2000) 'Media in South America: Between the Rock of the State and the Hard Place of the Market' in J. Curran and M. Park (eds.) *De-Westernizing Media Studies,* London and New York: Routledge, pp. 50–62.

Zadoff, M. (2003) 'El cine de las escuelas de cine' in F. M. Peña, (ed.) *Generaciones 60/90: cine argentino independiente*, Buenos Aires: Fundación Eduardo F. Constantini, pp. 268–75.

Leaving and Letting Go As Possible Ways of Living Together In Jorge Gaggero's *Cama adentro/Live-in Maid*

Ana Ros
Binghamton

In 1994, the Argentinean National Institute of Cinema (INCAA) organized a short film contest for debutante directors, compiling the best ten shorts in a film entitled *Short Stories* (1995).[1] This film was shown nationally and internationally and was very well received by both audience and critics, who proclaimed the emergence of a new generation of film-makers. In fact, throughout the following decade, the directors featured in *Short Stories* released what would become some of the most significant films of the New Argentine Cinema (NAC). As a clear representative of both this new generation and cinema, Jorge Gaggero was selected to participate in *Short Stories* with his short *Fire Eyes* and, ten years later in 2005, he released *Cama adentro/Live-in Maid*.[2]

Among other achievements in his career as a film-maker, in 1997 Gaggero won the Fulbright Scholarship to attend the Film Directing programme at the American Film Institute in Los Angeles, where he wrote and directed the Emmy award winner *A Piece of Earth* (2001). In 2001, he returned to pursue his dream of making his first film in Argentina, but he found his country besieged by unemployment, bankruptcy and mass migration caused by the most severe economic crisis in Argentina's modern history. Finding himself unemployed and moved by these bizarre circumstances, Gaggero decided to write the script of *Live-in Maid,* which he would finish two years later.

Like most of the films from the NAC, *Live-in Maid* was conceived as an independent, low-budget project: shot mainly in real locations combining professional and non-professional actors, and dependent upon external funding. Unlike industrial film-makers who were 'funded by companies like Patagonik and Pol-ka, which are… owned by various multimedia conglomerates with access to vast resources' (Falicov 2007: 143), independent film-makers have limited national funds to make their films[3] and competition is keen.

Even when the INCAA has supported NAC initiatives greatly, its funding awards are not enough to cover prize-winning films' production costs and, since independent films cannot compete with industrial films in terms of the box office, they are not profitable for the INCAA to increase the awards (Falicov 2007: 134–5). The fact that *Live in Maid*'s script was a finalist for the NHK Award at Sundance Institute and that the acclaimed Argentinean actress Norma Aleandro was willing to participate in the film helped to obtain the necessary financing. In fact, the film won grants in three competitions: the San Luis Province Second Script Competition, the Telefilms Competition on the Present Crisis and the Raíces Programme Competition. Thanks to this last award, *Live-in Maid* became a Spanish co-production as a result of an agreement between the INCAA and different cultural institutions from Galicia and Catalonia to finance potentially successful projects in their respective markets (Falicov 2007: 140).

In terms of screenings, when Gaggero's film premiered in Buenos Aires it had already won seven awards and six nominations in the circuit of national and international film festivals.[4] As Gaggero recollects: 'it was an opening with only ten copies and all the theaters were packed' (in Goldbarg 2007). Those who saw the film felt inspired and continued to talk about it at nearby bars, but, as Gaggero observes, *Live-in Maid* is also 'a movie that in Argentina some people segregated, because if you have a big actress, for some people it's not an independent film anymore. There is a prejudgement in it' (in Goldbarg 2007). This prejudgement is based on the strong connection between famous actors/actresses, such as Federico Luppi, Hector Alterio, Leonardo Sbaraglia, Norma Aleandro, etc., and the cinematographic model prevailing in the 1990s, i.e. higher budget commercial films, from which NAC wanted to distance itself.

Nevertheless, such prejudgement vanishes after seeing *Live-in Maid* and realizing that it subscribes to NAC's most fundamental principle: 'Son películas de autor en las que el autor se mantiene en silencio' [These are auteur films in which the author remains silent] (Quintín 2002: 116). This silence referred to by Quintín is a reaction against the 1980s and 1990s' Argentine cinema (didactic, sententious middle-class dramas developed through forced and excessive dialogues held by archetypical characters), and expressed in the NAC films in the form of:

> [f]inales abiertos, ausencias de énfasis, ausencia de alegorías, personajes más ambiguos, rechazo del cine de tesis, trayectoria algo errática de la narración... rechazo de las demandas identitarias y de las demandas políticas: todas estas decisiones... hacen a la opacidad de las historias, que en vez de entregarnos todo digerido abren el juego de la interpretación. (Aguilar 2006: 27)

> [open endings, lack of emphasis, lack of allegories, ambiguous characters, rejection of propaganda cinema, erratic storylines, rejection of identity

and political statements: all these decisions… constitute the opacity of
their stories which instead of offering us everything predigested, open
the game of interpretation.]

As part of this new film tendency, Gaggero also opens the 'game of interpretation' to
the audience. He confronts viewers with the familiar (but seldom-addressed)[5] problem of
tension between social classes in Argentina, but he does not offer a definitive perspective
on it: 'I want audiences to relate to these concerns and incorporate their own experiences,
and to incite them to look inside and search for an answer' (Prensa n.d.).

Live-in Maid tells the story of two women: Beba Pujol (Norma Aleandro), a wealthy
porteño woman in decline and Dora (Norma Argentina), her live-in maid for thirty years.
Deeply affected by the 2001 economic crisis, Beba can no longer afford to pay Dora's salary
and accumulates over six months of debt. In the midst of a hopeless economic situation,
Beba struggles to maintain her lifestyle, which includes Dora's invaluable services. In
turn, Dora struggles to quit her job despite the rising unemployment in Argentina. This
divergence between employer and maid is the point of conflict of the film but, far from
offering a clear expression of class struggle, the plot will develop in depth all of the many
levels that constitute these two women's relationship (labour, social, emotional, personal,
etc.), complicating its interpretation.

In this chapter, I propose that such complication is due, in part, to the fact that *Live-
in Maid*—as an example of NAC but also as a cultural response to the 2001 crisis—
challenges allegorical interpretations. In other words, Gaggero's film challenges the kind
of reading that equates every element in fiction with an element in 'structural reality',
according to abstract notions about how society works (such as 'class'). By 'challenging'
I do not mean disregarding abstract notions per se. On the contrary, I mean that
instead of establishing a link between abstraction and fiction to illuminate both fiction
and the social conflicts addressed in fiction, *Live-in Maid* takes a step further and also
illuminates theory by showing its limits. The fact that we cannot explain Gaggero's film
through a theory, without coming across obstacles and exceptions, speaks of a society
in crisis, constantly trying to adjust to the emergence of new situations that question
previously established and shared notions such as class, nation, citizenship, identity,
politics and State.

As Joanna Page observes, NAC directors conceive film 'as a tool ideally suited to the
representation of a crisis in social knowledge,' disappointing audience expectations
based on its 'semidocumentarist or neorealist styles' (Page 2009: 36). *Live-in Maid*,
like the films analysed by Page, also draws 'on structures and discourses of knowledge
to explore the limits of epistemology and to deconstruct the relationship between
visibility and knowledge' (Page 2009: 36). In this particular case, I reflect on Beba
and Dora's relationship drawing from the Marxist concepts of *commodification, use*
and *exchange value*, and the relationship of characters with commodities. I suggest

that by presenting objects, goods, and Dora's services as linked, but not reducible, to monetary exchange, *Live-in Maid* reveals a remnant in Dora and Beba's relationship that resists commodification. Such a remnant is the result of almost thirty years of shared intimacy between these two women and, the fact that it becomes visible during the crisis, produces a new configuration of social and personal aspects in their relationship.

But instead of explaining what this new configuration implies in terms of social effects, the director turns to the audience, leaving the answers to be discussed and discovered outside the movie theatre. In that respect, rather than being a film about the 2001 economic crisis,[6] *Live-in Maid* behaves as crisis itself in the etymological sense of the term (decision, judgement), as it introduces a 'break-down' or dislocation of traditional treatment of relationships between the different social classes, leading the audience to a more introspective understanding and analysis. As Gaggero refers:

> I think in the film the crisis is an excuse... The most important thing is that you have this external situation, and everybody thinks it's external and how we could be as a country in this situation. In the film, what I wanted to achieve was to think about how much of that crisis are us. How much of Beba is the crisis?... My cinema tries to explore how everyday life affects us—the good and the bad ones. In everybody there is racism, in everybody there is violence. We are constantly fighting and trying to understand. (in Goldbarg 2007)

Living (in) maid? The long-ignored commodification of life

Given that *Live-in Maid* begins in *medias res*, Beba realizes early into the film that her habitual luxuries, such as elegant friends, a spacious home, opulence, recognition, and imported whisky, start to fade once her money is gone. At first, she refuses to change her lifestyle and continues to conform to her typical views, tastes and habits while everything else falls to pieces around her. After a while, she tries to sell expensive objects from the house, although to the sales-clerk she pretends that she is doing a favour for a sick, elderly neighbour, who cannot go out to sell the objects herself. Upset by the little money she is offered for her objects, Beba desists from selling them and instead attempts to borrow more money from her ex-husband, Victor. But, since business is not going well for him either, he refuses Beba the loans and asks her to reduce her expenses by living more modestly. Victor suggests that she should either hire Dora by the hour or look for a new and less expensive maid, to which Beba replies impetuously: 'No lo voy a discutir. ¡Lo de Dora no lo voy a discutir!' [I am not going to discuss that with you. I am not going to discuss Dora!] (Gaggero 2004).

Not discussing Dora means not having to find a solution to the six-month-old debt. This, in addition to the fact that Dora's perspectives are not taken into consideration in the argument, illustrates a problematic interaction between social classes, based on their different experiences and interests, long rooted in Argentinean society. However, such problematic interaction is already present in the very notion of 'live-in maids,' quite conventional in Latin America, which implies the commodification of life. The concept of commodification, fundamental to a Marxist understanding of capital development, refers to the transformation of activities and relationships, previously alien to commerce, into buying and selling transactions. As Marx and Engels (1969: n.p.) observe in the 'Manifesto of the Communist Party', by introducing money exchange to relationships ruled by motives such as politics, religion, family and vocation, the bourgeoisie unveils the components of their self-interest and exploitation, reducing all motives to 'naked, shameless, direct, brutal exploitation'.

An illustration of this process is precisely the socialization[7] of women's labour: women market the labour power associated with the private sphere of their domesticity by carrying out tasks typically associated with their roles as wives and mothers. In the case of the live-in maids, this exchange is taken even further: they trade their lives to cover their basic needs such as housing, food and a minimum wage since, as the term indicates,[8] their life and work overlap almost entirely.[9] Such a situation perpetuates the cycle of dependency: the decision to serve a family results in most of the cases from the need to survive in a system where they are conceived as redundant workers who have nothing more than the labour associated with their gender to offer on the market. As in many real cases, Dora left her hometown in the economically-depressed region of El Chaco at the young age of seventeen in order to work at Beba's house. As far as we know, all she has after thirty years, apart from her job, is an unfinished house in a Buenos Aires slum, where she spends the weekends, and an unemployed boyfriend with whom she goes out to dance.

In this respect, *Live-in Maid* could be understood as a film about power inequality across the social classes, but the plot takes unexpected turns that lead us to consider a broader interpretation. From the moment the 'contract' between Beba and Dora is broken because of the debt, they start to move away from the positions of power and submission linked to their class origins and to their roles of employer and employed. In the same way, in Argentinean society, the 2001 economic crisis undermined the typical construction of social roles and destabilized some patterns of social relations by releasing power to circulate in new and unpredictable ways. Some significant examples are workers taking over the running of bankrupt factories and people defeating police repression and causing presidents to resign. Both in Argentina and in *Live-in Maid*, the 2001 crisis serves to reveal situations of oppression and fragmentation concealed in prevailing social relationships. The fact that a crisis was necessary to uncover these situations shows that the oppressive social relationships had been internalized and were

being reproduced—deliberately or not—by individuals. This concurs with Gaggero's aim of helping the audience to relate to the crisis (social conflicts in general) in a more personal way: 'how much of that crisis are us?'[10]

As in the case of Argentina, the lack of cash and the breaking of contracts create an unprecedented tension between Dora and Beba that expresses, among other things, the characters' relationship with commodities and commodification. As an example, I will analyse a specific sequence at the beginning of the film, composed of two intercalated scenes focused on the dynamics developed around an all-purpose cleaner and a teapot respectively. For a clearer analysis, I will address these two scenes separately, though in the film they are presented as part of an afternoon and alternate in the development of the daily routine.

An ow(n)ed all-purpose cleaner

In the first scene of the sequence, we see Beba coming back to the apartment in a taxi: she pays with a bill and tells the driver to keep the change. After having a short conversation with Dora about the teapot (which I will analyse later) and seeing that she is on her way out with a shopping cart, Beba asks her where she is going and Dora answers: 'Al chino. Se acabó el multiuso' [To the supermarket. We are out of all-purpose cleaner] (Gaggero 2004). Beba asks her to wait and gestures as if she is about to give her money, but at the last moment she claims that she cannot find the bill she thought she had in her purse. Dora complains and leaves the apartment. At the market's checkout, she hesitates before buying the all-purpose cleaner, which is essential to housekeeping, first making sure that she can afford it. When she returns to the apartment with the product, Beba tells her awkwardly: 'Bueno. Se lo debo' [Well, I owe you the money then] (Gaggero 2004). We could understand this scene as an example of Beba imposing on Dora from her position of power, but it also shows how Dora becomes stronger than her employer in relation to soundness of judgement and adaptability. While Beba acts under the illusion that she is still an upper-class woman without having any real grounds for this belief (for example, leaving generous tips when she cannot afford basic household products), Dora expands her own capabilities as well as her role in the house.

The transformations suffered by the characters in the privacy of the apartment have a clear correlation with their experience outside of it. For instance, while shopping in Beba's rich neighbourhood, Dora notices an advertising banner: 'Mucamas (como las de antes). Atención de ancianos. Nos avalan tres décadas' [Maids. Like in the good old times. Elder care. Quality guaranteed by three decades of experience] (Gaggero 2004). This is the beginning of Dora's appropriation of the exchange value of her labour power. In other words, she reconnects with the fact that apart from the value derived from satisfying specific needs—the use value of her work for Beba—her work also has a

more general, abstract value in the labour market—exchange value—that empowers her by offering her the option to leave. In contrast, Beba discovers herself to be a foreigner in ordinary people's world where the economic crisis forces her to move. Furthermore, unlike Dora, who has her labour to exchange, Beba depends on her family's money to survive: first living off her mother's inheritance, then off her ex-husband's business and now off her maid.

'Really unique' teapot pieces

The other key scene in the film that further exposes the shifting power dynamics between the two women revolves around a teapot, which brings the issue of value into Beba and Dora's relationship by functioning as a catalyst for conflict. The first scene of the film alternates between shots of Beba trying to sell her English porcelain teapot in a secondhand shop and shots of Dora looking for the teapot in the kitchen cabinets to serve the tea when her employer comes back. Beba does not accept the very low price she has been offered for the piece and when Dora asks about the missing teapot she lies, saying that she had taken it to be valued by a friend who collects antiques, who judged it as 'fabulosa: única en su estilo' [fabulous: really unique] (Gaggero 2004).

Seeing that her employer had not sold the teapot anyway, Dora reminds her that it is payday, thus suggesting a comparison—almost a rivalry—between Beba's appreciated objects and herself, now in the place of a less appreciated/valuable object. In their next conversation, Dora will perform this rivalry, making it even more visible to her reluctant employer. Dora brings up once again her plans for quitting the job and when Beba extorts her with humiliating personal information and the uncertainty of her job prospects outside the house in times of crisis, Dora throws and breaks the teapot in pieces, and demands that Beba subtract its value from her next paycheck.

By reducing the teapot to just matter, Dora returns it to its category of object with a price tag, divesting it of its role as an indicator of taste, class and power. By being 'really unique', as opposed to one of many, the teapot separates those who can afford it into an exclusive and powerful group in society. Nevertheless, the exclusive teapot becomes considerably less exclusive when it is sold in a secondhand shop. In the same way, the economic crisis helps to reconnect objects and work with use and necessity through the creation of barter markets and through the issue of an alternative quasi currency (*patacones* and *lecops* bonds).

But most importantly, Dora's reaction expresses what Beba is already implying by prioritizing keeping the teapot over paying her salary, but without admitting it, so as not to deal with its consequences. In order to expose Beba's incongruity, Dora creates an irony. By asking Beba to subtract the cost of the teapot from her next paycheck, Dora affirms that their contract is purely commercial. She also affirms that both the teapot and

Figure 1: Dora breaking Beba's teapot.

the value of her own work can be measured in money and therefore can be determined by either adding or subtracting. But this statement actually conveys the opposite: neither the teapot nor the salary mean just money for Beba and Dora respectively, since work as a commodity cannot be translated accurately and successfully into money. Beba's broken teapot and Dora's debt mean a 'break' and a 'debt' at a personal and affective level. Consequently, by indicating that a simple transaction (subtracting its value from the next paycheck) can solve the broken teapot situation, Dora underlines the opposite: the affective remnant in their relationship renders impossible its reduction to a business deal. In other words, through irony, Dora exposes the limits of commodification's 'tendency to resolve personal worth into exchange value', as Marx and Engels point out in the 'Manifesto of the Communist Party.'

Such an affective remnant is the result of having lived together for 30 years, becoming the closest and most stable person in each other's life: Beba is divorced, bankrupt, surrounded by superficial friends and alone since her only daughter has migrated to Spain. As far as Dora is concerned, Miguel, her boyfriend, flirts with other women while she is at work and leaves for San Luis at the end of the film. In contrast, Dora does not allow Miguel to speak ill of Beba, and she takes care of Beba's well-being, including her

health and public image (for instance, she refills imported whisky bottles with national whisky so Beba's friends do not realize how bad her situation is). In addition, when Dora talks on the phone with Beba's daughter, Guillermina, we can see that she loves her as if she were her own daughter. In turn, Beba shows her affection—in ways that are familiar to her—by inviting Dora to the hairdresser, offering 'more comfort' (like when she suggests she stay in Guillermina's former room, which has larger closets and an en-suite bathroom) and openly expressing her dependency on her. Probably one of the most meaningful scenes about their emotional connection is the one that shows Dora taking care of Beba's foot (which was hurt by a shard from the teapot) after their tense exchange of views, caressing it kindly.

But, how to rescue this affective connection, this remnant, from the labour context in which it was born and in which it is rooted? The answer implies enacting change by both characters, which apparently has been avoided in favour of waiting for an external situation to provide the solution/money. However, in spite of the characters' willingness to resolve the problem, a change does take place: after Dora's ironic revelation, return to the old harmonious façade is impossible, creating a growing tension between the two of them to be, somehow, resolved. The film expresses this tension through dialogue and also through the scenes' visual composition. For instance, in the teapot scene Dora and Beba are located in clearly-differentiated areas inside the apartment: the kitchen and the living room (connected through an open door) [Figure 1]. By placing them face-to-face, these independent territories become trenches from which to execute their conquest strategies.

However, this will not be an easy war for any of them. Dora knows and controls every object and place in the house and therefore has the advantage over Beba, who would be immediately lost if left alone: when she cuts herself with a shard from the teapot, she cannot even find the first-aid kit in the bathroom. On the other hand, Beba has the possibility of repaying her debt to Dora if she wants because, in spite of the crisis, she has many more possessions of value than Dora does and she can sell them to obtain cash. Actually, Beba could have been offered much more money for the teapot at the secondhand shop if she had taken the full set, but she is still reluctant to give up her possessions. The ever-present possibility of paying Dora's wages is Beba's way of keeping her hostage in the house.[11] But, how far can the tension between them go?

Not much farther: the growing tension between these two characters reaches its climax at Dora's next Rummy cards game with her female friends. She organizes the game as usual but with the hidden agenda of selling facial mud masks and beauty products to her friends (this is a commission-based business Beba has undertaken to make money, but it does not work because most of the time she is embarrassed to charge for the products). Consequently, Beba manipulates Dora into staying on her day off to help her organize the gathering and subjects her to her friends' impertinence, all the while not selling anything. This seems to be enough to break the dynamic in which Dora and Beba were trapped by worsening their tense opposition of interests and wills.

Leaving and letting go

As mentioned before, in order to preserve their emotional connection, these women need to go a step further. But taking that step will not be easy: it will require an inner transformation that would entail their willingness to think and act outside class patterns and expectations (regarding themselves and each other), abandoning those familiar but limiting territories. As the title of this chapter indicates, leaving and letting go are key aspects in this process of discovering new ways of 'living together'. For the main characters, those verbs represent more than just their definition: for Dora, 'leaving' means carrying out her plans of quitting her job in spite of the uncertainty of her future and the possibility of not collecting the money that Beba owes her.

Such decision becomes even more remarkable when considering the effects of growing labour uncertainty in post-industrial societies. By quoting Bourdieu, Page observes that such phenomena as labour casualisation—which Dora would have to confront if quitting her job at the crisis' peak—'prevents all rational anticipation and, in particular, the basic belief and hope in the future that one needs in order to rebel' (Page 2009: 58). Nevertheless, as we learn from the following dialogue, the decision is already taken:

> DORA. Miguel, voy a dejar de trabajar para la señora. [Miguel, I am quitting my job with Mrs. Beba]
>
> MIGUEL. Mejor aguantá, afuera está difícil…[You better wait. It is hard out there…]
>
> DORA. Estoy perdiendo el tiempo: La señora no me puede pagar. [I am wasting my time: Mrs. Beba cannot pay me]. (Gaggero 2004)

For Beba, letting go means renouncing goods, luxury, social status and money as the guiding principles of her social relationships and the structure of her life. Such reconsideration occurs when she sells her treasured gold earrings along with other expensive jewelry to pay Dora the now-seven months of overdue salary and a bonus for her many years of service. The gold earrings are the ones that Beba wears every time she goes out: they are part of her identity as Beba Pujol in the eyes of others. At some point in the plot, Beba mentions that she cannot sell them because she is planning on wearing them to her daughter's wedding—another typical occasion in which to reaffirm class identity through seeing and being seen.

In the scene of the sale, Beba is alone, surrounded by mirrors that multiply her image, (including the camera), revealing the fragility and externality of identity demarcations.

Figure 2: Jorge Gaggero. *Live-in Maid*. Aquafilm et al, Argentine-Spain, 2004. DVD, Koch Lorber 2007.

In *The Time-Image* (1989), Gilles Deleuze reflects on the implication of cinema images like this one, in which an actor reproduces him or herself in many others reflections causing indiscernibility between real and unreal, virtual and actual. As in the *Lady from Shangai* (Welles, 1947) there is a palace of mirrors: 'the mirror-image is virtual in relation to the actual character that the mirror catches, but it is actual in the mirror which now leaves the characters with only a virtuality and pushes him back out of field' (Deleuze 1989: 70). The reflected characters' double condition of virtual and actual refers to a world also ambivalent where past and present/real and imaginary constantly affect each other, introducing the possibility of movement and transformation in what is perceived as permanent and fixed.

Living apart/living together

The most important aspect of the decision these two women have taken is what it does to their lives: they will be able to experience each other's life and each other's influence in their lives for the first time. After Dora leaves, Beba's situation only gets worse: her electricity is cut off and she covers her furniture with sheets so as not to clean. She takes

Figure 3: Beba eating in tears after having traded some beauty products for a meal in a Chinese restaurant.

a shopping cart full of her valuables to sell at the secondhand shop and tries desperately to sell the beauty products door-to-door to repay her debt with the cosmetics firm. In the depths of her downfall, Beba goes so far as to trade products for a modest meal in a Chinese restaurant, which she eats in tears.

On the other hand, Dora expends all her money on luxurious flooring for her house, bosses Miguel around and orders him to work laying the floor even on Sundays. She also teaches the other maids she works with to do things elegantly, and is complemented around her neighbourhood for the nice quality of her clothes, which are Beba's hand-downs. In bed, at night, Dora looks nostalgically at the family picture (taken from Guillermina's fifteen birthday album before leaving) on her night table, while Beba, with the electricity cut off and surrounded by the darkness of her apartment, looks at Dora's empty room with sadness.

After Beba has experienced hunger and humiliation, after Dora has realized the influence of the rich neighbourhood on her, and after both of them have suffered the absence of each other, they are ready to find another way of 'living together', as the title suggests. For instance, Dora visits Beba unexpectedly on the day of her birthday: she gives her a cake and a little present (a pair of pantyhose like the ones she ruined with the shard), and lets her know

that she is looking for an hourly job so that she can have unpaid time to take care of Beba's housework. That same day Beba gives something to Dora as well: a bag full of clothing, more of the facial mud masks that Dora likes so much and a recommendation letter that attests her qualities so she can find a new job. Through these generous gestures the characters move from a market economy to a gift economy. As Page observes, regarding Martín Rejtman's films, '[i]n a gift economy goods and services are given without an explicit condition of reimbursement or exchange. Implicitly, something is expected in return, whether goods, favors or a nonmaterial benefit such as loyalty' (Page 2009: 78). According to Page, the fact that barter and gift economy exist in Argentina together with capitalist economy prevents the full development of the kind of sociability entailed by each of these models (Argentine society lacks the trust and loyalty characteristic of nonmarket communities but it also lacks the distance and anonymity 'essential to develop market economies') (2009: 80).

Similarly to Rejtman's works, this idea of a 'gift economy' becomes more complicated towards the end of the film, when Beba finally moves to a smaller apartment, and takes some of the furniture that does not fit in her new place to Dora's house. Beba says she brings the furniture in case something can be of use to Dora (which is still within the notion of gift), but among the pieces of furniture there is a grand piano, which make us suspect that perhaps Beba just wanted a place to store the piano until her economic situation improved. Repeating a very familiar interaction between them, Dora's initial reaction is one of surprise: '¡Señora!...¿Cómo se le ocurre?' [Madam...How could you?!] (Gaggero 2004). But she immediately takes charge of the situation by finding a place to put it in the backyard and, when Beba complains because the movers put the piano out of tune, she comforts her saying: 'No se haga problema. Yo después lo tapo con una lona' [Do not worry. I will put a cover on it] (Gaggero 2004).

We do not know why Beba really takes the furniture to Dora's, but judging only by the results of this action, it seems this is an opportunity to continue the relationship with Dora. This is the first time in 30 years that Beba has been to Dora's house. 'Perdoneme esto de haber venido sin avisar' [I am sorry I came without any notice] Beba says, and Dora replies: 'Usted no tiene que avisar' [You do not need to give me notice] (Gaggero 2004), indicating how, now that they do not have to see each other regularly because of work, they can start seeing each other because of other reasons. In fact, soon after Beba arrives at Dora's house we see them having tea together, sitting outside, and enjoying each other's company. Nevertheless, as a reminder that the social differences linked to their roles as maid and employer have not disappeared but repositioned within their relationship, Dora keeps calling Beba 'Madame' and treating her as such, and Beba keeps welcoming such a treatment.

The last dialogue Dora and Beba have in the film is very significant for the possible interpretations it opens. 'Buenos Aires es un infierno. Aquí corre una brisa tan linda' [Buenos Aires is hell. There is such a nice breeze here], says Beba, and a few minutes later Dora invites her to stay for the night, since it is getting dark (Gaggero 2004). At that very moment the movers download the last piece of furniture: the single bed that used to be Dora's. The

last shot of the film is a close-up of the single bed inside the house, or the 'cama adentro', evoking the Spanish expression 'muchacha con cama', used to refer to live-in maids.

Gaggero is clearly playing here with the possibility of role reversal, but in the context of what the characters have gone through, this is just a conspiratorial wink at the audience, since an inversion would just leave the traditional understanding of class interaction intact. On the contrary, by stressing personal and affective aspects in a situation apparently governed by money, the notion of 'living together' challenges the understanding of class interaction as just either depending to survive (living for others) or imposing (living off others). By integrating commodification and a remnant impossible to reduce to a commercial exchange in the very same relationship, class interactions become something susceptible to being affected and recreated.

But, is it possible to rescue and stress the effective remnant in a labour/commercial relationship without a crisis? For instance, could these two women from such different backgrounds have ever connected so profoundly had they not been cornered by the socioeconomic crisis? The director does not answer these questions, leaving the audience to connect the small anecdote of the film with the larger context of the Argentine society before and after the 2001 economic crisis, according to his or her kind of life. Probably, many social initiatives, which also challenged typical class interactions (such as recovered factories, neighbours' assemblies and barter markets), would have not developed without the 2001 economic crisis. In effect, only after losing their savings and privileges did the upper and middle-classes begin to understand the importance of engaging in social solidarity to defend their private interests (Vezzetti 2002: 163). The need for a crisis to realize about previously-ignored problems is not presented here as a concern but rather as an opportunity of using that experience to affect class relationships in concrete instances where they seem to be set and pre-arranged.

In fact, in the context of the film's release when the most difficult part of the Argentine crisis is over, and people start speculating about the future of the popular movements developed to cope with the crisis' consequences, Gaggero commented:

> I sometimes watch the film and find it too optimistic, and I wonder if people born in different social groups can really make substantial progress in understanding each other. I hope the answer is yes, but the times we are living in don't look too promising. On other occasions, however, I feel Beba and Dora have at least been able to get a little bit closer, and that makes me feel the most optimistic person I can ever be. (Prensa n.d.)

In this quote Gaggero is conveying two different ideas. On the one hand, he is referring to Dora and Beba's fictional characters and highlighting the importance of finding other spaces for a different kind of class integration in everybody's daily life, since, according to the director class tensions are everywhere: 'You don't have to go great distances to see

classes, people and situations in interaction and conflict' (Rother 2007). Here, again, the audience has the last word. Even when such a search can end with the creation of a collective project, it needs to start by introspection.

On the other hand, Gaggero is also referring to the actresses who played Beba and Dora's role, since working together was certainly a life-changing experience for them. Norma Aleandro, probably the best-known and most professional actress in the country, lives in the elegant Belgrano neighborhood, just blocks away from the building where most of the film was shot and, coincidentally, she also has employed the same maid for more than thirty years. Norma Argentina is a real maid who was encouraged by her employer to go to the casting session of the film. Both actresses got to know and appreciate each other while working together in the making of *Live-in Maid*, achieving an unsurpassable result from the combination of their very different talents.[12] Intentionally or not, the film itself served as a space for the encounter of different social classes (the film also included other non-professional actors from the San Luis community), connecting once again abstract notions with concrete situations in a way that challenges both and opens a space for the audience to reflect.

In conclusion, *Live-in Maid* is a reflection on the problem of class interaction in Argentina, but it is also a reflection on the importance of crisis in general as a driving force for insight, autonomy and change. It is a film about society but it is also about individuals. It is an observation about Argentina at the end of the millennium, but it is also a comment on the complexity of interpersonal relationships where domination, submissiveness, love, hate, loyalty and disillusionment co-exist. Precisely because of the intersection of so many levels, Gaggero's *opera prima*, his first work, is a film of striking currency, fundamental for considering, once more, the inequalities of the social classes in Argentina.

Acknowledgments

I would like to thank Ofelia Ros, Jakob Feinig and Diana Mathieson for their illuminating comments on this chapter. I also thank Mariana Morris Grajales and Diana Mathieson for editing this chapter in its different stages.

Notes

1. For more information about the context in which this contest emerged and its meaning within Argentinean film history, see: 'De la virtual extinción a la nueva ley: el resurgimiento' by Diego Batlle in Horacio Bernades et al (ed) (2002). *El Nuevo cine argentino: Temas, autores y estilos de una renovación* and 'Young Film-makers and The New Independent Argentine Cinema' in *The Cinematic Tango: Contemporary Argentine Film* by Tamara Falicov (2007).

2. The other directors participating in *Short Stories* who also continue making films are: Lucrecia Martel (*La ciénaga/The Swamp*, 2001), Daniel Burman (*Esperando al mesías/Waiting for the Messiah*, 2000), Israel Adrián Caetano (*Un oso rojo/A Red Bear*, 2002), Ulises Rosell (*Bonanza (en vías de extinción)/Bonanza (On the Verge of Extinction)*, 2001), Rodrigo Moreno (*El custodio/The Custodian*, 2006), Andrés Tambornino (*SOS Ex*), Bruno Stagnaro (*Pizza, birra, faso/Pizza, Beer and Cigarettes*, 1998) and Sandra Gugliota (*Un día de suerte/A Lucky Day*, 2002).

3. Therefore, film-makers have implemented all kinds of cost-reducing measures, including labour donation and 'new technologies such as the rise of digital formats to produce high quality broadcast images' (Falicov 2007: 144), and have also resorted to co-productions funds for cultural projects in developing countries.

4. Moreover, *Live-in Maid* made a significant impact in the United States. It sold out for two weeks at the Film Forum Theatre in New York City and received an excellent critical review in the *New York Times*. Accordingly, Andrew Herwitz's Film Sales Co. bought the remake rights of the film for producing an English version to be written and directed by Rodrigo García (*Things You Can Tell Just By Looking At Her*, *Nine Lives* and *Ten Tiny Love Stories*). Last, but not least, Gaggero was asked to adapt and direct Richard Ford's novel *Wildlife* (a three-million-dollar production), as the next step in his career.

5. Except for *La ciénaga/The Swamp* (2001) by Lucrecia Martel, which includes the relationship between a family of landowners in decay and their mestizo, working-class maids, very few other films (if any) work on the encounter of two different social classes—probably because there are no other clear spaces for that encounter to happen. Most NAC films work on characters and scenarios that 'have been invisible for previous Argentine cinema' formed by a restricted notion of citizenship 'European-influenced and inflected' (Falicov 2007: 133). For instance, Quintín mentions the incorporation of: 'La sociedad salteña de Martel y la de Moscoso, los marginales cordobeses o bolivianos de Caetano, el suburbio bonaerense de Trapero, el monte pampeano de Alonso' [The town of Salta's society portrayed by Martel and Moscoso, the deprived areas in the city of Cordoba or in Bolivia represented in Caetano's work, the Buenos Aires suburbs of Trapero or the hills of the Argentine pampas depicted by Alonso] (Bernades 2002: 118). Another example of this is how NAC directors start to 'show films from a grittier working class perspective' (especially after the economic crisis of 2001), in films such as *Un oso rojo/A Red Bear* (Caetano, 2002), *El bonaerense/The Policeman* (Trapero, 2002) and *Taxi, un encuentro/Taxi, an Encounter* (Gabriela Davi, 2001) (Falicov 2007: 134). Finally, in a very closely connected category, we find films that, also after the 2001 economic

crisis, expressed middle class decay, such as: *Un día de suerte/A Lucky Day* (Sandra Guigliotta, 2002), *Hoy y mañana/Today and Tomorrow* (Alejandro Chompsky, 2003) *Buena vida (delivery)/Good Live Delivery* (Di Césare, 2004) and *El delantal de Lili/Lili's Apron* (Mariano Galperin, 2004).

6. Films such as *El hijo de la novia/Son of the Bride* (Campanella, 2001) and *Luna de Avellaneda/Moon of Avellaneda* (Campanella, 2004), on the other hand, reflect on how the 2001 socioeconomic crisis affected Argentina as a country and Argentineans as a society through an allegory. Closer to *Live-in Maid*, the independent film *Una de dos/One or the Other* (Alejo Taube, 2004), resists an allegoric reading by persevering on literal aspects such as a character's contradictory behaviour. In his article 'La f(r)actura de la imagen: crisis y comunidad en el último nuevo cine argentino', Hernán Feldman (2007) addresses independent feature films that incorporate the crisis in the form of fragmented visual images, that either remind or warn the characters about imminent dissolution of social ties.

7. Marx elaborates this idea in *Capital: A Critique of Political Economy*, Vol. I. *The Process of Capitalist Production*, Part VIII, Chapter XXXII: 'Historical Tendency Of Capitalist Accumulation'.

8. The term in English, 'live-in maid', expresses clearly the overlap between life and work. The Spanish term 'mucama' originates during the colonial times in Brazil and Cuba as a general term to refer to the African female domestic slave (Roncador 2008: 8).

9. As an example of the referred subordination of all aspects of life to work, during the film we learn that Dora became pregnant twice by Luisito, the superintendent of the building (then a married man), and Beba paid for the two abortions. Beba's friends bring up the subject facetiously regarding the young and attractive maid who works for one of them. They talk about her as if she were not present in the room and she asks her employer to instruct her so that she does not share the same fate as young Dora. We can find a more literal example in the Mexican film *¿Dónde están sus historias?/Where Are Their Stories?* (Nicolás Pereda, 2007).

10. For a different interpretation of the role of the crisis in the film (as reactionary) see Nicolás Prividera's review.

11. For further elaboration on the representations of maid and employer dynamics in other Latin American countries, see Chapter 3 of *A Doméstica Imaginária:*

Literatura, Testemunhos e a Invenção da Empregada Doméstica no Brasil (1889-1999) [An Imaginary Maid: Literature, Testimonies and the Invention of the Maid in Brazil (1889-1999)] by Sonia Roncador (2008). Also, in Chapter 4, Roncador shows, through the analysis of testimonial literature, how a politically-engaged maid confronts the national culture of looking down on domestic labour by agreeing with the historian Marie François on understanding domestic labour as an hyperproductor of material and symbolic goods, as opposed to a reproductive activity excluded form the world of work, commonly associated with production. 'Ele produz imagens e personas públicas, mantém certo status e bens relativos a esse status e produz matéria prima para o consumo, assim como prepara sujeitos para areias política e econômicas' [domestic labour produces images of public pople, keeps certain status and goods related to that status and produces raw material to be consumed as well as it prepares subjects for the political and economic scenarios] (Ibid: 230)

12. Actually, both Norma Aleandro and Norma Argentina received awards for their roles in *Live-in Maid* and, since then, Norma Argentina has been featured in six more films including *City of your Final Destination* (2007) by James Ivory with Anthony Hopkins, Laura Linney and also Norma Aleandro (Del Moral 2007).

References

Aguilar, G. (2006) *Otros mundos. Un ensayo sobre el nuevo cine argentino*, Buenos Aires: Santiago Arcos.

Batlle, D. (2002) 'De la virtual extinción a la nueva ley: el resurgimiento' in H. Bernades et al. (ed.) *El Nuevo cine argentino: Temas, autores y estilos de una renovación*, Buenos Aires: FIPRESCI/Tatanka.

Bernades, H. (ed.) (2002) *El Nuevo cine argentino: Temas, autores y estilos de una renovación*, Buenos Aires: FIPRESCI/Tatanka.

Del Moral, C. (2007) 'Cama Adentro un retrato íntimo argentino,' http://cinelatinony. blogspot.com/2007/07/cama-adentro-un-retrato-ntimo-argentino.html. Accessed August 8, 2009.

Deleuze, G. (1989) *Cinema 2: The Time-Image*, Minneapolis, MN: University of Minnesota Press.

Falicov, T. (2007) *The Cinematic Tango: Contemporary Argentine Film*, London: Wallflower Press.

Feldman, H. (2007) 'La f(r)actura de la imagen: crisis y comunidad en el último nuevo cine argentino' in V. Rangil (ed.) *El cine argentino de hoy: entre el arte y la política*, Buenos Aires: Biblos, pp. 89–102.

Gaggero, J. (2004) *Cama adentro*, Aquafilm, Filma Nova, Libido Cine, San Luis Cine, Argentine-Spain.

Goldbarg, P. (2007) 'Interview with Jorge Gaggero', REALFIC(c/t)ION, http://pablogold-barg.blogspot.com/2007/07/interview-jorge-gaggero.html. Accessed August 18, 2009.

Marx, K. (1906) *Capital: A Critique of Political Economy*, (1st ed. 1867), Chicago: Charles H. Kerr and Co., http://www.econlib.org/library/YPDBooks/Marx/mrxCpA32.html#Part%20VIII,%20Chapter%2032. Accessed July 28, 2010.

Marx, K. and Engels, F. (1969) 'Manifesto of the Communist Party' in *Marx and Engels Selected Works*, Vol. I, (1st ed. 1848), Progress Publishers: Moscow, http://www.marxists.org/archive/marx/works/1848/communist-manifesto/index.htm. Accessed June 3, 2009.

Page, J. (2009) *Crisis and Capitalism in Contemporary Argentine Cinema*, Durham: Duke University Press.

Prensa, entrevistas y ficha técnica/ Press, Interviews and Credits (n.d.) http://www.aquafilms.com.ar/films/camaadentro/prensa/presskit_camaadentro.pdf. Accessed June 2, 2009.

Prividera, N. (n.d.) 'Cama adentro', *Cineismo.com*, http://www.cineismo.com/criticas/cama-adentro.htm. Accessed August 22, 2009.

Quintín (2002) 'De una generación a otra: ¿Hay una línea divisoria?' in H. Bernades (ed.) *El Nuevo cine argentino: Temas, autores y estilos de una renovación*, Buenos Aires: FIPRESCI/Tatanka, pp. 111–18.

Roncador, S. (2008) *A Doméstica Imaginária: Literatura, Testemunhos e a Invenção da Empregada Doméstica no Brasil (1889–1999)*, Brasília, DF: Editora Universidade de Brasília.

Rother, L. (July 15, 2007) 'A Part Made for Her, About Life With a Maid', *The New York Times* (Movies), http://www.nytimes.com/2007/07/15/movies/15larr. html?pagewanted=all. Accessed August 25, 2009.

Vezzeti, H. (2002) 'Scenes From the Crisis', *Journal of Latin American Cultural Studies* 11.2: 163–71.

Electoral Normality, Social Abnormality: The *Nueve reinas*/*Nine Queens* Paradigm and Reformulated Argentine Cinema, 1989–2001

Ana Laura Lusnich
University of Buenos Aires—CONICET

Nueve reinas/*Nine Queens* (Fabián Bielinsky, 2000) is part of a new era in Argentine cinema that, though it introduces new thematic and expressive techniques, is riddled with uncertainties and contradictions.[1] Although there are many film productions in the late 1990s, some films are not premiered in movie theatres, and/or they are only screened at film festivals. Moreover, there seems to be a variety of narrative forms. Within a large corpus of films, some cinematic productions renew the modes of representation, while others continue within certain traditions of Argentine cinema. *Nueve reinas* is a representative film of the former tendency. First shown in Buenos Aires in 2000, among 42 other national films corresponding to the varied tendencies of the fictional and documentary cinema of the time, *Nueve reinas* fits into a period of Argentine cinema that is defined by the articulation of two trends.[2] First, it is part of a renewed cinema industry that is rooted in local cinematographic traditions (costumbrist realism and film noir) and features performers who occupy the centre of the fields of television, theatre and film; and, second, it presents a series of parameters, solidified in the late 1990s, that reflect the dire sociopolitical consequences of Argentina's neo-liberal policies, gathering a large number of films under the 'New Argentine Cinema' classification. This first trend is seen in a number of films that recovered a conception of cinema similar to that prevailing in the classical-industrial period of the 1940s and 1950s. *Comodines*/*Jokers* (Jorge Nisco, 1997), *Plata quemada*/*Burnt Money* (Marcelo Piñeyro, 2000), *El hijo de la novia*/*Son of the Bride* (Juan José Campanella, 2001), *Luna de Avellaneda*/*Moon of Avellaneda* (Juan José Campanella, 2004) and *El nido vacío*/*The Empty Nest* (Daniel Burman, 2008) are all technically sound and fit the show business and narrative standards of institutional cinema: conceived as entertainment for broad

segments of the population.[3] Following this line, despite some possible deviations, these films were linked to the genre system, referring to comedy and family drama or to film noir preferably, and they also organized their stories according to a star system composed of actors that based their performances in communication and emotion and became renown in different media: Ricardo Darín, Héctor Alterio, Pablo Echarri, Norma Aleandro and Leonardo Sbaraglia, to name only a few. The movies that are part of the New Argentine Cinema established in 1997, the year in which the emblematic film *Pizza, birra, faso/Pizza, Beer, Cigarettes* by Adrián Caetano and Bruno Stagnaro received the Jury's Special Prize at the Mar del Plata International Film Festival, produced a renewal in both filmic structures and cinematographic circles in general.[4] On the pertinence and the possibility of this label, Argentine film scholar Gonzalo Aguilar astutely argues that it is not based on the films' common aesthetic programmes, but on two other factors: the ongoing filmic output by some of the directors (Adrián Caetano, Bruno Stagnaro, Pablo Trapero, Lucrecia Martel and Martín Rejtman) and the success that this way of dubbing them had abroad (Aguilar 2006: 13). Part of the trend of 'auteurist cinema' (limited in its budget, but brazen and diverse in its redefinition, transgression and cancellation of traditional genres) was its appeal to young actors who, new to the cinematographic field, influenced the reformulation of interpretative styles of the use of body and voice which sway between the austere and critical realism and anti-naturalism.[5]

Even if there are substantial differences in the ways of approaching the production, circulation and exhibition of the films from both tendencies—either through the Argentine government or through independent and/or international entities or as a co-production, etc.—a series of elements link them. Beyond a common political-financial situation—all of the movies were produced in a historical period marked by the consolidation and continuance of democratic institutions and the promotion of cinematographic activity by the National Institute of Cinema and Audio-Visual Arts—one of the elements that brings them closer together is the recording, in various degrees, of the consequences of the sociopolitical economics of Argentina's neo-liberal governments. The recession, the disarticulation of the state as a cohesive instrument of social mediation, the distortion of community values, the proliferation of dysfunctional members of society and the growing marginalization of wide segments of the population are the complex themes that underlie films of both trends. The paradox of 'electoral normality, social abnormality' reflects the social turmoil caused by the measures of democratically-elected governments that were detrimental to large segments of the Argentine population.[6] This sociohistorical context informs and shapes many of the films produced in the late 1990s.

Nueve reinas synthesizes a dialogue between industrial and commercial films and independent films. It was influenced by the oeuvre of other important Argentine film-makers, such as Fernando Ayala, Juan José Jusid and Adolfo Aristarain.[7] This influence conveys a strange and suggestive integration of the author's sensibility and the industrial standards of execution and production. In fact, Bielinsky's debut film installed an unusual

duality in Argentine cinema: it was conceived for a local audience and grew without an international market in mind, but then was quickly sold abroad and won several international awards. From a thematic point of view, it deals with universal topics—con-artists, the world of underground crime, etc.—but it presents a subtext that condenses the historical and political local reality.[8] With the release of his second and final film, *El aura/The Aura* (2005), Bielinsky made a leap that confirmed his career and suggested his presence as a hinge figure between commercial cinema and auteurist cinema. He re-elaborates the theme and prototype of *Nueve reinas* as a dark story that displaces the notion of 'crime' from a socially dysfunctional behaviour to the way of life for a lonely and disturbed man that finds, in an extraordinary act (the robbery of a bank vault in a far-off place in the southern part of Argentina), the reason for changing his life condition.

All of these points aim to construe the film *Nueve reinas* as a unique, culturally complex text that belongs to the climate of the moment (a neo-liberal Argentina, preceding the extended 2001 crisis) and that, at the same time, establishes an original narrative and entertainment-related perspective. If on one hand the film is included into the Argentine film tradition (an industrial way of production, a frame of genre-based roots, an updated star system), on the other hand it contributes a different, reformulated dimension to the characters and topics in it. Starting from these coordinates, the referential immediacy and the professed author's point of view make visible the explicit inhospitable dimensions of a world in crisis. This chapter explores these two tendencies in Bielinsky's *opera prima*.[9]

Nueve reinas and the tradition of Argentine cinema

Nueve reinas appeals to different horizons of expectation: tradition and change, submission to a canon—the mainstream cinema widely accepted among film-makers and audiences—and exploration of the author's universe. In its dialogue with the heritage and the precedent of Argentine cinematographic practices, it is possible to note an interest in recovering some of the parameters of two particular genres: the costumbrist drama and film noir (both developed in the 1970s and 1980s), updating them with regards to a new context of creation. In this direction, *Nueve reinas* is intertextually related to two paradigmatic films released during the most recent military dictatorship: *La parte del león/The Lion's Share* (Adolfo Aristarain, 1978) and *Plata dulce/Easy Money* (Fernando Ayala, 1982).[10] In Bielinsky's film, the narrative structure, the star system and the composition of the scenes/settings reform several aspects of these films. They show a necessary syncretism through which the related facts (typical of the thriller and the police drama) appear in a number of segments of the parodied and relativized stories, adopting at this point the critical dimension established by drama and costumbrist comedy between 1976 and 1983. The story in *Nueve reinas* unfolds in the course of nearly 24 hours. At the beginning of the day, Juan and Marcos, two petty criminals who

work separately stealing from passers-by and unaware employees alike, randomly meet each other and together hatch a huge, risky scam. They reach an agreement on their plan and get ready to carry it out. Marcos and Juan constitute an appealing and symptomatic couple: Marcos, a mature man, acts as the master who reveals the tricks of the trade to the young apprentice, Juan. The sale of a collection of fake stamps, supposedly coming from the Weimar Republic, for one million pesos becomes the greedy motivation of this pair of con artists, launching an intricate system of vicissitudes that reaches its climax with an unexpected twist: Juan receives a large sum of money that reveals that the web of deceptions was planned beforehand by this younger con artist, leaving Marcos in the utmost helplessness. In the twists and turns of the story, it is possible to see the confluence of characters and topics that connect Bielinsky's film to the aforementioned films of 1978 and 1982. First, it dwells on a narrative structure that substitutes the notion of honorable work for another set of values linked to the moments of crisis tangible in the historical-economic context of reference: the access to money by means of cons and disloyal relations. Second, it organizes a diegetic universe that assimilates the indexes of the historical reality (the long process of the annihilation of the Argentine state and the deregularization of the economy that began between 1976 and 1983 and caused, afterwards, different set-backs and advances that resulted in the 2001 crisis). Third, it deploys a star system that represents different local paradigms, including the opportunist *porteño* [a person from Buenos Aires] who enters into the crime world. Finally, *Nueve reinas* exhibits an urban topography that exacerbates, in the behaviour and relations of the individuals, the degree of the current social disintegration.

Nueve reinas continues a cinematic line originated by Adoldo Aristarain, director of a series of film noir which, by referring to specific historical times, are redefined as powerful metaphorical fictions.[11] For instance, Aristarain proposes in *La parte del león* a case of corruption that focuses on the story of a middle-class man who has failed in his professional ambitions and in his marriage. The initiation into crime, the idea of crossing the line of established morality and the need to find a financially profitable way out in a context of crisis are the points that connect *La parte del león* to *Nueve reinas*—though they portray different outcomes from and outlooks on the transgressions to the moral and social order. Aristarain's film presents an unstable and dubious lead character and a narrative closure that implies that taking other people's money is neither a financially viable nor a morally acceptable way of living. Bielinsky's film raises the stakes by suggesting that it is not only possible to commit a crime and count on the easy money, but also feasible to con someone from an older generation: Juan rips off Marcos, making obvious the existing inter-generational strains in Argentina.[12] Without a doubt, the 2001 political and economic crisis of Fernando de la Rua's presidency (vast unemployment, a plummeting gross national product, pervasive governmental corruption and a debilitating recession) boosted both of these social conflicts. The belief in the impossibility of recovering the country gave rise to two distinct attitudes (reflected in two popular slogans of the time:

'If I can't save the country, then I'll save myself' and 'All the politicians should go away'), which appear manifestly and syncretically in Bielinsky's debut film.[13]

Once these aspects relating to Bielinsky's and Aristarain's films are recognized, it is imperative to understand that the twists and turns of the stories and their resolutions are different, even opposite. In *La parte del león*, after the protagonist Bruno Di Toro (played by Julio de Grazia) decides to take over the stolen money he found and, starting from there, begins a new life, all the instances of his daily life related to his familiar and social environment get altered: Bruno does not manage to keep the money (the delinquents persecute and stalk him until they get it back), he separates from his wife and he betrays one of his friends. The narrative closure, imbued with a strong moral burden, emphasizes the erroneous choices of the protagonist: the story of Bruno Di Toro is the story of a man who—like many others in the context of the most recent dictatorship—has lived in degradation and failure.

In the exploration of different structural forms and new narrative patterns, *Nueve reinas* is linked, in turn, with costumbrist cinema, a highly prolific genre in the history of Argentine arts and culture.[14] *Plata dulce*, a film directed by Fernando Ayala and Juan José Jusid, was released in 1982, a key year in Argentine history due to the pre-announcement of the return of democracy. The film (again) depicts the average man who is seduced by the allure of favourable dollar rates and financial speculation, two of the patterns that marked the economic policies that Ministers of Economy José Alfredo Martínez de Hoz, Lorenzo Sigaut, Roberto Alemann, Dagnino Pastore and Jorge Wehbe designed and carried out during the years of the most recent military dictatorship. These policies included two central elements succinctly and famously defined by Argentine historian Luis Alberto Romero: 'To shrink the state and to silence society' (Romero 2001: 220). While the military government stabilized, the reforms that radically transformed the basic functioning norms of Argentina since 1930 were launched.

Set after Argentina's triumph in the 1978 World Cup, *Plata dulce* begins with the dilemma that confronts Carlos Teodoro Bonifatti (played by Federico Luppi) and Rubén Molinonuevo (played by Julio de Grazia). These brothers-in-law, owners of a furniture workshop, take different positions when given the opportunity to take part in a financial business deal that would bring them economic security. Teodoro decides to distance himself from the family business and in a short period of time takes over the management of a financial holding. Similar to the main character in *La parte del león*, Teodoro represents the average individual who has fallen into a trap and does not possess either the economic or the intellectual means needed to overcome the situation. The narrative structure, organized in two phases of ascent and fall, ends with a character who has failed in both his family life and his work life. The closure, of strong institutional impact, includes a moralist perspective that judges the behaviour of wide segments of the population, direct or indirect participants in the economic skirmishes of the time.[15] At this point, the costumbrist cinema (especially the dramas and comedies

released between 1976 and 1983) reflects one of the themes that started to characterize the Argentine novel and theatre of the 1950s and 1960s: the parallelisms between fiction and documentary (Avaro & Capdevila 2004: 219). The choice of register (documentary, fiction, etc.) and the possibility of establishing an equivalent among fictional practices and testimonials gathered force in this nucleus of writers, their ideas casting themselves onto other artistic disciplines (especially the field of cinema). Despite the tragicomic or grotesque resolution of *Plata dulce*, cinema, like other artistic expressions, conceives language as an instrument capable of testimony, description and representation of a certain situation in time. More so because of the narrative development and the imposed resolution, cinema constructs a personal image of reality and the present time which, in the example of *Plata dulce*, compromises the performances of the male lead characters as much as those constituting the social framework. For example, Hortensia, the grandmother of the family, deposits each payment of her retirement money in a fixed-term deposit in dollars, counting on the dollarization of the economy. Corroborating the idea of family 'mix-ups,' especially those committed by adults, Ayala and Jusid's film locates in the new generation (the kids of both families) the possibility of change and redemption: Carlos' son chooses to work and study, and Rubén's daughter finds a position in a foreign company.[16]

Nueve reinas and its innovative aspects

Unlike its predecessors—due to the fact (most likely) that it was released at a critical point in Argentina's history—*Nueve reinas* exposes the consequences of the neo-liberal politics implemented in Argentina several decades earlier.[17] However, besides serving as a sampler of the concrete results of this political-economic process, Bielinsky's film differs from its cinematographic referents in its ideological perspective, distanced from *La parte del león* and *Plata dulce* in its conception of characters and in the resolution of its story.[18] Another point of innovation is the formulation of an 'urban topography' that updates the metaphor of the city as a concrete jungle, tracing with this spatial-temporal design a direct relation with the film *Plata dulce* and partial links to some of the contemporary examples of the New Argentine Cinema.

The first of these aspects, the star system, incorporates the audience's identification with the protagonists and the breaking-off with the universe imposed by adults. In an interview carried out by Julián Gorodischer (2005), Bielinsky acknowledged his fascination with the kind of behaviour that his characters show. In *Nueve reinas*, the radical leap from idea to action extends over the subjects' two different aspects. If, at the beginning, it is possible to maintain that the performances conceal the learning of an alternative and extreme way of being (in *Nueve reinas*, Juan reveals in the final stretch an unknown dimension of betrayal that confuses his partner and even the audience), gradually the

spectator gains access to some other general motivations of the characters that involve him/her in different ways, accompanying him/her in the questioning of accepted values and instituted social practices. Regarding these affiliations and complicities, Bielinsky explains:

> The idea was to cross the line of the established moral... I find this fascinating. In *Nueve reinas*, I was already working it in a subtle way, convincing the spectator that it was possible to identify him/herself with the criminal, making him/her wish to jump over the line and that things would work on the other side. (Bielinsky in Gorodischer 2005: 2)

In order to achieve this identification (that entices the viewer to follow the character through the course of the story and even to empathize with him/her), the director appeals to notions of committing a crime and the ensuing consequences:

> You make a cut on reality and adapt certain parameters to achieve that identification and that will of being with the character. Then, with a non-violent crime, whose victims don't suffer or are impersonal—like an institution or a bank—or are disgusting, for example, you are pulling the strings to generate empathy, even when basically what you are looking at is someone committing a crime. I try to maneuver within these parameters. Cinema has always done it, and wonderfully. (Bielinsky in Reincke 2005)

In *Nueve reinas*, the male characters are defined by their narrative and resolutive actions: after they meet, the criminals decide by mutual consent to commit fraud and plan the subsequent steps. The reference to a full and fixed meaning is immobilized by a culture and by the updating of certain prototypes and roles. The lead male characters represent the con artists or opportunists that live in big cities, yet they differ by age and by the destiny that each assumes in the resolution of the story. The film, therefore, presents them as referential characters, for which Jesús García Jiménez identifies different degrees of readability, depending on the spectator's knowledge of and participation in that particular culture (García Jiménez 1996: 284). He differentiates the reception of national and international audiences, and even of local and regional audiences, depending on the reading and/or interpretation of those indexes of reality provided by the filmic accounts on their different levels, visual and/or audio-visual. Appealing to that understanding of the dramatic subject, and taking into account the transgression inscribed in the final scenes (Juan keeps the money after cheating his seasoned comrade), it is feasible to locate in this closure the rejection of the adult world. This world, beyond the traditional father figure, is oriented around other levels

of authority: the employers that exert pressure on their employees, exploiting them; and the politicians and others who lead Argentina.[19] Marcos, a middle-aged *porteño* (played by Ricardo Darín) occupies in a large portion of the film the role of leader or chief of the band, showing Juan his mistakes (his naïveté, his youth) and stating a series of maxims garnered from his experience and talent. In the first scenes of the movie, he asserts the following, with the intention of withholding his partner: 'This country is going to Hell,' 'What do you want, to survive?' and 'I can show you a couple of *yeites*.' Facing the strategies of the mature professional, Juan acts in an ambivalent way. If at some point in the beginning he accepts Marcos' protective and instructive nature, slowly he starts to interfere in basic decisions, distorting the expected outcome of the stamp sale. At this point, once we are aware of the alliance between Juan and his girlfriend Valeria (Marco's younger sister), the conspiracy against the older man allows several possible readings. Valeria's betrayal implies the punishment imposed by Marcos' familial relations (Valeria and his close family acknowledge the low moral status of Marcos, who has abandoned and swindled his loved ones on plenty of occasions). Juan's betrayal can be associated, in turn, to other orders of the local social reality: Marcos represents, in the eyes of the young, the boss, the leader and even the merciless *porteño*. After leaving Marcos at the gate of the Banco Sudamericano de Crédito, Juan initiates his return home; after a subway ride and a walk, he enters a storehouse located in some suburban neighbourhood. Juan reunites with his loved ones, some of whom participated in the sham that scammed Marcos (Berta, Sandler, the *Turco* and Valeria).[20]

Another innovative aspect of the film is the design of a narrative structure that contains, in its closure, a transgression of the standardized resolutions of institutional cinema, and a clear distance from the aforementioned antecedents from the national cinema. As already mentioned, *La parte del león*, like *Plata dulce*, leans toward a moralizing that implies the failure of those who opt for social self-exclusion and individualistic behaviour. Be it for weakness of character (the Achilles' heel of *La parte del león*'s main character Bruno Di Toro) or for personal inefficiency and ignorance (character flaws of *Plata dulce*'s Carlos Teodoro Bonifatti), the films of 1978 and 1982 judged the decisions and behaviour deployed by these characters, betting on the economic and social reconstruction of Argentina. In contrast, *Nueve reinas* naturalizes the state of affairs prevailing in the country in the year 2000 and, at some points, even presents a parodied outlook on the surrounding reality. In this regard, towards the middle of the film, with the intention of justifying his way of life, Marcos points out to Juan (and the spectator) a series of individuals hanging out in different points of the city, waiting for the best moment to commit a crime.[21] Marcos' severe countenance and distant and calculating pose convinces the spectator of the differences between a professional and a common criminal. The ironic intention accompanies, in turn, the closure of the story. At the moment in which Juan reunites with his girlfriend and the organized sham is disclosed, he remembers the title of a song whose melody had accompanied him throughout the

day. Evoked in passing at the beginning of the film (Juan claims that his mother listened to Rita Pavone), the concrete memory of the song unravels in the final moments: the festive 'Il ballo del mattone' is played during the closing credits.[22] In her study on the national and transnational qualities of the film *Nueve reinas*, Deborah Shaw interprets the film's resolution as a function of a national feature or characteristic: 'the desire to take action against the corrupt and the greedy (embodied in Marcos) in the absence of a reliable justice system' (Shaw 2007: 76). This situation reinforces the strategies implemented in the star system, a context in which the moral compass for the audience (according to Shaw) is Juan, reserving for Marcos the role of the antihero who is motivated by and for only himself.

Finally, another innovative aspect of the film is the opposition of two different geographical spaces (the city and the suburbs) and the association of the city with conflict and community disaggregation. In depicting the financial and commercial centre of Buenos Aires, the expressive use of certain significant elements makes visible the relations and social practices that characterized Argentina around the 2001 crisis. The environmental sounds in close-up, the roaming of the protagonists in streets filled with pedestrians, the shots of the subway entrances on main avenues and the exhibition of impoverished locales (hallways, subway shops, pubs), all show a heterogeneous and fragmented urban universe in which urgency and indifference trace the links among the individuals who walk there.

Conclusions

The revision and mixture of the genres of thriller, police drama and costumbrist drama expose a double movement of connection and reassessment of the local cinematographic tradition. In this regard, Aristarain's and Ayala's films, released during the most recent military dictatorship in Argentina, became appreciated cultural heritage, becoming immediate antecedents of Bielinsky's film. Moreover, in recent years, Bielinsky and other directors proposed renewal of the ideological parameters of those genres, a position that recognizes them as 'auteurs' that are capable of producing a personal and updated perspective of the stories and universes that are depicted. As can be inferred from the title of this chapter, the film establishes a mimetic depiction of the events that took place in the late 1990s and reached their peak in the last months of 2001. *Nueve reinas is* a rich and complex film that depicts the social abnormality of democratically-elected governments in Argentina from 1989 to 2001 that shaped Argentine society as made of groups interested in their own survival regardless of merit and a work ethic.

Notes

1. Director: Fabián Bielinsky; Script: Fabián Bielinsky; Cast: Ricardo Darín, Gastón Pauls, Leticia Brédice, Tomás Fonzi, Elsa Berenguer, Celia Juárez, Alejandro Awada, Ignasi Abadal, Vidal Gandolfo; Production: Pablo Bossi, Cecilia Bossi.

2. In its addenda on national premieres in the period of 1997–2005, Gonzalo Aguilar's book records 43 premieres for the year 2000, a number that increased in the subsequent years (Aguilar 2006: 228–9).

3. *El nido vacío* was the most-watched Argentine film of 2008.

4. 'New Argentine Cinema' was the syntagma with which Horacio Bernades referred to this trend in several of his articles for the *Página 12* newspaper; 'New New Argentine Cinema' and the 'Generation of the '90s' were other forms of denomination used for this process of renovation, clearly alluding to the national cinematographic tradition and in explicit reference to the 'Generation of the '60s,' a group of film-makers that called for both a break from cinematic tradition and a focus on more artistic productions.

5. 'Auteurist cinema' refers to films in which the unique stamp of the director is apparent, a stamp that binds together his/her body of works.

6. To understand the political and cultural panorama of this period, it is helpful to consult Hugo Hortiguera and Carolina Rocha's (2007) detailed introduction in *Argentinean Cultural Production during the Neoliberal Years* (1989-2001).

7. With these film-makers, Bielinsky established intertextual relations and a fruitful dialogue. The reference to costumbrist drama and police cinema and the search for new variations of traditional genres was characteristic of both productions of the director, who died prematurely in June 2006.

8. The film relies on a solid script that won a 'New Talents' competition in 1998 chaired by the director and professor José Martínez Suárez and sponsored by the producers of Patagonik Films, who had earlier rejected the script.

9. This is another aspect that links several industrial-commercial productions and the films of the New Argentine Cinema. Perhaps the most notorious difference in Bielinsky's film and similar ones is the exaltation of a perspective that presents

individuals that survive and even overcome the economic crisis at the expense of the degradation of their peers.

10. *La parte del león* is a metaphorical police drama that narrates the story of a man who finds money stolen from a bank and faces a difficult moral dilemma: the choice to give it back or to keep it and, in this way, improve his economic situation. *Plata dulce* is a costumbrist drama that, set during the most recent military dictatorship, tells the story of two friends; one of them holds on to a traditional job (running a furniture shop) while the other one opts for a financial career.

11. *La parte del león* (1978), *Tiempo de revancha/Time for Revenge* (1981), and *Ultimos días de la víctima/Last Days of the Victim* (1982) were all released during the most recent military dictatorship. These films condense the climate of violence and despair that characterized the average citizen (*La parte del león*) as much as the direct victims (*Tiempo de revancha*) and the victimizers (*Ultimos días de la víctima*) of this social and political maelstrom.

12. Many of the movies that conform to the New Argentine Cinema, starting with the aforementioned *Pizza, birra, faso*, illustrate this inter-generational strife, a meeting point between the film *Nueve reinas* and its contemporaries of the New Cinema.

13. These slogans served as rallying cries for the protestors who marched during the December 2001 crisis.

14. Costumbrist cinema, whether in its dramatic or comedic form, originated in Argentina during the silent film period and was consolidated in the classic-industrial period of cinema during the 1930s-1950s. Folkloric customs, characters and motifs, whether rural or urban, structure the stories that signal the representative areas of the country. The films of José Agustín Ferreya, Franciso Mugica and Manuel Romero (in the period of early sound) and those of Fernando Ayala and Juan José Jusid (in the 1970s and 1980s) contemplate, as Bielinsky proposes in *Nueve reinas*, the customs rooted in family values and hard work in urban and suburban areas.

15. David Bordwell distinguishes the narrative closure designed by the way of institutional representation from the first half of the decade starting from the inscription of an implausible resolution, and the promotion of values cherished by the society and the cinematographic institution (Bordwell 1997: 45).

16. The film includes some instances of audience complicity. Rubén's daughter leaves the country along with Arteche, the owner of the multinatiotal company where she works. In the United States, he keeps up with his fraudulent business.

17. The crisis of December 2001 in Argentina—the result of the dire political and economic situation of the preceding years—caused the resignation of President Fernando de la Rúa on December 20, 2001, and incited a situation of presidential turmoil and vacancy. During the events of December 2001, most of the participants of the demonstrations were independent, not affiliated with any political party or social movement.

18. Directly related to the neo-liberal crisis in Argentina, the repertoire of topics and motifs that this film develops includes the conception of honourable work as a negative value, the consolidation of an individual identity, social disintegration, the proliferation of egotistical behaviour, the disarticulation of the state as a cohesive instrument and social mediator, mercantilism and the growing marginalization of wide segments of the population. The inter-familial relations depicted by the character of Juan and his close social environment are presented as an exception to this social system, even when corruption is also material in this group.

19. They were precisely the film-makers of the 'Generation of the '60s' who exercised in the field of Argentine cinema the first break regarding the adult universe. Paula Félix-Didier and Andrés Levingson locate in those years three aspects that meet in this alteration of established values and patterns: 'the bursting of a culture specifically juvenile, the appearance of new film-makers in their twenties that, in general, question the kind of cinema produced by their elders, and the consolidation of the teenager figure within the visible universe of the Argentine society' (Félix-Didier and Levingson 2005: 91). Following these traits, the cinema produced in the last decade coincides with the renewal of the staff of directors, scriptwriters and actors and in the generalized rejection of the prevailing social agreement of the 1990s.

20. Marcos' arrival at the bank coincides with a series of events that occurred in the year 2001, a time when several banks declared bankruptcy and closed their doors to clients and investors.

21. The off-screen voice of Marcos, out of focus in some of these images, the identification of the spectator with the character of Juan, the use of 'travelling' and the camera movements that capture distinct situations are some of the procedures used in this singular fragment.

22. This song by Rita Pavone alludes to the first anniversary of Juan (who hides his real name, Sebastián) and Valeria. It is normally accompanied by a dance that must be carried out with a beloved person on a unique floor tile, without leaving any marks.

References

Aguilar, G. (2006) *Otros mundos: Un ensayo sobre el nuevo cine argentino*, BuenosAires: Santiago Arcos Editor.

Avaro, N. and Capdevila, A. (2004) *Denuncialistas. Literatura y polémica en los 50*, Buenos Aires: Santiago Arcos Editor.

Bordwell, D. (1997) 'La narración clásica' in D. Bordwell, J. Staiger and K. Thompson (eds.) *El cinema clásico de Hollywood*, Barcelona: Paidós, pp. 3-78.

Félix-Didier, P. and Levingson, A. (2005) 'Jóvenes viejos y el nuevo cine argentino', *Cuadernos de Cine Argentino* No 4, Buenos Aires: Instituto Nacional de Cine y Artes Audiovisuales.

García Jiménez, J. (1996) *Narrativa audiovisual,* Madrid: Cátedra, Signo e Imagen-Manuales.

Gorodischer, J. (2005) 'Fabián Bielinsky, de *Nueve reinas a El aura*', interview with Fabián Bielinsky, *Fotograma.com,* September 15. Accessed September 17, 2009.

Hortiguera, H. and Rocha, C. (2007) 'Introduction' in *Argentinean Cultural Production during the Neoliberal Years (1989-2001)*, Lewiston: Edwin Mellen Press, pp. 1-20.

Reincke, M. (2005) 'Yo no creo en Dios, pero creo en Billy Wilder', interview with Fabián Bielinsky, *Cinemanía*, No 17, August.

Romero, J. L. (2001) *Breve historia contemporánea de la Argentina*, Buenos Aires: Fondo de Cultura Económica.

Shaw, D. (2007) 'Playing Hollywood at Its Own Game? Bielinski's *Nueve reinas*' in D. Shaw (ed.) *Contemporary Latin American Cinema: Breaking into the Global Market*, New York: Lanham, Md: Rowman & Littlefield, pp. 67–85.

Landscape and the Artist's Frame In Lucrecia Martel's *La ciénaga/The Swamp* and *La niña santa/The Holy Girl*

Amanda Holmes
McGill University

In her first two feature-length films, Lucrecia Martel (born 1966) draws attention to spatial order and categorization, either by revising artistic approaches to the portrayal of nature in *La ciénaga/The Swamp* (Martel, 2001), or by the self-conscious representation of cinematic frames in *La niña santa/The Holy Girl* (Martel, 2004). Through a feminist lens that portrays the decadence of contemporary Argentine social structures, the Argentine film-maker counters hegemonic European perceptions of the New World that were never fully reworked to show the space experienced by the colonized.[1] New World spaces represented by European explorers who followed Alexander von Humboldt's natural observations of the nineteenth century, and by Latin American artists, authors and film-makers often trained in Europe, set the landscapes apart from Europe, defining them through a distant regard.[2] Martel's representation of this same space suggests that the New World is 'exotic' only insofar as it is regarded by foreigners. Her self-reflexive filming strategies underscore the constructiveness and the significance of personal perspective in projects of spatial representation especially with respect to Argentine cultural production.[3]

These Argentine films, examples of the *nuevo cine argentino independiente* [New Independent Argentine Cinema] are characterized generally as low-budget projects that consciously create a film aesthetic distinct from that of the 1980s and 1990s. Vitalized by the new 'Ley de Cine' in 1994, and initiated by Alejandro Agresti's *Buenos Aires vice versa* (1996), Martín Rejtman's *Rapado* (1996), and Adrián Caetano and Bruno Stagnaro's *Pizza, birra, faso/Pizza, Beer and Cigarettes* (1997), *nuevo cine argentino independiente* counters certain representational strategies of post-dictatorship cinema such as allegory and non-

realist techniques more common in films by Luis Puenzo, Eliseo Subiela, and María Luisa Bemberg.[4] The new independent film-makers share some traits of the Latin American movement of the 1960s and 1970s—Third Cinema or Imperfect Cinema—which claimed that film should reflect the economic underdevelopment of the region. In an attempt to differentiate between contemporary Argentine film-makers and Third Cinema, Gonzalo Aguilar argues that the New Argentine Cinema consists generally of a 'nuevo régimen creativo' [new creative rules] (Aguilar 2006: 14). These contemporary films are characterized more specifically by their flexible and original narratives that attempt to make sense of a changed world, and their use of non-traditional means for production and screenings.[5]

While much of the financing may be generated internationally—Martel's pieces were funded by Spanish, French, Italian, Dutch as well as Argentine sources—this new cinema reflects and comments on contemporary Argentine subjects. Martel produced her films at the turn of the twenty-first century, more than fifteen years after the Dirty War (1976–1983) in Argentina, and during the breakdown of a political leadership that favoured debilitating capitalist practices. The neoliberal crisis in Argentina came to a head in 2001, at which time access to personal savings accounts was restricted and even frozen, civic unrest resulted in mass demonstrations and supermarket lootings, and the country saw five presidents in only one year. As a result of extreme capitalist policies that allowed for the sale of practically all of Argentine industry and service sectors to foreign buyers, the economy crashed and many Argentines lost their life-long savings. Under the leadership of Eduardo Duhalde, Argentina reneged on its international debt and unpegged the peso to the dollar, both policies that have helped stabilize the economy. To give a statistical example, unemployment, which peaked at 24 per cent in 2002, decreased steadily to only 7.5 per cent in 2008, although the role of the government in adjusting these numbers has been questioned.[6] While the statistics suggest that Argentina is recovering economically, the country and especially the provinces suffered greatly through this turmoil.

Martel's films depict a social and psychological response to contemporary political and economic transformations. Both pieces are recounted through the eyes of female adolescents: representatives of the next generation who face a decadent and complex reality. Leila Gómez maintains that Martel's vision is one of a both socially and geographically marginal world: the protagonists are female adolescents and the settings are provincial Argentina, in the Northwest region of Salta. Gómez hones this designation further to identify four types of marginalization in the films: 'la edad de la adolescencia en familias disfuncionales, la domesticidad del rol femenino, la sociedad provinciana del noroeste argentino y un país venido a menos' [adolescence in dysfunctional families; the domesticity of the feminine role; provincial society in Northwest Argentina; and a country that is run-down] (Gómez 2005: 1). In the case of Martel, this marginalized vision represents not only the outlook of the female provincial adolescent, but the view from a national and identitarian periphery. I claim, furthermore, that these works serve as examples for new

perspectives on spatial categorization and construction: *La ciénaga* responds to cultural antecedents that portray the New World as exoticized landscape, while *La niña santa* defies hegemonic aesthetics for the framing and definition of interior space. In both pieces, the construction of spatial representation reflects questions about the formation of social and personal order in the complexity of contemporary Argentine society.

Perspectives on the Natural in *La ciénaga*

La ciénaga has been highly acclaimed, winning awards at European and Latin American film festivals for director, actors, script, cinematography, sound and, generally, as 'best film.'[7] Crafted skillfully to reflect the oppression not only of the summer heat, of the country's economic and political situation and the insalubrious family lifestyle, *La ciénaga* explores themes that are unique to the geographic periphery of Argentina, but also meaningful in an international context. Far from an image of a wholesome family retreat, this natural setting and the relationship among the film's characters creates a disturbing image of contemporary reality.

The film flashes images of the lives of an urban family who has come to their provincial ranch, La Mandrágora, for a summer vacation. The first scenes move between drunken middle-aged men and women slowly dragging lawn chairs beside an untended swimming pool filled with stagnant water; young boys with rifles running through a wooded mountainous area; and an adolescent girl lying on a bed in the deteriorating house beside another girl who is praying. The girl who prays, Momi (Sofía Bertolotto), moves, crying, to another bed to lie down beside her sister, Verónica (Leonora Balcarce). Some interaction between the characters begins when one of the drunken women around the pool, Momi and Verónica's mother, Mecha (Gabriela Borges), trips, drops her wine glass and falls on the shards of glass. The teens come to her rescue, and Momi, who does not yet have a licence, drives her almost-oblivious mother to the doctor in the closest town, La Ciénaga.

Continuing in the same incomplete and tense style, the narrative depicts interactions between the family that lives in La Ciénaga and their cousins who are staying in the country house. Relationships between characters rarely advance: Momi is upset that her mother has fired her indigenous girlfriend and servant, Isabel (Andrea López); the two mothers plan a trip, that never materializes, to Bolivia to buy school supplies; the youngest boy from La Ciénaga, Luciano (Sebastián Montagna), joins the other boys in their dangerous hunting escapades in the mountains; brother, José (Juan Cruz Bordieu), and sister, Verónica, flirt with each other. In his analysis of the film, Aguilar emphasizes the shifts in plot that dominate *La ciénaga's* narrative structure. Relationships that first involve Mecha and Momi centre next around Tali, then around José, to finally concentrate on Luciano (Aguilar 2006: 29, 49). The pieces that construct Luciano's narrative

conclude the film. Afraid of the African dog-rats, described by Verónica in a story she tells her siblings and cousins, young Luciano climbs the ladder in his backyard to see the neighbour's dog who is barking on the other side of the high wall. He falls off the ladder and dies. This final episode tragically concludes the disquiet of the anticipation that has been building from the beginning.

An uncaring passivity characterizes for the most part the relationship between the generations, suggesting that this attitude permits the perpetuation of a vacant lifestyle. The landscape clearly reflects and even influences these characteristics: the wooded mountains hide danger and violence; the oppressive heat and the stagnant water of the swimming pool point to an inactivity that leads to decay. By delineating the landscape through the cultural lens of the dysfunctional family, La ciénaga leads to a new perspective on nature framed through art. The filmed spaces reflect a disturbing vision of a decadent contemporary Argentine society that lacks the potential to advance, and only barely sidesteps annihilation by the imminent dangers that lurk there.

Martel's film concurs with the cultural geographer's definition of landscape as interrelated with a 'human investment toward space' (Lefebvre 2006: xiii). While 'nature' exists independently of human intervention, 'landscape' is framed by interpretation and defined by culture.[8] Martel expresses an awareness of the distinction between 'environment' and 'landscape' when she claims in her director's statement about La ciénaga that she refuses 'to accept the commonly held romantic idea that nature rhymes with harmony'. She, therefore, chooses not to represent landscapes as 'picturesque', but rather depicts the surroundings as 'neither pleasant nor welcoming'. Indeed, to draw attention to the centrality of spatial categorization and perception, the film is framed by landscape scenes. The first stills of La ciénaga recall framed paintings of landscape— palm trees shadowed by the sun in the background—or still life—red bell peppers drying on a balcony. When the camera moves into the house, it captures first a window that frames the light outside, and then, significantly, a landscape painting that hangs on the wall. The film also concludes with still shots of the settings, from the series of stills of Tali's home after Luchi falls from the ladder, to the final still of the mountains during stormy weather. This final frame closes the film's spatial argument; far removed from a notion of paradise-like beauty, this landscape has been revised so completely during the film that it now disturbs the viewer with the eeriness of what it conceals.

A striking contrast is drawn between the unruly and chaotic behaviour generated by the exterior settings—the jungle, the dike and the provincial city—and the dramatic passivity, almost despondency, evoked by the country house and pool. The adolescents penetrate the jungle with their rifles, recalling the European conquest of the New World: they move through the forest with uneasy determination; they attempt to dominate their surroundings with their weapons; they mistreat the indigenous boys who accompany them in their expeditions. Martel's construction of the jungle sets these images apart from notions of European domination. A comparison between European portrayals of the Latin

American jungle in German films like Werner Herzog's *Aguirre, Wrath of God* (1972) and *Fitzcarraldo* (1982), which reconstruct colonial projects, and *La ciénaga* evokes striking contrasts in filming strategies and perspectives. Instead of a representation on canvas, Herzog filmically paints a desired landscape of New World nature. As Issa María Benítez Dueñas has observed, regarding the reasons for painting landscapes, 'a landscape is painted precisely because it cannot be possessed; it is painted because it is desired' (Benítez-Dueñas 2003: 76). These notions of possession and desire, so central to the European conquest of the Americas, emerge continually in Herzog's contemporary portrayal of the Peruvian and Brazilian jungle. Indeed, the repeated conquest inherent in the production of these films— the on-site filming, the use of indigenous peoples from the region as actors, the destruction of a section of the rainforest to actually haul across a boat—are discouraging if one expects a more enlightened relationship between Europe and the post-colonial New World.[9] In the initial scene of *Aguirre*, the colonizers march single-file with their indigenous servants into a wooded valley of the New World. The camera pans across from above, amplifying the concepts of domination and conquest inherent in this movement through a natural setting. Both of Herzog's films contain lengthy scenes of the European protagonist standing on a boat on the Amazon nervously, but proudly, observing his coastal surroundings. The camera controls nature by framing it into landscape; the protagonists impose themselves on nature through the power of their weapons.

Through Martel's lens, the emotions of awe, fear and desire inspired by Herzog's panoramas are replaced by disquiet and unease. As a contemporary woman film-maker from Argentina, Martel's version of this environment is more intimate: the camera follows the group of children closely through the brush, recording tensions, threats and immature behaviour. These adolescents conquer their surroundings unaware of, uncaring about, or unresponsive to the dangers they pose to each other: Joaquín points his gun directly at his sister, Momi, and seems to consider shooting her before moving on; Luchi steps in front of the boys who have their rifles ready to shoot a cow that is stuck in the mud. The uneasiness never evolves into a desire for possession but, rather, records cruel racial hierarchies, physical injuries—Joaquín (Diego Baenas), the youngest of Mecha's children, lost an eye in a hunting accident—livestock dying in agony, and almost impenetrable undergrowth.

Evoking a similarly disturbing atmosphere in both the dike scene and the construction of the provincial city, Martel presents a series of disconcerting images which implicate dangers, but never create a comprehensive view of the entire setting. While the camera depicts a clear close-up of the children in the water, the dike as a whole is never portrayed. As in the jungle setting, the adolescents behave with a perilous disrespect during the trip to the dike: the boys abruptly beat the water with their machetes to catch fish in the midst of the group of teenagers; they play by the dike that suddenly propels water onto the adolescents. When the current of water blasts onto the youths, it sounds like a forceful rainstorm, rather than the water from the dike. Only at this point does the camera move

back far enough to represent a sense of the location—a filming strategy that serves to emphasize the uneasiness of the scene. The dike, never portrayed in its entirety, remains an unclear space. Similarly, La Ciénaga is only depicted during carnival—the adolescents run through the town throwing water balloons or drink and dance at a crowded open air carnival event. In one early scene, the intensity of the bus traffic along with a proliferation of signs and advertisements create a colourful, but chaotic portrayal of urban space.

The middle-class Argentines share many exterior spaces and forms of entertainment with their indigenous counterparts. The hunting expeditions in the jungle, the fishing in the dike and the carnival activities in the city are all shared by both social groups. While the lower classes are expected to serve their employers inside the homes, social roles are not as explicitly defined in the exterior spaces. The adolescents share in the outdoor activities together, but the middle-class youths repeatedly emphasize their upper-hand in the social structure. After the dike scene, Joaquín—out of sight and earshot of el Perro—throws to the curb the fish that the Indian boy has handed him, claiming that he would never eat this garbage. Isabel, who trails behind the family on their way back to the house, shocked and offended, picks up the fish that Joaquín threw aside and apparently cooks it for the family for dinner. An almost explicit analogy develops between the 'indios' and dogs: Joaquín comments that the 'indios' live and fornicate with the dogs; the oldest indigenous boy portrayed in the film, Isabel's boyfriend, is called 'el Perro' (Mario Villafañe). These racial divisions and tensions arise also in the unruly urban scenes of La Ciénaga: there, el Perro is taunted by Vero and Momi in an early episode at a clothing store and later—in the open-air carnival festivities—beats up José who has been flirting with Isabel (el Perro's girlfriend). The exterior spaces that allow for the possibility of easing racial and social hierarchies in fact exacerbate the tensions. Sharing the spaces creates a need on the part of the white adolescents to stress their position of power in the relationship.

The exterior settings contrast with the despondency related to the portrait of the country home. By locating the characters around a swamp-like swimming pool and a sombre house, the film portrays an oppressiveness in which the characters reflect the setting and the setting reflects the relationships among and the depressed attitudes of the characters. The illumination of the spaces in the deteriorating house oscillates constantly between light and dark: window shutters and hanging lamps swing to and fro; curtains flutter in the wind creating uncanny shadows in the interior. For the most part, the characters are shown lying in bed or sitting around the pool. After her poolside accident, Mecha slouches in her bed during the day with the lights off, wearing her dark sunglasses. Momi lies next to Isabel and then beside Vero in the first scenes; José lies down beside Mecha; Vero lies down with José. In their passive attitudes, the characters reflect the heaviness of the summer air and seem to merge with the decrepit setting of the house.

By evoking and constructing a leitmotif around the sighting of the Virgin in the area of La Ciénaga, these filmic landscapes interrogate the religious conceptions of New World space from the first incursions of the Europeans. This news item plays in the

background of several scenes to recount the hoped-for introduction of the spiritual into this provincial setting: the Virgin surfaces in an environment that begs for her saviour. While rumours of the sighting of the Virgin recur on television, or in comments between characters, her vision is only ever confirmed third-hand. However, Tali and Momi seem to wish that the rumours were true—an attitude that betrays the spiritual dissatisfaction of these two characters. The entrance of the Virgin offers optimism for an end to the vacancy, stagnation, and violence of their lives. Tali enthusiastically recounts to Mecha the clarity of the Virgin's appearance as she has heard it from a neighbour. At the beginning of the film, Momi, the most soulful of the adolescents, is praying; in the final scenes Momi seeks out the Virgin, but admits, disappointedly, '*no vi nada*' [I did not see anything].

The role of religion in the history of landscape art serves as a further explanation for the religious references in the film. Lucidly expressed by Benítez-Dueñas, to paint landscapes the artist has had to change his or her perception of the surroundings in order to represent a 'painting/window charged with its own values' rather than a 'product of some religious affiliation' (Benítez-Dueñas 2003: 76). During the Middle Ages, the Garden of Eden myth remained 'more real' than the natural environment, and landscape painting was 'more an act of prayer than an act of perception' (Ibid: 75). After landscape art first emerged with the work of sixteenth-century century Flemish artists such as Joachim Patinier, the development of the genre required a change in approach from the Medieval era: 'Man had to lower his gaze towards earth, for although nature is, indeed, all around us, landscape can only be born of an urban regard cast from afar, upon what is no longer one's workplace' (Ibid: 76). This enlightened transition from the religious to the personal was reflected in the portrayal of the New World from the accounts and representations of European colonial settlers to those of the natural scientists of the nineteenth century.[10] Latin American space was exoticized both by nineteenth-century European artist-explorers such as Johann Moritz Rugendas and Frederick Catherwood, who travelled to the New World, and Latin American artists who often trained in Europe and were influenced by movements such as Impressionism and Surrealism.

Defying hegemonic artistic norms and approaches to knowledge inherited from Europe, Martel instead represents her own understanding of the New World environment. That the sighting of the Virgin is recounted principally on television is one way in which spirituality is contrasted directly with science (represented by technology). While Aguilar finds irony in the representation of the Virgin on television, arguing that, here, television becomes both '*la productora de creencia y de una nueva religión*' [the producer of belief and of a new religion] (Aguilar 2006: 32), also ironic is the location of the sighting: on the roof of a house beside a water tank, a manmade object used to control and contain the water used in the house. With this spatial metaphor, Martel underscores the unsatisfactory results of both the religious and scientific means for making sense of the world. In *La niña santa* (2004), Martel revisits the conflict between religion and science

in order to liberate herself to express her perspective on this contemporary New World space. Ever self-conscious of representational frames, *La niña santa* again records the artistic process for overcoming religious and scientifically-defined spatial categories.

Structural and aesthetic frames in *La niña santa*

After the success of *La ciénaga*, Martel's second feature film was part of the official Cannes selection in 2004 and was chosen by the *New York Times* as one of the ten best films debuted in 2005. *La niña santa* contains certain playful connections to *La ciénaga*: a doctor in both films has the name Jano, and the adolescent protagonist, Amalia (María Alche), searches for spiritual meaning as if continuing Momi's failed attempt in *La ciénaga*. A dance scene as well as the high-pitched excited screams of adolescents in several instances of *La niña santa* also recall the former film. The plot revolves principally around Amalia, the 'holy girl,' and her youthful interpretation of her religious calling to save a medical doctor who has groped her. The doctor is attending a conference at her family's hotel in Salta, and Amalia's quest is contrasted by the presence of myriad doctors at work discussing medical treatments. Amalia and her close friend and cousin, Josefina (Julieta Zylberberg), with whom she attends the Catholic youth group meetings, spend much of their time together discussing their spiritual vocations and exploring their sexuality. While Amalia pursues Dr. Jano (Carlos Belloso), this doctor and Amalia's mother, Helena (Mercedes Morán), are attracted to each other and begin their acquaintance through a hearing test that the doctor performs on Helena. Amalia swears Josefina to secrecy when she confides in her about her passion and quest, but Josefina, in trouble with her mother, finally blurts out Amalia's sexual incident. Dr. Jano's family arrives to spend the last days of the conference with him, and the film ends after Josefina's mother has reported the groping of Amalia, immediately before the public announcement of the incident.

While nature is 'framed' by the lens of the camera and constructed into landscape in *La ciénaga*, almost every film frame in *La niña santa* is outlined self-consciously again by architectural elements of the decadent provincial hotel. A door or window frame, a piece of a wall or a screen all serve as borders for the scenes in this film. The action may occur within this frame, but often key actors in the scene are talking off-screen, a technique that emphasizes even more completely the process of scenic construction for the production of this film. Even the name, Jano, is borrowed from the two-faced mythical figure, protector of thresholds and doorways.[11]

The fact that the film is set in a hotel generates questions for the definition of 'private' interior and 'public' exterior spaces. From a feminist perspective, the blurring of these boundaries creates new categories for the gendered dominance of different spatial spheres. Helena and her brother Freddy (Alejandro Urdapilleta) are the hotel owners,

but the hotel is really managed by Mirta (Marta Lubos), the administrator. Indeed, as Leila Gómez has shown, although Helena thinks she is in charge of the hotel, she and Freddy act like children in comparison to Mirta, who even advises Helena on her personal life (Gómez 2005: 5). Helena and Freddy also live in the hotel, merging the home (the private woman's sphere) with the space of work (the public man's sphere).[12] For her part, Amalia, often accompanied by Josefina, spends her days roaming freely around the hotel, swimming in the pool, spying on guests, hanging out in the laundry room, and eating in the restaurant. Clearly an unusual lifestyle, Josefina's mother gossips that Amalia '*necesita una casa, un hogar*' [needs a house, a home], although she qualifies this with a comment on Amalia's mother, '*Helena se crió en un hotel. Para ella es muy normal.*' [Helena was raised in a hotel. It is normal for her.] Far from having private space for herself, Amalia shares a bed with her mother in their room of the hotel, and her uncle Freddy pushes Helena and Amalia aside to lie down with them for the night as well.[13]

To complicate the distinctions between male and female spheres even further, during the time frame of the film, rather than serving as temporary home for vacationers and travellers, the hotel is hosting a business meeting of professionals. Public and private spaces conflate here, as the doctors not only pursue professional contacts, have formal meetings and dinner gatherings, but also share living quarters with each other. Indeed, when Dr. Jano first arrives, a private room is not yet available for him in the hotel, and he reluctantly agrees to share one with a colleague. Later, he is not left alone even in his own room: the maid is shown cleaning his space, and Amalia sneaks in to examine Dr. Jano's living quarters.

On the other hand, the fact that Amalia lives in a hotel allows her a large area to explore and in which to feel comfortable. Amalia is a product of this environment, her identity crafted by the badly-maintained surroundings. This comfort is expressed filmically as an intimacy with the structures of the hotel. In an almost sensual attitude with the elements of the building, Amalia's hand touches the wall of the hallway as she moves silently through it, or the camera films her lying down on a pile of towels in the laundry room or fingering furniture in the guests' rooms. Her movements exemplify Giuliana Bruno's observation in *Atlas of Emotion* concerning the haptic nature of both cinema and architecture: 'In their fictional architectonics, there is a palpable link between space and desire: space unleashes desire' (Bruno 2002: 66). The intimacy evoked in the touch of body and building enhances the representation of her adolescent desire. Her appearance in the building becomes uncanny, especially for Dr. Jano who starts to dread her presence. As if by a ghost, the hotel is haunted by the provincial Argentine adolescent.

For Dr. Jano, the comfort and familiarity of the hotel, the '*heimlich*' or home-like feeling of this temporary home, becomes definitively '*unheimlich*' or un-homely (uncanny)— following Freud's definition of the term from his essay 'The Uncanny' (1919)—because of

the presence of Amalia. The safe 'familiar' adolescent object of Jano's sexual desire returns and controls the gaze, now gaining authority over and disturbing the doctor in this space. While the plot and character development evoke a disquiet, the uncanniness of the art of photography and, by extension, film, often leads to the exploitation of this sensation to call attention to the artistic constructiveness of the moving image.[14] German Expressionist films such as F. W. Murnau's *Nosferatu* (1922), Paul Wegener's *The Golem* (1920) and Robert Wiene's *The Cabinet of Dr. Caligari* (1920) exemplify an early and more stylized representation of this cinematic self-reflexivity.[15] These films represent manmade inanimate objects that become animate, the dead that becomes un-dead, or the magic of the moving picture itself; all images of artistic creation depicted within the artwork of the film.

It is not surprising, therefore, that Martel employs self-conscious imagery of artistic creation to parallel the sensation of the uncanny evoked in *La niña santa*. Carefully selected camera angles promote the sensation of a subjective framing of the scene's events, calling attention not only to the personal nature of the analysis of experience but also to the notion of artistic creation as a controlling process through which to represent concepts of reality. Characters are filmed from below, or in extreme close-ups of the ear or cheek. In some scenes, the camera has captured only the characters' torsos. Even more disconcerting are the scenes in which the main action occurs outside the frame of the camera lens: at different moments, Helena and Mirta are almost out of the scene while they are obviously speaking to another character who appears on screen; Dr. Jano in the telephone booth is almost completely out of the camera's eye. The appearance of certain characters is often also obstructed by some sort of screen, an obfuscated window or glass door. In Josefina's apartment, the naked neighbour, who suddenly falls from the second storey onto their patio, emerges embarrassed from behind a white voile curtain—fodder for the adolescents' Catholic imaginations—into the room. In this incident, the viewer first hears a loud noise before the camera focuses on the window with the curtain from behind which the man walks into the living room. Similar obfuscations behind screens occur with Josefina behind the whitened glass shower stall while her mother talks to her, and with Amalia behind a translucent plastic screen beside the hotel pool. In this instance at the pool, Amalia's shadowed image sneaks to the edge of the screen and taps with a key on a metal post while peeking out at Dr. Jano in the pool.

Still another means of emphasizing the frames that define the artist's vision, Martel focuses the camera on architectural elements of the hotel that serve as frames within that of the camera's lens. In many instances, door and window frames surround a scene; the elevator scenes outlined by the moving cubic frame emphasize this point. However, two scenes stand out as prominent examples for their accumulation of frames within frames: when the doctors give Helena a hearing test; and when Dr. Jano calls his family from the phone booth. In the case of the hearing test, Helena is seated in a small sound-proofed room with a window that separates her from the doctors. She listens through her headphones to the words pronounced for her as the doctors test her hearing. In this

scene, the camera is positioned first behind yet another frame, that of the doorway onto the hall. It moves to the interior to shift between a focus on Helena through reflections on the glass window and the face of Dr. Jano listening to the test. Therefore, the frame of the camera lens is framed once by the doorway and then again by the interior window, which presents an unclear image of Helena, hazy because she is superimposed by reflections on the window.

Similarly, a series of architectural elements of the hotel compound to form a sequence of frames during Dr. Jano's phone conversation with his son. Dr. Jano, who speaks from inside a wooden phone booth in the hallway of the hotel, is first filmed in this scene from outside the phone booth behind a partial divider—an architectural detail, made of small glass windows. The perspective of the scene shifts to inside the phone booth with the doctor to turn outward from his perspective into the hall, in which the viewer sees Amalia climbing up the stairs past the moving elevator in her bathing suit. A large dark wooden slab, part of the phone booth, cuts the image in half, as the camera captures Dr. Jano's anxiety over seeing Amalia while he speaks with his family. Frames, therefore, explicitly represent the different perspectives of the characters on the situations, as well as self-reflexively serve as a comment on the subjectivity of filmic and artistic vision.

While the film questions the capacity of the senses to organize and understand reality—both the sense of hearing with the example of Helena and of sight with the series of obfuscations constructed by the filming positions and screens—it also explores the possibilities of religion and science to categorize and comprehend these surroundings.[16] Amalia seeks self-definition in her Catholic group that she attends with her friend Josefina. Despite her mother's disapproval, while Amalia watches the happenings in the hotel, she sings hymns or recites passages of the Bible to evoke the Virgin Mary to 'save' Dr. Jano. Indeed, it is immediately following a meeting of the Catholic group that Amalia is first groped by the doctor. Notably, in this instance, they have gathered around a theremin player to listen to the music.

The theremin or thereminvox, one of the first electronic instruments, invented in 1919 by the Russian Léon Theremin, produces music through electric signals controlled by the musician. Because the electric currents are invisible, it appears as if the musician were magically creating sounds by touching the air above the instrument. Moreover, the sound of the instrument evokes an other-worldliness that has made it attractive for use in science fiction films. Aguilar notes the attention paid to this particular element of the film in that Martel hired a professional musician for the role—Manuel Schaller, apparently the best theremin player in Argentina—rather than an actor (Aguilar 2006: 97). In separate articles, Viviana Rangel and Joanna Page interpret the contrast between an emphasis on the (lacking) touch in Jano's sexual approach and this instrument that is played without touch (Page 2007: 16; Rangil 2007: 216).[17] For her part, Martel claims that she wanted to create a tension during the sexual encounter without explicit drama or over-acted gestures. The music of the theremin merges the spiritual and the

scientific perspectives of Amalia and Jano respectively; the strange sounds appeal to the spiritual, while the performance of the instrument involves the scientific understanding of electricity. Not only does the theremin music serve as the background for the sexual imposition by Jano on Amalia, but also as the music for the interaction between Jano and Helena during the dinner.

As Ana Forcinito has argued, Helena and Amalia contrast the religious and the scientific perceptions of the world in their involvement with Dr. Jano. While Amalia plays the holy girl in her quest with respect to the doctor, Helena becomes the patient of the doctors, agreeing to serve as an example in a role-play the doctors intend to perform on the final evening of the conference. Forcinito underscores the patriarchal nature of these two approaches, as well as Amalia's unique sexual interpretation of her 'calling' (Forcinito 2006: 9). Amalia's adolescent understanding of the concept of religious vocation leads her to confuse her sexual desire with her spirituality, an analysis that amounts to a personal subversion of religion. For her part, Helena happily consents to the hearing test, although she shows discomfort during the testing scene, and seems more interested in the project for the possibilities of sexual fulfillment than for the medical results of the tests.

From their location in this provincial hotel, the sexual desires of Helena and Amalia cause them to move beyond the hermeneutic constraints of science and religion defined by male hegemonic approaches. The revision of filmic frames highlights this shift in emphasis, and suggests an artistic perspective that redefines spatial categories. By underscoring the significance of perspective in artistic construction through the revision of the New World landscape in *La ciénaga* and through self-reflexive frames in *La niña santa*, Martel also points to her awareness of the location of her subject in the provincial Argentine setting—considered the periphery of the already 'peripheral' Buenos Aires, to use Beatriz Sarlo's terminology with respect to the unfinished project of modernity defined as hegemonic European culture. It is only appropriate that, to construct credibility, the marginalized voice of the Argentine woman film-maker who represents the experience of adolescents in this provincial environment would exploit filming techniques to highlight her subject position. Only by calling attention to the subversion of hegemonic strategies for the portrayal of landscape or to the re-visioning of the perception of architectural space through the lens of the camera can Martel overturn the artistic crafting of settings based on male European models. Rather than exotic, these contemporary Argentine spaces are imbued with a disquiet that develops from an unfulfilled desire to find existential meaning there. The complexity of this experience remains unresolved by religious or scientific analyses, but seeks comprehension in the revision of perspective and the generation of a more complete understanding of culture.

Notes

1. See Leila Gómez (2005) and Ana Forcinito (2006) for an analysis of the feminist aspects of Martel's films.

2. According to Mary Louise Pratt, Alejo Carpentier's 'marvelous realism,' along with the expression of other Boom authors, betrays a New World vision that does not veer from a European perspective underscored by Humboldt (Pratt 1992: 191, 196). Pratt goes so far as to claim that 'Carpentier is playing Humboldt's role, occupying his discourse, as blithely as if no history separated them at all' (Ibid:196).

3. For a discussion of spatial representation in film, and of the similarity between the artistic production of film and architecture, see, especially, Mark Lamster (ed.) *Architecture and Film* (2000); Martin Lefebvre (ed.) *Landscape and Film* (2006); and Juhani Pallasmaa, *The Architecture of Image: Existential Space in Cinema* (2001).

4. In the Introduction to *Generaciones 60–90*, Fernando Martín Peña (2003) discusses this new law in some detail before also chronicling and categorizing Argentine films from the late 1990s and early 2000s. Also, see Gonzalo Aguilar (2006) for a detailed interpretation of the characteristics of 'nuevo cine argentino.'

5. Aguilar reviews the list of traits he has identified in New Argentine Film: 'transformar las relaciones entre producción y estética, segmentar la elaboración del film para financiarlo, inventar modos no convencionales de producción y exhibición, acudir a las fundaciones internacionales, lograr el reconocimiento del INCAA y de la crítica, reclutar y formar nuevo personal artístico-técnico, instaurar un modo novedoso de hacer *casting*, evitar la 'bajada de línea' rechazando la demanda política y la identitaria, construir narraciones abiertas que puedan incluir lo accidental, retratar a personajes fuera de lo social, competir con otros medios en la producción del lo real, procesar el impacto de los cambios de un mundo que ya no es el mismo' [transform the relationship between production and aesthetics; divide film production into sections in order to obtain financing; invent non-conventional means for production and exhibition; turn to international foundations able to gain recognition from INCAA and critics; recruit and educate new artistic and technical professionals; introduce a new means for casting a film; reject political and identitarian demands that would result in the 'lowering of the bar'; construct open narratives that can include the accidental; portray characters outside the social norm; compete with other media in the production of the real; process the impact of changes in a world that is no longer the same] (Aguilar 2006: 37).

6. These statistics are from *Latin Focus*: http://www.latin-focus.com/latinfocus/countries/ argentina/argunemp.htm. (Accessed September 14, 2009). *Index Mundi* records the change as 21.5% in 2003 as compared to 8.5% in 2008: http://www.indexmundi.com/ argentina/unemployment_rate.html. (Accessed September 14, 2009). An analysis of these statistics should take into account that Instituto Nacional de Estadística y Censo (INDEC) has been accused recently of adjusting the unemployment rate in the government's favour. The article by Mariano Martín, in the Buenos Aires newspaper, *El país*, acknowledges some of the complications and inconsistencies regarding unemployment figures (not accounting for subemployment, and not including those who have given up searching for employment). Martín also reports that unemployment figures reached over 24% in 2002, but have decreased steadily since then until the second quarter of 2009 in which they rose to 8.8%: http://criticadigital. com/index.php?secc=nota&nid=28411. (Accessed September 14, 2009).

7. The film won awards in the Berlin International Film Festival (2001), the Havana Film Festival (2001), and the Toulouse Latin American Film Festival (2001). Martel won the Silver Condor for Best First Film from the Argentinean Film Critics Association (2002).

8. In separate studies, Simon Schama (1995), Denis Cosgrove (1984) and W. J. T. Mitchell (1994) discuss the influence of culture and ideology on the perception of nature and its construction into landscape.

9. See Lutz P. Koepnick (1993) for his article on the filming of Herzog's films. Also in the documentary film, *Burden of Dreams* (1982), Werner Herzog describes the 'making-of' *Fitzcarraldo*.

10. See the collection of essays by Jorge Cañizares-Esquerra (2006) on the importance of the New World for the development of the natural sciences.

11. Both Gonzalo Aguilar (2006) and Ana Forcinito (2006) discuss the mythological aspects of *La niña santa*.

12. These gendered categories of spatial configuration have been called into question in recent years. One of the most cogent criticisms is that the traditional role of woman in the home is to serve the man; therefore the so-called female sphere was in fact designed for the man's peace of mind.

13. As Joanna Page aptly argues, following contemporary discussions of the political nature of the personal, the private sphere in Martel's films becomes a political space

that opens up the possibility of generalized social commentary through her films (Page 2007: 165). This revision of the meaning of political and spatial categories is stressed explicitly in the merging of public and private in the space of a hotel.

14. In one chapter of *The Uncanny* (2003), Nicholas Royle interprets the disquiet evoked by the animated picture.

15. See Steven Jay Schneider's *Horror Film and Psychoanalysis* (2004) for a discussion of the use of the uncanny in film.

16. The use of sound in the film has been analysed thoroughly by Gonzalo Aguilar (2006: 97–105).

17. Page observes further that Dr. Jano's colleague exclaims 'No toca nada, nada' with reference to the theremin player ironically at the same time that Jano is running from Amalia (Page 2007: 161–2).

References

Aguilar, G. (2006) *Otros mundos: un ensayo sobre el nuevo cine argentino*, Buenos Aires: Santiago Arcos Editor.

Benítez-Dueñas, I. M. (2003) 'Paradise Lost? Contemporary Landscape in Latin America' in D. M. Gerson (ed.) *Paradise Lost: Aspects of Landscape in Latin American Art* (Trans. Ricardo Armijo), Coral Gables: University of Miami, pp. 75-8.

Bruno, G. (2002) *Atlas of Emotion: Journeys in Art, Architecture, and Film*, New York: Verso.

Cañizares-Esguerra, J. (2006) *Nature, Empire, and Nation: Explorations of the History of Science in the Iberian World*, Stanford: Stanford University Press.

Cosgrove, D. E. (1984) *Social Formation and Symbolic Landscape*, London: Croom Helm.

Forcinito, A. (2006) 'Mirada cinematográfica y género sexual: mímica, erotismo y ambigüedad en Lucrecia Martel', *Chasqui* 35.2: 109–21.

Gómez, L. (2005) 'El cine de Lucrecia Martel: La Medusa en lo recóndito', *Ciberletras:* 13.

Koepnick, L. P. (1993) 'Colonial Forestry: Sylvan Politics in Werner Herzog's *Aguirre* and *Fitzcarraldo*', *New German Critique: An Interdisciplinary Journal of German Studies* 60: 133–59.

Lamster, M. (ed.) (2000) *Architecture and Film*, New York: Princeton Architectural Press.

Lefebvre, M. (ed.) (2006) *Landscape and Film*, New York: Routledge.

Martel, L. (2004) *La niña santa,* Screenplay by Lucrecia Martel.

Martel, L. (2001) *La ciénaga,* Screenplay by Lucrecia Martel.

Martín, M. (2009) 'El Gobierno reconoció más desempleo,' *El País*, http://criticadigital. com/index.php?secc=nota&nid=28411. Accessed September 14, 2009.

Mitchell, W. J. T. (1994) *Landscape and Power*, Chicago: University of Chicago Press.

Page, J. (2007) 'Espacio privado y significación política en el cine de Lucrecia Martel' in V. Rangil (ed.) *El cine argentino de hoy: entre el arte y la política*, Buenos Aires: Biblos, pp. 157–68.

Pallasmaa, J. (2001) *The Architecture of Image: Existential Space in Cinema*, Hömeenlinna: Building Information Ltd.

Peña, F. M. (2003) *Generaciones 60/90: cine argentino independiente*, Buenos Aires: Fundación Eduardo F. Costantini.

Pratt, M. L. (1992) *Imperial Eyes*, New York: Routledge.

Rangil, V. (2007) 'En busca de la salvación: sexualidad y religión en las películas de Lucrecia Martel' in V. Rangil (ed.) *El cine argentino de hoy: entre el arte y la política*, Buenos Aires: Biblos, pp. 209–20.

Royle, N. (2003) *The Uncanny*, New York: Routledge.

Schama, S. (1995) *Landscape and Memory*, New York: Vintage Books.

Schneider, S. J. (2004) *Horror Film and Psychoanalysis: Freud's Worst Nightmare*, Cambridge: Cambridge University Press.

Transactional Fiction: (Sub)urban Realism In the Films of Trapero and Caetano

Beatriz Urraca
Widener University

A new cinema for a new Argentina

> 'Eso se acabó, se terminó eso, no existe más.'
> *Un oso rojo*

The artistic production of Argentine film-makers immediately before, during and after the 2001 collapse of the nation's economy provides insight into the cultural developments and social repercussions surrounding the crisis. With a self-avowed disinterest in either being faithful to reality (Bernades 2002) or re-examining the foundational moments of national history (Fuster Retali 2002), Pablo Trapero and Israel Adrián Caetano examine the consequences of displacement among the marginalized and disenfranchised working class in the Greater Buenos Aires metropolitan area. Along with contemporaries who are also part of a 10-year-old informal phenomenon known as the New Argentine Cinema,[1] these directors are creating a unique audio-visual language that responds to Argentina's need to look at itself and redefine its twenty-first century identity with tools other than the neohistorical and social protest themes that characterized much of the literary and filmic production of the preceding decades.

Recent patterns of globalization have transformed the historical identification of the city of Buenos Aires with the great metropolises of Europe into a more fragmented imagery with links to the rest of Latin America and to the conflicted post-industrial,

post-colonial suburban belts of modern Europe. Though grounded in the specificity of the place and historical moment they portray, the films of Trapero and Caetano share a focus on the sordidness and desperation of those living in the more marginal urban-sprawl environments all over the world. They consciously depart from the aesthetics and ideologies of the 'New Latin American Cinema' of the 1960s and 1980s, which had been a two-part multinational and transcultural movement that challenged Hollywood's hegemony, in favour of 'a marginal, politicized, often clandestine cinematic practice that... managed to change the social function of the cinema in Latin America' through its commitment 'to the sociopolitical investigation and transformation of the underdevelopment of' the continent (López 1990: 309–11). Its best-known example in Argentina may be *La historia oficial/The Official Story*, a film whose polished aesthetics and reliance on the star system to denounce the military repression of the 1970s won director Luis Puenzo an Oscar for Best Foreign Film in 1986. However, despite critical claims stating the absence of politics in the new cinema (Quintín 2002: 113; Fontana n.d.: n.p.), it is disingenuous to say that these film-makers have no intention of transforming social conditions when recording images and stories that are uniformly violent, unpleasant and hopeless.

Caetano has emerged as one of the leaders of the new style. His first feature film, entitled *Pizza, birra, faso/Pizza, Beer, Cigarettes,* co-directed with Bruno Stagnaro in 1997, is said to have 'changed the course of current Argentinian cinema' (Kantaris 2003: 183). This film focuses on the lives of the marginalized youth of Buenos Aires; its raw portrayal of contemporary Argentine urban society conveys an appearance of realism that made it possible, and even fashionable, to tell stories differently. After *Pizza, birra, faso* it became acceptable to justify, and even glorify as purely artistic, decisions that were dictated by economic considerations: the use of nonprofessional actors; a fluid script that adapts to rather than shapes filming conditions; a hand-held camera that appears to record sights and ambient sounds indiscriminately; a weakened *mise-en-scène*; and nearly nonexistent postproduction. The film's success opened the door for Caetano and his University of Cinema Foundation schoolmate Pablo Trapero to direct a series of four films about single men dealing with situations of displacement such as migration and parole. Trapero's *Mundo grúa/Crane World* (1999) and Caetano's *Bolivia* (2001) make the best of economic conditions similar to those in which *Pizza, birra, faso* was created. However, both directors deliver a much more ambitious product in *El bonaerense/The Policeman* (Trapero, 2002) and *Un oso rojo/A Red Bear* (Caetano, 2002) as greater resources became available. These four films are similar in the utilization of themes, settings, techniques and a filmic discourse that contributes to reflecting modes of social interaction defined by the precarious and the temporary, the transactional and the contractual. The visual images that create such settings are dominated by traffic, billboards and store signs even as the soundtracks' tangos, *cumbias* and Andean *quenas* [pan flutes] periodically remit us to the artificial nostalgia of simpler times and more intimate places. Meanwhile, the

characters' lives are fuelled mainly by the need to acquire the next meagre paycheck and, in the process—whether at the end of the day or at the end of the film—they often find themselves back where they started.

In *Mundo grúa*, Trapero opts for a black-and-white aesthetics and an emphasis on nostalgia which evoke the Italian neorealism of the 1950s (Beceyro et al. 2000: 1–2; Wolf 2002: 38; Kantaris 2003: 179). The camera follows the daily struggle of Rulo, a divorced, middle-aged former musician forced by the economic depression of the 1990s, to bounce from one job to another, from one defeat to another. During the first part of the film, Rulo learns to operate a crane at a construction site in Buenos Aires' industrial belt. After he fails to pass the physical examination required to keep his job, his friend Torres convinces him to move to the Patagonian city of Comodoro Rivadavia to work temporarily as a bulldozer operator. These employment prospects fail as well when the company is unable to pay the workers. At the end of the film, Rulo finds himself en route, presumably back to Buenos Aires and to an uncertain future. *Mundo grúa* was followed by a full-colour feature entitled *El bonaerense*, a film that takes suburban neorealism to the next level by exploring the initiation of Zapa, a young petty delinquent from the provinces, into the metropolitan police force, known locally as 'la Bonaerense'. Zapa's quiet, submissive demeanour and rural naïveté make him an ideal target for his crooked superiors to involve him in more serious degrees of criminality. He returns to his village at the end of the film, his spirit broken by the corrupt environment that had engulfed him and his body damaged by a gunshot wound to the leg inflicted by his own Commissioner in an attempt to make a thief's cold-blooded execution appear to be self-defence.

Caetano's second full-feature film, *Bolivia*, is a stark account of the last two days in the life of an illegal immigrant named Freddy, who works as a short-order cook in a neighbourhood café. There he meets Rosa, a Paraguayan waitress, and the bar's regulars: several homeless drunks, a homosexual peddler and a group of xenophobic, homophobic taxi drivers, one of whom kills Freddy in a fight at the end of the film. Shot in 16mm black and white, the film also evokes the 1950s, both through its nod to Italian neorealism and through its racial references: it was in that decade that the first wave of *cabecitas negras* ['black heads' or dark-skinned people] arrived in the capital from the provinces as well as from Paraguay, Uruguay, and Bolivia in search of work (Chiozza 1983: 426). *Bolivia*'s success and recognition at international film festivals made it possible for Caetano to direct a third film entitled *Un oso rojo* the following year with the full backing of Lita Stantic, one of Argentina's leading producers. An increased budget allowed for professional actors and postproduction facilities, resulting in much more polished technical accomplishments. Here Caetano tells the story of Rubén 'Oso' [Bear], an ex-convict on parole who returns to the suburban neighbourhood of San Justo where his wife, Natalia, now lives with her boyfriend and Oso's daughter, Alicia. The newly-free Oso is forced by his past to lead a double life: on the one hand he sincerely seeks to re-establish a relationship with his daughter, but on the other he never looks for honest

work to support her (he does drive a taxi, but he seems to be using the vehicle purely for personal business). When he is not with Alicia, he spends his days attempting to be repaid by his former accomplices for the heist that put him in jail in the first place.

These four films form a coherent corpus whose thematic and technical elements stem from similar social and artistic concerns. Paramount among them is the isolation of the male protagonists from any kind of social environment or human interaction that is not marked by some kind of economic transaction or contractual relationship. For example, Rulo initiates a romantic relationship with Adriana after purchasing sandwiches at her *quiosco* [shop], and Freddy's liaison with Rosa begins after they agree to share their tips. The men try to make money through a variety of legal, semi-legal and downright illegal means in a rapidly disintegrating suburban milieu where they do not seem to belong. It is also difficult to find any other character in the films that can be said to 'belong' anywhere. Even the employed, the law-abiding and the seemingly stable families are struggling economically, and the struggle is threatening to destroy personal relationships at every level. What these films portray is the final stages in the breakdown of traditional forms of community, which as Anthony Giddens argues, stem from the replacement of faith and trust in fellow human beings with a 'trust in abstract systems [that] cannot supply the mutuality or intimacy of personal trust relationships', a process which results in the 'transformation of intimacy' (Giddens 1990: 114). A brief conversation between a longtime customer and a bar owner in *Un oso rojo* underscores the fact that, in post-2001 Argentina, there is no looking back to an idyllic past when disinterested mutual help could be expected:

> 'Dale papá. Hoy por ti, mañana por mí.'
> 'Eso se acabó, se terminó eso, no existe más.'

> ['Go on, man. Today it is for you, tomorrow it is for me.'
> 'That is finished, it is over, it does not exist anymore'].

The process of globalization and modernization which has challenged both the national and the individual as the axes around which identities are fixed is represented in these films as they evoke an older Argentina through a simultaneous look at personal pasts and national symbols, both of them portrayed as glorified, fictionalized mementos that bear minimal significance to the characters' present lives. Rulo is hounded by the memories that his friends and acquaintances have of him as a younger, thinner, successful musician. As they peruse the photographs he keeps hidden in the attic and hum the songs that made him famous, he appears uninterested in the products of a camera whose purpose is to freeze moments in time, 'Ése era yo, no más que ahora estoy diferente' [That was me, but now I am different]. For him, time has not stood still because his current preoccupations have much less to do with recovering the bass he lent to his teenaged son—after all, he had

not played it in fifteen years—than with working at a paying job the following day. On the other hand, in *El bonaerense,* Trapero dwells on the disastrous consequences of remaining stuck in the past, which catches up with Zapa because he can never stop inquiring into the whereabouts of el Polaco, the man who framed him for the crime. When el Polaco shows up requesting a repeat performance of the drilled safe, Zapa may have been able to exact vengeance, but then he finds himself back in his village, maimed and isolated, a different man. Similarly, Oso in *Un oso rojo* never stops trying to recover the money he stole before going to jail, which leads him into an even more violent crime spree. Eventually he walks away alone, having given up both money and family.

Filming techniques such as documentalism and non-synchronous sound—a cinematic technique that combines sounds from one source with visuals from another—turn expressions of nationalism into ironic counterpoints, making 'the old (history) into a specific spectacle… History and exoticism play the same role… as the 'quotations' in a written text' (Augé 1995: 110). *Mundo grúa* evokes a timeless Argentina through the archival images used by Trapero to show the celebration of the *Día Nacional del Gaucho* [National Day of the Gaucho]. The use of documentalism—the incorporation 'into a fictional narrative [of] archival material as part of the expository texture of the narrative…[that] anchors a narrative in a specific sociopolitical reality to trigger allegorical associations' (Foster 1992: 12)—distances the film's day-to-day action from the context of national history and culture. Even the quality of the image is different: soft-focused in contrast to the graininess of the rest of the film, emphasizing the fantastic and unrealistic quality of the cinematographic quotation in contrast to the purported realism of Rulo's life. Trapero turns animals and gauchos into a spectacle that Rulo and his mother watch from beach chairs set up on the sidewalk, placing them in the central streets of the very city whose process of identity formation required that its urban culture become the antithesis of the rural, provincial culture symbolized by the gaucho. Thus Trapero subverts both the historical context of the city and the imagery associated with its traditional uses, with a hybrid combination aimed at highlighting the unrecoverability of the lost myth.

In another continuous scene where history is presented as participatory spectacle, the flag-waving, anthem-singing schoolgirls in *Un oso rojo* are juxtaposed with the violent, barbaric segment during which Oso steals a car, shoots a policeman and kills all of his accomplices after robbing an appreciable sum of cash from a factory. As the children sing the verse 'o juremos con gloria morir' [or let us swear to die gloriously], the shootings commence and the concept of 'glory' is redefined as the bodies of policemen and criminals alike litter the path traced by Oso from the scene of the crime back to el Manco's bar at the end of the film. Here, hybridity is presented through non-synchronous sound. The flag ceremony, gradually reduced to sound, cannot compete with the attention demanded by the images of violent, unglorious death.

Suburban dramas

'Siempre andan a los tiros, como en el Far West.'
Un oso rojo

The films of Trapero and Caetano privilege the suburbs as the location where the dramatic action resides. The suburbs have become the expendable locations of the global consumerist marketplace, where socio-economic considerations and transactional relationships often take precedence over more traditional forms of social interaction. To put this in context, Greater Buenos Aires is the tenth-largest city in the world, a megalopolis where the word 'suburb' denotes, along the lines of the European urban model, the sprawling ring of haphazardly-built apartment highrises and lowrise housing projects that surrounds the city and where the majority of migrants from neighbouring countries as well as from other Argentine provinces concentrates.[2]

The four movies under discussion occupy that seemingly endless space surveyed from the Obelisk, a massive, centrally-located monument commemorating the first founding of the city of Buenos Aires, gradually displacing the action away from the city centre. In these films, the well-known landmarks of the Federal Capital cede their centre-stage position to the cityscape of the nondescript side streets and neighbourhoods—un 'centro que se ha convertido en periferia' [a centre that has become the periphery] (Jacovkis 2003: 79)—and to the increasingly more populated *conurbano* [suburban belt]. A virtual, composite city emerges 'where people do not live together and which is never situated in the centre of anything' in contrast 'with the *monument* where people share and commemorate' (Augé 1995: 107–8). These films have a stake in the problems of location as seen and heard through the images and sounds provided by the camera. The drama, as Trapero and Caetano depict it, focuses on the practices of everyday life rather than on the monuments, buildings and streets of the Federal Capital that formerly lent Argentine cinema a sense of place and identity (Young 2003: 300).

Until recently, the Federal Capital had been the domain of the Europeanized middle and upper classes that dominated the city's political, economic and cultural life, but it is now just as populated by immigrants, *cartoneros* [waste pickers] and the working poor as the suburbs. The 2001 crisis placed extreme poverty in the most central of the city's streets, as the barriers that had sustained this compartmentalization through the 1990s began to show signs of breaching, making it necessary to acknowledge an increasing lack of differentiation between city and suburb. It is perhaps more appropriate now, when we speak of restricted circuits of usage by certain populations, to take into account both the urban and suburban spaces—such as cafés, arcades, dance halls or churches—where the internal and external migration congregates, as well as the new urban networks and (sub)urban corridors that they are in the process of creating.

Three of the films under discussion—*Mundo grúa* being the exception—constitute a series of urban westerns where vigilantism and the sound of gunfire are common and lives are expendable. In *Bolivia*, Freddy is shot by an angry xenophobic customer at the restaurant where he works; in *El bonaerense*, casualties line the streets, victims of the corrupt policemen's 'gatillo fácil' [easy trigger]; and in *Un oso rojo* the protagonist, having served a seven-year sentence for killing a policeman, eventually gets involved in a second robbery that ends in not one but three violent shootouts, echoing a character's prescient remark about this seemingly sleepy suburb: 'tené cuidado, siempre andan a los tiros, como en el Far West' [be careful, they are always shooting, like in the Far West].

The streets of the suburb and the city are a contested space of lawlessness ruled by a police force that is accountable to no one. They are often deserted, even during the day, and offer no witnesses or protection as people move about enclosed in the bubbles of their aging cars or the taxis they drive for a living. When Freddy walks alone aimlessly after work, with no place to go, he is searched, humiliated and threatened without provocation by two officers: 'Si te vuelvo a ver por acá, te llevo preso' [If I see you again around here, I will arrest you]. Similarly, Oso in *Un oso rojo* is frisked at the playground in front of his 9-year-old daughter as she watches him from the merry-go-round. Passersby in *El bonaerense* are also threatened and even shot to death simply for getting in the way of the police, and the officers extort bribes from criminals and businesspeople. The message, reminiscent of the days of the dictatorship, is simply to avoid the police, and to continue to ignore the law—whether it means robbing an armoured car or hiring an illegal immigrant—since the struggle for survival takes precedence.

Most of the action in the films takes place in public, transitional spaces such as streets, cafés and taxicabs because private spaces are hard to come by. They only live in the romanticized mothers' homes in *Mundo grúa* and *El bonaerense*, country houses where the air is clear, the birds sing and the old woman—played by Trapero's own grandmother—is always there to provide a clean environment and good food while she worries about her son's future. Elsewhere in the city, the men are homeless or are forced to live—always temporarily, as new urban nomads—in tiny, cramped and squalid quarters. As his lot in La Bonaerense improves, Zapa is eventually able to stop sleeping on park benches, in the police cruiser or in the sentry box and rent a small apartment where he eats and sleeps on the floor because a mattress is all the furniture he owns. Rulo has his own place, so small that it includes a 'dual-function' TV that can be watched from either the bed or the kitchen, and so dirty that his friend Torres starts washing dishes there one day. Rulo feels hardly at home there when his teenaged son comes and goes at all hours, waking him up in the middle of the night and asking him to leave when he brings in girls. Rulo has even less privacy when he moves to Comodoro Rivadavia and has to share a house with several other workers, some of whom sleep on the hallway floor. Things are no better for Natalia, Oso's ex-wife, who is about to be evicted from her drab house in a family-oriented neighbourhood of San Justo because she cannot afford the rent. In the end, even

the grandmother's rural idyll is revealed as a fake: after living there for a while, Rulo's son Claudio goes from aspiring rock musician to helping his grandmother spool wool while she pesters him about his lazy habits.

Transactional relationships, transitional spaces

> '¿Sabés dónde te metés?'
>
> *El bonaerense*

Despite their wider context of urban sprawl, all of these stories are filmed in restricted, stifling, almost claustrophobic locations where the protagonists fail both to understand and adjust to prevailing and highly-regulated codes of behaviour that are opaque to outsiders. Familial and romantic relationships are rendered dysfunctional as a consequence of crime, imprisonment and migration. Rather than develop new, lasting relationships during the films, the characters increasingly isolate themselves from everyone except employers, co-workers and accomplices: to use Paul Goldberg's term, transactional situations (2005: 139) take the place of nearly all relationships. Romantic liaisons are short-lived and marked by desire as much as by lies, betrayal and abandonment. Freddy must leave his mother, wife and three daughters in Bolivia in order to pursue work in Buenos Aires, where he rushes into a purely physical relationship with Rosa. Zapa leaves his girlfriend and a close-knit family in the provinces and, in turn, is abandoned by Mabel, the police academy instructor and single mother who had initiated a passionate sexual relationship with him, when she realizes that he has become corrupt. Rulo, who is divorced, lies to his mother, evicts his 16-year-old son, who is showing signs of becoming a useless drifter, and is forced to break off his relationship with Adriana when he loses his job. Oso's wife, Natalia, finds it impossible to communicate with her boyfriend, her daughter or her ex-husband; alone in front of the mirror, she lets her hair down and nearly undoes the buttons of her dress as she mourns the passing of her youth and beauty while the two men in her life are somewhere else, stealing or gambling.

People are expendable, replaceable and interchangeable, as demonstrated in *Bolivia* by the hotel owner's resignation when he learns that yet another immigrant has died without clearing out his room first. In the final scenes of the film, Freddy's entire existence is first reduced to a few personal effects and later erased as Enrique puts the 'Se necesita parrillero' [Cook Wanted] sign back on the café window. Rulo is replaced at the controls of the crane on the very day he was to start operating it. At the end of *Un oso rojo*, Oso hands the stolen money over to his wife's boyfriend because—and he does tend to speak in catchphrases—'a la gente hay que cuidarla' [people need to be looked after] and, after all, like Robin Hood (Batlle 2002), he believes that 'toda la guita es afanada' [all money

is stolen]. He walks away from his daughter's life because 'A veces para hacerle bien a la gente que uno quiere lo mejor es estar lejos' [Sometimes in order to do right by the people you love, it is best to be far away]. Throughout the film he had tried to buy his daughter's love with toys and other gifts, but he realizes that the only way he can retain his old life is to pay someone else to live it for him. As viewers, it is as hard for us to cheer for Oso as it is to mourn for Freddy, Rulo or Zapa, for we know that they are all replaceable.

These films show a situation in which all the protagonists are outsiders. In *Bolivia*, immigrating from another country, as Freddy does, is not the only cause of isolation: so is migrating from or to the provinces, as Zapa and Rulo do. Oso's prison record also marks him as different and unwanted. The system of norms, which Oso, as an outlaw, is able to exploit to his advantage, is in fact only available to insiders in the other three films: in order to get ahead, you must know somebody, you must make some kind of deal through a friend or a relative willing to bend the rules to repay favours, and by the time you realize where you are, you find yourself with no work in a cramped shack in Patagonia or taking bribes from prostitutes on the other side of Avenida General Paz, a wide thoroughfare that divides the city centre from the suburbs and which features prominently in *El bonaerense* as the place where Zapa's sentry box is located. Because the men rely solely on these dysfunctional male networks—appropriately symbolized by the maze-like scaffolding in *Mundo grúa*—everyone, including the women, ends up isolated, never fully acquiring a substantive urban citizenship.

A construction site, a sentry box and corner cafés are the micro-societies where the 'real' action takes place, and where the protagonists, with the exception of Oso (Bernini 2003: 105), are powerless to drive the action because they put their trust in a system of mutual support, especially among males, that is no longer viable. When the police commissioner asks Zapa in *El bonaerense*, '¿Sabés dónde te metés?' [Do you know what you are getting into?], the question—which could also have been put to Freddy in *Bolivia* and even to Rulo in *Mundo grúa*—implies the protagonist's ignorance of those codes: a depth of established meanings and relationships to which he is about to fall victim and from which he can only emerge broken or dead. Oso is not all that different: though he may be in control and fully at home in the café, he is just as lost as a newly-arrived immigrant in the family-oriented suburb where his former family lives. Permanently exiled to the other side of the fence that separates him from Natalia and Alicia, he finds it impossible to communicate except by passing objects through the bars, as though he were still in prison.

The restricted locations reinforce the impossibility of escape, which is also suggested by the circular structure of the narratives. Scene by scene we find ourselves peering through gates, doors and windows that split, divide and frame the interior of tiny corner cafés, vehicles, jail cells and squalid apartments or hotel rooms, and that lend a sense of claustrophobia and entrapment to the protagonists' lives. In *Bolivia*, Enrique, the restaurant's owner, tells Rosa that 'la puerta está abierta, para entrar y para salir' [the

door is open, to enter and to leave], yet the characters are drawn to the bar everyday, whether they are customers, employees or even Enrique himself, for they have no place else to go. Ironically, the Bolivian cook dies at that very doorway, shot in the heart by a customer after a fistfight provoked by his anger that immigrants like him are taking jobs from Argentines; his body lies lifeless across the doorway, half in and half out of the place from which he could never walk out alive. *Mundo grúa* ends, inconclusively, with a slow fade-in of Rulo's face on his way back from Patagonia. The face shot is half white and half black, half in light and half in shadow, neither here nor there. In *Un oso rojo*, doorways and windows feature prominently, constantly framing the characters as if they were still pictures, boxing them in and restricting many of their face-to-face interactions. Reminiscent of the determinism of much European, North American and Latin American naturalist fiction of the late 1800s, the main characters and their cast of family, friends and acquaintances appear to be both the victims and products of an environment marked at all times by the struggle for economic survival and the non-viability of change.[3]

This last point is best illustrated by the kinds of interactions that take place in the café-bar, the mainstay of male social life in Buenos Aires, which serves as an anchor for the neighbourhoods and as a location that these films use as a substitute for the home and for private space in general. The cafés in these movies, which evoke less a meeting-place for *porteño* intellectuals than a social environment that has replaced family and home, a place where men traditionally congregate to drink, play pool, listen to music, watch televised sporting events, gamble and discuss women, is, according to Troncoso, 'imprescindible para recibirse de hombre en la pedagogía esquinera' [mandatory to graduate as a man in the pedagogy of the streets] (Troncoso 1983: 300). A look at the scenes filmed in bars and cafés reveals a whole cast of extras lingering alone at their own tables, smoking, staring at the television or reading a newspaper, isolated from one another even as they share the same space. In these films, the corner bar has a well-defined social function besides providing employment for some and company and entertainment for others: on both sides of the bar, the men are there to plan deals that range from the shady to the criminal, attempting to find ways out of their economic problems through the personal connections the café provides. But because there is no way out of the volatile economic situation of Argentina at the turn of the millennium, the café, rather than a refuge, is beset by violence. In the suburban cafés of Greater Buenos Aires, men face human relationships through a pervasive process of commodification that turns them into replaceable cogs in an underground economic machine, their value lasting only as long as they may be useful to complete the next deal.

El bonaerense begins with a shot of men sitting motionless at the outdoor tables of a corner café in a rural town. In stark contrast with the menacing overtones of the urban cafés in the other films, here a group of young men sits around barely moving, doing absolutely nothing. It is a sunny day, birds are singing, and a policeman stands motionless, looming over the group as though embodying a premonition of the events

about to unfold. The viewer's gaze is allowed to linger on this almost bucolic tableau, seen first in a long shot from outside, then from inside a building whose door and window frame the scene, dividing it in two and boxing it in. The scene is interrupted by someone coming to get Zapa, who is wanted by el Polaco in a very different bar, a dark, dirty hole from which Zapa will emerge as a criminal.

In *Un oso rojo,* when Oso is released from prison, he immediately searches for a café, even before he goes to see his daughter. But he is seeking neither sympathy nor community. An elderly man who, as his name suggests, has one paralysed arm, el Manco runs a series of illegal schemes from behind his bar's colourful *façade* in La Boca, a poor immigrant neighbourhood of Buenos Aires. Cool and collected, he reigns in this small kingdom, where the regulars address him as 'papá' and everyone puts down their pool cues to stand at attention at the mere sight of his raised beer bottle. El Manco is a 'godfather' character who constantly needs to be reassured that everyone knows who the boss is. What Oso wants is the money that el Manco owes him from the heist that sent him to prison. But the old man prevaricates and, instead of paying up, entangles Oso in a new scheme to rob an armoured car. What Oso does not know, but soon discovers, is that his accomplices have been instructed to kill him and split his share. This sleepy Argentine neighbourhood café turns into a western saloon when Oso, a loner who has been in control of the situation throughout the film precisely because he does not need this bar community for a social network, pins el Manco's only functioning hand to the bar with a knife and proceeds to shoot everyone else in a flawless impersonation of Clint Eastwood in his spaghetti western days,[4] walking away with all the money. No one but Oso leaves that bar alive; even el Manco remains there, unable to remove the knife from his hand.

Bolivia is filmed in a café almost in its entirety; its characters are depicted as a family whose members have nowhere to go. Freddy is homeless at first, before moving into a narrow room in Rosa's hotel, and the rest of the characters are only seen coming and going in front of the restaurant's door in taxicabs to and from nowhere in particular. Enrique, the white-haired owner of the restaurant, is portrayed as a father figure, alternately stern and benevolent, a little more so than el Manco in *Un oso rojo.* Enrique is, however, always motivated by profit; he is often seen counting money. Although he hires illegal immigrants and exploits them with extremely low wages, long hours and menial work, he appears to care deeply not only for his employees, but also for his regular customers. But it is all a carefully-orchestrated appearance: during his gentle reprimand to Rosa, the waitress, when she is late for work, it is revealed that he does not pay her the required overtime that she works on Saturdays. He later asks Freddy to throw out two vagrants who are sleeping at their tables. This is an ironic moment for Freddy who, after work, must go to a similar bar, order a cup of coffee and rest his head on the table just as they do. These examples underscore the fact that economic differences among the characters are minimal, and that most of the conflict that takes place in the movie is intra-class (Fontana n.d.).

Journeys to nowhere

'Parece ser que en Buenos Aires son todos así, ¿no?'

Bolivia

Neither the crane nor the bulldozer Rulo learns to operate eventually build anything; the taxi drivers in *Bolivia* and *Un oso rojo* never carry paying passengers and, like the country, never appear to have a specific destination; the police in *El bonaerense* actually spend more time partying than upholding the law. Despite the high-paced action in some of the films, there appears to be no actual advancement in the situation of any of the characters, who, if they survive, do so only to end up worse off as they lose their hope, their dignity or their life. The circularity of the stories, all of which have back-to-the-beginning endings, suggests a society where nothing ever changes.

While the multicontextuality of Trapero's and Caetano's filmic texts may not have been designed to moralize (Jacovkis 2003: 80), criticize or alter socio-economic conditions, their purported reflections and recordings of contemporary 'reality' provide some guidelines for reflection on how filmic production has engaged the process of suburban identity formation and its sociocultural frameworks. In its portrayal of the modern Latin American conurbation, film plays a crucial role in defining space and construing new roles played by the characters and by the spaces they inhabit. These spaces tend to be transitional and public, rather than permanent and private; alienating and chaotic. Cafés, hotels, construction sites and police stations are also the spaces where daily economic transactions brand all human relations; cars and taxicabs operate as shells that isolate individuals from one another as their windows and windshields place a barrier between them and the viewer. In the end, all four films tell stories of daily survival in the unforgiving environment of Greater Buenos Aires at the turn of the millennium, depicting the mundane as its monotony is occasionally interrupted before routine and drudgery are once again restored with little or no change. They provide an insight into the modern uses of the city through the symbiotic relations between characters and spaces, as well as into the ways in which those spaces condition and determine human interactions.

Acknowledgements

A version of this chapter was previously published under the title 'A new cinema for a new Argentina' in *Cuaderno Internacional de Estudios Humanísticos y Literatura/ International Journal for Humanistic and Literary Studies*, VII (2007): 128–51.

Thanks to Paul Goldberg and Carina Yervasi for their comments on this article.

Notes

1. See David Oubiña (2003), Emilio Bernini (2003) and Beceyro et al. (2000) for definitions of the movement.

2. See Davis (2006: 31) and Gilbert (1996: 13) for distinctions between First-World and Third-World suburbs. Laura Ainstein has demonstrated that 'parts of peripheral Buenos Aires are just as deprived as other regions of the country' (1996: 140).

3. Bernini sees a clear differentiation between Caetano and Trapero on this point (2003: 102-103).

4. The film's reviewers have pointed out this similarity with Hollywood westerns (Batlle 2002, Fontana n.d., Oubiña 2003).

References

Ainstein, L. (1996) 'Buenos Aires: A Case of Deepening Social Polarization' in A. Gilbert (ed.) *The Mega-City in Latin America*, Tokyo, New York and Paris: United Nations University Press, pp. 133–54.

Augé, M. (1995) *Non-Places: Introduction to an Anthropology of Supermodernity*, London and New York: Verso.

Batlle, D. (2002) 'Un oso rojo', http://www.fipresciargentina.com.ar/archivo/unosorojo. htm. Accessed May 20, 2005.

Beceyro, R., Filippelli, R., Oubiña, D., and Pauls, A. (2000) 'Estética del cine, nuevos realismos, representación [Debate sobre el nuevo cine argentino]', *Punto de vista* 67: 1–9.

Bernades, H. (2002) 'Entre botones', *Página 12,* http://www.pagina12.com.ar/diario/ suplementos/radar/9-382-2002-09-15.html. Accessed May 23, 2006.

Bernini, E. (2003) 'Un proyecto inconcluso: Aspectos del cine contemporáneo argentino', *Kilómetro 111* 4: 87–106.

Caetano, I. A. (2002) *Un oso rojo,* Argentina: Lita Stantic.

Caetano, I. A. (2001) *Bolivia,* Argentina: Cinema Tropical.

Caetano, I. A. and Stagnaro. B. (1997) *Pizza, birra, faso,* Argentina: Palo y a la Bolsa Cine.

Chiozza, E. M. (1983) 'La integración del Gran Buenos Aires' in J. L. Romero and L. A. Romero (eds.) *Buenos Aires, historia de cuatro siglos,* Buenos Aires: Editorial Abril, pp. 421–49.

Davis, M. (2006) *Planet of Slums,* London: Verso.

Fontana, J. C. (n.d.) 'Nuevas generaciones de realizadores en el cine y la televisión rioplatenses', http://www.goethe.de/hs/cor/nonfictional/castellano/literatura/spliteraturafichatecnica.htm. Accessed January 6, 2006.

Foster, D. W. (1992) *Contemporary Argentine Cinema,* Columbia: University of Missouri Press.

Fuster Retali, J. (2002) 'La ausencia de la historia argentina en el cine nacional,' *Cuadernos Hispanoamericanos* 624: 77–91.

Giddens, A. (1990) *The Consequences of Modernity,* Stanford: Stanford University Press.

Gilbert, A. (1996) *The Mega-City in Latin America,* Tokyo, New York and Paris: United Nations University Press.

Goldberg, P. (2005) 'La conciencia globalizada: comportamiento y consumo en *Lodo* de Guillermo Fadanelli,' *Hispanic Journal* 26.1-2: 137–49.

Jacovkis, N. (2003) 'Influencias globales y estética local en el cine argentino contemporáneo,' *Tinta* 7: 77–85.

Kantaris, G. (2003) 'The Young and the Damned: Street Visions in Latin American Cinema' in S. Hart and R. Young (eds.) *Contemporary Latin American Cultural Studies,* London: Arnold, pp. 177–89.

López, A. M. (1990) 'An "Other" History: The New Latin American Cinema' in R. Sklar and C. Musser (eds.) *Resisting Images: Essays on Cinema and History,* Philadelphia: Temple University Press, pp. 308–30.

Oubiña, D. (2003) 'El espectáculo y sus márgenes: Sobre Adrián Caetano y el nuevo cine argentino,' *Punto de Vista* 76: 28–34.

Puenzo, L. (1985) *La historia oficial,* Argentina: Cinemania.

Quintín (2002) 'From One Generation to Another: Is There a Dividing Line?' in H. Bernades, D. Lerer and S. Wolf (eds.) *New Argentine Cinema. Themes, Auteurs and Trends of Innovation,* Buenos Aires: Fipresci Argentina, pp. 111–17.

Trapero, P. (2002) *El bonaerense,* Argentina: Cameo Media.

Trapero, P. (1999) *Mundo grúa,* Argentina: Prod. Cinematográfica Argentina Producciones.

Troncoso, O. (1983) 'Las nuevas formas del ocio' in J. L. Romero and L. A. Romero (eds.) *Buenos Aires, historia de cuatro siglos,* Buenos Aires: Editorial Abril, pp. 299–308.

Wolf, S. (2002) 'The Aesthetics of the New Argentine Cinema: The Map Is the Territory' in H. Bernades, D. Lerer and S. Wolf (eds.) *New Argentine Cinema. Themes, Auteurs and Trends of Innovation,* Buenos Aires: Fipresci Argentina, pp. 29–39.

Young, R. (2003) 'Buenos Aires and the Narration of Urban Spaces' in S. Hart and R. Young (eds.) *Contemporary Latin American Cultural Studies,* London: Arnold, pp. 300–11.

Trigger-Happy: Police, Violence and the State In *El bonaerense/The Policeman*

James Scorer
University of Manchester

In 1997 La Bonaerense—the police force of the Province of Buenos Aires—underwent a series of reforms designed to combat internal corruption, bribery, and drug and car trafficking. La Bonaerense had become an organization more preoccupied with running itself as a private business than with protecting the citizens of Buenos Aires. In addition, the police force had also been implicated in the 1994 car-bomb attack on the Asociación Mutual Israelita Argentina (AMIA), which killed 85 people, and in the 1997 murder of José Luis Cabezas, a photographic journalist for *Noticias*, a news publication famous for revealing corruption and scandal. Already tainted by its direct involvement in detentions, torture and disappearance during the 1976–1983 dictatorship, the image of La Bonaerense was further damaged by increases in crime over the course of the 1990s as a result of the polarizing effects of neoliberal economics, alongside heightened sensitivity to crime fuelled by an ever-more sensationalist media.

In this chapter I will reflect on the changing relationship between state and police in Argentina by looking at Pablo Trapero's 2002 film *El bonaerense*. Narrating the trials and tribulations of Zapa, a young police cadet, Trapero's feature was filmed during the economic collapse of 2001, creating a direct link not just to the state's financial difficulties but also to how it was policing its citizens. Over the course of the two days of December 19 and 20, 2001, the repressive actions of police forces throughout Argentina, sanctioned by the President, resulted in the death of 39 people. Film is also particularly pertinent for reflecting on the relationship between the state and its institutions precisely because Argentine cinema over the past two decades has been predominantly funded by the state. Cinema thus plays an important role in debates on sociopolitical questions in

contemporary Argentina precisely because the state has had such a prominent role on in its quantitative and qualitative output (Aprea 2008: 10).

My inter-disciplinary analysis of *El bonaerense*, therefore, intertwines cinematic analysis with the film's sociological and political context. The film is discussed in as much as it says something about the changing relationship between police, citizen and state. This approach is not merely validated by Trapero's own statement that cinema is, in and of itself, a political act (Aguilar 2008: 64), but also because it allows us to consider the role of cinema in the construction of that relationship. Cinema both represents state violence and plays a role in the perceptions that construct and justify that violence. As Catherine Leen (2008) has suggested, fear of that—especially urban—violence is a recurring trope in contemporary Argentine cinema. As a reflection on policing in the metropolis, analysing *El bonaerense* allows us to reflect on the relationship between the state and its citizens, at the heart of which lies the precarious nature of state-sanctioned violence, highlighting how fear and violence impact on modes of inhabiting the contemporary urban space.

The neoliberal economic policies of Carlos Menem's government transformed the state over the course of the 1990s. During his presidency the government reduced public spending, oversaw a series of privatizations and encouraged private foreign investment, all with a currency pegged at one to one with the US dollar. The implementation of these policies was part of the state's conviction that the market would create equitable opportunities for all citizens. But if the immediate benefits of Menem's policies were to stop the hyperinflation that had plagued the 1980s, to stimulate the market and to improve the communications infrastructure, the longer-term effects were a growth in unemployment, a starker social divide between rich and poor and an increasing reliance on loans from the International Monetary Fund and the World Bank.

The 'withdrawal' of state presence, a direct influence on unemployment and the wealth divide, led to a growth in crime and informal criminal networks, mainly based on goods trafficking and drugs. Wealthier sectors of Argentine society reacted to this increase in crime with a discourse and practice of self-defence. One visible impact of such fear on the urban landscape has been the huge increase in both *barrios cerrados* [enclosed neighbourhoods located on the urban periphery], and *torres jardín* [tower blocks which play on a similar combination of security with amenities but which are located in the heart of the city]. Equally significant, however, has been the upsurge in the use of private security firms, not only outside banks, restaurants and clubs, but also in booths on street corners in the city's wealthier areas, measures bolstered by the purchase of private firearms and alarm systems and the establishment of neighbourhood watch schemes (Smulovitz 2003: 146). The consequence of these practices of security has brought Buenos Aires in line with the contemporary urban paradigm of self-protection and fragmentation. From Mike Davis' studies of the way that architecture in Los Angeles has been, as he called it, 'padding the bunker' (1999: 364), to Teresa Caldeira's analysis of the ghettos and enclaves of São Paulo in *City of Walls* (2000), the American city is all too often a segregated space.[1]

The reliance on private security measures in Buenos Aires is not only explained by police corruption but also by the problematic nature of the police in Argentina, which has historically always held a corporate identity (Kalmanowiecki 2000: 197). Since the end of the last dictatorship, furthermore, the principal approach of the Argentine government towards the country's police forces has been one of non-intervention. As political scientist Marcelo Fabián Sain has suggested, the Argentine State has allowed the development of a self-governing, autonomous body that finances itself extra-institutionally through a network of criminal activities, which, when combined with the increase in private security measures, has led to a breakdown of the State's monopoly over public security (Sain 2002: 9–10). The unspoken pact of non-State intervention is that the police can be employed to garner and enforce political support at elections (Kalmanowiecki 2000: 209; Sain 2002: 41–2).

Given the prominence of crime, police and security in Argentina over the course of the 1990s, it is unsurprising that they have all played an increasingly dominant role in the national media and culture. Works such as Horacio Cecchi's *Mano Dura: Crónica de la masacre de Villa Ramallo* (2000), which used narrative and comics to relate the police's mishandling of a robbery, and Carlos Dutil and Ricardo Ragendorfer's *La Bonaerense: Historia criminal de la policía de la provincia de Buenos Aires* (1997), had a significant impact on the image inhabitants of Buenos Aires had of their city and its police. Written in a true crime style by investigative journalists, these works revealed the inherent corruption and criminality of La Bonaerense in unprecedented fashion. Similarly, crime was a recurrent theme in Argentine cinema in the 1990s, particularly at the turn of the new millennium. Aside from *El bonaerense*, the most prominent among such films were *Plata quemada/Burnt Money* (Marcelo Piñeyro, 2000), based on Ricardo Piglia's novel of the same name; *Nueve reinas/Nine Queens* (Fabián Bielinsky, 2000); and *Un oso rojo/A Red Bear* (Adrián Caetano, 2002).[2]

Police in these films are portrayed in one of two ways. In *Plata quemada* and *Un oso rojo*, the police are presented in a starkly negative light. In *Plata quemada*, for example, the police are not subject to any character development. They lack a figurehead, appearing rather as a collective force whose most notable act is to rape and beat up the girlfriend of one of the robbers. The criminals, on the other hand, are rounded characters, who achieve ultimate victory by burning the money they have stolen in a romantic gesture of defiance. For all their defects, they are alluring characters. Likewise, in *Un oso rojo*, the protagonist, recently released from jail and on a crusade to set things right with his daughter, not only has to deal with the corrupt cops hanging out at the local bar but is also harassed by the police when he takes his daughter on an innocent trip to the local park. The alternative manner of portraying the police—as entirely absent—is evident in *Nueve reinas*. In a film all about crime capers, scams, theft and forgery, the police do not appear even once. The closest the film gets to producing an officer of the law is when the thief Marcos pretends to be a detective to get his future accomplice Sebastián out of a

failed scam. The absence of the police is suggestive of the way the film engages with the disinterest of the State to intervene in a city that has become the territory of (in this case) harmless crime in which stealing is a business and criminals have a moral hierarchy. All these films, therefore, albeit in different ways, engage with the changing nature of the police in contemporary Argentina.

Despite these visual critiques of the police, these films all benefitted from an atmosphere of cinematic rejuvenation and direct state intervention brought about by the 1994 'Ley de Cine' in Argentina, which generated new funds for national cinema, promoted its presence in cinemas nationwide, encouraged the establishment of film schools and indirectly bolstered a resurgence in film festivals such as that in Mar del Plata. Indeed, contemporary Argentine cinema would not exist as such were it not for the development of state funding for film. Why, then, would cinema go to such great lengths to illustrate how that self-same state was not protecting its citizens, reminding viewers that the state's very arm of protection was ever more disjointed from its other institutions, acting independently in a city rife with internal divisions, payoffs and trickery? Two reasons explain this apparent irony. First, the very nature of the state as a collective set of institutions encourages partial as well as overall reflections. Just as the state divides its tasks, even its image, between its various institutions, so does culture engage with those various separate institutions. Second, however, it would be a mistake to assume that state funding necessarily creates homogeneity. The fact that of the more than 50 films made in Argentina in 2004, only three received 64 per cent of the viewing public indicates that many state-funded films are still marginal. As Gustavo Aprea points out, various kinds of cinema co-exist under the state umbrella, and not all of them are in harmony: 'Production facilities and the creation of publics that are fragmented but still made up of enthusiasts have multiplied exhibition spaces and, at the same time, allowed the emergence of diverse cinematographic lines that are developing on the margins of INCAA financing and regulation' (Aprea 2008: 24).

For these reasons cinema has been able to develop new conceptions of police and urban violence. Not just revealing police autonomy, films such as *Plata quemada*, *Un oso rojo* and particularly *El bonaerense* also illustrate that the police's apparent 'independence' is only possible precisely because of its fundamental tie to the state: it can only act with impunity because its violence is ultimately sanctioned by the state. The rape is possible in *Plata quemada* both because the police are given the tools to employ violence and because they have the authority of the state behind them. Likewise, the police in *Un oso rojo* are protected both by their guns, uniforms and badges, and also by a state that defends them when they kill a taxi driver's innocent grandchild in a shooting. Thus, the Argentine state of the 1990s was not so much a weak state as a state that delegated its powers (whether in terms of policing or economics) to institutions that could be variously included or excluded from state discourses according to public opinion. In its supposed withdrawal, the Argentine state both ceded power and retained it in that

very act of loss, drawing attention away from its persisting power by creating a space dominated by the internal struggle of citizen vs. citizen. In a city dominated by a politics of survival-of-the-fittest, the state's sleight of hand was to withdraw and protect itself in and through the chaos it left behind.

The film that engaged most directly with this shift and with the nature of the La Bonaerense more specifically was the 2002 film *El bonaerense*, co-written by the aforementioned Ricardo Ragendorfer. The title was a play on words, referring both to a man from the Province of Buenos Aires and a policeman of La Bonaerense. The film relates Zapa's journey from being a small-town locksmith to becoming a police cadet in the city. Set up by his boss Polaco, Zapa becomes the fall guy for a safe robbery. After his arrest, he is bailed out of the local jail by an uncle, who sorts out his release in return for Zapa heading to the metropolis to enrol at the police cadet school. Once there, Zapa progresses with the help of Gallo, an officer who, during the course of the film, becomes police superintendent.

A far cry from Argentina's long tradition of analytical detectives, evident in literary works by Jorge Luis Borges, Manuel Peyrou, Rodolfo Walsh and Ricardo Piglia, the relationship between Gallo and Zapa highlights the presence of a rather different model of policeman from that of the amateur sleuth or the tough but morally-upstanding hardboiled detective. Instead, Gallo and Zapa highlight the corporate nature of the police, the mafioso, back-scratching world of personality politics. The collection of bribes throughout the film—whether in terms of backhanders or goods taken from a van during a routine vehicle inspection –, together with the cuts from bar owners and prostitutes in the name of protection, indicate how the police is able to run financially-independent operations. Such corporatism is evident when Gallo gives Zapa credit to buy a gun (with a discount) or when he sorts out Zapa's delayed first pay packet.

Such extra-official transactions mirror the broader practices of corruption characteristic of Menem's government. Indeed, Menem himself openly modelled himself on the nineteenth-century *caudillo* [strongman] Facundo Quiroga. Eduardo Duhalde was the archetypal contemporary *caudillo*, who, before becoming interim president in 2002, was a long-term governor of the Province of Buenos Aires. The Province of Buenos Aires is key to any Argentine election since it has by far the largest voting constituency in Argentina, making its Governor the third most powerful political figure after the President and the Governor of Capital Federal. Duhalde was well known for his complicity with and use of the police in the electoral sphere, one of the reasons why, before he reluctantly called for police reform, he called La Bonaerense 'the best police-force in the world'.

Throughout the film, therefore, there is an uneasy relationship between police and citizens. Gallo's promotion speech, which echoes the 1997 police reform, sets out a new code of ethics: 'We're here to resolve the problems of the community because we're part of the community... Such problems shouldn't be resolved either with weakness or by

being trigger-happy, alright? This is a new period, dictated by morals, by ethics.' His discourse of reform, however, contrasts starkly with his rise to power facilitated by corruption. In an earlier scene, the police cadets are taught Law 81 of the penal code. The instructor explains: 'death occurs beyond the harm itself. That means: the harm exists, but not the intention to kill. If you and I have some kind of political argument, I push you, you fall over and crack your head open—ah well, I meant to push you but not to kill you.' Here the police interpret the law in a way that safeguards them from accusations of malpractice by the very group of people they are designated to protect, allowing them greater freedom to act 'within' the law. The other interactions between the police and citizens in the film are principally fraught affairs in the police station, where the physical aggression of some of those who have been arrested exists alongside the general oppressive atmosphere of the city, clearly in the grips of a humid Argentine summer, with frequent shots of sweating characters in enclosed spaces. The disjointed tie between police and citizen is symbolized by the crowded, chaotic police station on Christmas Eve, with angry citizens demanding attention. When one reminds a passing policeman that they all pay his salary, he retorts, 'you could be more generous', a sarcastic reflection on the poor working conditions of the police in Argentina. The extra-official network of corruption and purchase of weapons evident in *El bonaerense* are, at least in part, due to a lack of state funding and low salaries.

Gallo's reference to being trigger happy in his speech is a clear reference to the 1990s, when the police were frequently criticized for being quick to open fire when resolving incidents. Gallo himself berates the cadet Zapa for helping out at a substation without a gun: 'A policeman without a weapon isn't a policeman. What'll happen when a crook comes in here with a piece? What are you going to say, that you're a cadet?' The gun as a symbol of power and violence is a key image in the film. Firearms not only provide protection but are also used to express drunken happiness, as when the police fire their weapons skywards at the Christmas party, to demonstrate the corporate nature of the force, illustrated by the fact that many policemen buy their own, more powerful guns rather than use the standard issue. Indeed, Zapa's progression through the film can be measured in terms of guns: his initial naïveté is symbolized by the fact that he waves a sparkler at the party where others are firing guns; later, when cleaning the substation he is seen firing a spray-cleaner like a gun; finally, he begins to use his gun, albeit uncertainly, in live shootouts. So if one of the principal ironies of the film is that Zapa's punishment for his initial crime, ostensibly one of naïveté as anything else, is to enter the police force, then his process of 'rehabilitation' is in fact one in which he learns how to employ violence.

If the film is essentially about Zapa's integration into the police force, it is one reason why training and learning are such prominent themes in the film (Ricagno 2003: 44), then this raises uneasy questions about teaching citizens how to use violence. As Kalmanowiecki notes, police officers in Argentina often simply regard themselves as professionals (2000: 202). That professionalism, however, should not be understood in the sense of doing one's

job according to state-sanctioned rules and legality but in the sense of earning a living. With the film's release, the Argentine daily *La Nación* published a piece on young cadets and those considering the police as a career (Scherer 2002). The article emphasizes that, for many poorer citizens of Buenos Aires, entering the police is often perceived to be the only viable financial alternative to crime. But policing is not a job 'just like any other' precisely because of its inherent tie to force and violence. The police's discretionary power to use 'legitimate' violence where deemed necessary illustrates that violence is not only a threat to labour but that it has become labour itself. Thus, the training scenes in *El bonaerense*, which include shooting at the firing-range, entering buildings with weapons drawn, and approaching hostile vehicles, are intertwined with scenes illustrating Zapa's gradual financial independence. Zapa's sells his growing ability to threaten and enact violence.

El bonaerense, therefore, illustrates the manner in which violence in Zapa's life gradually becomes part of the rhythms of everyday urban life. The way violence seeps into Zapa's life is evident in his relationship with Mabel, the instructor in drugs at the cadet school. In their first sexual encounter, Mabel pleads Zapa to stop as part of an erotic, sexual game in which she clearly takes the lead. With their developing relationship Mabel takes Zapa on a shopping trip where he buys a flak jacket, symbolizing the way that violence begins to pervade their relationship. The final scene between the two is a brutal, animalistic encounter, bordering on rape. Mabel's whispered, urgent begging for Zapa to stop is no longer a game but rather fear at the way that Zapa physically dominates her into submission, not least because Mabel is distancing herself from a man she realizes is becoming increasingly involved in police corruption. The violence that Zapa has learnt in the supposed controlled and separate sphere of the police, in which the cadet school trainer sanctions a fight over Mabel as if in their 'duel' the cadets were following some kind of masculine code, has here crossed the boundary into personal violation. This violence is not one that represents a suppressed desire to enact justice in the face of an ineffective state, a trait evident in other earlier Argentine films (Rocha 2009), but simply a violence that becomes Zapa's means of engaging in human relations.

Zapa's journey from province to city positions the city as the locale of violence. Violence emanates from being in the city itself. From the opening shot itself, which depicts the static, eventless nature of the small town where Zapa lives, the film engages with the differences and tensions between the small-town interior and the metropolis. Even if the idyll is shattered by the way that Zapa is made the fall guy, the town is a place where everyone knows your name. When the local police arrest Zapa they know his mother well enough to call her Graciela and, as they put Zapa in the car with an almost embarrassing degree of friendliness, she reassures herself by reflecting that her son is in their capable hands, before she waves off the car as if it contained departing friends. After this initial provincial friendliness, however, Zapa is gradually inscribed with a new identity by both police and city. When first arrested, the local policeman knows his nickname but has to ask for his given name, the first in a series of questions

that institutionalize his life into full name, alias, age, profession, nationality, the contents of his pockets and fingerprints. On his first day as a recruit, Zapa looks at himself while he has his head shaved, as if coming to terms with his new identity.[3]

This dichotomy of friendly interior and brutal city follows Gustavo Remedi's (2004) argument about the appearance of a 'neo-gauchesca' aesthetic in contemporary cinema, in which the modern city becomes a Wild West ruled by urban gauchos. Though more strictly applicable to *Un oso rojo*, Remedi's trope is a reminder of how, in *El bonaerense*, it is as if Domingo Sarmiento's classic and defining trope, in which Buenos Aires was the symbol of cultural progress, education and economic development, and the interior the symbol of backwardness and *caudillo* politics, has been reversed: here it is the city that is the locale of barbaric *caudillismo* and the interior that of civic virtue. Zapa does not so much lose his provincial innocence to Buenos Aires (the name itself shining out from the front of the night-time coach he takes to the city), however, as to a particular neighbourhood: when the police trainer asks the recruits where they are from, they have to reply in unison 'La Matanza'. The film is about internal boundaries within the city as much as boundaries between city and country. Gran Buenos Aires (the city that is in the Province of Buenos Aires) and the autonomous, central Capital Federal have historically always been in tension, the latter traditionally regarding the former as, in various guises, the locale that harbours the threat of violence in the form of the Latin American other (Gorelik 2004: 93). The police force of Capital Federal policies the boundary between the two—Avenida General Paz—as if it were the frontier between civilization and barbarism. As Trapero says, if you come from Gran Buenos Aires, 'you feel like a foreigner in Capital' (quoted in Lerer 2002: 68).[4]

Zapa's punishment is not only to have to enter the police but also to have to live in this fragmented city inscribed by boundaries, territories and insiders and outsiders. It seems as if violence gives him a means, not just of surviving within that city but also of expressing himself and escaping its vast anonymity. But Zapa is only a protagonist in the city insofar as he follows the script that is written for him. He follows orders and reacts to circumstances rather than taking responsibility for creating alternatives. That inability—or unwillingness—to escape the path laid out for him is evident in the film's climax, where he helps the reappeared Polaco to break into a safe. As they leave the crime scene, Zapa handcuffs Polaco to the stairwell, waiting for Gallo to arrest Polaco. Gallo, however, shoots Polaco dead and then falsifies the crime scene by shooting the surprised Zapa in the knee and putting Polaco's fingerprints on the gun. When Zapa is promoted for his 'bravery', his response to Gallo's congratulations is one of restrained aggression, as if he were about to refuse the decoration. Far from learning any semblance of a moral lesson, however, Zapa accepts his promotion. When he subsequently visits his family he looks uncomfortable with the friendliness of both his relatives and of the police who arrested him at the start of the film. The final shot shows Zapa returning to the city, head bowed, his limp symbolizing the violent legacy of the urban environment.

Zapa's passivity is evident in many characters in contemporary Argentine cinema, suggestive of how shared political struggle and collective action are no longer evident— or perhaps even relevant—in today's city, a marked cinematographic shift from the militant cinema of the 1960s and 1970s (Aprea 2008: 91). With the film's release, several critics emphasized how a similar passivity was evident in the stance of the director. In *Página 12*, for example, Luciano Monteagudo wrote that Trapero 'never has the need to raise his voice, to dictate a speech, to point his finger' (2002: 23). As Gonzalo Aguilar has suggested, however, 'if in the 1960s politics tied showing to acting, denouncing with reacting, in the 1990s the question lies elsewhere: the difficulty is not in knowing what is happening but rather in how to act' (Aguilar 2008: 11).

The thrust of *El bonaerense*'s politics—and its unsettling irony—, is that it is precisely the institution of the police force that inscribes violence into Zapa's everyday life. This violence is of the kind that Ignacio Lewkowicz has described as changing the nature of social ties, ties that are characterized by the substitution of discourse for violence, making the pure act of violence one without words (Lewkowicz 2004: 60–1). Zapa speaks very little throughout the film, his silence reflecting his passivity—he makes no protest when he is arrested, for example. Instead, it is precisely his gun that gives him a voice in an environment that is otherwise beyond his control. To study any police force is to recognize that violence or, at least, the promise and threat of violence, is constituent of the well-oiled state machine. As well as an implicit critique of the blurred boundary between law and crime depicted in the film (Aguilar 2008: 40), *El bonaerense* encourages us to consider the dangers of passively accepting the violence of everyday life, a violence that, in essence, constructs urban alienation and loneliness. The final shot of the film, Zapa walking along a road in an empty landscape, emphasizes the violence of his alienation—the loneliness brought about by violence.

The contemporary city is inhabited by 'citizens of fear': urban violence and the (often disproportionate) fear of that violence combine to create an environment in which citizens are pitted against each other (Rotker 2002: 17). This is a city inhabited by corrupt police officials watching over cities that, as Diego Levy's (2001) photographic essay *Sangre* seems to suggest, are awash with blood. But even if many citizens of Gran Buenos Aires fear the police more than criminals (Smulovitz 2003: 137), urban dwellers have a responsibility to look beyond the violence of everyday life. There is a need to shift our perspective away from those that, in a variety of forms, stress the contemporary urban paradigm not as 'murder *in* the city but the murder *of* the city' (Martín-Barbero 2002: 26). Such perspectives fuel an increasing sense not only of fear in the city but also fear of the city. If fear has become the basis of contemporary citizenship (Rotker 2002), then that fear should be confronted with a politics of commonality that overcomes fragmentation and alienation.

In this chapter I have illustrated how *El bonaerense* is indicative of the changing nature of the police. Despite being an increasingly independent institution, the police force retains such autonomy precisely because of its nature as a state institution, indicating how that

selfsame state has hardly withdrawn but has merely reconfigured its image. *El bonaerense* highlights the dangers of such shifts, portraying how the transformation of violence into labour inevitably leads to the introduction of violence into everyday urban life. What is particularly concerning in the film is precisely Zapa's passive acceptance of the way that violence is written into his life and onto his body. In one brief moment, as Zapa makes his way through the city to enrol at the police station, he passes a protest march. On the one hand, the film emphasizes Zapa's distance from the collective political action the march expresses: a politics—not least in a cinematic sense—more pertinent to the 1960s and 1970s. Yet the presence of the march not only indicates, as Trapero suggests, that Zapa's life is still political even if the march passes him by, but also that there are alternatives to Zapa's alienation. The march is a fleeting reminder of where an affirmative future of the city might lie: a future that leads away from loneliness and fragmentation and towards a politics of urban living in which city dwellers undo violence in and through commonality.

Notes

1. Two recent Latin American cultural texts that engage with the tie between State, citizenship and violence through the city of private security are Claudia Piñeiro's 2005 novel *Las viudas de los jueves* (now a film directed by Marcelo Piñeyro) and the Mexican Rodrigo Plá's 2007 film *La zona*.

2. In addition to these cinematic productions, Adrián Caetano's television series *Tumberos* (2002, América TV) also engaged with this framework of criminality by depicting the lives of inmates and guards at a state penitentiary.

3. An alternative vision of the way that the police moulds its employees is evident in the song 'Hijo de yuta' [Son of a Cop] by the band El Indio. As the song goes, 'Pero vos no tenés la culpa / por haberte hecho botón, / sos hijo de la yuta. / La yuta que te parió…' [But it's not your fault / for becoming a cop, / you're a son of the force / the force that gave birth to you…]. This quote, which plays on the phonetic similarity between the words 'yuta' and 'puta', meaning bitch, is one example of the strong anti-police discourse to be found in *cumbia villera*, the musical genre of Buenos Aires' shantytowns.

4. Trapero has also stated that his recurring choice of Gran Buenos Aires was a reaction against Argentine cinema of the 1980s which was predominantly set in Capital Federal (Peña, 2003: 199). Several films contemporary to *El bonaerense* engage with the tension between interior and city. In the first episode of *Mala época/Bad Times* (dir. Various, 1998), for example, a young man comes to

Buenos Aires to seek work only to become involved in a violent encounter with a neighbour in which the latter is killed. He calls his brother to help him dispose of the body before both escape the city and its violence. In Adrián Caetano and Bruno Stagnaro's *Pizza, birra, faso/Pizza, Beer, Cigarettes* (1998), the protagonist Córdoba, his nickname emphasizing his provincial identity, is killed while trying to escape Buenos Aires to Uruguay. In *Bolivia* (2001), an illegal immigrant is murdered by a drunk, xenophobic local.

References

Aguilar, G. (2008) *Estudio crítico sobre El bonaerense*, Buenos Aires: Picnic.

Aprea, G. (2008) *Cine y políticas en Argentina: Continuidades y discontinuidades en 25 años de democracia*, Buenos Aires: Biblioteca Nacional and Universidad Nacional de General Sarmiento.

Bielinsky, F. (2000) *Nueve reinas*. Buenos Aires.

Caetano, A. (2001) *Bolivia*. Buenos Aires.

Caetano, A. and Stagnaro, B. (1998) *Pizza, birra, faso*. Buenos Aires.

Caldeira, T. (2000) *City of Walls: Crime, Segregation and Citizenship in São Paulo*, Berkeley and London: University of California Press.

Cecchi, H. (2000) *Mano Dura: Crónica de la masacre de Villa Ramallo*, Buenos Aires: Colihue.

Davis, M. (1999) *Ecology of Fear*, London: Picador.

Dutil, C. and Ragendorfer, R. (1997) *La Bonaerense: Historia criminal de la policía de la provincia de Buenos Aires*, Buenos Aires: Planeta and Espejo de la Argentina.

Gorelik, A. (2004) *Miradas sobre Buenos Aires: historia cultural y crítica urbana*, Buenos Aires: Siglo XXI.

Kalmanowiecki, L. (2000) 'Police, Politics, and Repression in Modern Argentina' in C. A. Aguirre and R. Buffington (eds.) *Reconstructing Criminality in Latin America*, Wilmington: Scholarly Resources, pp. 195–218.

Leen, C. (2008) 'City of Fear: Reimagining Buenos Aires in Contemporary Argentine Cinema', *Bulletin of Latin American Research* 27.4: 465–82.

Lerer, D. (2002) 'Pablo Trapero: el hombre suburbano' in H. Bernades et al. (eds.) *El nuevo cine argentino: Temas, autores y estilos de una renovación*, Buenos Aires: Tatanka, pp. 61–8.

Levy, D. (2001) 'Sangre', http://www.zonezero.com/EXPOSICIONES/fotografos/levy/contenido.html. Accessed July 21, 2009.

Lewkowicz, I. (2004) *Pensar sin Estado: La subjetividad en la era de la fluidez*, Buenos Aires: Paidós.

Martín-Barbero, J. (2002) 'The City: Between Fear and the Media' in S. Rotker (ed.) *Citizens of Fear: Urban Violence in Latin America*, New Brunswick, New Jersey, and London: Rutgers University Press, pp. 25–33.

Monteagudo, L. (2002) 'Un horizonte siempre azul… oscuro', *Página 12*. September 19: 23.

Peña, F. (ed.) (2003) *Generaciones 60/90: Cinema argentino independiente*, Buenos Aires: Museo de Arte Latinoamericano de Buenos Aires (MALBA).

Piñeiro, C. (2005) *Las viudas de los jueves*, Buenos Aires: Alfaguara.

Piñeyro, M. (2000) *Plata quemada*. Buenos Aires.

Plá, R. (2007) *La zona*. Mexico City.

Remedi, G. (2004) 'De *Juan Moreira* a *Un oso rojo*: Crisis del modelo neoliberal y estética neo-gauchesca', http://www.henciclopedia.org.uy/autores/Remedi/JuanMoreira1.htm. Accessed September 29, 2009.

Ricagno, A. (2003) 'Lectura de los géneros en 'el cuerpo mutante' del cine argentino: De textos y texturas' in *Imágenes en libertad: Horizontes latinos*, San Sebastián: Festival Internacional de Cine de San Sebastián, pp. 29–59.

Rocha, C. (2009) 'Violence and Masculinity in Popular Argentine Cinema of the 1990s', *Ciberletras*, http://www.lehman.cuny.edu/ciberletras/v21/rocha.htm. Accessed September 29, 2009.

Rotker, S. (2002) 'Cities Written by Violence: An Introduction' in S. Rotker (ed.) *Citizens of Fear: Urban Violence in Latin America*, New Brunswick, New Jersey, and London: Rutgers University Press, pp. 7–22.

Sain, M. (2002) *Seguridad, democracia y reforma del sistema policial en la Argentina*, Buenos Aires: Fondo de Cultural Económica.

Scherer, F. (2002) 'Contra la pared', *La Nación*, 'Via Libre' supplement. September 27: 6–8.

Smulovitz, C. (2003) 'Citizen Insecurity and Fear: Public and Private Responses in Argentina' in H. Frühling, J. S. Tulchin and H. A. Golding (eds.) *Crime and Violence in Latin America: Citizen Security, Democracy, and the State*, Washington, D.C.: Woodrow Wilson Center Press, pp. 125–52.

Trapero, P. (2002) *El bonaerense*. Buenos Aires.

Various directors. (1998) *Mala época*. Buenos Aires.

The Socially Productive Web of Brazil's Urban Über-dramas

Piers Armstrong
University of California, Los Angeles/
California State University, Los Angeles

Introduction

This chapter examines a genre of films which have been prominent in Brazilian cinema in the first decade of this century, and which are here called 'urban über-dramas'. The term is a neologism for the sleight of large-scale, graphic films which depict the more tumultuous features of contemporary urban dysfunction. These stylistically hybrid films draw on real-life dramas and integrate documental aspects, yet often make recourse to techniques not usually associated with conventional realism, including MTV and cyber-culture touches. Despite these creative variations, they are realist works marked by psychological verisimilitude and social representativity. These features mark deep shifts from Brazil's Cinema Novo avant-garde of earlier decades. The contemporary scene presents a genre continuum both between the real and the fictional, and between media. Directors, writers, performers and audiences move between film and other media, including broadcast television. This shift suggests a greater integration of film-makers into the everyday, commercially driven affairs of society at large; this chapter argues that this also means a different attitude to the social.

The key über-dramas here are Fernando Meirelles and Kátia Lund's *Cidade de Deus* (2002), which is considered emblematic, Hector Babenco's *Carandiru* (2003), and José Padilha's *Tropa de Elite* (2007). These are considered in the context of a productive web which includes earlier films (especially *Pixote*, 1981), contemporary related films (*O Invasor*, 2002; *O Homem do Ano*, 2003; *Contra Todos*, 2003; *Quase Dois Irmãos*,

2005; *Cidade Baixa*, 2005), documentaries (*Ônibus 174*, 2002; *Edifício Master*, 2002; *O Prisioneiro da Grade de Ferro*, 2004) and television (*Cidade dos Homens*, 2002–2006; *Carandiru—Outras Histórias*, 2005).

The films thus respond to currents of social sensibility which circulate in different productive arenas, and may precipitate a renewal and redefinition of these sensibilities, or provoke objections as to the validity of the filmic representation. In both cases, they point to a productive environment in which commercialization and sociological concerns coincide. This shift began in the 1980s and has consolidated since, so that it is roughly contemporaneous and consonant with the political process of democratization after the dictatorship of 1964–1985. The democratic landscape that has emerged is no utopia; rather, it presents the spectacle of dysfunction on a dramatic scale. Film-makers capture this and depict conditions which are often extreme and precarious, but also telegenic.

Today, many critics consider that the production team, as an ensemble, is displacing the role of the director-auteur. In the Brazilian case, this collectivization of creative agency is complemented by a more direct take on sociological subject matter; the treatment of contemporary urban dynamics is no longer allegorical as it typically was in Cinema Novo, but literal, or at least more conventionally realist. Despite the shift in perspective and method, the earlier generation's sense of ethical mission often persists among contemporary film-makers, and may even be enhanced. Though the tendency of ensemble production to suppress subjective extremes partly reflects commercialization, a certain democratization occurs simply because the subject matter is closer to the audience's realm of experience. Thus, the contemporary process is relatively more democratic, industrial and socially participatory.

Partial convergence of mainstream and vanguard

As Cinema Novo and the commercial industry both lost steam in the 1970s, art-house and mainstream film-making to some degree converged. Cacá Diegues' *Bye Bye Brasil* (1979), for example, reflects on cultural transformation while maintaining the burlesque flow of cabaret and even of *chanchada* (an earlier, light commercial genre). Similarly, his *Xica da Silva* (1976) oscillates between subversive farce and conventional recreation of official history. While the blockbuster of the period, Bruno Barreto's *Dona Flor e Seus Dois Maridos/Dona Flor and Her Two Husbands* (1976) was a commercial project, as an adaptation of Jorge Amado's important eponymous novel of 1966, it was also artistically ambitious. Dealing respectively with the contemporary interior (non-urban Brazil), national historical cornerstones and the provincial ambient of Salvador, these films, made during the middle years of the dictatorship by two of the handful of emerging heavyweight directors, sought to capture cultural essence and to prosper at the box-office while eschewing the 'elephant in the living-room'—contemporary

urban social and political subject matter, particularly that of São Paulo, the country's demographic magnet and the centre of political dissidence. During the hardest years of the dictatorship, 1968–1974, an alternative cinematic avant-garde movement called *Udigrudi* (adapted from 'underground') had dealt more directly with urban experience and civil dysfunction (see Xavier 1993). However, its self-conscious social and aesthetic marginalism precluded both box-office self-sufficiency and the corporate subsidized funding awarded to the projects of eminent Cinema Novo directors.

With the *abertura* of the early 1980s (the 'opening up,' i.e. the shift out of dictatorship into democracy) came films which thematize the urban environment and treat it less as a peculiar Brazilian cultural phenomenon and more as a social issue. Meanwhile, the persistence of poverty and repression through the transition into democracy somewhat defused both the attribution by progressives of a pernicious central role to the military, and also the revolutionary and millenarian themes so forcefully elaborated by Glauber Rocha, the most famous of the Cinema Novo directors.

Subsequent cinematic high-waters have deftly blended personal pathos and *denúncia* [social critique]. Perhaps the outstanding Brazilian film of the 1980s, Hector Babenco's *Pixote—A Lei do Mais Fraco/Pixote, the Law of the Weakest* (1981); henceforth, *Pixote*, masterfully balances the lead characters' individual psychologies with collectively representative portraiture. As in Buñuel's Mexican masterpiece, *Los Olvidados/The Forgotten Ones* (1950), the preponderance of children and the motif of victimhood contribute both to a humanist exemplarity and to a general psychological typification. A further achievement in *Pixote* was the vivid documentation of industrial Brazil and the civil dysfunction of its corrective institutions. Though it could not compete commercially with Bruno Barreto's *Gabriela, Cravo e Canela/Gabriela* (1983), *Pixote* did well and made its mark as a precursor film to later works addressing the deterioration of urban conditions.

The most acclaimed Brazilian film of the 1990s, Walter Salles' *Central do Brasil/ Central Station* (1998) aptly suggests by its title both intersecting personal trajectories and socially representative niches, including the tribulations of the urban lower-middle-class, the strange banality of an analogous rural class with newly constructed row-homes, and atavistic Northeastern religious praxes. The pattern is sustained in the lead film of the following decade, Fernando Meirelles and Kátia Lund's *Cidade de Deus/City of God* (2002) based on the 1997 best-selling eponymous novel (or, rather, sequence of inter-related chronicles) by Paulo Lins, a research assistant to urban anthropologist Alba Zaluar in the Rio *favela* [slum], Cidade de Deus. *Central do Brasil* and *Cidade de Deus* were each the Brazilian box-office champion of their respective decades, both domestically and abroad. Another blockbuster of the early 2000s, Babenco's *Carandiru* (2003), a graphic depiction of the 1992 massacre of 111 inmates at Carandiru prison in São Paulo, might be construed as an extension of *Pixote*, moving from the level of Dickensian child reformatory to a kind of adult hell, and from mere abuse to outright

slaughter. Thus, recently, in contrast with the Cinema Novo era, films with a sociological rather than an elite intellectual viewpoint have carried the film industry.[1]

Social webs

Meanwhile, as the sociologist Paulo Jorge Ribeiro (2003) has documented, the book and then the film of *Cidade de Deus* precipitated an extraordinary kind of extended social happening, first with cast-members drawn from *favelas* and trained as actors, and then with community debates on the legitimacy of the cinematic representation and on the actual social problems to which it pointed. Globo, the perennially dominant and generally conservative Brazilian television network, then developed *Cidade dos Homens/City of Men* (2002–2006), a television series based on characters from *Cidade de Deus*. With tremendous verve, this series dramatized both daily life inside the *favela* and the interaction with Rio's wealthy Zona Sul. A genuine shift in mainstream consciousness seemed to occur. The urban periphery, or, rather, Rio's *morros* (slums built on steep hills), became the country's psycho-social epicentre, both as fashion and as threat. Urban crime was disrupting daily life to an unprecedented degree. Meanwhile, social scientists had grasped that the tactics and some of the rhetoric of *favela* drug lords (notably, the *Comando Vermelho*, or Red Command) derived from Leftist guerrilla resistance to the dictatorship in the 1970s, thus colouring delinquency with sociopolitical implications (Zaluar 2004).

The blockbuster of 2007, José Padilha's action drama, *Tropa de Elite/Elite Squad*, focuses on Rio SWAT-type police (the Batalhão de Operações Especiais, or Bope) charged with imposing authority in a *favela* during the Pope's 1997 visit. Once again, the film is based on testimony—primarily in a 'faction' (fact and fiction) book, *Elite da Tropa* (Soares, Pimentel & Batista 2005). Drawing on personal experience, a former SWAT captain called Rodrigo Pimentel co-authored the book with an anthropologist and then co-wrote the film script. The film exposes widespread police corruption as well as bourgeois hypocrisy in the form of university students who criticize police violence but contribute themselves to the drug trade as buyers and re-sellers.

The social concerns of the fore-mentioned films can be read as an organic expression of the democratization of Brazilian politics, expressed in the exercise of a new licence to revisit the sins of the dictatorship, and, later, to explore ongoing civic dysfunctions and new ones emerging under democracy. Another film of moderate commercial success which consciously explores social and personal bonds is exemplary. Lúcia Murat's *Quase Dois Irmãos/Almost Brothers* (2005) presents dual protagonists, one from Rio's poor Zona Norte, the other from its rich Zona Sul, both of whom are imprisoned under the dictatorship. The film documents historical hardships and also argues for a strong symbiotic relation between the two classes represented respectively by the two lead characters. The proximity of brutal power relations and relative intimacy between classes points to a subtext,

grounded in the work of Brazilian socio-anthropologists, such as Gilberto Freyre (1933) and Roberto DaMatta (1978), on the peculiarities of the country's ethno-social relations.[2] The sociological resonance of the fore-mentioned films, together with the violence and raw sexuality they present, suggest a powerful new realism in Brazilian cinema, combining social awareness with muscular cinematography and broad commercial appeal.

Realism as a psycho-social construct

If the films discussed above come across as more realistic, both in subject matter and market pragmatism, it is worth scrutinizing this realism as a psycho-social construct. Realism typically supposes an implicit psychological contract with the viewer which might be summed up as a suspension of disbelief based on recognition of the legitimacy of the content—an intuitive sense of the appropriacy and good judgement of the novelist or film-maker. Where fiction most 'rings true', there is a paradoxical relation between fantasy and authenticity. It follows that lacunae in terms of verisimilitude may provoke social objections. When a story presents itself as socially authentic, improbable turns of plot or breaks of style seem to constitute a travesty of the social fabric depicted.

This occurred with *Cidade de Deus*, which was accused of a sort of Brazilian-style 'blaxploitation'.[3] For some critics, *Cidade de Deus* presents such strident stylistic deviations from realist norms as to undermine the sense of authenticity. Lins' book presents a long series of acts of physical and sexual violence, usually referenced succinctly in the text and not graphically described. The film greatly inflates the scale of the violence and in some scenes depicts it with a kinaesthetic energy verging on phantasmagorical fetish. If people were killed in real life at the rate portrayed in the film, the *favela* would presumably implode and cease to exist. Brazilian critics quickly noted the likely stylistic sources: MTV, Tarantino, action thrillers. Rodrigo Carrero and Angela Prysthon sum up the charge incisively: 'It's such a pop film that it borders on kitsch' (2003: 65, my translation).[4] Ribeiro succinctly catalogues further negative reactions by critics, such as the argument by well-known Cidade de Deus rapper MV Bill that the film's notoriety merely stigmatized the residents (Ribeiro 2006: 9). The film's directors drew on such a heterogeneous range of cinematographic *langages* (or simply stylistic quotes) that it is indeed difficult to encapsulate the overall feel of the film. Yet its manifest capacity to capture the imagination of many viewers makes clear that somehow its combination of social reference and sensational action does communicate an urban mythology with roots in real experience. The viewer is left with the puzzle of simultaneously valid judgements: on the one hand, that it was a sort of exoticism, on the other, that it was extraordinarily socially productive, engaging a local community movement and precipitating a progressive reinvention of commercial TV in the adapted series, *Cidade dos Homens*.

The social imaginary

The premise of this chapter is that most of the Brazilian urban über-dramas are susceptible to the tensions revealed in the debates about *Cidade de Deus*. The concern here is not so much the stylistic shifts internal to the cinematic medium as the external factors influencing the relation of film-makers to the social, that is, the social imaginary they bring to the table as citizens in a national culture. To bring this out, we need to consider a range of factors in the cultural landscape.

The first point is that the social logic of most views in these debates correlates validity with authenticity. Socially redolent representation has often been the default agenda of subsidized films in Latin America. Only a minority of films are made purely for entertainment and judged on their merits as such; most Brazilian and Spanish American films are still made with aspirations to artistic canons. In Cinema Novo, these tended to fall into the art-house framework of small, privileged audiences. Brazilian films are often still subsidized (Babenco's *Carandiru,* for example, was co-financed by the oil giant, Petrobrás) and have a social commitment, but have also more often appealed to mass audiences.

The next point, slightly contradictory to the first, concerns the construction of national narratives. Brazil is a narratologically centripetal society, that is, one where summative articulations of national identity are widely disseminated and deeply digested, for example, in telenovelas and popular music. The notion that what is representative portrays the national dynamic, and vice versa, fosters social mythologizing in art. In the Brazilian case, the balance between the social and the aesthetic in representative narratives tends to lean toward the imaginative. This susceptibility to national myth plays out in popular artistic domains, academic speculation and political history. Just as importantly, micro domains of social intercourse can present features replicating mythic motifs or warranting their own mythification. To underscore how this sensibility is expressed in genres other than the fiction films considered above, some related documentaries will now be discussed.

When life imitates art: some notable documentaries

When, in 2000, Rio city bus No. 174 was hijacked by a single assailant, his negotiations with police and his discussions with hostages were captured on television. José Padilha and Felipe Lacerda's documentary of this event, *Ônibus 174/Bus 174* (2002) contains scenes so intense as to seem at times like a *cinema verité* combination of Jan de Bont's *Speed* (1994, about a hijacked bus) and Sydney Lumet's *Dog Day Afternoon* (1975, based on a real bank robbery and taking of hostages in 1972). The assailant of the bus was a young man and former street urchin, Sandro do Nascimento. The documentary alternates

between television video of the four-hour stand-off between Sandro, the hostages and the police, and a biographical investigation of Sandro, emphasizing past trauma and his social milieu as the root-causes of his actions. One hostage was fatally wounded when the police attacked Sandro, who was later suffocated to death by police in a van. During the siege, he kept a gun to the head of a university student for a long period, sometimes talking to the police, sometimes to her, and getting her to write messages in lipstick on the window. The woman, Janaína Lopes Neves survived, and, in interviews shown in the documentary, describes the relations which slowly unfolded during those hours.[5] She asked Sandro about his religious beliefs and persuaded him to accept a religious medallion. She also intuited that in order to impress the police he wanted her to look like she was scared, so she herself suggested this as a strategy to him and negotiated how she should act to convey that impression. Sandro reached deals and then broke them, commented with the hostages on his views of the police, and gesticulated and improvised, evidently appreciating and intensifying his unique moment of empowered dialogue.

Though the main narrative motif in *Ônibus 174* is the drama of mortal danger, the interaction described above depicts in spectacular microcosm a Brazilian behavioural phenomenon whereby even confrontational situations like assaults may involve a considerable margin of intimate psychological interaction. It also portrays a socio-existential fluidity which is characteristic of Brazil. While this phenomenon is hard to define and beyond the scope of this chapter, the general point is that Brazilian reality affords video artists not just spectacular scenery or spectacular violence, but also distinctive modes of social interaction. Brazilian documentaries routinely reveal a remarkable theatricality in everyday life which seems to invert the documental/fictional relation, as life imitates art. A striking example is Eduardo Coutinho's documentary, *Edifício Master/The Master Building* (2002), in which the inhabitants of a modest Copacabana apartment relate intimate elements of their life stories with remarkable candour and verve.

Paulo Sacramento's extraordinary and widely-seen documentary, *O Prisioneiro da Grade de Ferro/The Prisoner of the Iron Grate* (2004) was based on visits to Carandiru and other prisons, and used footage shot and narrated by prisoners in a video workshop, graphically revealing the brutal conditions, the quantity of rats, the general tolerance of moonshine alcohol and drugs, as well as rather shocking recreational practices. On one level, the horrific situation is pregnant with local colour for the documentarian. On another level, the lack of institutional order affords a creative autonomy to the prisoners and expands their possibilities of agency in the establishment of a specialized sociability. The frequency of such challenging, unregulated environments in Brazil generates singularly creative subcultures outside as well as inside prisons.

Controversies within academia

The diverse factors outlined above (the sense of social imperative, the confluence of traditionally separated media, and the interfaces between amateurs and professionals, between communities and narratives, and even between the fantastic and the real) do not necessarily make for a cinematic magical realism. The argument here is, first, that the confluence of all the above factors has made for a jarring ensemble of hyper- and quasi-realisms which the über-dramas and related genres invoke, and, second, that despite the violations of realist orthodoxy in über-dramas, this cinematic current is socially conscious and constructive, consonant with democracy, and reflective of its imperfections.

I argued above that the subsidized production of most Brazilian cinema implies a social relationship between film-maker and public. Within this tradition, the contemporary situation suggests more precisely a sort of communitarian, civic awareness poised between the social and the directly political. The first of these communitarian features is the social continuum between film-makers, critics and the socially disenfranchised communities depicted in urban über-dramas. From the 1990s on, a wealth of communication studies scholarship has emerged in Brazil in response to urban violence and its penetration of both print journalism and the creative arts including cinema, literature and music—in short, both as a social problem and, in a DeBordian sense, in its spectacular nature (Coutinho 2008; Freire Filho & Herschmann 2005; Freire Filho & Vaz 2006). The considerable circulation of views and even exchanges of roles between persons of different social stations is evident in the *Cidade de Deus* case, in which *favela*-dwellers became actors and then critics, while university critics based in Rio's Zona Sul became involved in social intervention and action research initiatives.

Again, this process should not be seen as utopian. In due course, scholars as well as film-makers faced the charge of class-voyeurism. In an influential newspaper article entitled, 'Da Estética à Cosmética da Fome' [From the aesthetics to the cosmetics of hunger], the Brazilian film scholar Ivana Bentes (2001) sceptically summarized the transition from Cinema Novo to the new wave of films about poverty and violence. She later decried 'the camera that surfs over reality, the sign of a discourse which values the 'beauty' and 'quality' of the image... an 'international popular' or 'globalized' cinema... Folklore-world...' (Bentes 2003).[6] The counter allegation of communications studies scholar, Fernando Mascarello, in a 2004 article entitled 'O dragão da cosmética da fome contra o grande público: uma análise do elitismo da crítica da cosmética da fome e de suas relações com a Universidade' [The cosmetic hunger dragon versus mass audiences: an analysis of the cosmetics of hunger and its relation to the University], is that films like *Cidade de Deus* and *Carandiru* enhanced critical debate and awareness and that it is the scions of the ivory tower that are alienated, not the film-makers or the public.

Notwithstanding this polemic, the point here is the productive circle between artists, academia, press and community. In comparison with the United States, academic

cultural studies in Brazil are more focused on creative urban currents. The sheer volume of attention to civic dysfunction in the media occurs both at the level of potentially sensational crime reportage and highbrow editorial criticism, and as an organic response to incredibly high levels of violence. Despite their spectacular nature, then, the urban über-dramas are often depicting actions which are within the realm of experience. Regardless of the efforts of the upper classes to protect themselves from exposure to the poor, problems deriving from poverty have a ubiquitous impact because of the level of delinquency in downtown areas. At a different level, opportunities created out of poverty have a substantial impact on social infra-structure and the socio-cultural imagination. In Northeastern and other cities, NGOs working with the poor constitute a significant economic sector, and invoke constructive socio-cultural narratives and ethical principles which eventually reflect both in the cultural tourism profile of the cities and in affirmative action quotients in university admissions. The ideological contours of urban policy speak to an intertwining of class and ethnic interests. Within academia, this had been a theme since Gilberto Freyre, albeit in a politically dubious way (McNee & Lund 2006). The difference now is that the subaltern is seen, or cast, as the central protagonist, and the scholar is often seen (appropriately) as an interested party, a professional in a culture industry, rather than as an objective observer. There is, then, a dialogical system of representation and production, a new contiguity between activism from the margins, outreach from 'the system', and cinematic depiction.

Privileged motifs in mythologies of social centre and margin

In the fiction films discussed above, certain narratives prevail over others and attain mythic proportions. One important urban myth presents a narrative of fraternal symbiosis. Its ground-zero locale is the Rio-centric juxtaposition of *morro* and *asfalto* (the asphalt paved strips of flat land between *morros* and the sea). This is the *favela* of photogenic verticality and dramatic proximity to wealth, rather than the prosaic poverty-scape of the *favela* of the flat *periferia* (the outlying areas of Rio and other Brazilian cities, distant from the city's leading features, generally poor, and associated more with the lumpenproletariat than samba). In the film, *Cidade de Deus,* the Cidade de Deus *favela* is initially presented (appropriately) as flat *periferia,* though scenes more typically associated with the *morro* are later interpolated. By the time of the TV series, *Cidade dos Homens* (Globo network 2002–2006), *morro* has effectively supplanted *periferia.* Though the eye onto poverty is dubiously selective, *morro/asfalto* is an eminently poetic construct. The telegenic *morro* suggests the unconventional ascension of its outlaws, the maze of its narrow streets a labyrinth where Cartesian and bourgeois order breaks down. The *morro/asfalto* juxtaposition also points to a visceral connection between rich and poor in Brazil.

In recent cinema, this picturesque juxtaposition is developed in terms of parallel class trajectories. *Quase Dois Irmãos* is again emblematic: after the white middle-class and poor black characters have run their course into middle-age, the teenage daughter of the former is drawn to the transgressive ethos of the *favela* and seeks love there. At the root of this narrative system lies a deeper myth, of bastard brothers, arbitrarily separated into different colours and classes. This myth answers to the perennial Brazilian desire to transcend the horror of the country's divisions of race and class through cultural union. This myth is the subtext, and the one redeeming narrative motif, of Sérgio Machado's otherwise bleak *Cidade Baixa/Lower City* (2005) which presents the bloody misadventures of two inseparable young men, one black, one white, and their consort, an incipient prostitute of an intermediary colour. Like *Cidade de Deus, Cidade Baixa* takes its title from a real city region, the low-lying, flat expanse of reclaimed land in Salvador (Bahia). The intention of the film is a disavowal of the idea of poverty as picturesque (a conceit which informs the touristic niche of Salvador, the most folklorized of Brazilian cities). In the film, lowness is a metaphor for social disempowerment, and consistent with the lowly status of the area (in an inversion of the Rio layout, Salvador's Cidade Baixa lies below the wealthier parts of the city). The intention of gritty authenticity, however, is undercut by the recourse to the redeeming fraternal narrative motif, and this contradiction is symptomatic of the tension in the Brazilian imagination between harsh socio-economic realities and cultural affect.

The major negative variant of this symbiosis mythology presents the social margin as a savage, unredeemable malevolence which either invades the centre, or simply preys on itself. To give it a name, we might call it the myth of the diseased margin, connoting social periphery, bodily extremities and perverse psychological potentialities. The homeland of this system is the flat *periferia* of industrial São Paulo rather than the Rio *morro,* its key conceit sociological blight rather than cultural reinvention. *Pixote* is again particularly interesting; its story moves from a São Paulo prison to Rio as the place of liberation, thereby marking an axis between these poles, and suggesting a sort of narrative fulcrum between them.

José Henrique Fonseca's *O Homem do Ano/The Man of the Year* (2003) is based on a story set in São Paulo (Patrícia Melo's 1995 novel, *O Matador).* The film was shot and set in Rio, but, in keeping with its bleak theme, set not in the *morro* but in the *periferia* of the Baixada Fluminense (the river flats surrounding Guanabara Bay, far from the wealthy parts of the city). Roberto Moreira's *Contra Todos/Up Against Them All* (2003) portrays dysfunction in São Paulo's periferia in the drama of a family where the father is a hit-man who thinks he wants to leave for spiritual renewal in the countryside, his promiscuous daughter uses drugs and listens to heavy metal music, and his wife has a lover. In keeping with the negative myth, there is no hope, and the lover is not only killed but also castrated.

The assault of the *periferia* as genuine menace is captured in Beto Brant's much admired *O Invasor/The Trespasser* (2002). In this film, two business partners contract a hit-man from the underclass to kill their third and senior partner. The hit-man does

his job but then, attracted by their wealthy world, invades their lives. He also begins a romantic relationship with the victim's daughter. *O Invasor* is not so much a thriller as a drama, building on a broader perspective than generic white middle-class paranoia. In *O Invasor,* one of the partners undergoes a moral crisis after the crime, but it affords no solution. The sociological charge of the relationship of the hit-man with the daughter is suggested in scenes where the two look out over the expanse of the city at night and philosophize. While the implicit sadism of the hit-man's participation in the relationship is psychologically unpleasant, the daughter's receptivity reiterates the continuum of corruption between him and her family. Finally, the film documentally transcribes its subject city by accumulating scenes in a wide range of urban and suburban locations. To Paulistanos (residents of the city of São Paulo) in particular, the familiar topography makes the perversions depicted more disturbing. The film thus 'invades' the peace of mind of the viewer, leaving a residue of unresolved, social interrogation.

Stories as social cycles, realist frames, and American comparisons

If in these fiction films the Brazilian metropolis itself emerges as a diseased or mutilated protagonist, it remains a social entity. In the more famous über-dramas, it tends toward a crude urban warfare propelling telegenic spectacles. In *O Invasor,* it is something of a sphinx slouching toward Bethlehem, vast and inscrutable, dangerous and compelling. In all of these films, the city presented is proximate to everyday experience. The civic dysfunction is realist rather than fantastical; the Rio-São Paulo of these films is not the Gotham of *Batman* films, nor the Los Angeles of Ridley Scott's *Blade Runner* (1982).[7] And yet the conventional bounds of realism are stretched beyond the more austere narrative framing of the metropolis in American analogues (semi-documental urban violence films) such as the New York of Sydney Lumet's *Serpico* (1973) or the Los Angeles of Dennis Hopper's *Colors* (1988) or John Singleton's *Boys N the Hood* (1991).

In the United States, even though each of these films was inspired by civic indignation, they remained one-off pieces, restricted to the universe of film drama. In contrast, reflecting their relation to ongoing front-line civic debates, the Brazilian urban über-dramas are anchored, with other sorts of work, in creative eco-systems. The *Cidade de Deus favela*-crisis cycle includes the best-seller chronicles, the film and the *Cidade dos Homens* TV series and the spin-off film (*Cidade dos Homens,* 2007, directed by Paulo Morelli).

The pattern continues with the other über-dramas. The Carandiru incarceration-crisis cycle begins with the 1992 massacre itself, which provoked songs by pop stars, including Caetano Veloso and Gilberto Gil's 'Haiti,' and Racionais MCs' 'Diário de um Detento'. It continues with the shocking memoirs of a volunteer medic at the prison Drauzio Varella, *Estação Carandiru* [Carandiru Station] (1999). This served as the initial base for Babenco's

2003 film, and also inspired Paulo Sacramento's *O Prisioneiro da Grade de Ferro*. Like the feature film, that documentary served to expose existing conditions in penitentiaries. It also created opportunities for agential roles for the victims. By making Carandiru prisoners (who were participating in a video workshop) the creators of scenes, a range of powerfully subjective discourses emerge. Though the montage remained controlled by the director, the prisoners' control of the camera, together with their inherently radical subaltern status, make this documentary as constructively novel as it is socially shocking. The cycle continued with the 2005 Babenco-produced television series for Globo, *Carandiru—Outras Histórias/Carandiru—Other Stories*, which used actors from the film.[8]

The *Tropa de Elite* cycle begins with the faction book by Soares, Pimentel and Batista *(Elite da Tropa)*. It also links the progressive documentary and the urban über-drama: Padilha, who co-directed the *Ônibus 174* documentary, went on to direct the big budget action adventure *(Tropa de Elite)*. The Bope police corps depicted in the feature film was also the one involved in the *Ônibus 174* drama. Several police involved in the earlier incident would go on to work in the production of the fiction film—thereby bringing policemen into the creative mix, an integration perhaps more surprising than that of subalterns as actors.

The *Pixote* cycle refracts from 'faction' to fiction and on to history in an even larger and more extraordinary arc. The film was based on *Infância dos Mortos* [The childhood of the dead], the 1975 *romance-reportagem* (a fictionalized version of journalistic reporting), by outspoken crime-journalist José Louzeiro, about a 1974 incident where São Paulo police beat 93 detained minors and then dumped them over an embankment in a Minas Gerais town (subsequently known as 'Operação Camanducaia,' after the name of the town). Fernando Ramos da Silva, the child actor who played Pixote was a 12-year-old amateur, drawn from Diadema in São Paulo (the industrial periferia rather than a *favela*). After further acting work in Rio ran dry, he returned to his family base, married and fathered a child, unsuccessfully attempted to set up a business locally, got involved in local petty crime, and, in 1987, was shot to death by police in his home at age 19. The extraordinary outcome was widely reported in the press at the time, and the mythic aspect of the story was patent. Several of his brothers were also murdered in other incidents. José Joffily's 1996 docudrama, *Quem Matou Pixote?/Who Killed Pixote?*, takes these incidents as a point of departure for an exposé of poverty and civic dysfunction. Felipe Brisso and Gilberto Topczewski's documentary, *Pixote, In Memoriam* (2005) examines the whole production cycle of *Pixote* and its afterlife in the Ramos da Silva trajectory.

These aestheticized myths about national social history manifest as productive cycles mediating through different arenas of social, critical and creative domains. It is apt that of all these remarkable instances, *Pixote,* a brilliant synthesis of social documentation, psychological pathos and artistic execution, presents the most extraordinary case of mirroring between life and art. In his study of Babenco's adaptations of *romance-reportagem* (in addition to *Pixote,* his eponymous adaptation of Louzeiro's even grimmer

Lúcio Flávio, o passageiro da agonia/Lúcio Flávio, the passenger of dying, (1977), Randal Johnson (1987) examines how the director deliberately pastiched documental touches into his film fiction. Johnson also touches on film scholar Ismail Xavier's contrary critical perspective on stylistic appropriacy in documental fiction films. Xavier (1993) rejects conventional realist dramas, including *Pixote,* in favour of a method of juxtaposition of fragments of fiction and documentary so that the viewer is forced to maintain critical, negative consciousness.

Xavier's critique is still relevant today, and resonates with Bentes' *cosmética da fome* argument. It is, however, circumscribed within a theoretical, politicized sphere—it makes more sense under dictatorship than under democracy. Regardless of the margin of non-verisimilar touches in recent works, it is Babenco's conventional method, in which suspension of disbelief is maintained, that has flourished in the *retomada*. This is suggested in the neutrality of the term *retomada* itself: unlike Cinema Novo, the accent is on production per se rather than any stylistic novelty. The 'real' is found not in any prescriptive denunciation, but rather in the simpler act of representation of socially-relevant phenomena. The critical view is determined by the film-makers, but with limited autonomy. There is, instead, a common trend to juxtapose and thus relativize various viewpoints and stances. The dramas portrayed (drug wars, police violence, misogyny, etc.) are already conspicuous in real life and involve as many normal as marginal persons. The directorial view is mediated by and likely to reflect a social triangulation of community, press and academia. As such, it is now more likely to have both the broad fairness and the mediocrities and half-truths of actual democracies.

From a politically critical point of view, the *Pixote* creative system (*romance-reportagem,* film, documentary, etc.) is, rather a productive cycle, a vicious circle which should be cause for demands for forcefully imposed reforms rather than artistic opportunism. But there are grounds for cautious optimism. The depiction of subaltern sites also incorporates subaltern artists and to some degree empowers them beyond those sites. To return once again to the Cidade de Deus/*Cidade de Deus* context, the author, Paulo Lins, is an exemplary bottom-up figure. He was a resident of the *favela* and a poet, who became a research assistant and then a novelist. He has since become a player in the film and TV industry, directing an episode of the TV programme *Cidade dos Homens* and working as a writer in unrelated projects such as Murat's *Quase Dois Irmãos.* In a parallel manner, rising actors such as Lázaro Ramos (the star of *Carandiru, Cidade Baixa,* and Karim Ainouz's 2002 film *Madame Satã/Madame Satan,* who has roots in communitarian theatre rather than the Globo telenovela star stable (Ramos originally rose to prominence in the Bando de Teatro Olodum, a theatre troupe linked to the Afro-centric Salvador carnival club, Olodum), suggest that, if nothing else, the film industry has become more socially porous.

Conclusion

The situations, cosmovisions and cinematic styles of contemporary film-makers differ from those of the vanguardists almost as much as the political regimes of the respective eras. Nevertheless, the imperative of socially representative realism suggests a continuity of aims, despite the difference of means. Cinema Novo was in part the adaptation of the French *nouvelle vague* to a Third World context where social urgencies outweighed existential caprices as a thematic imperative, culminating in the allegorical repudiation of the ideologies of the dictatorship. That canonical heritage endures more in ethical than in cinematographic terms. The old art-house logic, whereby the audience rather obediently yields to the superior imagination of the director, has ceded to agendas which are more germane to the audience's own urban experience. This more familiar sphere of reference and the integration of mainstream production values are the marks of a new realist style, which tends, paradoxically, to both a stronger psychological verisimilitude and to kinaesthetic sensationalism.

Beyond the telegenic physical aspect of Rio's *morro*, Brazilian social realities can seem larger than life. Contemporary cinema seems to have shifted focus from the individual genius of the director as auteur toward a notion of society at large as a dynamic and inherently creative space with diverse everyday protagonists whose real adventures are worthy of portrayal. The urban über-dramas draw on real-life dramas and consciously integrate documental aspects, and yet are susceptible to fantastical stylistic elements. Overall, their aspiration to social mimesis successfully sustains the psychological compact of realism. Despite their sensationalism, they should be recognized as part of a creative social cycle which links to community politics and to an informal social science education. Meanwhile, from the other side of the fact-versus-fiction divide, Brazilian documentaries also move toward the overlapping centre, drawing not only on graphic Third World miseries but also, more intriguingly, on the discursive performativity of their real-world subjects and the intense local colour of real-life adventures.

Notes

1. In Brazil, initial box office attendances (in the first year of release) were as follows: *Cidade de Deus*, 3.1 million; *Central do Brasil*, 1.1 million; *Carandiru*, 4.5 million; *Tropa de elite* (discussed below), 2.1 million (source: Internet Movie Data Base, www.imdb.com, retrieved July 2, 2008). The first two were more widely and successfully distributed internationally. On balance, *Cidade de Deus* was the most commercially successful.

2. Freyre's (1933) seminal narrative asserts that, and describes how, the interdependence of Brazilian racial castes (poor coloured, and advantaged Euro-Brazilians) evolved into a mutual social seduction. DaMatta (1978) concurs, but emphasizes the reversal of power, or at least of symbolic capital, that occurs between classes during carnival.

3. Blaxploitation, from 'black exploitation,' is a negative descriptor for a sub-genre of American films of the 1970s which featured black protagonists in glamorous but criminal contexts; such films are considered as contributing to a negative stereotype; the most famous is Gordon Parks' *Shaft*, of 1971, immortalized by Isaac Hayes' soundtrack.

4. Original: 'É um filme tão pop que chega quase a ser kitsch.'

5. Segments of the film including the testimony of the victim and the death of the hostage holder can be seen on YouTube (for example, the clip entitled 'Sociologia - Ônibus 174' http://www.youtube.com/watch?v=FqQMXSDPMd8, retrieved May 15, 2009).

6. '…a câmera que surfa sobre a realidade, signo de um discurso que valoriza o 'belo' e a 'qualidade' da imagem… Um cinema 'internacional popular' ou 'globalizado'… Folclore-mundo.' My translation. Source: www.eco.ufrj.br/semiosfera/especial2003/ http://www.eco.ufrj.br/semiosfera/especial2003/entrevis/txtentre.htm. Accessed November 12, 2007 (no longer available).

7. The most recent *Batman* film, Christopher Nolan's *The Dark Knight* (2008), is interesting in this respect. Its plot departs from the escapist fantasy of its prequels, and events are made to hinge on a positive social effort made under great stress by a crowd of ordinary people (on a ferry boat where there may be a bomb). From there the film reverts to escapist fantasy.

8. At the BRASA IX conference, (2008, New Orleans), Robert Stam presented an as-yet unpublished overview of the Carandiru cycle, looking beyond the immediate creative products to international 'Prison Theory' and to the 'discursive afterlife of Carandiru.'

References

Ainouz, K. (2002) *Madame Satã*, Rio de Janeiro: Vídeo Filmes; Paris: Lumière.

Aquino, M. (2002) *O Invasor*, São Paulo: Geração.

Babenco, H. (2005) *Carandiru—Outras Histórias*, São Paulo: HB Filmes.

Babenco, H. (2003) *Carandiru*, Rio de Janeiro: BR Petrobrás/Globo Filmes/Columbia TriStar Filmes do Brasil/HB Filmes.

Babenco, H. (1981) *Pixote –A Lei do Mais Fraco*, Rio de Janeiro: Embrafilme/São Paulo: HB Filmes.

Babenco, H. (1977) *Lúcio Flávio, o Passageiro da Agonia*, São Paulo: HB Filmes.

Barreto, B. (1983) *Gabriela, Cravo e Canela*, Rio de Janeiro: Sultana.

Barreto, B. (1976) *Dona Flor e Seus Dois Maridos,* Rio de Janeiro: Carnaval Unifilm.

Bentes, I. (2003) 'Estéticas da violência no cinema,' *Interseções: Revista de Estudos Interdisciplinares* 5.1:217-37. Reprinted in the UFRJ e-journal, *Semiosfera* [Online] 3.3. Available from: www.eco.ufrj.br/semiosfera/especial2003/http://www.eco.ufrj.br/semiosfera/especial2003/entrevis/txtentre.htm. Accessed November 12, 2007.

Bentes, I. (July 8, 2001) 'Da Estética à Cosmética da Fome,' *Jornal do Brasil.* Caderno B: 1–4.

Brant, B. (2002) *O Invasor*, São Paulo: Drama Filmes.

Brisso, F. and Topczewski, G. (2005) *Pixote, In Memoriam*, Documentary, São Paulo: BigBonsai Productions.

Buñuel, L. (1950) *Los Olvidados,* Mexico, D.F: Ultramar Films.

Camus, M. (1958) *Orfeu Negro*, Rio de Janeiro: Dispat Films.

Carrero, R. and Prysthon, A. (2003) 'Da periferia industrial à periferia fashion: dois momentos do cinema brasileiro,' *Eco Pós* 5.2:56–67.

Cidade dos Homens (2002–2006) Television series, Rio de Janeiro: Globo Filmes.

Coutinho, E. (ed.) (2008) *Comunicação e Contra-hegemonia*, Rio de Janeiro: Editora UFRJ.

Coutinho, E. (2002) *Edifício Master*, Rio de Janeiro: VideoFilmes.

DaMatta, R. (1978) *Carnavais, Malandros e Herois: Para uma Sociologia do Dilema Brasileiro*, Rio de Janeiro: Zahar.

De Bont, J. (1994) *Speed*, Los Angeles: 20th Century Fox.

Diegues, C. (1979) *Bye bye Brasil*, Rio de Janeiro: Luiz Carlos Barreto Produções Cinematográficas

Diegues, C. (1976) *Xica da Silva*, Rio de Janeiro: Embrafilme/Terra Filmes

Fonseca, J. H. (2003) *O Homem do Ano*, Rio de Janeiro: Conspiração Filmes.

Freire Filho, J. and Vaz, P. (eds.) (2006) *Construções do Tempo e do Outro. Representações e Discursos Midiáticos sobre a Alteridade*, Rio de Janeiro: Mauad.

Freire Filho, J. and Herschmann, M. (eds.) (2005) *Comunicação, Cultura e Consumo. A (Des)construção do Espetáculo Contemporâneo*, Rio de Janeiro: E-papers.

Freyre, G. (1933) *Casa Grande e Senzala*, Rio de Janeiro: Maia & Schmidt.

Hopper, D. (1988) *Colors,* Los Angeles: Orion Pictures Corporation.

Joffily, J. (1996) *Quem Matou Pixote?*, Rio de Janeiro: Coevos Filmes.

Johnson, R. (1987) 'The *romance-reportagem* and the cinema: Babenco's *Lúcio Flávio* and *Pixote*', *Luso-Brazilian Review* 24.2: 35–48.

Lins, P. (1997) *Cidade de Deus*, São Paulo: Companhia das Letras.

Louzeiro, J. (1977) *Infância dos Mortos*, São Paulo: Record.

Louzeiro, J. (1975) *Lúcio Flávio, o Passageiro da Agonia,* Rio de Janeiro: Civilização Brasileira.

Lumet, S. (1975) *Dog Day Afternoon*, New York: Artists Entertainment Complex.

Lumet, S. (1973) *Serpico,* New York: Artists Entertainment Complex

Machado, S. (2005) *Cidade Baixa*, Rio de Janeiro: VideoFilmes.

Mascarello, F. (2004) 'O dragão da coméstica da fome contra o grande público: uma análise do elitismo da crítica da cosmética da fome e de suas relações com a Universidade,' *Intexto* 11.2, http://www.seer.ufrgs.br/index.php/intexto/article/view/4076/4449. Accessed May 20, 2008.

McNee, M. and Lund, J. (eds.) (2006) *Gilberto Freyre e os Estudos Latinoamericanos*, Pittsburgh: Instituto Internacional de Literatura Iberoamericana.

Meirelles, F. and Lund, K. (2002) *Cidade de Deus*, Rio de Janeiro: O2 Filmes/VideoFilmes.

Melo, P. (1995) *O Matador*, São Paulo: Companhia das Letras.

Moreira, R. (2003) *Contra Todos*, São Paulo: Coração da Selva/O2 Filmes.

Morelli, P. (2007) *Cidade dos Homens*, Rio de Janeiro: Fox Filmes do Brasil.

Murat, L. (2005) *Quase Dois Irmãos*, Rio de Janeiro: Taiga Filmes.

Nolan, C. (2008) *The Dark Knight*, Los Angeles: Warner Brothers.

Padilha, J. (2007) *Tropa de Elite,* Rio de Janeiro: Zazen Produções.

Padilha, J. and Lacerda, F. (2002) *Ônibus 174*, Rio de Janeiro: Zazen Produções.

Parks, G. (1971) *Shaft*, Los Angeles: Metro-Goldwyn-Mayer (MGM).

Ribeiro, P. J. (2006) 'Discutindo práticas representacionais com imagens – *Cidade de Deus*,' Seminar – Centro de Estudos da Metrópole, São Paulo. July 10, 2006, www.centrodametropole.org.br/seminarios/5cidade_de_deus.pdf. Accessed May 17, 2007.

Ribeiro, P. J. (2003) 'Cidade de Deus na zona de contato—alguns impasses da crítica cultural contemporânea,' *Revista de Crítica Literaria Latinoamericana* 29.57: 125–39.

Rocha, G. (1965) 'Uma estética da fome,' *Revista Civilização Brasileira* 1.3: 165-70.

Sacramento, P. (2004) *O Prisioneiro da Grade de Ferro*, São Paulo: Olhos de Cão Produções Cinematográficas.

Salles, W. (1998) *Central do Brasil*, Paris: Canal+.

Scott, R. (1982) *Blade Runner*, Los Angeles: The Ladd Company

Singleton, J. (1991) *Boys N the Hood*, Los Angeles: Columbia Pictures Corporation.

Soares, L. E., Pimentel, R. and Batista, A. (2005) *Elite da Tropa*, Rio de Janeiro: Objetiva.

Souza, P. de (1983) *O Prisioneiro da Grade de Ferro*, São Paulo: Traço.

Varella, D. (1999) *Estação Carandiru*, São Paulo: Companhia das Letras.

Xavier, I. (1993) *Alegorias do Subdesenvolvimento: Cinema Novo, Tropicalismo, Cinema Marginal*, São Paulo: Brasiliense.

Zaluar, A. (2004) *Integração Perversa: Pobreza e Tráfico de Drogas*, Rio de Janeiro: Fundação Getúlio Vargas.

Fernando Meirelles' *Cidade de Deus/City of God*: The Representation of Racial Resentment and Violence In the New Brazilian Social Cinema

Vanessa Fitzgibbon
Brigham Young University

Bakhtin's theories of dialogic interrelations and utterances reveal that literary concepts of heteroglossia, also referred as multi-languagedness, and polyphony, or many-voicedness, offer a valuable contribution to modern forms of representation and performance, in particular in the field of Latin American social cinema. Bakhtin's concepts of dialogic narrative, carnivalization, orchestration of voices, authoritative and authorial discourses, and double-voiced character-narrators seem to fit the principle that heteroglossia, the 'centrifugal, stratifying forces' that promote a verbal-ideological process of decentralization and disunification (Bakhtin 1981: 272), represents a key mechanism for the representation of current marginal situations of social, cultural, racial, political and historical distress. In the search for 'the authentic environment of an utterance, the environment in which it lives and takes shape' (Ibid: 272), Fernando Meirelles' *City of God* (2002) reveals the authentic 'dialogized heteroglossia' that transformed the film into 'a crucial event, a borehole in the conscience of the country' (Jabor 2005: iii). As Meirelles has stated, his goal was to have the spectator leave the film with more than a memory of 'an individual story, but the perception of the social, cultural, geographic, and even poetic context where the story really took place' (Meirelles 2005: 13).

This chapter examines several aspects of Bakhtin's heteroglossia and polyphony as key elements found in the ability of *City of God*'s narrator to orchestrate the voice and the internal speech of the 'otherness'. However, we will limit ourselves to analysing the historical, social and cultural circumstances that create the racial resentment faced by Afro-Brazilians throughout the escalation of violence. As heteroglossia insures the

predominance of historical and social circumstances outside the text, the marginal voices portrayed in Meirelles' film will corroborate in the establishment of the utterances as an individual's expression of the national language, which points to the spectator's active role in the process of awareness urged by the storyline. According to Bakhtin,

> ... the role of the *others* [spectators] for whom the utterance is constructed is extremely great... the role of these others, for whom my thought becomes actual thought for the first time (and thus for my own self as well) is not that of passive listeners, but of active participants in speech communication. From the very beginning, the speaker expects a response from them, an active responsive understanding. The entire utterance is constructed, as it were, in anticipation of encountering this response. (Bakhtin 1986: 94)

As we will observe in *City of God*, one of its most intriguing aspects consists in the creation of a polyphonic microcosm of more than 200 characters with 'a plurality of consciousness, with equal rights and each with its own world' (Bakhtin 1984: 6), revealing 'major heroes' who are '*not only objects of authorial discourse but also subjects of their own directly signifying discourse*' (Ibid: 7, emphasis added). They desperately attempt to transpose their monological marginal discourses onto a dialogical discourse with the world outside of the *favela* [slum]. As a result, the discourse immerses in the narrative and attempts to present a narrator orchestrating a diversity of marginal speeches, mimicking not only the multiplicity of voices of the characters but also the chaotic state in which the *locus*, the individual and society find themselves. Beginning with a deconstructive, cyclical and dynamic process, the narrator juxtaposes lyricism with prose, violence with reflection, resentment with humour. Marginal utterances defy Brazil's hegemonic discourse developed by centuries of oppression of Afro-Brazilians by their white masters, and a new authoritative utterance sets the tone of the narrative, which becomes as powerful as the bandits' war arsenals. Heteroglossia then becomes a natural technique to depict the anthropological, sociopolitical, economical, cultural, literary and historical elements that culminate with racial tension, placing the *favela*'s discourse, words and utterances in their proper context. Hence, the narrator's comments, interruptions and cuts are woven into the story in an attempt not only to reproduce the linguistic interplay between the signified and the signifier, but also to make the dialogue with the spectator more effective.

In *City of God*'s opening scene, the trivial and banal preparation of a typical Sunday meal set to the vibrant rhythm of the samba calls to mind the stereotype of Brazil as the nation of Carnival where 'everything turns into a samba'. The relation between the characters and the complexity of the situation that follows can be interpreted as a modern day Menippean satire as described by Bakhtin in *Problems of Dostoevsky's Poetics* (1984: 112–22), a connection which surfaces several times throughout the film. Satire and humour will bring relief to high-stress situations of violence and transgression, as well as

a bearable balance to the narrative and to the audience. As Bakhtin elucidates, although the original menippea does not allow polyphony, it can 'prepare certain generic conditions necessary for polyphony's emergence' (Ibid: 122). In this case, spectators identify with carnivalization, becoming to a certain degree closer to the characters as together they depart to the 'reverse side of the world (*'monde à l'envers'*)' (Ibid: 122) represented by the *favela*. In the case of the opening scene, carnivalization also triggers the narrator Rocket's problematic existence as 'a chicken who knows too much,' as Walter Salles (2005: 3) puts it. Salles also comments on how Rocket becomes a chicken in both senses of the word: literally, when the narrator trades places with the animal, and symbolically, as a coward who is trying to escape his inevitable fate. After a 180-degree turn of the camera, the trapped narrator tragically notes that 'things here in the City of God are like this: if you run, you'll be caught; if you stay, you'll be eaten alive.' As Rocket becomes the character-narrator who will denounce an alienated and repressed society, his individual utterances will also represent the collective voice of the 'otherness'.

This metaphorical interplay between the literal and the symbolic reflects an endemic and deeply-rooted fatalism, and the concept is reinforced by the effect of the camera, which, as it repeatedly makes 180-degree turns, gains momentum and, without interruption, becomes a kind of time machine, or a way to rewind the film, transporting both narrator and spectator to what should be perceived as the birthplace of this tragedy. At this moment, the audience sees that 'the chicken caught in the crossfire at the beginning... is not only a chicken. It is the reflection of so many Brazilians trapped in an unjust country' (Salles 2005: 3). This transition and allegorical shift awakens spectators to the fact that their involvement with the film is not passive since, little by little, and in part subconsciously, they are being educated about this stigmatized and undesirable world, and their involvement proves to be much more tangible than expected.

The constant narrator

As Meirelles places the audience in the centre of the imaginary circle created by the camera effect, he also establishes a sympathetic relationship with Rocket, a black adolescent (let us stress *non*-mulatto and *non*-white). He alone is responsible for carrying forward the narrative's unity and orchestrating the diverse voices and testimonies presented, which also expresses the 'dialectic of the oppressed' that educates the spectator about the inconceivable reality of drug-trafficking. As an oral narrator, Rocket represents the 'common people': 'a storyteller is not a literary person; he belongs in most cases to the lower social strata, to the common people... and he brings with him oral speech' (Bakhtin 1984: 192). It is through the guidance of Rocket that the audience is able to understand the utterances of the cinematic plot, which otherwise might appear confusing or ambiguous due to the cuts, flashbacks and fast forwards. In this sense, Rocket becomes

a translator for the *favela*'s residents and drug dealers. His speech appears fully detached and alienated from the formality of the educated discourse of Brazil's middle and upper classes. The narrator's authenticity and trustworthiness is established in part by his age and the favelian reality that poor bandits die before they turn 25 (Zaluar 1994: 7). It is this knowledge that death will come early and tragically that establishes Rocket as a trustworthy storyteller who deals with centrifugal and centripetal forces that allow the spectator to grasp the heteroglossia of this unimaginable world.

As the narrative flashes back to the 1960s, we find Rocket as a little boy playing goalie in a pick-up soccer game where he proves to be an unskilled player. This flashback brings the story line to the three members of the *Trio Ternura* [Tender Trio], Shaggy, Clipper, and Goose, a melding of Robin Hood and Hollywood. These images given in a yellowish tone create a sense of nostalgia and romance, thus setting up one of the first contrasts with the violence suggested by the opening scene. Upon returning to the genesis of the story, the audience is able to verify that the bandits portrayed at this point in the film 'do not possess political significance, nor do they pose a threat to the social order. Instead the film seeks a realistic representation of this social type... in order to chart the disappearance of social banditry in contemporary society' (Line 2005: 73). This relocation to a remote time, with special emphasis given to the use of colour, solidifies the film's *locus* as the main character in the story and those who live in the slum, as will be discussed later. The whole set of techniques and devices used in this segment of the narrative work together to establish a contrasting tone between the past, present and future. At the same time, this dialogization between the different times is maintained in order to help spectators, as part of their education, identify the historical reasons for discrimination that will culminate in the uncontrollable acceleration of violence.

The story line articulated in this first part of the film, accentuated by the romantic dialogue between one of the members of the *Trio Ternura*, Shaggy, and his girlfriend, Berenice, further traces the transformation of the characters from this time into the bandits we see in the opening scenes, pursuing the chicken and ending up in a face-to-face confrontation with the police as a direct result of the social discrimination and economic challenges the country is facing in the 1960s. In this transition, the mystery that surrounds the motel robbery is crucial to the transformation of both the *persona* and the *locus* in question. The massacre makes the headlines of the newspapers due to the extremely barbarous nature of the act, attributed to the *Trio Ternura*, and calls into question the trustworthiness of the narrator: could there be in the images shown a glamorization of violence, or simply an omission by the narrator of the real mass execution, favouring the image of the *good crook* over the cold-blooded killers? The romantic (and even innocent) aura in which the first stage of the story is wrapped gradually disappears. The scenes mount in intensity and violence, highlighted by the chromatic discolouration of the various takes, marking the end of an era of disillusionment. A new phase starts and a sense of hopelessness develops with the dead-end street foreshadowed at the beginning by Rocket. From its beginning, the

film establishes the complicity among outcasts, community, family and police, in a place where there is no judicial system or social order that can point out where a crime begins or ends. Justice is built on a subjective foundation, since the police themselves share in the perpetuation of violence and corruption. As Salles (2005: 3) notes, '*City of God* does not offer the comforting and touristy image of the Brazilian slums that Marcel Camus' 1959 film *Orfeu Negro/Black Orpheus* sold to the world. This film is about a nation within a nation, about the millions of *olvidados* [the forgotten ones] that are statistically relevant, but scarcely represented on screen.' Thus, it becomes the narrator's responsibility to favour and reveal the victims and those whose voices have been stifled and never represented, presenting those voices as both victims and perpetrators.

The *Locus* as a Character

According to the narrator, the City of God is a residential complex built by the Brazilian government in the 1960s in response to floods and fires set by arsons. The majority of the residents of the complex moved there under the illusion and promise of a better life, but they soon discovered that they were in a marginalized area with none of the standard improvements common to urban infrastructure, an area to which mostly blacks and *nordestinos* [impoverished migrants from Brazil's drought-stricken Northeast] had been relocated. As Rocket tells us:

> The bigwigs in government didn't joke around. Homeless? Off to City of God. There was no electricity, paved streets or transportation. But for the rich and powerful, our problems didn't matter. We were too far removed from the picture postcard image of Rio de Janeiro.

It is important to note that this little piece of discourse, which deals with the residents' perception of the government, is one of the very few references to the world outside of the *favela*. There is no other reflection or indication regarding this period of Brazilian history and the political unrest that prevailed at that time. The military dictatorship (1964–1985), which marked one of the most restless eras of Brazilian history, is reduced almost to a footnote, thus emphasizing two fundamental aspects of Meirelles' work: first, the portrayal of the slum communities as totally detached from the rest of the country, shut out from any engagement in political and economical activity; and second, the ideological isolation of Meirelles' work, which resists becoming a mere memory jogger of former political oppression, but rather opens up a discussion of the social problems faced by 'other' Brazilians.

As Meirelles skillfully isolates the community without juxtaposing the parallel historical context with which Brazilians are familiar, he succeeds in focusing our attention on the human and social drama that distressed a large part of the population at the time, but

which had gone unnoticed and ignored in many levels of society.[1] Slowly but surely the residents, the condition of their lives, the attacks, the deception—all the details that are inserted into the drama—leave no doubt about the characterization of the *locus* as a living and active agent, albeit one isolated from the national scene. According to Else Vieira (2005: xiii), the *favela* takes on a new dimension 'because it describes more than a geographic place inhabited by poverty; it highlights a number of other dimensions and connotations. It conveys a strong sense of marginalisation and the socio-economic condition of those disenfranchised by modernisation policies.' The feeling the spectator gets is that the slum, a very undesirable place, is not as far away as one might imagine or desire.

From its inception, Rio's City of God, being located near one of the main social, cultural and economic centres of the country, has represented a threat to the postcard image that modern Brazil would like to project to the world. The *favela* becomes a magnet where the main groups excluded from Brazilian politics and economics, namely Afro-Brazilians and migrant *nordestinos*, come together. By creating these housing projects, the government ends up not only isolating these outcasts from society but also demonstrating an expectation on the part of the elite that this mass of people will eventually 'self destruct'. As Ivana Bentes (2005: 86) notes:

> The *favela* is a controversial postcard, a kind of museum of misery, a not yet overcome historical stage of capitalism. And the poor, who should have started becoming extinct through the production of wealth in the world, are part of this strange 'reservoir', 'preserved', but likely to fall outside the grip of the government and blow up, thus 'threatening' the city.

These individuals, contrary to the anticipation that they will increasingly work themselves out of the slum, end up as marked persons because '[v]ulnerability and extreme discomfort mark out their lives. They are those who have to cope with constant threats because, deprived of a place to live, they occupy irregularly; they are thus exemplary of the survival strategy of the undesirables' (Vieira 2005: xiii). Moreover, the social, historical and political components pointed out by Bentes and Vieira echo the nineteenth-century eugenic theories originally formulated by Francis Galton that predicted the disappearance and self-destruction of inferior races.[2]

With the passing of time, the failure of the theories of the 'non-survival of the non-fit' has had catastrophic results: instead of phasing out a race considered 'undesirable', there has occurred an exponential multiplication of social violence and estrangement. If, on the one hand, part of society wants to forever exorcize the *favela* from the official national landscape, there are, on the other hand, other segments that argue that this portrayal of outcasts by Brazilian cinema is as a result of trends engendered by globalization, inviting the denunciation of all these 'other' voices and underworlds that generate the present violence and the multi-languagedness that will be represented.

As Meirelles' film moves to the 1970s, the audience begins to see the portrayal of violence in a much broader context. Now 18 years old, Rocket reappears side by side with a group of friends on the beach, his first camera in hand. This is the only shot of a Rio tourist spot, which until now has been hidden from the spectator's view. The narrator then shares with the viewer, through the use of voice-over and flashback, the organization of a new capitalist empire: the founding of the Boca dos Apês gang, and hence the start of institutional drug-trafficking. Characters from the past populate the scene and their transfiguration is accompanied by the physical transformation of the *locus*, already dehumanized and dominated by violence and trafficking.

The story resumes in a dark, dirty, torn-up apartment surrounded by an aura of mysticism and spectres that appear and disappear, making clear that in the City of God the only law that exists is the reign of violence. Li'l Dice, an 18-year-old, arrives with Benny and another young man and articulates his own personal transformation: 'Li'l Dice, my ass! My name is Li'l Zé now!' In a new flashback and voice-over, a digression leads to the night of the motel robbery and the narrator's trustworthiness is re-established as the audience is informed that it had been Li'l Dice who had perpetrated the massacre that incriminated the *Trio Ternura*: 'That night, Li'l Dice satisfied his thirst to kill…' In a tangled web of voice-overs, flashbacks and fragments, not everything is expressly connected, heightening the complexity of the characters' situation while leaving some blanks yet to be filled in.

As important as what has been narrated and seen may be (with the scenes carefully selected from Rocket's memory), that which we do not hear or see is of equal significance; utterances and heteroglossia are found only in the visual representation of selected scenes, being the spectator's responsibility to identify them and establish their relation to the world outside of the *favela*. In the evolution of Li'l Dice into Li'l Zé and the circumstances that turned him, at the age of 18, into one of 'the most wanted robbers in Rio', the composition of Li'l Zé's personality becomes very problematic and creates doubt regarding the source of the violence he exhibits. At first, due to the lack of context for his actions, there is no historical relationship that can link the character to his surroundings or contextualize his inherited hate and resentment. Yet Li'l Zé, although ostensibly a fictional character, brings together real-world traits whose patent dehumanization transfigures him into a paradigm of violence. Li'l Zé gives a voice and a visibility to the current widespread savagery and social rejection, while at the same time bringing the diverse facets of the Good/Evil binary to the forefront.

At this point, the spectators have been exposed to a series of transformations that allow them to now see drug-trafficking as a well-established entrepreneurship. The spectators' discernment of Good and Evil is challenged once again and attains a new perspective when they find Li'l Zé taking on a new role—that of *enforcer* and *lawman* responsible for maintaining relative order in an otherwise lawless realm. The spectators then witness one of the most powerful scenes in the film, pushing the edge of the unbearable. After the armed robbery of a bakery, the young boys of the Runts (another gang) hide in the

backstreets with the spoils of their heist, but suddenly they are cornered by Li'l Zé and his mob. As the law-enforcer, Li'l Zé decides their punishment: a bullet in either the hand or foot of one of the Runts. More than the punishment itself, this episode dramatizes the loss of innocence for the gang kids who have been trapped like animals, as well as for Steak and Fries, a 12-year-old boy tasked with executing the punishment dictated by Li'l Zé and thereby becoming a 'man'. At this point in time, reality totally dominates the viewer, who is now pulled into the scene on several different emotional levels. Ismael Xavier comments on the impact of this scene, where 'the boys under pressure end up crying, their denied childhood emerging on faces otherwise trained to look tough. The scene is long so we have time to process our emotions, and the effect is a mix of catharsis and identification' (Xavier 2003: 30). This is a crucial dialogical moment between images and the spectator is left alone by the narrator to ponder the implications of the scene. Victims themselves of the aggressions on the main streets of Brazil, the (Brazilian) audience begins to judge the situation of the film based on their own daily experiences with violence from the boys on the street, the delinquents and gangs that stand threatening on every street corner. The concept of Good and Evil becomes obscured and forgotten as a consequence of the pervasiveness of the violence portrayed. If Li'l Zé's cruelty was condemnable earlier, viewers are forced to re-evaluate his microcosm now that he is portrayed as a protector and enforcer of law and order. It is the spectator who will associate these outcasts in this unknown Rio with the Rio de Janeiro of Corcovado and Sugar Loaf. The almost unbearable feeling conveyed to the audience is as a result of the documentary and technical nature of the film, which Meirelles portrays with precision. For example, the scene with the Runts was filmed with two handheld cameras, providing a sense of continuity and reality that has impressed even the most sceptical critics. The documentary character of the work and the absence of any form of metaphorical portrayals are strongly supported by the camera's going in and out of focus and by the absence of sets and lighting. Nevertheless, the highlight of the work is the performance of the amateur actors, where real utterances merge with fiction to create a powerful outcome. While filming, real tears pour out in a kind of trance through which the boys pass as they fuse the emotion of fiction with their own personal experiences, mixing realism with fantasy (Mantovani, Meirelles & Muller 2003: 110–11) and leaving even the production team unsure as to whether the tears were good acting or the product of real suffering.

Aided by the fact that no makeup was used that could detract from the authenticity of the scene, the spectator immediately becomes conscious of the fact that the aggression and violence that have been witnessed are irreversible processes that often transcend the sphere of perceived reality. Underlining all of this buildup is a faint ray of hope that the *favela* and its evils can be overcome, especially when Rocket meets Knockout Ned, a young black worker who has been seeking a way to break out of the vicious cycle of crime in the slums, with whom Rocket starts to identify. However, Knockout Ned follows a path pre-determined by the story of many young men in similar circumstances. With

the rape of his girlfriend and the humiliation he has to bear, the issues of vengeance and fighting for one's wounded honour arise in Knockout Ned's mind as expected, proving his powerlessness in transcending the circle of crime and violence established by the *locus*: 'In seeking revenge, he allows himself to be co-opted and reproduces the dynamic of which he had been a victim' (Soares 2005: 119). After the rape scene, Rocket leads the spectator to a new story (Knockout Ned's), which he introduces with a dose of black humour: 'The problem was simple: Li'l Zé was ugly. Knockout Ned was handsome… It was a duel between the handsome good guy and the ugly bad guy.'

Knockout Ned's desire for revenge materializes when he joins Carrot's gang, setting off a chain reaction of one of the most violent (and true) wars in the history of Rio's *favelas*. With fast-action scenes, disjointed edits and the lack of colour and lighting in most of the scenes, Meirelles establishes the rhythm of violence and also reinforces the rhythm of gunfire. The documentary power of the film is bolstered by a recorded segment from the *Jornal Nacional* news broadcast in which commentator Sérgio Chapelin announces the arrest of Manuel Machado (Knockout Ned) after being shot in a battle between the two gangs. This montage emphasizes the fact that what we see as fiction is part of the official history of the country and introduces the placement of a new weapon into the hands of the bandits—the media. Furthermore, as Bentes suggests, 'The film also shows the attraction and fascination that the lads in the *favelas* have for guns, for the exercise of power, and for the pleasure of being feared and respected. If they are not respected as citizens, then they'll be respected as figures in the media, as criminals' (Bentes 2005: 89). Li'l Zé's obsession is no longer the visibility that a bandit of the 1960s could achieve through a simple photograph, but rather the notoriety and the recognition by the outside world of his power to inflict chaos. This opens the door for Rocket, giving him the chance to pass himself off as a photographer and get out of the favelian maelstrom in which he exists. The narrative shifts back to the point where it left off in the beginning; the symbolic chicken again comes into play, this time removed from its carnivalization, since 'violence does not know laughter' (Bakhtin 1986: 134). Now it carries a three-fold meaning: chicken-bird, Rocket-chicken/coward, and Knockout Ned-chicken/handsome.[3]

As we come to the anticipated denouement of this narrative, the irony of the death of Li'l Zé and Knockout Ned shows that the story does not end there. What has been told to the spectator up to this point was only the beginning of the perpetuation of violence, with power now being passed on to the Runts and the introduction of a new gang, the Falange Vermelha [Red Phalanx], that rises to a new level of violence in Rio's criminal underworld. The violence emblazoned on this final stage is presented without any historical justification, confirming Gerard Martin's contention about Colombian cinema, which can also be said of Brazilian cinema:

> The current violence is experienced as an eruption of the past but at
> the same time as a 'violence without history… massacres are related to

conflicts between local power contenders as guerrilla and mafia-type organizations, without references to a general cause, while no other points of anchorage are available: collective identities, civil rights and political citizenship are already historically weak and have suffered and were partially destroyed by the new violence. (Martin 2000: 183)

In the case of *City of God* the official history of the nation is overpowered by the violence in the discourse and lives of the 'otherness' revealing what the government and the elites wished to be left forgotten. As a result, the *locus,* represented as an active, autonomous character, gains power and strength to trap and stigmatize those whose visibility has been denied by racial discrimination.

Racial resentment: The voiceless and the unseen

As the film exposes the polyphonic voices of an obscured and violent world, Meirelles creates almost imperceptible filters to bring out the subtle problems of racial discrimination, in part blurred by the tensions created by the narrative itself, decoding this unknown world into identifiable utterances for the audience. As Thomas Allen Harris' documentary *That's my Face* (2001) suggests, in Brazil the skin colour 'black' is closely associated with poverty and ignorance, which are also related to the stigma of the *favela*. People will therefore identify themselves linguistically as 'light mulatto', 'tan', 'chocolate' and 'coffee milk', but never as 'black'. The 'whitening' process sought after by *City of God*'s characters confirms this stereotype, a 'mythological image' (Bakhtin 1981: 369), while also pointing one more time to the nineteenth-century eugenic tendencies in Latin America, according to which a person's skin colour was much more 'sociological than biological' (Stepan 1991: 65). In this sense, the characters' escape from the inner circle of the *favela* would not just guarantee them life over death, but it would also cover up their stigma, allowing them to become socially visible and active. As several utterances have already been determined, at this point we are able to identify three different moments when the consciousness of racial discrimination confirms each utterance presented, creating the ideological and representational meaning that allows heteroglossia to transpose linguistic barriers into a cinematic representation. It is through these three examples of racial resentment that Meirelles' work validates Bakhtin's emphasis of heteroglossia as a necessary mechanism to 'wash over a [sealed-off] culture's awareness of itself and its language, penetrat[ing] to its core, relativiz[ing] the primary language system underlying its ideology and literature and depriv[ing] it of its naïve absence of conflict' (Bakhtin 1981:368). The transformation of each character presented then corroborates the plurality of voices and the multi-languagedness expressed by the narrator's orchestration.

The first recognizable endeavour to transpose the circle is found in Clipper, a character who looks for regeneration in Protestantism, making him the only member of the *Trio Ternura* to survive. In a scene shrouded in magical realism and mysticism, Clipper searches for a type of protection that could take away the stigma of his racial and social condition by accepting guidance from a 'higher force'. In this case, it is the Christian faith and its aura of honesty,[4] which is characterized mainly by its physical and psychological traits that transform both individuals and society's acceptance of them.

The second and most dramatic example of the consciousness of a double-standard criterion of discrimination can be found in Benny's attempt to transcend the circle. Caught within the 'inner' circle of the *favela* by his association with Li'l Zé, as he acquires money and prestige he faces the *external* circle, represented by his girlfriend and the groovies. Members of the latter group, however, are physically allowed to be part of both worlds and are not discriminated against as 'black', even though some of them live in the same housing project or are frequent visitors there. For Benny, the whitening process to which he subjects himself is based on standards of conduct and social acceptability, identified not exclusively by his colour of skin or afro hair, but also by economic status, as he projects himself to the outside circle of the *favela*. Despite the good nature that permeates this character, however, the *favela*'s uncontrolled violence does not spare him from a tragic end, demonstrating once again how the majority of these young people are locked into their circle.

The third attempt to leave the *favelian* circle comes from Rocket, who 'refuses to engage in the gang wars, substituting a camera for a gun, culture for violence' (Xavier 2003: 28). After overcoming his fears and confrontations with Li'l Zé, he is able to reconcile both worlds, understanding what should or should not be done to keep this interaction possible. This posture becomes clear in the end when he contemplates the photos showing the bloodshed that led to Li'l Zé's death, reflecting on the paths and options he could choose. As Rocket wisely ponders: 'This picture of the hood will get me the job. This one will make me famous. It'll even make the cover of a magazine... But the cops?' As Luiz Eduardo Soares concludes, 'the narrator sacrificed the Truth for a life without risk, giving us, paradoxically, this unforgettable film that unmasks what he disguises' (Soares 2005: 119). Rocket subjects himself to co-opting the hegemonic discourse as the result of a deep reflection on his true racial and social condition established by the stigma of the *favela*. Later, the question of racial identity on an outcast is emphasized when the film shows that the same individual can be subject to the transforming power of the media. While Manuel Machado becomes known 'officially' by his nickname Knockout Ned, branding him as an outcast, the opposite is true for Rocket. He becomes Wilson Rodrigues, photographer, due to his acceptance in social circles outside the *favela*, thus becoming known by a legitimate first and last name.

Conclusion

Meirelles' use of Bakhtin's heteroglossia and polyphony transforms the violence found in the film's portrayed utterances into a confrontation between truth/reality and what the public and the critics want to see. After the release of the film, hegemonic classes argued about the representation of the banality of violence, while accusations of the appropriation and glamorization of the *favela* made the Brazilian society and government aware of the stigmatization of the *favelados*. However, if we consider Bakhtin's statement that in all times and in 'each social circle... there are always authoritative utterances that set the tone...which are cited, imitated, followed' (1986: 88), then Brazilian society's reaction reveals the fear of a threat imposed by a new discourse, an 'external multi-languagedness speech' (Bakhtin 1981: 368), establishing a new cultural trend. A close analysis of *City of God* confirms Bakhtin's analysis by faithfully reproducing the utterances of a population that, up until then, had no voice, no name, and no face, but that became visible and audible at an alarming rate. The polyphonic voices harmonized by Rocket end up being converted into a unique, tragically authoritative utterance, indicating causes of class order, economic and social, in a society that brought upon itself the present state of violence, savagery and uncontrolled drug-trafficking. Violence afflicts not only the historical aggressor, colonizer or oppressor, but, even worse, those who have already been attacked, colonized and oppressed for many centuries, perpetuating their predicament and revealing an obsession to get revenge for a traumatized past. Meirelles' use of cinematic techniques applied to the narrative's heteroglossia reveals in a compelling and insightful way a tragedy of racial bias and discrimination that had been missing from national memory and conscience, but has finally emerged for the spectator of Latin American social cinema.

Notes

1. To further stress who the target audience of the film originally was, Meirelles himself affirms that 'there are images in the film which an international audience would not understand' (in Shaw 2005: 68), thus demonstrating his sole concern for first telling the story, rather than producing something more commercially palatable.

2. In Brazil, Galton's eugenic theories were mainly defended by Raimundo Nina Rodrigues in *As raças humanas e a responsabilidade no Brasil* [The human races and responsibility in Brazil] (1894), and Renato Kehl, who founded the São Paulo Eugenics Society in 1918, the first step towards the establishment of the new science in Latin America (Stepan 1991: 47).

3. Knockout Ned's original name in Portuguese, Mané Galinha, connotes a man who attracts many women (a galinha [chicken]).

4. As Ricardo Grinbaum points out, the growth of Protestant churches and their consequent embrace by this segment of the population, is explained by the 'aura of honesty' that their members acquire because they come out 'formally dressed with their hair combed and the Bible on their lips,' an image that becomes 'a good calling card…[leading to] getting jobs, avoiding police raids, and, at times, being left alone by some of the crooks…Their image is one of correctness and discipline. It is the reverse of the old rogue' (Grinbaum 1996: 54, my translation).

References

Bakhtin, M. (1986) 'The Problem of the Text in Linguistics, Philology, and the Human Sciences: An Experiment in Philosophical Analysis' (Trans. V. McGee) in C. Emerson and M. Holquist (eds.) *Speech Genres and Other Late Essays*, Austin: University of Texas Press, pp. 103-131.

Bakhtin, M. (1986) 'From Notes' (Trans. V. McGee) in C. Emerson and M. Holquist (eds.) *Speech Genres and Other Late Essays*, Austin: University of Texas Press, pp. 132-158.

Bakhtin, M. (1984) 'Problems of Dostoevsky's Poetics' (Trans. C. Emerson) in C. Emerson (ed.) *Theory and History of Literature*, Vol. 8, Minneapolis: University of Minnesota Press.

Bakhtin, M. (1981) *The Dialogic Imagination* (Trans. C. Emerson and M. Holquist), Austin: University of Texas Press.

Bentes, I. (2005) 'The Aesthetics of Violence in Brazilian Film' (Trans. E. M. Lopes) in E. Vieira (ed.) *City of God in Several Voices: Brazilian Social Cinema as Action*, Nottingham: CCC, pp. 82–92.

Camus M. (1959) *Orfeu Negro*, France: Dispat Films; Italy: Gemma; Brazil: Tupan Filmes

Grinbaum, R. (1996) 'O brasileiro segundo ele mesmo', *Veja*, January 10: 48–57.

Harris, T. A. (2001) *That's My Face/É minha cara*, New York: Chimpanzee Productions, Inc.

Jabor, A. (2005) 'Preface' in E. Vieira (ed.) *City of God in Several Voices: Brazilian Social Cinema as Action*, Nottingham: CCCP, pp. iii-iv.

Line, J. (2005) 'Trajectories of *Malandragem* in F. Meirelles's *City of God*' in E. Vieira (ed.) *City of God in Several Voices: Brazilian Social Cinema as Action*. Nottingham: CCCP, pp. 71–81.

Mantovani, B., Meirelles, F. & Muller, A.L. (2003) *Cidade de Deus: O roteiro do filme*, São Paulo: Objetiva.

Martin, G. (2000) 'The 'Tradition of Violence' in Colombia: Material and Symbolic Aspects' in A. Goran and J. Abbink (eds.) *Meanings of Violence* New York: Berg, pp. 161–91.

Meirelles, F. (2005) 'Writing the Script, Finding and Preparing the Cast' (Trans. E. M. Lopes) in E. Vieira (ed.) *City of God in Several Voices: Brazilian Social Cinema as Action*, Nottingham: CCCP, pp. 13-25.

Meirelles, F. and Lund, K. (2002) *Cidade de Deus*, Rio de Janeiro: 02 Filmes/VideoFilmes.

Salles, W. (2005) 'A Traumatised Chicken in a Crossfire' in E. Vieira (ed.) *City of God in Several Voices: Brazilian Social Cinema as Action*, Nottingham: CCCP.

Shaw, M. (2005) 'The Brazilian *Goodfellas: Cidade de Deus* as a Gangster Film?' in E. Vieira (ed.) *City of God in Several Voices: Brazilian Social Cinema as Action*, Nottingham: CCCP.

Soares, L. E. (2005) 'The City of God and of the Devil' (Trans. J. Line and N. Alves) in *City of God in Several Voices: Brazilian Social Cinema as Action*, Nottingham: CCCP, pp. 117-20.

Stepan, N. L. (1991) *'The Hour of Eugenics': Race, Gender, and Nation in Latin America*, Ithaca and London: Cornell U P.

Vieira, E. R. P. (2005) 'Introduction: Is the Camera Mightier Than the Word?' in E. Vieira (ed.) *City of God in Several Voices: Brazilian Social Cinema as Action*, Nottingham, CCCP, pp. v-xxviii.

Xavier, I. (2003) "Angels With Dirty Faces," *Sights and Sounds* 13.1: 28–30.

Zaluar, A. (1994) *Condomínio do Diabo*, Rio de Janeiro: UFRJ Editora.

Staging Class, Gender and Ethnicity In Lucrecia Martel's *La ciénaga/The Swamp*[1]

Ana Peluffo

University of California, Davis

There is a well-known saying about Argentines and their national origins that I would like to use as a point of departure for my reflections on the cinematic vision of Lucrecia Martel in *La ciénaga/The Swamp* (2001): 'Los mexicanos descienden de los aztecas, los peruanos de los incas y los argentinos de los barcos' [Mexicans descend from the Aztecs, Peruvians from the Incas, and Argentines from the ships]. In this ideologically-charged dictum, the metaphor of the ship obliterates the cultural contributions of an Indigenous Other that was geographically there, occupying the land, before the arrival of massive European immigration. As sociologists Mario Margulis and Marcelo Urresti have perceptively observed in *La segregación negada* [The Denied Segregation] (1998), the idea of the Argentine nation has been shaped both by the multicultural concept of the '*crisol de razas*' [melting pot] and by the cultural invisibility of an indigenous population that contradicts the desired homogeneity of the national self. If all cultures rely on a principle of collective identity based on the imagined cohesiveness of a desired 'Us', the above-mentioned saying depicts Argentines as displaced Europeans who try to distance themselves from their Indigenous past.

When trying to define what has recently been called New Argentine Cinema, critics have identified a tendency to complicate the centre-periphery dichotomy that has structured cultural thought in Argentina since the beginning of the nineteenth century (Wolf 2002; 30; Falicov 2007). The focus on Buenos Aires as the cultural referent of the cinematic gaze (Caetano, Rejtman, Villegas and Acuña among others) coexists in contemporary film with an interest in areas of Argentina that were often excluded from the discourses of modernization (Alonso, Murga, Sorín, Martel, Katz). While

in the past Argentine film-makers presented a 'Europeanized' vision of the nation in which Buenos Aires assumed the role of an impoverished Paris of Latin America, contemporary directors now construct a city in ruins, marked by abandonment and economic devastation.[2] In the case of Martel's *La ciénaga,* the film's imagined community is an almost feudal society in which the upper classes from Salta (an economically disadvantaged province from the North) fantasize about Andean Bolivia as a new shopping Mecca and in which the 'modernity' of Buenos Aires is all but a distant echo. Although much has been written about *La ciénaga,* a film that has achieved iconic status in recent years, critics have focused mainly on gender issues, failing to reveal the way in which class and ethnicity add depth and complexity to the construction of cinematic identities. In this chapter, I read Lucrecia Martel's film as a visual exposé of the contradictions of the ideology of racism in contemporary Argentina, a country that, following Sarmiento's ideas about 'civilization and barbarism', has attempted to represent itself as more 'European or civilized' than its Latin American neighbors.[3]

Lucrecia Martel's *La ciénaga* shares with *Bolivia* (2001) by Adrián Caetano an impetus to turn racial oppression into an explicit film topic.[4] The fact that Martel grew up in Salta, a province that has a large indigenous population, helps to explain the film's focus on interlocking systems of marginalization. Perhaps it is not a complete coincidence that the film came out in the context of the 2001 Argentine crisis precipitated by the complete collapse of the economy and the bank system. The dire state of the economy forced President Fernando De la Rúa (term of office 1999–2001) to freeze bank accounts [*corralito*], unleashing unprecedented social protests and revolt. The 'crisis of the millennium', as Flavia Fiorucci and Marcus Klein have called it, signalled a shift in how Argentines viewed their cultural identity (2004: xi). When images of extreme poverty, including malnourished street children, starving indigenous communities, and families of *cartoneros* searching for cardboard in garbage piles inundated the television screens, it became clear that Argentina had fallen catastrophically from the *grandeur* of its own European illusions. Following the crisis, the devastating consequences of years of neoliberal policies that decimated the most vulnerable sectors of the population through corruption and aggressive privatization became too visible to ignore.

In the aftermath of a crisis that took many years to develop, the loss of employment resulted in the growth of unregulated and informal jobs (Whitson n.d.). Salient among these was domestic service, an occupation that constituted throughout history one of the largest sources of employment for lower class women in contemporary Argentina. As an anti-modern occupation carried over from feudal times, domestic service tends to be performed by women of *mestizo* and indigenous backgrounds who undertake this type of work out of economic desperation, lack of education, and limited options in the public sphere. As Judith Rollins points out in *Between Women: Domestics and their Employers,* domestic service is a globally despised occupation because 'it is one of the two forms of work historically accepted as women's labor (the other being prostitution) that has an

ancient and modern association with slavery' (Rollins 1985: 59). Performed in almost complete isolation from other workers, domestic helpers 'are essentially "invisible" to themselves and to society' (Chaney & García Castro 1989: 4). In analysing the complexity of a relationship that is both affectionate and exploitative, hostile and intimate, Rollins argues that maternalism is 'the dynamic around which the relationship pivot [s]' (Rollins 1985: 178). In feudal paternalism's feminized version, maternalism proposes a logic of exchange by which an employer will not only offer food, shelter and a minimum salary but also affection and protection in exchange for obedience, deference, and childish submission. What differentiates domestic work from other blue-collar occupations is that it takes place in the realm of the private and that it is modelled on the affective caring that occurs between a mother and a child. If the figure of the paternalistic boss is invested with an aura of patriarchal authority that his feminized equivalent lacks, the feminization of the bond must accentuate class superiority as a place from which authority and power can be exerted.

Recent readings of *La ciénaga* have detected in it a feminocentric slant that highlights the opposition between two upper class women and their families: Mecha (Graciela Borges) and Tali (Mercedes Morán).[5] Less attention, however, has been paid to the filmic representation of the domestic worker and to the homo-sentimental alliance that develops between Isabel (Andrea López) and Momi (Sofía Bertolotto). The asymmetrical bonds between *empleada* [maid] and *patrona* [mistress] complicate our desire to read the film from a gendered perspective while ignoring ethnicity and class as markers of identity. Contrary to feminist expectations, household work does not create gender solidarity among women in a private sphere that Martel depicts as fractured by many tensions. In order to analyse the intersectionality between race, gender and class in the film, I focus on the household as a contact zone where Indian domestic workers [*kollas*] have to build their identity in the context of a hierarchical relationship with the more 'European-looking' upper classes. Werner Sollors (1995) has underscored the importance of language in the invention of ethnicity following Benedict Anderson's ([1983]2006) ideas about the construction of national identity. Just as nationalism 'invents nations where they do not exist', says Sollors (1989: xx) paraphrasing Anderson, the paradigm of rhetorical construction can be equally productive to understand ethnicity. In my reading of *La ciénaga*, I will draw upon Sollors' idea that ethnicity is not a self-evident category or a biological essence but a linguistic construction that emerges as the result of clashes and encounters between intersecting social groups (Ibid: xix).

In *La ciénaga*'s opening frame, Momi is praying by her servant's sleeping body, thanking God for giving her Isabel. Taking the sleeve of the maid's uniform to her lips as if it were a rosary, Momi mutters her prayers in a private *mise-en-scène* that highlights the confused geography of the house. The lights that the curtain reflects on the wall emphasize the shadowy and claustrophobic undertones of a taboo relationship that is occurring behind closed doors. It is not until the next frame that the viewer learns that Isabel is the live-in

maid, and that Mecha (Momi's racist mother) wants to fire her because she believes she is stealing towels. The physical position of the two bodies on the single bed underscores Momi and Isabel's contradictory sentimental needs. By turning her back to the upper class girl, Isabel communicates to the camera her need for privacy in a very crammed household where she is always under the panoptic gaze of her employers. In Momi's case, her desire to touch Isabel's sleeping body emphasizes an emotional necessity for affection and physical closeness that will be rejected by Isabel's involuntary body movements.

In Momi's prayer, Isabel becomes a precious commodity, indispensable for the girl's survival in a chaotic household where both parents are alcoholics. As a counterpoint to *La ciénaga*'s inaugural scene by the pool in which the eye of the camera focuses on fragments of decrepit bodies –legs affected by cellulite, protruding middle aged bellies, bald heads, wounds, and wrinkles—the female bodies in the bedroom scene are young, beautiful and multi-racial (Isabel's skin is slightly darker than Momi's). For Momi, an insecure teenager who is always nervously chewing on the neck of her shirt, Isabel is a fetishized Other who performs multiple roles as mother substitute, sister, and object of desire. The intensity of the girl's feelings becomes evident in a tearful dialogue with her sister Verónica (Leonora Balcarce) filmed through a rare close-up shot of Momi's face: 'No quiero estar más con nadie que con Isabel', she tells her [I do not want to be with anyone but Isabel].[6] The phrase calls attention to the rebelliousness and vulnerability of a middle class girl who is clearly at odds with her family's worldview. Momi's visionary powers stem from her liminal position in a family that ultimately resents her brutal lucidity and her ability to foresee her mother's future. As Laura Podalsky (2007) puts it in 'Out of Depth: The Politics of Disaffected Youth and Contemporary Latin American Cinema', the importance of Momi as one of the main characters with whom the camera identifies is that she is 'the only one to sense the latent forces ignored by the other characters' (Podalsky 2007:117).

In *Otros mundos* (2006), Gonzalo Aguilar makes a distinction between sedentary and nomadic films in Argentina that places *La ciénaga* in the former category based on its naturalistic movement towards decline. In a centripetal film depicting a family in crisis, orphanhood becomes a key topic. Technically, Momi is not an orphan because she has a family, but she frequently appears lost and zombie-like in the stagnant atmosphere of the domestic swamp.[7] Mecha, Momi's mother, is physically present but affectively absent, and the father does not even know how old his daughter is: 'Ya te dije que tenés que sacar el registro' [I already told you that you need to get a license], he says to Momi in the aftermath of Mecha's fall. 'Pero tengo quince años' [But I am fifteen] she responds, reminding her father that in Argentina you have to be 18 to be able to drive. In this dystopian scenario, Isabel becomes Mecha's domestic double, the person who performs the degraded work that the upper class woman refuses to do. Mecha, who drinks all the time, delegates all maternal duties on to the servants and, by doing so, she manages to appear transgressive and dominant in a society that wants women to be like her maternal and domestic cousin, Tali. In the cinematic depiction of the female genealogy, the maid

214

mitigates Momi's feelings of maternal abandonment. Thus, it is Isabel who tells Momi that she needs to get dressed or take a shower, and it is she who warns Momi not to go into the rotten pool because she can get sick. And yet, the maternal reading of the affective bond between Momi and Isabel does not do complete justice to the lesbian feelings that Momi has for her domestic servant. The romantic liaison is more asymmetrical than reciprocal, stemming mostly from Momi's side.

In the binary logic that the dominant classes use to structure the family chaos (clean/dirty; hard-working/lazy; promiscuous/pure) Momi and Isabel share an unstable position that frequently coincides with the devalued term of the equation. In a telling scene at a store in town, Verónica (Leonora Balcarce) is buying a shirt for her brother José (Juan Cruz Bordeu) while the camera, situated inside the store, captures Momi's anguish at seeing Isabel and el Perro (Fabio Villafañe) talking intimately outside. Martel uses depth of field to highlight the tensions between the three social groups (upper class girls, Isabel and *kolla* men) in a very dense frame constructed in layers. In a hierarchical community symbolically divided by the glass store window that separates the insiders (Verónica and her cousins) from the outsiders (el Perro and his friends), Isabel's comings and goings point to her marginal position in both groups. While the location of the girls in the interior of the shop allegorizes their privileged role as consumers in a capitalist economy that excludes other sectors of society, Isabel leaves the store to join members of her own ethnic group. Isabel's gender position pulls her in the direction of Momi and her sisters but her class and ethnic affiliation create a discomfort zone that tears her apart in the direction of el Perro and his friends. If the 'I' of the colonized is shaped by contact and interaction between different social groups, as Ella Shohat and Robert Stam (1994) claim, Isabel's sudden impulse to briefly abandon a world where she occupies the space of the Other suggests that, for her, ethnic and class bonds are stronger than gender solidarity. Isabel's identification with el Perro as a male racial Other in this scene, underscores the importance of class and ethnic bonds in the ongoing social negotiations that lead to the construction of cultural identities. In the case of Momi, the wish to separate el Perro from Isabel and his friends is less determined by an inclusionary or democratic impulse to welcome him into her social group than by a repressed lesbian desire to separate Isabel from her heterosexual companion.

In the opening scenes of the film, a subjective camera follows Momi's sentimental obsession with the domestic worker spying on Isabel's whereabouts from windowpanes and doorframes. The eye of the camera turns Isabel into an object of *scopophilia* [pleasure of viewing], a Freudian term coined by Laura Mulvey (1985) in the seventies that, as Lola Young demonstrates in *Fear of the Dark* (2006), does not pay enough attention to the representational specificities of women from different ethnic groups.[8]

The relationship between Momi and her servant is marked by a constant tension between closeness and separation, affection and disdain. The tears that Momi sheds at the beginning of the film for fear that Isabel will be fired by her mother are echoed in one of the final scenes, when Isabel silently cries in Momi's bed, on the night of her imminent departure. In

a dysfunctional family that, as the barred windows seem to imply, has turned into a prison for Momi, the mobility of the maid, who leaves *La mandrágora* on weekends, becomes a source of anxiety for sedentary Momi, building momentum until the very end. The multiple separations between the two women become an anticipation of the last departure scene in which Momi watches a pregnant Isabel from the window as she leaves the house forever to start a new life with her boyfriend. While el Perro waits for her at the fence, holding his bicycle, a subjective long shot captures Isabel's tiny silhouette crossing the bright green lawn.

In Martel's filmic community, women hire domestic workers not only to get help with household chores but also to affirm an invisible class status based on a racialized process of cultural differentiation. In a white household inhabited by the maid as a racial Other, the upper classes are constantly building symbolic barriers to create an artificial sense of distance between themselves and their domestic servants. If ethnic differentiation is a discourse typically based on a process of magnified contrast by which one social group seeks to distance itself from another, as Sollors has observed (1995: 288), the filmic text shows how the dominant group resorts to racial stereotypes that emphasize antithesis, negativity and difference. In the case of Mecha's family it is precisely the physical proximity and daily intimacy between the two groups that triggers the mistress' desire to put down the servant as a way of elevating herself. Through the use of racial epithets and animalistic expressions, Mecha asserts a power that depends on the depersonalization and bestialization of the other. Albert Memmi has characterized this refusal on the part of the colonizer to see the humanity of the colonized as the 'mark of the plural'. As he points out in *The Colonizer and the Colonized* (2003), the dominant subject never sees the colonized as an individual but as a specimen belonging to a collective group. When Mecha tells Isabel that she is lazy, promiscuous, ungrateful, ignorant or a thief, she does it by invoking negative stereotypes that encircle Isabel's subjectivity in different variations of the 'así son todas' [they are all the same] phrase. Isabel's role in the family is to perform that negative or deficient identity that Mecha 's racist gaze has assigned her in a pre-existing script. In her analysis of the mistress-domestic worker dyad, Rollins opines that 'the presence of the deference-giving inferior enhances the employer's self-esteem as an individual, neutralizes some of her resentment as a woman, and, where appropriate, *strengthens her sense of self as a white person*' (Rollins 2003: 180, my emphasis).

The film represents the bond between *empleada* and *patrona* as an unequal power relationship in which the mistress makes the domestic worker unable to be heard. In the departure scene from *La ciénaga*, Isabel fondles nervously an empty glass between her hands while she tries to find the courage to tell her female boss that she is quitting her job. The glass prop, so important in the inaugural scene as a source of the diegetic sound of the clicking ice, appears again, this time empty and soundless. When Isabel says deferentially: 'Señora, tengo que hablar con usted' [Madam, I have to talk to you], Mecha interrupts her with a blunt command: 'Tomá, traeme hielo' [Here. Bring ice]. The formal and respectful 'Usted' [You] that Isabel utters contrasts with Mecha's abrupt orders.[9] Since Mecha does

not see Isabel as a human being but as a piece of property, she does not have time to listen to what her subaltern has to say. Nor does she feel compelled to use the word please or to phrase the command as a rhetorical question ('¿Podrías traerme?'). In the second part of the verbal exchange, Isabel tries again to make herself heard, emphasizing that she is not leaving out of choice but forced by necessity. 'Señora *le tengo que decir* que *me tengo que ir* a la casa de mi hermana' (my emphasis) [Madam. *I have to tell you* that *I have to go* to my sister's house]. From her colonial position, Mecha reads Isabel's departure as a personal offense ('Yo te necesito acá' [But I need you here]) and as a confirmation of her suspicions about her domestic assistant's sexual excess: '¿Cuál será el motivo? no? China carnavalera' [I wonder what the motive must be. Right? Wild Indian Girl].[10] Mecha sees Isabel as an archetype, an undifferentiated member of a collectivity of 'chinas' (indigenous women) who put up temporarily with Mecha's abuses ('favours' in the eyes of Mecha) to eventually leave her with surprising regularity: 'Una les da todo. Familia, casa, comida y así te pagan. Son todas iguales. Siempre te dejan' [One gives them everything. Family, lodging, food and this is how they pay you. They are all the same]. Isabel's deferential manner and her inability to speak from a marginal position underlines her vulnerability as an employee and the successful ways in which her authoritarian boss has instilled inferiority in her. Isabel's pregnancy worries Mecha, not because she is a teenager who will not have the means to support her child but because it will alter the lethargic rhythm of her own quotidian life. As a result of Isabel's departure, Mecha will have to look for another servant, who will also, probably, end up abandoning her. Since Mecha hired Isabel not to enter the labour market as a professional woman like Mercedes, but to make Isabel perform devalued domestic duties, her imminent desertion provokes a moment of panic that unleashes racist anger.

La ciénaga thematizes how the upper strata construct an ethnic barrier that allows them to portray themselves as superior in a racial hierarchy that is inextricably linked to class.[11] Tali and her husband look more *mestizo* than light skinned but their class status prevents them from seeing themselves as Indigenous. In one telling scene, Tali, who is sometimes considered Mecha's opposite, makes racist remarks about the carnival music that she hears off screen performed by kollas/Indians. 'Estos indios me tienen harta', she says, 'toda la noche machacan. Dale que dale, no dejan dormir a nadie' [I am sick of these Indians… they make noise all night. They do not let anybody sleep]. In what ultimately becomes a cinematic depiction of the contradictions of the ideology of racial difference, the camera stresses the physical resemblances between the two social groups. The ideological disengagement between the narrative and the visuals follows a zigzag pattern that situates the spectator in a critical, an almost satirical position, with regards to racial clichés.[12] In the aftermath of the fishing expedition, Joaquín (Diego Baenas) discards a fish saying that only Indians would eat such a disgusting thing. 'Estos kollas de mierda comen cualquier cosa' [These fucking Indians will eat anything], he tells one of his cousins. Isabel, who is trailing behind, sees the fish, picks it up from the ground and cooks it for the family dinner. When Mecha and Joaquín praise the taste of the fish,

it is clear that Martel wants the viewer to read the scene politically as a condemnation of Joaquín's rabid racism. The compliments that the children give Isabel on her cooking are not shared by Mecha, who puts her in her place by telling her that the food has too many peppers, a vegetable that is the means by which the family makes a living. In a feminotopic triangle that includes Mecha, Momi and Isabel, the hierarchical and vertical bond between mistress and domestic worker is apparently at odds with the seemingly horizontal relationship between Isabel and her indigenous nanny. If the generational gap exacerbates the hierarchical distance between Mecha and Isabel, Momi must find subtle ways of differentiating herself from a person who is her equal in age and gender.

At first, Momi's affection for Isabel creates an inter class sorority expectation for the viewer and the camera. Momi allows herself *to love* Isabel, which is no small thing in a house where the maid is constantly being insulted and humiliated by other household members. Momi frequently defends Isabel from her mother's accusations, and she has a physical intimacy with her that both Vero and José fear and resent.[13] Most of all, the closeness between Momi and Isabel causes anxiety in Mecha, who at some point tells Tali, referring to her daughter 'Meta amiguear con la sirvienta nomás. Mirá como está. Mirá el pelo que tiene esta chica' [She is always befriending the maid. Look at her. Look at her hair]. In Mecha's view, Momi's dirtiness is not just literal, stemming from her unwillingness to shower, but from spending too much time with an indigenous maid that, in the eyes of José and Mecha, is having a contaminating effect on her daughter's identity. In response to her family's prohibitions, Momi intensifies the bond with Isabel in a relationship that both transgresses and reproduces the ideology of racism. What Martel shows in the end is that children of the upper classes (and Momi is not an exception to this) have internalized the racist discourse of the older generation even in cases where they have been raised and educated by domestic workers. At one point in the film, Momi whispers to Isabel 'China carnavalera' [Wild Indian Girl] clearly echoing her mother's insults. In another scene, Momi accuses Isabel of stealing 'something' from her ('Che, ¿qué me estás sacando?' [Hey, what are you taking away from me?]) when actually Momi was the one who had stolen, or in her words 'borrowed', a bracelet from the maid. When Isabel tries to act motherly towards Momi, picking an outfit for her to wear, Momi seeks to re-establish the cultural distance between the two that the circulation of affect seeks to subvert. 'Florcitas y rayas no combinan' [Flowers and stripes do not match], she tells her caretaker in a phrase that cancels the inter-racial intimacy that Isabel had initiated. By questioning her nanny's sense of taste, Momi denies her the possibility of exerting sentimental power over her. In Momi's view, it is she, as an upper class girl, who has to educate the maid and not the other way around. What the scene seems to imply is that, in a feudal and racist society like the one represented in the film, even the trangressive gaze partakes of a dominant racial ideology that turns culturally constructed differences into natural and biological ones.

If there is one scene that would have promised to temporarily blur the barriers between the two social groups, it would have been the carnival dance. The carnival dance takes place

during the month of February in a town that has been affected by the exuberant disorder of the popular festivity. Allusions to carnival appear in the street scenes when teenagers throw water balloons at each-other, in the costumes that the girls wear while singing close to the fan, and in Tali's negative remarks about the indigenous music of the *comparsa* that does not let her sleep at night. In *Unthinking Eurocentrism: Multiculturalism and the Media* (1994), Shohat and Stam read carnival aesthetics, following Bakhtin, as a 'dress rehearsal' for utopia that 'suspends hierarchical distinctions, barriers, norms and prohibitions' (Shohat and Stam 1994: 306). In Martel's version of the carnival dance, as Aguilar has perceptively shown, hierarchies are solidified rather than overturned when the maid becomes a victim of racial hostility and sexual harassment. While we hear a loud *cumbia* about how not to trust women (*De las mujeres no hay nada más que hablar*), a jittery camera follows Isabel, who is trying to move across a tight crowd of dancing bodies. When José sexually attacks Isabel, thinking that he can extend to the public realm the power that he has over her in the private sphere, the catastrophe unfolds. In a violent fight scene that deploys in visual terms the triangular nature of desire, el Perro and his friends come to Isabel's rescue. In the grammar of the film, social differences do not disappear, even under the coat of white flour that, as a carnival prop, superficially homogenizes all dancing bodies. If at the end of the fight scene the owner of the club wrongly blames el Perro and his friends for the violence expelling them from the club, José's wounded body allows Isabel and el Perro to become heterosexually productive. In a masculine sphere divided along racial and class lines that contrasts *Creole* and indigenous masculinities, José's flaccid and wounded body allegorizes a type of non-productive masculinity that must be replaced by his indigenous counterpart. Thus, in a soundtrack where aural motives constitute a dense semantic field, it is not infrequent to hear the disturbing and dissonant sound of clinking ice every time that José, a future Gregorio (Martín Adjemián), appears on screen.

La ciénaga has a circular structure: it begins and ends with the diegetic sound of metallic chairs sliding through the cement pool deck. In the opening frames, when Mecha falls, the camera contrasts Isabel's mobility and efficiency with the languor of the upper classes who are vegetating by the putrid pool in the suffocating heat of the tropical siesta. Wounded Mecha, however, is not receptive to Isabel's solidarity, even when she is the only one who reacts to the serious character of the situation: 'Dejame vos, soltame' [Leave me alone. Do not touch me], she tells Isabel while whispering to herself 'Esta India me quiere llevar así a La Ciénaga' [This Indian wants to take me like this to La Ciénaga]. In the closing scene, we see the same rotten pool, but this time Momi and Verónica are the ones dragging the metallic lounge chairs from the house in order to literally occupy their mother's social space. While Momi has suffered a personal and domestic trauma that has left an undeniable trace on her now-wounded subjectivity: 'No vi nada' [I did not see anything], she says, in a sentence that stresses her sense of alienation from the popular religiosity of the town: Verónica's dark glasses remind us of Mecha's inability to perceive her own demise. In the deterministic grammar of Martel's

film, the spiralling decline has entrapped all members of a dysfunctional community who struggle without much success against the engulfing forces of the swamp.

Notes

1. Earlier versions of this chapter were delivered at the University of California, Davis, at a symposium on The Many Faces of Latin American Cinema organized by Mayra Appel, and at the Latin American Forum on Art and Politics in Argentina at Carleton College organized by Silvia López. I thank the organizers and participants for their comments. I am especially indebted to Carolina Rocha, and the anonymous reader for their useful critiques.

2. For more on contemporary renditions of Buenos Aires in film, see Rocha (2008). When I refer to a break with the past I allude to films produced in the decade of the sixties that constructed the city following the conventions of Italian neo-realism (Antonioni) and the nouvelle vague (Resnais). As Castagna (1994) points out in 'La generación de un mito', David José Kohon, Manuel Antín and Rodolfo Kuhn filmed Buenos Aires trying to emulate the urban modernity of Paris or Rome.

3. For Sarmiento, the fetishization of the Northern European immigrant, the Swiss or the British, was based on his intention to whiten the local population.

4. Lucrecia Martel was born in Salta in 1966. She directed three short features titled *El 56* (1988), *Piso 24* (1989), *Besos Rojos* (1991) and *Rey Muerto* (1995) and a television series entitled *D.N.I.* (1995). *La ciénaga* gained instant recognition when it appeared in 2001. It won the Bauer Award for the first feature at the Berlin Film festival in 2001. It also won four prizes at the Havana Film Festival of New Latin American film, and a film prize in Toulouse. The interest that Martel's first feature film generated led Almodovar's Deseo Production Company to co-produce with Lita Stantic Martel's second major feature film, *La niña santa*. In her last film, *La mujer sin cabeza/The Headless Woman* (2008), Martel delves deeper into the topic of racial and social tensions in Salta. For more biographical information on Martel, see Falicov's chapter in this volume.

5. Luciano Monteagudo in 'Lucrecia Martel: Whispers at Siesta Time' makes almost no mention of Isabel as a protagonist of the film. He says: 'There are two women, two mothers, as the protagonists of *La ciénaga*' (2002: 69). For an excellent feminist reading of the film see Forcinito (2006).

6. Unless otherwise indicated all translations for the film dialogues are mine.

7. Martel does not make any explicit references to Salta as a geographic region in the film. However, in an interview with Luciano Monteagudo, she says that the title, La ciénaga, refers to a geographical area in Salta where heavy rain leaves a particular density: 'In summer, a certain area is called 'la ciénaga' because the mountain rivers overflow and flood it. But it is something that if you see it in the winter you say: 'Where is the swamp?' It comes across to me as an area generated at a certain moment that is difficult to cross. It's not necessarily a mortal danger; it's not a swamp. And besides the region that is formed at that time, there are areas that, contrary to one's image of it, are places that scream with numerous insects and birds and small creatures. They are very intense places' (Monteagudo 2002: 76).

8. Although Laura Mulvey's 'Visual Pleasures and the Narrative Cinema' was originally published in 1975, it has become an almost canonical piece in feminist film criticism. According to Mulvey, cinema produces a complex interaction of three modalities of the gaze that add complexity to the production of gender discourse: the gaze of the camera filming women, the gaze of the characters within the film and, finally, the gaze of the spectator. The most polemical aspect of the article is that, for Mulvey, voyeuristic scopophilia is a masculine practice that puts women in a passive/female position.

9. In the way she treats her maid, Mecha is not that different from Beba in *Cama adentro/Live-in-maid* (2004) by Jorge Gaggero. Although the vision of the relationship between Beba and Dora is more sentimental in Gaggero's film, Beba still uses disrespectful commands to address Dora. Thus phrases like 'Dame un whisky' [Give me a glass of whisky], 'alcanzame el teléfono' [Pass me the phone], 'huacha de mierda' [Fucking bitch], or 'qué bruta' [What a brute] question the otherwise fairly benign depiction of Beba as an upperclass subject who is suffering economic distress.

10. In the Spanish subtitles for La ciénaga they translate 'China Carnavalera' as 'Party Animal'. The word China in the North of Argentina has racial implications that allude to the indigenous origins of the girl.

11. In *La segregación negada. Cultura y discriminación social*, Mario Margulis, coins the phrase 'racialization of class relationships' to account for the prestige of each ethnic group in Argentina and its economic conditions (Margulis & Urresti 1998: 17).

12. Gonzalo Aguilar (2006) makes this observation with regards to *Bolivia* in *Otros mundos*.

13. See, for example, the scene in which José calls and asks Isabel to leave Momi's bed.

References

Aguilar, G. (2006) *Otros mundos: Ensayo sobre el Nuevo Cine Argentino*, Buenos Aires: Arcos editor.

Anderson, B. ([1983]2006) *Imagined Communities. Reflections on the Origin and Spread of Nationalism*, London/New York: Verso.

Bernades, H., Lerer, D. and Wolf, S. (eds.) (2002) *New Argentine Cinema: Themes, Auteurs and Trends of Innovation*, Buenos Aires: Tatanka/Fripesci.

Castagna, G. (1994) 'La generación del 60: Paradojas de un mito' in S. Wolf (ed.) *Cine argentino. La otra historia*, Buenos Aires: Buena Letra, pp. 243-63.

Chaney, E. and Castro, M.G. (eds.) (1989) *Muchachas No More: Household Workers in Latin America and the Caribbean*, Philadelphia: Temple University Press.

Falicov, T. (2011) 'New Visions of Patagonia: Video Collectives and the Creation of a Regional Movement in Argentina's South' in C. Rêgo and C. Rocha (eds.) *New Trends in Argentine and Brazilian Cinema*, Bristol: Intellect.

Falicov, T. (2007) *The Cinematic Tango. Contemporary Argentine Film*, London: Wallflower.

Fiorucci, F. and Klein, M. (eds.) (2004) *The Argentine Crisis at the Turn of the Millennium. Causes, Consequences and Explanations*, Amsterdam: Aksam.

Forcinito, A. (2006) 'Mirada cinematográfica y género sexual: Mímica, erotismo y ambigüedad en Lucrecia Martel', *Chasqui: Revista de Literatura Latinoamericana* 35: 109–30.

Margulis, M. and Urresti, M. (eds.) (1998) *La segregación negada. Cultura y discriminación social*, Buenos Aires: Editorial Biblios.

Memmi, A. (2003) *The Colonizer and the Colonized*, London: Earthscan.

Monteagudo, L. (2002) 'Lucrecia Martel: Whispers at Siesta Time' in B. Lerer and S. Wolf (eds.) *New Argentine Cinema. Themes, Autheurs, and Trends of Innovation*, Buenos Aires: Fripesci, Tatanka, pp. 69–92.

Mulvey, L. (1985) 'Visual Pleasure and Narrative Cinema' in B. Nichols (ed.) *Movies and Methods: volume II*, Berkeley: University of California Press, pp. 303–14.

Podalski, L. (2007) 'Out of Depth: The Politics of Disaffected Youth and Contemporary Latin American Cinema' in T. Shary and A. Seibel (eds.) *Youth Culture in Global Cinema*, Austin: University of Texas Press, pp. 109–30.

Rocha, C. (2008) 'The Many Faces of Buenos Aires: Migrants, Foreigners and Immigrants in Contemporary Argentine Cinema (1996–2008)' in D. Araujo and D. W. Foster (eds.) *Images and Visual Communication: Urban Representations in Latin America*, Porto Alegre: Ed. Plus.

Rollins, J. (1985) *Between Women. Domestics and their Employers*, Philadelphia: Temple University.

Shohat, E. and Stam, R. (1994) *Unthinking Eurocentrism: Multiculturalism and the Media*, London: Routledge.

Sollors, W. (1995) 'Ethnicity' in F. Lentricchia and T. McLaughlin (eds.) *Critical Terms for Literary Study*, Chicago: University of Chicago Press, pp. 288–305.

Sollors, W. (ed.) (1989) *The Invention of Ethnicity*, New York: Oxford University Press.

Whitson, R. (n.d.) 'Beyond the Crisis: Economic Globalization and Informal Work in Urban Argentina,' http://media.web.britannica.com/ebsco/pdf/26/26998983.pdf. Accessed May 16, 2010

Wolf, S. (2002) 'Las estéticas del nuevo cine argentino: el mapa es el territorio' in H. Bernades, D. Lerer and S. Wolf (eds.) *New Argentine Cinema: Themes, Auteurs and Trends of Innovation*, Buenos Aires: Fripesci, Tatanka, pp. 29–39.

Young, L. (2006) *Fear of the Dark: Race, Gender and Sexuality in the Cinema*, London: Routledge.

The Dystopian City: Gendered Interpretations of the Urban in *Um Céu de Estrelas/A Starry Sky* (Tata Amaral, 1996) and *Vagón fumador/Smokers Only* (Véronica Chen, 2001)

Charlotte Gleghorn

Royal Holloway, University of London

Contemporary women's film production in the revivals

The cinematic revivals which emerged in Argentina and Brazil during the 1990s have both been marked by the increased participation of women directors. In fact, when viewed within the parameters of the film revivals in both countries, the increased visibility of women directors is one of the few discernible features of these umbrella movements, which otherwise display a vast array of aesthetics and themes. Record numbers of female directors released films in the year 2005 in Argentina, constituting approximately twenty per cent of national releases for that year (Vilaboa & García 2007). Similarly, in Brazil it is estimated that approximately twenty per cent of the productions released from the mid- to late 1990s were directed by women (Schild 1998: 125).

Increased women's participation in both movements has been associated with the measures taken by the state to promote cinematic production in adverse circumstances. Following the near collapse of Brazil's film industry under President Fernando Collor de Melo (1990–1992), the implementation of the 1993 Lei do Audiovisual [Audio-Visual Law] succeeded in stimulating the rebirth of film production in the country. Whilst a number of established film-makers continued to make films throughout the 1990s, thus consolidating this rebirth, one of the most discernible features of the *retomada* is the emergence of new directors who had previously only worked on short-films. The competitions for *opere prime* have had a particularly noticeable effect on the

225

numbers of Brazilian women directors, with 41 women directing debut feature films between 1990 and 2002 (Caetano 2007: 208). Indeed, *Um Céu de Estrelas/A Starry Sky* (Tata Amaral, 1996), the Brazilian film to be analysed in this chapter, is one such *opera prima*.

In Argentina, whilst the 1980s witnessed a revival in production following the dearth of national productions under dictatorship rule, the early 1990s once again marked a crisis in the industry. The Instituto Nacional de Cine y Artes Audiovisuales (INCAA), which substituted the Instituto Nacional de Cinematografía (INC) in 1994, formed a fund for low-budget film production and introduced competitive categories for first-time film-makers, including a special category for debuts by women directors, as part of its Ley de cine [Cinema Law] legislation. These incentives account for many of the filmic interventions of the 1990s, coupled with the surge in attendance at film schools. In addition, the Mar del Plata international film festival relaunched the 'La mujer y el cine' [Woman and Film] competition in 1996, thus providing an international platform for women film-makers (Rangil 2001: 8).

Although the increased participation of women directors is repeatedly cited as one of the key features of these two film revivals, little in-depth analysis of their films has been undertaken, resulting in a general appraisal of the notable presence of women directors, coupled with a critical disengagement with their films. In light of the above, the present chapter analyses two films directed by women, *Um Céu de Estrelas* (Tata Amaral, 1996) and *Vagón fumador* (Verónica Chen, 2001), from Brazil and Argentina, respectively, with regards to their depiction of city space. As films which map urban dynamics and anxieties, they offer valuable insights into how women cultural practitioners negotiate and interpret cities, offering alternative visions of the metropolis to those presented in commercially successful and internationally distributed Latin American films of recent years.

The gendering of space

Integral to this discussion of the gendered and sexualized nature of urban space is the constructed separation between public and private spheres. The Habermasian distinction made between the two realms, as articulated in *The Structural Transformation of the Public Sphere* (1991), rests on the assumption that all sectors of the population have equal access to public space, where they may engage with political processes as *citizens* and demand that the governing body be held accountable for its actions. However, these same public spaces simultaneously regulate activities which should remain out of view, namely, although not exclusively, sexual relations.

The recent international successes of a number of urban-themed Latin American films, namely *Amores Perros/Love's a Bitch* (Alejandro González Iñárritu, 2000), *Pizza, birra,*

faso/Pizza, Beer, Cigarettes (Adrián Caetano & Bruno Stagnaro, 1998), *Cidade de Deus/ City of God* (Fernando Meirelles & Kátia Lund, 2002) and *Tropa de Elite/Elite Squad* (José Padilha, 2007), have disseminated a largely dystopian vision of the city. Furthermore, these films have done much to inculcate a predominant aesthetic of the city, marked by handheld camerawork, location shooting, music-video editing and the striking inequalities which exist between distinct sectors of the population, usually associated with equally distinct zones of the city. These depictions of the city are also, as Geoffrey Kantaris notes, invariably sexualized, 'tend[ing] to pander to a stereotypical conflation of hypermasculinity and violence' (Kantaris 2008: 163). Indeed, the omnipresent figure of the male assassin or drug dealer, and the secondary, 'ornamental' roles female characters often play in these films, underline a predominantly masculine perspective on urban space which neglects the experiences of women who inhabit these same cities. The following discussion of *Um Céu de Estrelas* and *Vagón fumador* demonstrates that there are alternative ways to portray the Latin American megalopolis which contrast with the hyper-masculine imaginaries typical of the aforementioned productions.

Um Céu de Estrelas

Um Céu de Estrelas tells the story of Dalva (Alleyona Cavalli), a young woman from Moóca, São Paulo, who has won a plane ticket to Miami to take part in a hairdressing competition. She dreams of leaving her mundane life in Moóca and aspires to a greater future away from her mother (Néa Simões) and her ex-boyfriend, Vítor (Paulo Vespúcio). Dalva's preparations take a tragic turn when Vítor pays an unexpected visit to her house as she is packing her suitcase. He demands that Dalva gives him another chance and, angry and dejected, informs Dalva's mother that her daughter is planning to leave without telling her. Later, he shoots and kills the mother, holding Dalva hostage to his violent outbursts. After the first shooting the police are alerted and surround the house, encouraging Vítor to release Dalva and her mother, whom they do not realize is already dead, and turn himself in. After a series of dramatic confrontations between the couple inside the house, Dalva kills Vítor with his gun and emerges from the house, ashen and traumatized by the experience, under the watchful eye of the television reporter (played by Lígia Cortez) who is documenting the hostage situation.

Um Céu de Estrelas is based on the homonymous novel (1991) by Fernando Bonassi, who was also one of the screenwriters involved in adapting the novel for the film version. In the transition from novel to screen, however, the narrative undergoes some important changes, notably in the gender optic of the protagonist and in the downplaying of the sociopolitical context of the urban district of Moóca. In Bonassi's original the narrative is written from the point of view of the male character, the unemployed and frustrated Vítor, but in the filmic version it is his ex-girlfriend, Dalva, who assumes the lead role.

Indeed, this shift in perspective reflects Tata Amaral's broader cinematic project of investigating female archetypes in the three feature films she has hitherto directed: *Um Céu de Estrelas* (1996), *Através da Janela/Through the Window* (2000), and most recently the film version of the highly successful Globo television series, *Antônia* (2006).[1]

The film is divided into two parts: the first, a short film by another director, Francisco César Filho, and the second, the main feature directed by Tata Amaral. The short film, named 'Moóca, São Paulo, 1996' in titles which appear on the screen, literally maps the social and physical coordinates that provide the backdrop for the main narrative, and was commissioned by Amaral to extend its duration as she was advised that at barely one hour long her feature film was unlikely to secure theatrical release (Amaral 1998: 28). The opening short both serves to establish the location for the main film and dialogues with the central narrative in the repetition of aural motifs which appear on the soundtrack of both the short and the longer feature which comprise *Um Céu de Estrelas*.

Moóca, located to the East of the centre of São Paulo, was one of the principal zones of industrialization in the early twentieth century, when the city was expanding its horizons and rapidly 'modernizing' its infrastructure and industries (Caldeira 2000: 13–14). Primarily settled by immigrant Italian families, the area has since suffered the effects of deindustrialization as many factories have relocated to the outskirts of the city. The short film which launches *Um Céu de Estrelas*, shot in Hi-6 video and in black and white, confirms the area's foundations as an Italian neighbourhood, opening with insert shots of passport photographs of Italian immigrants. These photographs then cede to a white screen before the camera rests on the image of a still urban landscape of factory chimneys with high-rise buildings in the background, an establishing shot which determines the film's urban location from the outset. Titles appear superimposed on the cityscape, alerting the spectator to the exact location and time of the images— 'Moóca, São Paulo, 1996'—and the noises of traffic and trains begin to sound. A vertiginous camera explores the structure of factories and houses in the area from all angles, climbing the walls, traversing them and then descending them on the other side. In addition, the editing cuts in time with the frenetic percussion on the soundtrack as the camera changes direction of movement at frequent intervals. The movement of the camera, coupled with the hallmark sounds of a busy city, contrasts with the images of disused warehouses and factories, buildings in decay which had once been the edifice of modernity and industrialization.

The central narrative, filmed in 16mm, emerges as a counterpoint to the short film, both in theme and aesthetic style. The austere black, white and greys of the filmic prologue give way to the vivid colours of Dalva's home, creating a marked contrast between the shots of life on the streets of Moóca and the interior experience of Dalva in her home (Bastos 1998: 77). Indeed, Brazilian film scholar Lúcia Nagib (2000), in her analysis of the differences between the politically committed and utopian perspectives typical of the Cinema Novo films of the 1960s and more recent productions, suggests that the latter are

more interested in *micro*-narratives, personal stories which make up the Brazilian 'whole'. Nagib states, 'instead of the political Brazil which the Cinema Novo film makers wanted to reveal, it is an intimate Brazil that they aspire to portray' (Nagib 2000: n.p.). She cites *Um Céu de Estrelas* as a prime exponent of this 'cinema of intimacy' which surfaces in 1990s' Brazil, as it 'concentrates obsessively on the individuality of the characters to the detriment of the social context, being limited basically to two protagonists enclosed in the tiny rooms of a poor house' (Nagib 2000: n.p.). However, the film's commitment to depicting the interior world of Dalva's life does not undermine the broader sociopolitical concerns the film expresses. Rather, it is in the film's delicate balance between the domestic argument which occurs within the house and its framing within a broader discourse of violence in the city that *Um Céu* is most effective in establishing the perceived boundary between public and private realms.

The opening scene is illustrative of the tension established between the inside and outside world in the narrative space of the film. It begins with the interior of Dalva's bedroom, covered in bright coloured posters and decorative items, as she packs her suitcase to leave for Miami. The bedroom window gives onto a cityscape with a grey sky; a city punctuated with the relentless sound of traffic and trains. The doorbell rings and the camera momentarily abandons Dalva, zooming through the window frame to observe her neighbourhood, whilst she leaves the bedroom to answer the door. In this way, the opening scene clearly establishes the contrast which exists throughout the film between the events contained *within* the frame and those which move *beyond* it, in the exterior world.

The friction between the domestic environment, where we see Dalva preparing for her future trip to Miami, and the diegetic elements which enter the narrative from outside the camera's frame, also suggests Dalva's containment and suffocation in domestic space. Indeed, much scholarly work has considered the development of the division of space in gendered terms and the prohibited 'public' sphere of the city streets for women citizens. Feminist scholars have been particularly attuned to the need to view domestic space as a sphere which is not beyond public institutions and policies but rather deeply affected by them, particularly in the case of domestic violence. As Nancy Duncan (1996) writes,

> Paradoxically the home which is usually thought to be gendered feminine has also traditionally been subject to the patriarchal authority of the husband and father. Personal freedoms of the male head of household often impinge on, or in extreme cases, negate the rights, autonomy and safety of women and children who occupy these spaces. The designation of the home as a private space limits the role of political institutions and social movements in changing power relations within the family. (Duncan 1996: 131)

The violent domestic situation in which Dalva is caught up certainly suggests that the home is deeply embedded in the daily practices of patriarchy. The focus on Dalva's domestic space both offers a window onto the intimate experience of suffocation which characterizes her existence in this neighbourhood and, moreover, visually and aurally demonstrates the overlap of private and public concerns as the domestic *mise-en-scène* is frequently polluted with exterior influences. The film thus creates a continuum between the oppression Dalva experiences within the enclosed space of the home and the urban environment which envelopes it.

Dalva's preparations for her travels are rapidly disturbed with the unannounced arrival of Vítor, her ex-boyfriend, at the door. Dalva first sees him through the bars on her front door, bars which once again alert the spectator to her suffocation and confinement within the four walls of her home. These bars point to the threat of external violence, exemplified in the disruptive force of Vítor who invades her private space. The violence which disrupts Dalva's life is significantly configured as an exterior force which comes from the space of the city around her. Indeed, the frequent shots of Dalva pressed against openings in the walls, windows which are an aperture onto the world, emphasize her desire to leave home and escape her domestic space.

Teresa Caldeira's (2000) discussion of what she terms the 'aesthetics of security' in modern-day São Paulo is illustrative here of the delineation of public and private space in the city (Caldeira 2000: 291). Caldeira suggests that the increased use of surveillance systems, gates, barriers and bars on windows and doors, and the emergence of self-contained enclaves which erect fortressed walls around themselves, point to the collapse of social relations in a city which is fraught with fear and violence. Caldeira's analysis not only undermines the persistent distinction made between private and public realms, as both spheres may in fact 'feed' each others' practices, but also highlights the importance of *visual* strategies of spatial demarcation. According to Caldeira,

> The built environment is not a neutral stage for the unfolding of social relations. The quality of the built environment inevitably influences the quality of the social interactions that take place there... The material spaces that constitute the stage for public life influence the types of social relations possible on it. (Caldeira 2000: 298–9)

This spatial demarcation is brought to the fore in *Um Céu de Estrelas* in the repeated shots of bars across windows and doors as Dalva looks out from her 'private' space onto the 'public' space below. The views glimpsed from the windows reveal a distorted city, with the heat waves affecting the image of the tower blocks outside. This 'aesthetic of security' as Dalva looks through the bars, which seemingly incarcerate her in domestic space, is not, however, completely impenetrable.

Soundscapes and media violence

Throughout the film, sounds of the city, such as trains, traffic and even police announcements given over megaphones, perforate the illusion of a hermetically-sealed domestic private space, as they collapse the perceived barrier which separates public from private realm. All of these sounds are present in both the short film and the main feature, thus fomenting a kind of sound bridge, a cross-fertilization of aural motifs, between the two sections of the film.[2] Furthermore, the role of sound in *Um Céu de Estrelas*, contributes significantly to what Carlos Alberto Mattos (1997) has termed the 'espaço off' [off-camera space] in the film—those elements which are not rendered visible in the frame but which assume an important role in the construction of the film's narrative as a whole. As Mattos writes in his review of the film, 'é o inferno sonoro do subúrbio, assombrado pelos cultos, pela TV, pelo crime e pelo mau gosto. Nada aparece no quadro, mas penetra-o com virtual violência' [this is the hellish sound of the slums, overshadowed by religious cults, television, crime and bad taste. Nothing appears in the frame yet it is penetrated with virtual violence] (Mattos 1997: n.p.). Indeed, this 'virtual violence' is integral to the film's dissection of public and private space, and the media discourse which surrounds violence in the city of São Paulo today.

The tension between the interior and exterior perspectives on the events which unfold in Dalva's home is most flagrantly accentuated with the arrival of the police and the television crew. The 'off' action of the police, which penetrates the *mise-en-scène* by way of the powerful spotlight beams that circulate the front room from outside, coupled with the sirens and megaphone appeals to Vítor to turn himself in, references a particularly dominant public discourse on violence in the city. This discourse is further illustrated in the second key 'off' action, namely the televised scenes of the *seqüestro* [kidnapping], which package this domestic dispute to satisfy the morbid curiosity of the wider public.

The television report outside the house engulfs the entire frame of the film as Dalva and Vítor watch the events from home, and the spectator discovers along with the protagonists the media's interpretation of events. The journalist's report appears with a small 'VIVO' [LIVE] to the upper right-hand corner of the screen, highlighting the immediacy of the event and exaggerating this *fait-divers* as an example of escalating violence in the society as a whole. The reporter informs us that the GATE, a special branch of the Military Police in São Paulo, are heavily armed and poised for action on the rooftops of neighbouring houses, as they await the fate of the hostages in Dalva's house. The direct discourse of the live television transmission mediates the 'action' for the spectator, literally transmitting it in its precise moment. Indeed, *Um Céu de Estrelas* is not the only recent Brazilian film to explore the predatory nature of media representations. *Ônibus 174/Bus 174* (José Padilha & Felipe Lacerda, 2002), which portrays the bus hijacking which took place in broad daylight on June 12, 2000, in Rio, bears striking parallels with *Um Céu de Estrelas* in the

sense that it conveys a disjuncture between 'inside' the bus—the film goes to great lengths to describe the hijacker's life and past—and the discourse portrayed 'outside', in the media's coverage of the event. Amaral's film similarly experiments with the inadequacies of media discourse, which cannot capture the true meaning of the hostage situation in which Dalva is involved—emphasized by the contrast between the frequent point-of-view shots from Dalva's perspective in the house and the television's objectification of her in the report.

The power of the media to not only penetrate Dalva's experience but also *inform* it could be viewed as an example of the prevalence of reality discourse in contemporary society. *Um Céu de Estrelas* enacts a distorted *mise-en-abyme* of Dalva's situation, as the latter realizes that she has been *seqüestrada* [kidnapped] only by way of the television images and journalist's report on the small screen in her kitchen. Indeed, given the fact that Vítor is not a stranger in Dalva's life, the archetypal intruder or *favelado* [slum dweller], it is perhaps understandable that Dalva herself does not perceive this situation as a hostage situation but rather a domestic dispute. From the outside, the reporter informs the spectator of the full names of the people involved in the hostage situation, names which further embed the characters in the Italian heritage of Moóca (Dalva and Lurdes Bartolotto). Their age, professions and personal history also feature in the reporter's version of events, information which has hitherto been withheld or only partially insinuated in conversations between the two former lovers. Whilst the television reporter highlights the fact that the victim and aggressor were romantically involved and due to marry until a few weeks prior to the hostage scenario, she nonetheless hyperbolizes this violent situation in the language of the predatory media.[3] The juxtaposition of Dalva's interpretation of Vítor's violence (domestic dispute) and the media's interpretation (fear of violence of city) in the film frames the former in terms of the latter, thus suggesting that the microcosm of the domestic situation might act as a synecdoche for broader societal disintegration. The voyeuristic imperative of the live television event, exemplified both in contemporary news coverage and in the explosion of reality TV programmes, pervades city space, transmitting violence and fear to citizens who become increasingly insecure and retreat from the public spaces of transport, streets and squares. This in turn dramatizes the permeable boundaries between public and private as the former penetrates the latter and transforms the situation. In this way, the film delineates a boundary between the realism of the images of the hostage situation within the house, and the simulacra of reality created in the journalist's account of what is happening.

The collapse of the distinction between private and public realms is visually reiterated in the spectator's subsequent collusion with the voyeuristic eye of the television camera. The camera mediates our involvement in the events which mark the end of the film, negotiating the spectator's gaze on Dalva as the cameras enter the house following the sound of the gunshot heard from outside. In the end it is the 'olho da cidade, através do olho da TV, que invade a casa, é o ambiente que cerca a casa... que leva à espetacularização

da mídia frente ao problema. A tragédia se completa com a invasão da casa pela cidade/ mídia' [city's gaze, by way of the TV's gaze, which invades the home, it is the atmosphere which surrounds the house... which leads to the spectacularization of the media when confronted with this situation. The tragedy becomes complete when the house is invaded by the city/media] (Alvarenga, 2004: 141). In this way the structure of the film comes full circle, with the reinscription of the city, and Moóca, in the close of the film. The specific place where the hostage situation occurred is restated following the closing credits, all the while accompanied by the sound of urban disturbance characterized by police sirens and helicopters, when the reporter reappears to finally close *Um Céu de Estrelas* with the tragic words 'duas mortes aqui na Moóca, zona leste de São Paulo' [two deaths here in Moóca, in the East of São Paulo]. Dalva's domestic tragedy is thus incorporated into a greater tragedy of violence in the city.

Where *Um Céu de Estrelas* takes place almost entirely in Dalva's home, *Vagón fumador* sustains a dialogue with the overtly public space of the streets of Buenos Aires. Intimate relations which, according to modernist approaches to city living, should be kept behind doors, here evolve in the *plazas* and cash machine cubicles of the Argentine capital. The police and the television reporter, who together constitute the 'city gaze' in *Um Céu de Estrelas*, find a parallel in another technique of panopticism: the watchful eye of the CCTV camera perspective which mediates the spectator's vision of events in *Vagón fumador*.

Vagón fumador

Verónica Chen's first film, *Vagón fumador*, could ostensibly be described as an unconventional love story set in nocturnal Buenos Aires. The film speaks of the doubts and frustrations of the protagonist, Reni (Cecilia Bengolea), who dreams of moving far away to begin a more meaningful life. Her counterpart, Andrés (Leonardo Brezicki), is a rent boy who works in the confined, and overtly public, spaces of the cash dispenser cubicles in the city. Together, they wander the streets of Buenos Aires, discussing their hopes, fears and aspirations. However, their relationship unfolds into a doomed love affair; whilst Reni verbalizes feelings of alienation and disenchantment with the metropole, Andrés believes the city fulfills his needs and desires.

Like *Um Céu de Estrelas*, *Vagón* establishes a strong contrast between private, interior space and the public space of the city streets and buildings from the onset. This is highlighted in the opening scenes when Reni is first introduced to the spectator. She appears alone and naked in a bathroom, accompanied by the sound of running water in the bath. The camera is disorienting: it reveals the contours of her body in fragments, with extreme close-ups of her feet and waist, disturbing our sense of her physical whole. The camera watches as she undresses and then assumes her perspective as she submerges

herself in the water, blowing bubbles and looking up at the reflection above. This sequence finishes with a shot of the window above the bath, the outlet onto the world, which, instead of openness and freedom, seems to evoke confinement with its prison aesthetic of vertical bars. Indeed, these vertical bars are reminiscent of Dalva's confinement and the 'aesthetics of security' in São Paulo, echoing the same domestic enclosure of the Brazilian film in the *mise-en-scène* of the bathroom scene in *Vagón*.

This image of imprisonment contrasts starkly with the credit sequence which follows, depicting trees and sky shot from a train accompanied by the sound of a train travelling on tracks. The vast open space of the sky and the natural vitality of plants and trees viewed from the train appear as the antithesis of the closed, blanched space of the bathroom. This contrast is further underlined when the film abruptly cuts back to the bathroom scene to witness Reni smashing something on the floor and cutting her wrist with the sharp edge. Although this event is not explained in the narrative, the spectator can only infer that this is a suicide attempt, as we are encouraged to contemplate her blood dispersing in the water in slow motion. The image of the blood staining the transparency of the bath water, moreover, points to the theme of contamination which becomes a central concern of the film's discussion of prostitution and urban space. The juxtaposition of the colourful, expansive exterior and the sterile, tiled interior of the bathroom effectively establishes the contrasting aesthetics used to represent private and public space in the film.

Voyeurism and surveillance

As Reni wanders around the city streets she consistently deciphers her surroundings through the gaze, most notably in the trope of looking at Andrés as he engages in sexual relations with his clients in the ATM spaces of the Banco Francés. Her 'reading' of the city propels the rhythm of the film as the editing cuts between objects of her gaze and intermittently slows down or speeds up the footage. Laura Mulvey's seminal essay 'Visual Pleasure and Narrative Cinema' (2000) is instructive here in its analysis of voyeurism and scopophilia as integral to the architecture of cinema. Mulvey's article theorizes the relationship between the bearer of the look, the character being looked at, and psychoanalytic theory on gender difference. Mulvey describes 'woman as image, man as bearer of the look' (Mulvey 2000:39), effectively reiterating the position of 'structures of ways of seeing and [the] pleasure in looking' in cinema (Mulvey 2000: 35). These structures, which permeate the form, content and reception of cinematic texts, are similarly delineated in Chen's film.

Reni's looking is first thematized through a shot of her staring directly at the cash machine area. Observing the two men in the confined area of the bank, the erotic pleasure and intrigue of looking is established by way of a point-of-view shot from Reni's perspective. Yet significantly here, Reni's curiosity, illustrated through her staring at the

men, challenges the assumption that women are generally constructed as object of the gaze. The protagonist's intrigue for the sexual exploits of Andrés renders the man-on-man encounter a spectacle and reverses the classical construction of the woman's body as fetishized object. Whilst Andrés later emerges to hold a predatory sexualized gaze as well—and it is important to underline that Reni's ultimate involvement in prostitution is far from liberating—it is significant that Chen's female protagonist should yield some aspect of scopic power.

Reni's visual deciphering of the city, whilst radically different in terms of gender, class and epoch, harks back to the literary construct of the *flâneur*, which in turn reveals the film's concern for the experience of modernity. The *flâneur*, the elite male character who interprets the arcades and boulevards of Paris in the texts of Charles Baudelaire, has become the subject of much critical enquiry, particularly regarding possible permutations of the character in the twentieth and twenty-first century. Moreover, in its cinematic form, the *flâneur* expressly conflates voyeurism and power. According to Nezar AlSayyad, 'the advent of cinema itself has enabled a 'new mode of *flânerie*', a wandering around the city and a new ability to conceive of it as a spectacle and a source of sensory experience' (AlSayyad 2006: 35). The visual saturation and sensory experience of which AlSayyad writes may be intuited throughout *Vagón,* with the soundtrack's abstract chiming musical notes adding flavour to the nightscape of overexposed neon lights. Moreover, Reni's embodiment of the *flâneuse* defies the restricted movement of women on the street and questions the modernist assumptions which legitimized this strict distinction between public and private realms, relegating women to the home.[4]

There is, however, a more sinister watchful eye which is portrayed at this early stage of the film's narrative, illustrative of the urban surveillance culture commonly associated with late capitalist societies. AlSayyad suggests that 'in an era when cameras and other systems of surveillance are ubiquitous in both public and private spaces, the boundaries of the city are no longer defined by monumental entrances, but by electronic devices' (AlSayyad 2006: 147). *Vagón fumador* exhibits these controlling mechanisms of technology by illustrating footage shot from a security camera. A centre establishing shot of the front of the Banco Francés in the city switches to black-and-white CCTV footage of Andrés and his male client as they are filmed by the security cameras directed at the ATMs. Within the confines of the cubicle Andrés engages in sexual activities in exchange for money, all the time under the watchful eyes of Reni and the security camera. This panoptic authority, the invisible voyeur-machine, is emphasized by the angle of the footage we are presented with; the spectator looks, by mediation of the security camera, *down* on the couple as they interact by the cash machine, illustrating the power hierarchy inherent in this camera perspective. Moreover, the use of the enclosed spaces of cash machines as the setting for the exchange of sex for money underlines the flows of capital in an increasingly unequal and consumer society. Andrés himself underlines this connection as he willingly places a price on his body when he proclaims in the film 'Andrés es caro, el que quiere celeste que

le cueste, Andrés cuesta $150' [Andrés is expensive, nothing ventured, nothing gained, Andrés costs $150]. Andrés's statement also refers to himself in the third person, thus emphasizing his alienation and his detached status as a citizen.[5]

'The voyeur-god': flânerie, panopticism and the city

Reni's attempt to make sense of the city through the gaze is further problematized in a scene where the couple looks out from a roof top, dazed by the lights of nocturnal Buenos Aires. Indeed, this scene recalls the words of theorist Michel de Certeau, who describes the position of the person who looks down on the cityscape as a 'voyeur-god', thus expressing the power relationship embodied in such a panoramic shot (de Certeau 1984: 93). The height turns the characters into 'voyeur-god[s]' of the city, as they gaze and attempt to dominate and rationalize the space below them. Reni's description of Buenos Aires as a 'pulpo con miles de tentáculos' [octopus with thousands of tentacles] is effectively imaged as we trace the city's tentacles of lights at night, spreading out in different directions as the camera pans around the space, finally resting on the couple as the centre—the head—of the octopus. This shot explicitly reveals the interconnectedness of the characters and the city: Reni and Andrés are to be found at the centre of the monster, yet simultaneously they are isolated and distanced from the tentacles of activity. Their vision of the city down below does not, however, enable a true grasp of the space and design of the city; rather, it appears as a mirage, an illusion and construct which will always remain intangible, beyond their reach, pointing to a decidedly frustrated attempt at dominating the urban environment through panopticism.

Urban symbols: monuments and memory in the city of Buenos Aires

The disjuncture between the modernist dream of rational urban utopia, embodied in the monumental landmarks of Buenos Aires, and the reality of social exclusion and loneliness, is at the heart of *Vagón*'s depiction of the city. Moreover, *Vagón*'s exploitation of the cityscape as the backdrop for the narrative in many ways echoes Henri Lefebvre's (1996) interpretation of urban space:

> On its specific plane the city can appropriate existing political, religious and philosophical meanings. It seizes them to say them, to *expose* them by means—or through the voice—of buildings, monuments, and also by streets and squares, by voids, by the spontaneous theatricalisation of encounters which take place in it. (Lefebvre 1996: 113–14)

This 'theatricalisation of encounters' becomes a particularly potent concept when considering the inventive appropriation of urban landmarks in Chen's film. The rearticulation of monumental space within *Vagón* comes to the fore in the setting of the Plaza San Martín—one of the main squares in central Buenos Aires commemorating the country's liberator—which features in the film as the hangout for prostitutes. This square, which not only celebrates San Martín but is also flanked by imposing militaristic buildings, such as the Palacio La Paz which houses the Military Officers' Association, here appears as a site of sexual transactions as the taxi-boys negotiate their next client's rate, all the time circulating the plaza on rollerblades. The film does not dwell on mapping recognizable places of Buenos Aires, but instead destabilizes landmarks of the city and nation by reworking their significance or by repositioning their centrality at the margins of the frame. Indeed, one could even suggest that Chen's film displays a certain playful irreverence at these sites of national pride.

This particular interface between the body and the city contests the urban legislation which censors the occupation of public space for non-normative practices. Indeed, in the specific context of Buenos Aires, this issue came to the fore following the implementation of the *Código de Convivencia Urbana* [Code of Urban Co-existence] in 1996, which provoked a fierce debate on the presence of prostitution in different areas of the city. This constitution repealed the existing laws governing homo- and transexuality, and was finally approved in March 1998, although it underwent numerous amendments in the months which followed (Álvarez 2000: 137). Both the media hype surrounding the Code, and the neighbourhood rallies against prostitution on the streets of selected neighbourhoods, enacted an 'othering' of certain sectors of the population, mapping sexual dissidence onto latent racial prejudice, as exemplified in the following exclamation by the prominent television personality, Mirtha Legrand: 'Todo lo que es prostitución y travestismo ya llega hasta la zona de Recoleta, vienen de países limítrofes' [Now the prostitutes and transvestites even reach the Recoleta neighbourhood, and they come from neighbouring countries] (quoted in Sabsay 2005: 176). Thus, the debate surrounding the Code redefined the 'city as resident-space, as an aggregate of neighbourhoods besieged by undesirables who did not belong, who, that is, were not residents' (Álvarez 2000: 138). *Vagón fumador*'s central focus on prostitution, then, mirrors the societal changes in Buenos Aires of the late 1990s, performing the anxiety of some city dwellers towards the illicit activities of the night through the perspective of the curious yet reluctant Reni.

Desamor

The prevalence of monuments and consumerism in *Vagón fumador* serves to emphasize the cityscape's dominance over the characters' lives and creates a greater contrast between the dream of another (utopian) space and the city itself. This is clearly illustrated in a

flashback scene towards the end of the film when Reni and Andrés escape to the 'country' to celebrate her birthday. Here an interstitial space emerges at the outskirts of Buenos Aires by the Río de la Plata, in the Reserva Ecológica Costanera Sur, with a beach by the river and the towers of the metropole's centre behind them, echoing Beatriz Sarlo's description of *las orillas* [the river bank] as 'an indeterminate place between the city and the countryside' (Sarlo 1993: 169). Furthermore, the pollution of the river, which prohibits the couple from bathing, references the all-pervasive influence of the metropolis and its contamination of space. Reni's attempts to leave the city thus seem continually undermined by the reassertion of the city in seemingly non-urban spaces. Indeed, the elliptical nature of the film's structure, which continually returns to the apparently suicidal act which occurs at the beginning of the film, seems to suggest that the cutting of her wrist was precipitated by the doomed love affair between Reni and Andrés. The permeable nature of private and public space is here brought to the fore as tensions which evolve in public play themselves out in intimate spaces. In both of these respects *Vagón fumador* seems to resist the spatial binaries of private and public, rural and urban.

The closing scene of *Vagón fumador*, however, implies Reni's escape from the city, as we see her look out of the train window, light up a cigarette and find a place of belonging as she leaves Buenos Aires behind. Thus, the oppositional relationship established in the film between the utopian place which lies beyond the limits of Buenos Aires and the city itself is brought to fruition in a third space: the no-man's-land of the train carriage which inspired the film's title. Nevertheless, Reni's efforts to liberate herself are not entirely fulfilled—whilst, on the one hand, she appears to finally understand who she is and what she wants, on the other, she remains firmly under control in the contained and prohibitive space of the smokers' carriage. Furthermore, the train carriage, as de Certeau insightfully pointed out, is 'a bubble of panoptic and classifying power, a module of imprisonment that makes possible the production of an order, a closed and autonomous insularity' (de Certeau 1984: 111). Reni's retreat to this monitored and enclosed space thus enacts a return to the panopticism of the city, even as she is seemingly in transit towards another space.

Conclusion: spatial discourse and failed projects of modernity

Both the 'voyeur-God' and CCTV panopticism in *Vagón fumador*, and the disjuncture between Dalva's subjectivity and the version of events presented by the media, reference the dissolution of promise in the urban milieu. Where once the city heralded a utopian future, with the possibility of equality and inclusion, here, the cities of São Paulo and Buenos Aires emerge at moments of national upheaval in the filmic imaginary. *Vagón's* prescience into the stark connection between bodily commodification and the economic crisis reveals the intimate connection of body and city on the streets of Buenos Aires, pointing to the uneven experience of the megalopolis and its inhabitants' rights.

For its own part, *Um Céu de Estrelas* breaks with the common filmic techniques to represent the *periferia* [outskirts], avoiding establishing shots of the city and the *favelas* [slums], and preferring to highlight the invasion of Dalva's domestic space by the discourse of urban violence and marginalization. It also, significantly, offers a feminine interpretation of the cityscape, highlighting the often-ignored violence which goes on behind closed doors and offering the protagonist agency through the camera's perspective throughout the film. Like the *menemista* privatization of space which promoted a retreat into the enclosed spaces of the city, also reminiscent of the restricted use of public spaces during the dictatorship era, *Um Céu de Estrelas*'s depiction of the media's manipulation of Dalva's tragedy highlights the spectacularisation of violence under Cardoso's presidency (1995–2002), suggesting that private violence may act as a cipher of familial and urban disintegration.[6]

Both films attest to the disjunctive experience of the metropolis in light of the exaggerated, yet disputed, distinctions between public and private realms accommodated by neoliberal economic policy and urban planning. These films present female protagonists in films directed by women, thus counteracting the commonplace masculinization of the city in recent Latin American film. Through their renegotiation of power structures, and resistance to standard ways of representing the city, these directors re-imagine the celluloid body as the privileged site to reassert the inter-pollination of private and public spheres.

Notes

1. All three feature films are based in São Paulo. *Antônia* in particular brings the marginalization of the *favela* [slums] to the fore in its setting in Vila Brasilândia, in the North of São Paulo.

2. In fact, whilst the visuals were already completed when Amaral commissioned Francisco César Filho to direct the short film, she had not finalized the audio track, and thus the overlap of aural motifs was made possible between short and main feature (Amaral 1998: 30).

3. It is worth noting that the television reporter appears as a caricature of the media's reporting of events and as such self-consciously mocks the journalist's sensational and exaggerated tone.

4. In the Brazilian context, the film *A Hora da Estrela/Hour of the Star* (Suzana Amaral, 1985) also interrogates the motif of the wandering woman on the streets of São Paulo, but challenges the opportunities of the city available to the protagonist of the film, Macabea, an impoverished *nordestina* [northeasterner] who struggles to make a living

and has no family. The film is based on the homonymous novel by Clarice Lispector (1977) but significantly shifts its urban location from Rio de Janeiro to São Paulo.

5. The exploitation of such a space to stage the narrative reveals a poignant prediction of the fast approaching economic crash which would unfold in late 2001. Whilst the director herself acknowledges that there was no intended connection to be made between the economy, consumerism and sex, the film has undoubtedly been interpreted in light of the crisis.

6. Emanuela Guano writes of the perceived primacy of the private in the military dictatorship's discourse when it was intent on silencing public opposition. Whilst there are obvious differences between *menemista* spatial discourse and that of the military generals, the emphasis on enclosed, private spaces is nonetheless a common element of both regimes (Guano 2002: 187).

References

AlSayyad, N. (2006) *Cinematic Urbanism: A History of the Modern from Reel to Real*, New York & London: Routledge.

Alvarenga, N. (2004) 'Trágico sem Catarse: Cidade e Cinema Brasileiro Contemporâneo', *Lumina* (UFJF) 7: 133–51.

Álvarez, A. G. (2000) 'The City Cross-Dressed: Sexual Rights and Roll-backs in De la Rúa's Buenos Aires', *Journal of Latin American Cultural Studies* 9.2: 138–53.

Amaral, T. (1998) 'O Processo de Criação de *Um Céu de Estrelas*', *Estudos de Cinema* 1.1: 23–38.

Bastos, M. (1998) 'A Dramaturgia Interior de *Um Céu de Estrelas*,' *Estudos de Cinema* 1.1: 75–93.

Bonassi, F. (1991) *Um Céu de Estrelas*, Rio de Janeiro: Siciliano.

Caetano, M. (2007) 'Cinema Brasileiro (1990–2002): da Crise dos Anos Collor à Retomada', *Alceu* 8.15: 196–216.

Caldeira, T. (2002) 'The Paradox of Police Violence in Democratic Brazil', *Ethnography* 3.3: 235–63.

Caldeira, T. (2000) *City of Walls*, Berkeley & Los Angeles: University of California Press.

de Certeau, M. (1984) *The Practice of Everyday Life* (Trans. S. Rendall), Berkeley: University of California.

Duncan, N. (1996) 'Renegotiating Gender and Sexuality in Public and Private Spaces' in N. Duncan (ed.) *BodySpace*, London: Routledge, pp. 127–45.

Guano, E. (2002) 'Spectacles of Modernity: Transnational Imagination and Local Hegemonies in Neoliberal Buenos Aires', *Cultural Anthropology* 17.2: 181–209.

Habermas, J. (1991) *The Structural Transformation of the Public Sphere: An Inquiry into a Category of Bourgeois Society*, Massachusetts: MIT Press.

Kantaris, G. (2008) 'Lola/Lolo: Filming Gender and Violence in the Mexican City' in A. Webber and E. Wilson (eds.) *Cities in Transition: The Moving Image and the Modern Metropolis*, London & New York: Wallflower Press, pp. 163–75.

Lefebvre, H. (1996) *Writings on Cities* (Trans. E. Kofman and E. Lebas) in E. Kofman and E. Lebas (ed.), Oxford: Blackwell.

Lispector, C. (1977) *A Hora da Estrela*, Rio de Janeiro: Rocco.

Mattos, C. (1997) 'Off É Fundamental para Essa História de Amor e Ovo Frito'. *O Estado de São Paulo*, June 27.

Mulvey, L. (2000) 'Visual Pleasure and Narrative Cinema' in E. A. Kapplan (ed.) *Feminism and Film*, Oxford & New York: Oxford University Press, pp. 34–47.

Nagib, L. (2000) 'The New Cinema Meets Cinema Novo: New Trends in Brazilian Cinema', *Framework: The Journal of Cinema and Media* 42: n.p.

Rangil, V. (2001) 'Changing the Face of Argentinean Cinema: The Vibrant Voices of Four Women', *Afterimage* 28: 7–9.

Sabsay, L. (2005) 'Representaciones culturales de la diferencia sexual: figuraciones contemporáneas' in L. Arfuch (ed.) *Identidades, sujetos y subjetividades*, Buenos Aires: Prometeo Libros, pp. 155–70.

Sarlo, B. (1993) 'Modernity and Cultural Mixture' in J. King et al. (eds.) *Mediating Two Worlds: Cinematic Encounters in the Americas*, London: BFI Publishing, pp. 161–74.

Schild, S. (1998) 'Cinema Feminino: um Gênero em Transição?', *Cinemais* 9: 123–28.

Vilaboa, D. and García S. (2005) 'El año de las directoras,' http://www.artemisanoticias. com.ar/site/notas.asp?id=40&idnota=1150. Accessed March 23, 2007.

Reimagining Rosinha with Andrucha Waddington and Elena Soarez: Nature, Woman, and Sexuality in the Brazilian Northeast from Popular Music to Cinema

Jack A. Draper III
University of Missouri, Columbia

The natural and human geography of the Northeastern Brazilian interior have often been featured in popular cultural production. One seminal example of such work is the musical genre of *forró*, especially the lyrics of the most famous *forrozeiro* [*forró* musician], Luiz Gonzaga, and his partners. *Forró* is an important form of country music in this region that has gained national acclaim and popularity through the careers of Gonzaga and his successors in subsequent generations. Lyricists of this genre have historically taken a special interest in imaginaries uniting the natural beauty and abundance of the *sertão* [backlands] in the rainy season with the figure of the Northeastern woman and her beauty. This lyrical association is most famously developed with the figure of Rosinha in the Northeastern regional anthem, *Asa Branca* [White Wing].

More recently, a young film-maker named Andrucha Waddington, along with screenwriter Elena Soarez, has developed an aesthetic with striking similarities to this union of Northeastern woman and nature. In two of Waddington's recent fictional features, *Eu tu eles/Me You Them* (2000) and *Casa de areia/House of Sand* (2005), he explores the connection between strong female characters and various arid, rural environments in the Northeast. It is reasonable to assume that Waddington is familiar with the lyrical discourse of *forró* since the genre comprises the entire score of *Eu tu eles*. However, Waddington and Soarez go further than traditional *forró* in their attempt to thoroughly explore the complex desires of their female protagonists, mirroring developments in the genre of *forró* forged by female artists exploring their own desires. This chapter will seek

to frame Waddington's work over the past decade as a rereading of the union of woman and nature in the traditional *forró* repertoire. What is especially unique in Waddington's films is that this focus on Northeastern women's perspectives takes place either in past eras (*Casa de areia*) or in the heartland of traditional rural culture (*Eu tu eles*). These are times and places that have been dominated by the more traditionalist nostalgic male view of the woman-nature tie. For this reason, Waddington and Soarez's revisionist approach to gender and sexuality in both the contemporary and the historical rural Northeast can properly be called a feminist cinema, as defined by Theresa de Lauretis: 'feminist cinema' is… the notation for a process of reinterpretation and retextualization of cultural images and narratives whose strategies of coherence engage the spectator's identification through narrative and visual pleasure and yet succeed in drawing 'the Real' into the film's texture' (De Lauretis 2000). The film-maker/screenwriter partnership of *Eu tu eles* and *Casa de areia* has succeeded in a remarkable, delicate balancing act of feminist cinema, combining a narrative exploration and visual celebration of regional popular culture and history with a reinterpretation of women's agency and subjectivity in the face of the historical 'Real'—in this case, patriarchal domination, economic marginalization and geographic isolation.

Woman and nature in Northeastern popular culture and beyond

The natural environment of the *sertão* or Northeastern backlands is a profoundly important medium for *forrozeiros*. Through nature, they paint a picture not only of the idyllic beauty of their home region but also of its potential productivity. The latter image helps to combat stereotypes of the Northeastern interior as a barren wasteland. The *sertão* suffers periodic droughts, which in the past drove many poor Northeasterners out of the region, but it can also be very beautiful and green during the rainy winter months. However, perhaps the most common trope in *forró* lyrics is to metaphorically associate nature with the lover whom the singer left behind in the Northeast.

Probably the most famous song featuring such a metaphorical union of woman and nature is Luiz Gonzaga and Humberto Teixeira's 'Asa Branca' [White Wing] (1947). The natural environment of the Northeastern interior is extremely important in this song, which is often referred to as the 'hymn of all Northeasterners' because of its centrality in the traditional *forró* repertoire and in that of Northeastern popular music in general. The Asa Branca is a type of bird that leaves the *sertão* during times of drought, and thus serves as a clear symbol of the plight of Northeasterners displaced from their homes and often from their traditional occupations of small-scale or subsistence farming, or raising cattle, in the rural interior. 'Asa Branca' begins with a detailing of a long series of afflictions of the dry *sertão*. These exist to such a severe degree that the singer suggests the drought is a punishment from God: 'A Deus do céu, ai/Pru que tamanha judiação'

[Oh God in the sky, oh / Why such great torment] (Ramalho 2000: 94). The migrant awaits the return of the rains that will bring life back to the *sertão* and allow him to return to his lover there. She is closely associated with the singer's plantation through this striking trope: 'Quando o verde dos teus óio / Se espaiar na prantação' [When the green of your eyes / Disperses into the plantation] (Ibid.). Woman, nature and the rural economy are all profoundly intertwined by the nostalgic, traditionally-male desire of *forró* discourse. It should be noted that the relatively active role of migration and return, as in the narrative of 'Asa Branca', is traditionally reserved for the male migrant, while the migrant's lover embodies a passive role of awaiting his return.

We can situate this discourse associating woman and nature in the Northeastern landscape within broader literary and filmic traditions. For example, Elizabeth Ginway cites studies by Annette Kolodny and Regina Zilberman which demonstrate that literary representations of land as woman have been common since the Romantic period in both Brazil and the United States (Ginway 2004: 92). In the case of Brazil, one has only to think of novelist José Alencar's fictional heroine Iracema, an indigenous princess intimately associated with the natural environment of the state of Ceará in the colonial era (Alencar [1875]2006). Iracema also shares with the *forró* heroine Rosinha the role of passively waiting for her lover to return to her. Alencar's Brazilian origin myths featuring Portuguese explorers and noble Brazilian Indians also have a special relevance to cinema, since they were a popular subject of Brazilian film adaptation in the silent era—with no less than three versions of Iracema's story alone filmed during that period (Stam 2003). More recent filmic adaptations of Brazilian literature reveal a continuing interest in tracing ties between woman and land. For instance, Bruce E. Williams analyses how the protagonist of *Gabriela* (Barreto, 1983), a film adapted from Jorge Amado's eponymous novel, is closely associated with nature:

> [Gabriela's] relationship to the elements is suggested by the opening sequence in which she first appears covered by sand and sweat (earth and water) as she traverses the backlands with an unidentified group of *sertanejos* [backlanders]. In this scene, she is shown anonymously as part of the countless migrants seeking a better life through their journeys. Like the archetypal Great Mother, her origins are thus a mystery, particularly in light of the distance traveled. (Williams 1990: 26)

These examples point towards a broader history of narratives in music, cinema, and literature set in the Brazilian Northeast which focus on the fertility of women as it relates to that of the natural landscape. The typical tropes associated with both land and woman in this traditional pairing are that of the nurturing mother, and of the lover to be conquered or possessed (both Gabriela and Iracema play these roles at various points in their respective stories, mirroring the nurturing or fertile qualities of the land/nature).

From an ecofeminist perspective, Ginway emphasizes that although these kinds of associations might seem to idealize women, the conflation of woman and land ultimately limits women's agency and subordinates them to steretypical roles like that of the Jungian 'Great Mother' defining Gabriela's character in the passage above (Ginway 2004).

It is from this background of traditional representations of women in the Brazilian rural landscape that we can best appreciate the reinterpretation achieved by Waddington and Soarez in *Eu tu eles* and *Casa de areia*. At the same time, one can consider their contribution within the context of broader international cinematic trends in recent decades that challenge patriarchal conventions concerning women in natural landscapes. For this purpose, Anna Dempsey's overview of the 'nurturing genre' in North American cinema provides a revealing comparison (Dempsey 2005). In contrast to traditional filmic depictions of landscapes as merely the passive objects of a male gaze, such as those portrayed as backdrops to many American Westerns, films in the nurturing genre 'recuperate the power of the feminine landscape' and feature women who 'enlist the nurturing power of nature and of those marginalized by the dominant culture to produce spaces in which they can subvert the violence of the white, masculine gaze' (Dempsey 2005: 119). Dempsey discusses four films from the 1980s and 90s in which she sees the development of 'hybrid spaces… in which multiple discourses can be heard,' thus allowing for an inclusive politics of difference between the main female characters and their allies despite the continued presence of dominant patriarchal structures in the society (Dempsey 2005: 119). There are clear elements of the nurturing genre in both *Eu tu eles* and *Casa de areia* and, in my discussion of the films below, I will demonstrate the characteristics of a nurturing community first shaped in the landscape of the *sertão* of the earlier film, only to be more fully developed in the isolated sand dunes of the latter.

Re-envisioning Woman in the Backlands: *Eu tu eles*

Andrucha Waddington's 2000 feature film *Eu tu eles* certainly takes inspiration from the gendered imaginary of the Northeastern backlands developed in *forró* standards. Firstly, it shows this inspiration on the musical level through the inclusion of many traditional *forró* songs on the soundtrack along with songs in the same style written by the musical director, Gilberto Gil. Secondly, it follows a similar aesthetic path to *forró* through a filmic appreciation of the *sertão* and its unique natural beauty, at times harsh and at times lush. Here Waddington also follows in the footsteps of Cinema Novo classics like Nelson Pereira dos Santos's *Vidas Secas/Barren Lives* (1963) and Glauber Rocha's *Deus e Diabo na Terra do Sol/Black God, White Devil* (1964). Waddington, however, leans towards a milder, less aesthetically shocking depiction of the region, utilizing a palette primarily composed of muted browns and oranges. This visual shift from the

stark lighting of early Cinema Novo films set in the *sertão* is less pronounced, however, than some of the other departures from filmic tradition which Waddington makes in his portrayal of life in the Northeastern backlands.

In a more general sense, Luiz Zanin Oricchio describes an epochal shift in filmic portrayals of the *sertão* from the 1960s to the 1990s:

> Whereas Cinema Novo in the 1960s used the *sertão* as the most obvious expression of social divisions, conflict and discord, Brazil's new cinema associates this setting with a sense of community, the accomodation of opposites and the elimination of differences. (Oricchio 2003: 153)

Films such as those of Rocha and Dos Santos mentioned above were made to confront inequality in the backlands and to stimulate revolutionary change in Brazilian society. The ideological context has of course evolved radically since the politically tumultuous early 1960s in Brazil, and film-makers' approaches to cinema have developed accordingly. As evidence of Brazil's new cinema and its framing of the *sertão* landscape, Oricchio points to *Eu tu eles* along with earlier films such as *Central do Brasil/Central Station* (Salles, 1998). With regard to Waddington's film specifically, Oricchio's description of new approaches to the *sertão* seems generally accurate, especially with regard to the importance of community and the attempts made by the protagonists of *Eu tu eles* to overcome conflict within their small circle. This emphasis on community resonates with the discourse and rhythms of *forró* music that accompany the dramatic action and underline, through a common cultural heritage, the solidarity of poor Northeasterners. The way Oricchio describes the 'new cinema' in Brazil, though, does not capture all of the specific contributions of Waddington's film.

The innovation unique to *Eu tu eles* centres around the female protoganist and her efforts to achieve a certain degree of autonomy and emotional/sexual fulfillment in a patriarchal, rural setting. This is not to say, as one scholar has suggested, that this economically marginal region of Brazil has become a 'sexually liberating place' in Soarez and Waddington's script (Caballo-Márquez 2008). Indeed, it was for quite the opposite reason that the true story the film is based on (described further below) received national media attention. No one expected a woman to depart so much from conventional gender roles in the traditional culture of the Northeastern backlands. Thus Brazilian scholar Walnice Nogueira Galvão likely describes it best when she characterizes the film *Eu tu eles*, along with *Central do Brasil*, as demonstrating a crisis in the patriarchy (Galvão 2004). Both of these films focus on the absence of the traditional father figure to some degree. But in *Eu tu eles* especially, whose entire narrative takes place in the *sertão*, the patriarchal norms have not been defeated or abolished. We do, however, see them being tested and sometimes subtly, sometimes more overtly, challenged by the character of Darlene (Regina Casé) and those she influences. This renegotiation of normative

conventions within a traditional setting distinguishes *Eu tu eles* from both (1) the starker social conflicts portrayed in the *sertão* of Cinema Novo classics as well as (2) the conciliatory or redemptive 'sense of community' emphasized in more recent depictions of the *sertão* (and referenced by Oricchio in the passage cited above). The key distinction to be found in Waddington's work from the latter, conciliatory imaginary is that in his films we see small communities in the process of (re)formation rather than a pre-existing traditional community attempting to accommodate and reconcile various members. In *Eu tu eles* specifically, the question of the members of the community reconciling is in fact left entirely unresolved at the close of the film. Rather than emphasizing communal reconciliation, Waddington and Soarez are focused on rereading the very idea of Northeastern community.

We can start to get an idea of the elaboration of a reformative social process in Waddington and Soarez's narratives if we compare the main character of *Eu tu eles* with the traditional, regional female icon featured in *forró* lyrics. Darlene is to some extent similar to Luiz Gonzaga's Rosinha character, another flower of the *sertão* (forró muses are often compared to flowers, and 'Rosinha' itself is a Portuguese variant of the name Rose). Like Gonzaga's muses, Darlene remains, for the most part, rooted in the rural landscape and culture of the backlands. She in fact loves *forró* itself and is corporeally associated with the music in several dance scenes. However, it is in the area of gender roles where Darlene truly defies expectations, failing to live up to the traditional passive model of patience and loyalty. Rosinha and other *forró* 'flowers' waited for their lovers to return with the rains. They were thus associated along with nature as something to be possessed by men when they deemed it most advantageous. Waddington portrays Darlene, on the other hand, as a woman who is empowered to fulfill her own desires even when faced with the most traditional and obstinate of husbands in her own household. Ultimately, we see that through her influence over the man she loves, she is able to significantly reshape the communal structure of this household.

The inspiration for Darlene came from the real-life story of Marlene Sabóia, a resident of the hamlet of Morada Nova in Ceará. Sabóia cohabited and was romantically involved with three men in her household. The daily *Folha de São Paulo* depicted her as someone who courageously 'confronted the machismo of the Northeast' by claiming for herself a right that men had been claiming for ages—that of having relationships with multiple partners simultaneously (Bartolomei 2000). Waddington saw coverage of this unique domestic situation on a Brazilian television news magazine programme and was inspired to develop a screenplay with the aid of writer Elena Soarez. The character Darlene similarly takes on three 'husbands' over the course of the film in order to meet her various economic, emotional, and sexual needs.

From the outset *Eu tu eles* establishes that Darlene has been abandoned at the altar, pregnant with her first child. She has thus been betrayed not only by her lover but by the traditional matrimonial norms of the society, and the expectation to be 'taken care of'

by her child's father. It is clear she must somehow find her own way in life—there will be no promise from afar from her lover to return to her side when the time is right. She agrees to a marriage of opportunity with a rather misanthropic, stick-in-the-mud older man (perhaps in his sixties) named Osias (Lima Duarte) who owns a house in the area. In the case of Marlene Sabóia, Darlene's real-life counterpart, the first marriage was arranged by her parents with a 42-year-old man when she was 19. Darlene's marriage with Osias provides her and her son with some financial security and the respectability of a societally-recognized relationship; however she must still work in the sugarcane fields to supplement the household income along with doing all of the domestic work. Osias, on the other hand, idles away his time in a hammock listening to *forró* on the radio and occasionally picks up his pension cheques in town. Even this small task, however, is usually left to Darlene.

At this point Darlene could easily become a tragic figure, like those silently suffering heroines found in *cordel* [popular-fokloric literature] and *forró* epics such as Patativa do Assaré's 'A Triste Partida' [The Sad Departure] (1960) or in novels such as Graciliano Ramos' *Vidas Secas/Barren Lives* (1938). These women are ground down or forced into exile by the circumstances of life in the *sertão*. Instead, we begin to see her as someone who acts independently in order to gain more autonomy over her own psychological well-being. She organizes a kind of extended family that satisfies her emotionally and sexually while providing an added pool of labour and financial resources for the household. First, she begins a relationship with a relative of Osias named Zezinho (Stênio Garcia) who treats her far more affectionately than her own husband. This relationship flowers on the dance floor of the local bar, where Darlene is often seen dancing *forró* in the film without her husband, Osias, who almost always refuses to accompany her. In fact, Darlene first dances with Zezinho at the reception of her wedding to Osias while the latter mopes in his house. It is in the act of dancing that her character seems most empowered and able openly to choose her partner, forcing us to see both *forró* and this rural region in a new light. Indeed, the importance of dance demonstrated by the film is confirmed by recent research which demonstrates the profound significance of bodily movement in *forró* as a form of expression (Lawless 2008). Extending the idea beyond the realm of dance, all of Darlene's activities outside of the home (i.e. Osias' house) seem to be the most challenging to traditional gender roles—including her work in the canefields, an abortive attempt to leave Osias, and her extramarital liaisons in the yard or on the banks of the local watering hole.

Yet within her household, too, Darlene manages to challenge gender norms by constructing a functioning polyandric family. In so doing, she does not play the traditional role of silently accepting the very limited satisfaction (and suffering) gained from her first, legal marriage to Osias. Darlene's alternative womanhood and her ability to at least partially fulfill her own desires challenge the norm as seen in traditional *forró* lyrics, yet it should be recognized that she is far from being able to directly challenge and overcome the patriarchal order and the insecurity of machismo. In fact, even as a woman Darlene

is seen to stand alone since the only other female character of any significance is Osias' sister Raquel, who dramatically and disparagingly accuses her brother of being a cuckold after seeing Darlene's youngest child born. Nevertheless, Darlene and her husbands at least provisionally transform their household into something like the hybrid space of the nurturing genre—a space in which a more inclusive politics of difference is possible, although by no means guaranteed.

Some of the original music on the soundtrack of the film also re-envisions both the role of women in the Northeastern *sertão* and the association of female sexuality with the abundance of the rainy season. This rethinking of the traditional male perspective of songs like 'Asa Branca' is especially clear in Gilberto Gil's *O amor daqui de casa* [Love here at home] (2000). The piece is subtitled *Darlene's Theme* and is clearly associated with Darlene herself through its appearance on the soundtrack during many of her more solitary moments. 'O amor daqui de casa' is a slow lament that features some of the tragic elements of canonical *forró* lyrics with regard to the periodic droughts which can destroy subsistence crops and livestock. However, Gil's song also clearly references Darlene and her various pregnancies (these are evident in the film as well). One important change to note from a *forró* standard like 'Asa Branca' is that the 'here' of the title of Darlene's theme song places the singer's perspective geographically within the Northeast. It is as if Gil and Waddington have shifted our perspective from that of the singer of 'Asa Branca' to that of his lover Rosinha, who remains behind in the *sertão* when he migrates looking for work. This shift almost automatically implies more agency for the *sertaneja* [female backlander], since she is now recognized as an actual subjective force in the present rather than a static symbol associated with the fertile potential of the rural Northeast in the rainy season. In traditional *forró*, the Northeastern woman along with the natural environment represented the chance for some future redemption, and was thus primarily part of a utopian future (when not simply referred to as a partner on the dance floor).

Beyond this basic shift in geography and gender, 'O amor daqui de casa' inverts the typical association of woman's fertility with that of nature. As noted above, 'Asa Branca' features the lyrical imagery of the green of Rosinha's eyes spreading out into the landscape as the rains return. The purpose of this imagery is clearly to suggest that both woman and nature will be appreciated together upon the male singer's return at the opportune moment. In the sequel song to 'Asa Branca', 'A volta da asa branca' [The Return of White Wing] (1950), we learn that this appreciation includes the promise to marry if the rains are steady and there is a good harvest (Ramalho 2000: 127). However, in Darlene's theme song the lyrics do not associate female fertility with returning rains and an abundant harvest. Quite the opposite—the opening lines of the first two verses describe a drought occurring at the same time that 'menstruation does not come' and 'labour pains will return'. Rather than the romantic, male-gendered perspective of 'Asa Branca' that assumes a lover frozen in time until the migrant can triumphantly return to the home region, Gil's song takes a

more realist perspective in which the woman's life must continue despite the hardships she faces due to drought and poverty. This contrast with canonical *forró* discourse highlights the underlying assumption in the traditional songs that the 'Rosinha' back in the Northeast would somehow put her life on hold until she could be rescued by her man upon his return from the South. 'O amor daqui de casa' gives the listener the opportunity to experience, along with the viewer of *Eu tu eles*, what life might be like for a Northeastern woman who faces great hardships, but at the same time tries to fulfill some of her own desires—whether or not these have been valorized by a traditional male gaze.

Agency within isolation: The women and environment in *Casa de areia*

Elena Soarez and Andrucha Waddington are interested in the *sertão* not only as a picturesque backdrop but also as an isolated setting that provides the opportunity to explore the interconnected relationships of the main characters in depth. Waddington presents Osias's house in the backlands as a space of its own that incorporates little more than Darlene's family itself—we see no other passersby, traffic, or even neighbours in the vicinity. Outside the house, as mentioned above, Darlene uses the opportunity of trips to town to dance *forró* with men in the local bar and explore the possibility of new romances entering her isolated home. In his subsequent feature film *Casa de areia*, Waddington takes this interest in isolated Northeastern settings to a new extreme, while maintaining his focus on a strong female protagonist. The setting of *Casa de areia* in the dunes of Maranhão is in fact so isolated that the film is more or less *deregionalized* in comparison with *Eu tu eles*, all the more so due to the absence of regional music on the soundtrack. These dunes are a coastal environment unique to the state of Maranhão and not as iconic of the Northeast as a region as the *sertão*, the semi-arid backlands area featured in *Eu tu eles* and common to all the nine Northeastern states of Brazil. Through the new setting, the film also, to some degree, steps outside the tradition, discussed above, of films going back to Cinema Novo which privilege the *sertão* as a rural setting for traditional culture. Regarding this new setting, Waddington has said: 'In this case I got to create an entire universe from scratch. It's like these two women are living on the moon and don't even know it' (in Rohter 2006). Based on this comment, it seems clear that the director found a new degree of freedom in his choice of a unique, isolated environment, one in which he and Soarez could narrowly define the cultural variables of the atmosphere in which their female characters would develop.

Rather than being inspired by a story or biography, the narrative of *Casa de areia* has its origins in a single photograph of an abandoned house in the dunes of Maranhão, found by Brazilian producer Luiz Carlos Barreto (Waddington 2005, DVD Extras). Barreto suggested making a film based on the image to Waddington, and thereafter Waddington partnered with Soarez again to write a screenplay. Thus Waddington provided a certain continuity by

working with the writing team of *Eu tu eles*. However, the more recent film focuses much more on the manner in which the main character Áurea's gender identity and sexuality are able to develop in the film's unique micro-cultural context. The time period has also shifted from *Eu tu eles*'s more or less contemporary action, as this film begins in the early twentieth century with Áurea (Fernanda Torres), her husband Vasco de Sá (Ruy Guerra), and her mother Maria (Fernanda Montenegro) arriving in the coastal dunes to establish a solitary homestead. This time, Soarez and Waddington's female protagonist is provided with the opportunity of forming a non-normative family when her husband meets an accidental death early in the film. She and her mother are left to fend for themselves, although they eventually receive some help from Massu (Seu Jorge), a member of a nearby *quilombo* (a community founded by fugitive slaves) who has also lost his spouse. The film's setting is shown to be so isolated from the rest of Brazilian civilization that the older residents of the *quilombo* still refuse to believe that slavery has ended, even several decades after abolition. The isolation and even desolation of the locale are filmically emphasized by frequent use of wide-angle landscape shots that dwarf the actors in the vastness of the dunes. Much of the dramatic tension in the film centres around Áurea's initial desire to leave these lonely dunes and return to her native São Luís and civilization. It is Áurea's mother Maria that first raises the point that returning to civilization will involve a loss of the new autonomy they have found with their independent status in their new home. The shift in the female characters from the strictures of bourgeois life of the time to a new independence is symbolized as they gradually jettison their fashionable hats, scarves, and corsets and favour looser, lighter clothing more appropriate to the desert environment.

But it is through her sexuality that Áurea is ultimately shown to come to terms with her new home and to let go of her dreams of returning to the more fashionable, bourgeois lifestyle she knew in the city. She and her mother are first somewhat wary of the *quilombola* Massu, but proceed slowly to develop a trusting relationship with him as he teaches them to survive in the dunes. The changes in Áurea with the passage of time are periodically suggested with close-up shots of the continually shifting and flowing sand of the dunes (the similarity of the name Áurea with the Portuguese word *areia*, or sand, in the film's title bears mentioning here). Through her initiation of sexual intercourse with Massu, outside in the omnipresent landscape of the shifting dunes, the film-maker conveys Áurea's decision to settle down here permanently. Much like in traditional *forró* lyrics, in Waddington's films female sexuality is closely associated with the regional environment of the Northeast. However, as seen here and above in Darlene's theme song from *Eu tu eles*, the environment and man's exploitation of it do not determine the female protagonist's future. Both *Eu tu eles* and *Casa de areia* develop narratives of women who are somehow able to transcend, at least partially, the gender roles and limitations thrust upon them by male desire, regional culture, and a harsh climate.

Unlike the character Rosinha from the *forró* classic 'Asa Branca', Áurea is much less restricted or held in limbo by her environment or the need to wait for her lover to rescue

her. She even challenges social barriers to white middle-class women by crossing the lines of social class and race in initiating her romance with the Afro-Brazilian *quilombola* Massu. Waddington demonstrates the environment's ability *to empower and liberate* this Northeastern woman, once she has come to terms with leaving her former life behind. As the director himself describes Áurea's struggle, 'People fight to find happiness for themselves [in] their own garden' (Talcott 2006). Through force of will and the help of her family and small community, the protagonist is able to transform this desert into a garden, an environment akin to the 'hybrid spaces' typical of the nurturing genre. As in films of this genre, the protagonists of *Casa de areia* are marginalized by the dominant culture, yet are able to thrive through the establishment of a micro-community with an inclusive politics of (class, racial and sexual) difference. The autonomy Áurea achieves is all the more striking if one considers the more restrictive gender roles of the historical period when she settles in the dunes, in the second decade of the twentieth century.

Yet the prolonged period over which Áurea struggles to break free of the norms of urban, bourgeois lifestyle is not without cost. Through her complaints and dissatisfaction with the dunes and her constant talk of returning to civilization in the early years of her daugher's life, Áurea engenders a dislike of the region in the young Maria even as she herself comes to embrace it. Nevertheless, Áurea fully recognizes after Maria becomes a young woman that she wishes to explore the world beyond the dunes. Thus when the opportunity arises, she empowers her daughter to leave for urban Brazil by convincing a visiting soldier to take her with him. Áurea thus demonstrates solidarity with other women and a recognition of their desires left unexplored in *Eu tu eles*, whose protagonist interacts almost exclusively with men.

A brief look at other Northeastern female characters

Waddington and Soarez's skill at creating and portraying Northeastern female characters with greater agency and complexity, in narratives with rural Northeastern settings, is unparalleled in the films of other contemporary directors set all or partly in the Northeast. Consider, for example, Walter Salles's *Central do Brasil/Central Station* (1998), Vicente Amorim's *O caminho das nuvens/The Middle of the World* (2003), and Carlos Diegues's *Deus é brasileiro/God is Brazilian* (2002). Suffice is to say that in these other films, Northeastern women—when portrayed at all—are given the stereotypically Catholic roles of mother, virgin or whore. In fact, even the names of the Northeastern female characters and their relatives in these films tend to bolster such stereotypes: Madá (short for Madalena, played by Paloma Duarte), the Mary Magdalene of *Deus é brasileiro*, and Ana (Soia Lira), in *Central do Brasil*, who is cast as part of a biblically-inspired family—as the estranged wife of an absent man named Jesus and the loving but ill-fated mother of Josué (or Joseph, played by Vinícius de Oliveira). The name of

the lead female character of *O caminho das nuvens*, Rose, is not quite as scripturally symbolic—although it does echo the name of the traditionally passive *forró* character discussed above, Rosa (or Rosinha). In the film, unlike the Rosinha of musical fame, the character Rose (Cláudia Abreu) leaves the Northeast with her husband Romão (Wagner Moura), but then goes to great lengths throughout the narrative to support her husband's quixotic pilgrimage to find a working-class job that would support their large family and maintain her in the position of full-time mother/homemaker. Rose thus ultimately re-establishes the passive, supporting role featured in traditional forró lyrics and in the related literature and film of past eras.

Conclusion

I have demonstrated how traditional Northeastern popular music valued the *sertão*'s potential as a beautiful and fertile place. *Forró* lyrics of the past drew a close parallel between this beauty and productiveness and that of the Northeastern woman, at the same time assigning a more passive gender role to the woman of patiently waiting for her beloved man's return. Similarly passive and stereotypical roles have traditionally been assigned to (Northeastern) Brazilian women in literary and filmic depictions of the natural landscape. Waddington and Soarez focus instead upon the perspective of the women of the Northeastern interior and their agency within the cultural and natural landscapes of the region. Waddington cites traditional *forró* but proceeds to renew and expand its perspective along with his musical director Gilberto Gil in *Eu tu eles*. Waddington and Soarez then background issues of regional identity in *Casa de areia* in order to explore female agency in even greater depth, and in an environment and era that seem all the more potentially harsh and restrictive for women.

Thus Soarez and Waddington break new ground in the field of Brazilian film with their works, parallel to the efforts in recent decades of film-makers in the North American nurturing genre. Within Brazil, the strong female protagonists of Waddington and Soarez find echoes in recent developments in Northeastern popular music. The lyrics of some contemporary *forró* songs, written and performed by female artists, could refer to the characters of Darlene or Áurea: Roberta de Recife sings 'I will give myself again / Cry I will not cry anymore / Nor suffer for anyone' (Recife n.d.), while Bete Nascimento of the Fortaleza-based band Mastruz Com Leite affirms 'I'm going to search for another dream / And never turn back' (Nascimento n.d.). In Brazilian film and in popular music, then, we can see at least a few indications of an expanded horizon of possibility for the representation and agency of Northeastern women. It remains to be seen whether a new generation of female film-makers from the Northeast will be able to rise up on this horizon and push the limits of regional film still further.

References

Alencar, J. ([1875]2006) *Iracema*, New York: Luso-Brazilian Books.

Amorim, V. (2003) *O caminho das nuvens*, Rio de Janeiro: Globo Filmes/Miravista.

Bartolomei, M. (2000) '*Eu tu eles* é inspirado em história real de mulher e 3 maridos,' *Folha de São Paulo - Folha Online Ilustrada*, 17 Aug., http://www1.folha.uol.com. br/folha/ilustrada/ult90u3799.shtml. Accessed March 14, 2008.

Caballo-Márquez, R. (2008) 'Narrativas transatlánticas corporales en la era de la globalización,' *Ciberletras* 19, http://www.lehman.edu/faculty/guinazu/ciberletras/ v19/caballomarquez.html. Accessed May 2, 2009.

De Lauretis, T. ([1987])2000 'Strategies of Coherence: Narrative Cinema, Feminist Poetics' in A. Kaplan (ed.) *Feminism & Film*, Oxford: Oxford University Press, pp. 265–86.

Dempsey, A. (2005) 'Nurturing Nature and Cinematic Experience: The American Landscape and the Rural Female Community', *Journal of Cultural Geography* 23.1: 115–37.

Diegues, C. (2002) *Deus é brasileiro*, Rio de Janeiro: Globo Filmes/Columbia TriStar.

Galvão, W. N. (2004) 'Metamorfoses do sertão', *Estudos Avançados* 18.52: 375–94.

Gil, G. (2000) 'O amor daqui de casa', *Gilberto Gil e as canções de Eu tu eles* [Listening notes], Conspiração Filmes.

Ginway, E. (2004) *Brazilian Science Fiction: Cultural Myths and Nationhood in the Land of the Future*, Lewisburg, PA: Bucknell University Press.

Lawless, M. (2008) 'Corporal Accents: Deciphering Regional Sotaques of Forró,' Brazilian Studies Association Congress, March 27-29, Tulane University, New Orleans.

Nascimento, B. (n.d.) 'Vou tentar te esquecer', *Mastruz com Leite: Do forró do grilo a New York* [Listening notes], Somzoom.

Oricchio, L. Z. (2003) 'The *Sertão* in the Brazilian Imaginary at the End of the Millenium' in L. Nagib (ed.) *The New Brazilian Cinema*, London: Tauris, pp. 139–56.

Ramalho, E. B. (2000) *Luiz Gonzaga: A síntese poética e musical do sertão*, São Paulo: Terceira Margem.

Ramos, G. ([1938] 2003) *Vidas Secas*, Rio de Janeiro: Record

Recife, R. de (N.d.) 'Quando um amor', *Aquela estrela* [Listening notes], Special.

Rohter, L. (2006) 'Happy Birthday. Here's an Inspiration,' *New York Times*, July 23, Sec. 2: 9–10.

Salles, W. (1998) *Central do Brasil*, Rio de Janeiro: Columbia TriStar.

Stam, R. (2003) 'Cabral and the Indians: Filmic Representations of Brazil's 500 Years' in L. Nagib (ed.) *The New Brazilian Cinema*, London: Tauris, pp. 205–28.

Talcott, C. (2006) 'Building the 'House of Sand', *New York Times*, Sept. 15, T48.

Waddington, A. (2000) *Eu tu eles*, Rio de Janeiro: Columbia TriStar.

Waddington, A. (2005) *Casa de areia*, Rio de Janeiro: Sony Pictures.

Williams, B. E. (1990) 'A Captive of the Screen: Archetype and Gaze in Barreto's *Gabriela*', *Film Criticism* 14.2: 24–32.

Taking Initiative: Brazilian Women's Film-making Before and After the *Retomada*

Leslie L. Marsh
Georgia State University

In March of 1990, then-president Fernando Collor de Mello instituted a series of cultural policy measures in Brazil that, among other acts, extinguished fiscal incentive laws for cultural production, demoted the Ministry of Culture by replacing it with a Secretary of Culture, eliminated public companies and foundations such as the Brazilian Film Foundation and dissolved agencies such as the Empresa Brasileira de Filmes (Embrafilme). This dramatic limiting of the role of the State in the culture sector meant that film projects were immediately suspended, production funds were lost and film production contracts were broken.[1] Film-making in Brazil came to a virtual standstill.

New cultural policies were passed quickly, starting with the 1991 Federal Cultural Incentive Law (or, *Lei Rouanet*) and the 1993 Audio-visual Law which were aimed at bolstering audio-visual production. Both laws allowed Brazilian companies to contribute portions of their yearly tax liabilities towards cultural projects, providing much-needed funds for cultural producers. After a few years, Brazilian film-making began to pick up, which brought forth optimistic claims that the industry was experiencing a rebirth or a *Retomada*. Between 1994 and 1998, critical years in the redevelopment of Brazilian cinema, a total of 20 films directed by 17 different women directors were released in Brazil. This historically high number, combined with the fact that Ana Maria Magalhães was one of only seven directors to release a film in 1994, Carla Camurati's 1995 film *Carlota Joaquina: Princesa do Brazil/Carlota Joaquina: Princess of Brazil* was a box-office success, and the films *Terra Estrangeira/Foreign Land* (1996), co-directed by Daniela Thomas and Walter Salles, and *Um Céu de Estrelas/A Starry Sky* (1996) directed by Tata Amaral received critical acclaim nationally and internationally, prompted the problematic

assertion that women directors were at the forefront of the *Retomada*. Taking note of these events, critics resuscitated discussion of the category of 'films by women', an area of film studies that had been addressed extensively in the 1970s and 1980s. From an optimistic vantage point from the late 1990s, film critic Susan Schild predicted a slow, gradual increase in the number of Brazilian women directing feature-length films (Schild 1998: 124–25). In many respects, Schild's prediction was correct. At most recent count, there are no fewer than 30 women in Brazil directing or co-directing feature-length fiction or documentary films. However, in terms of overall film production from Brazil, women still very much occupy a minority status. From 1990 to 2009, films directed by women represent approximately 14 per cent of all short, medium and feature-length fiction and documentary films produced in Brazil.[2]

This chapter has two goals. First, I aim to reflect on women's film-making in Brazil before and after the period of the *Retomada*, including directors' perspectives on issues of production financing, access and their film practice. I draw on commentary from film-makers such as Ana Carolina Teixeira Soares, Tizuka Yamasaki, Helena Solberg, Lúcia Murat, Suzana Amaral, Eunice Gutman, Tetê Moraes, Tereza Trautman, Ana María Magalhães and Sandra Werneck whose careers began in the late 1970s and early 1980s and have continued into the current period. These film-makers provide valuable insights into how their film practices have changed over time, the key sociopolitical issues that continue to concern them, and their views on the ever-changing landscape of cultural production. I also include the perspectives of a younger generation of film-makers who began directing films in the late 1980s and whose first feature-length films were produced and released in the mid-1990s, after the closure of Embrafilme and in the middle of the *Retomada*. A second goal for this chapter is to provide a critical accounting of where women's film-making in Brazil stands in the current audio-visual landscape.

Films by women

Before proceeding further, it seems appropriate to address the question of women's cinema. The return of film-making in the mid-1990s and the participation of women film-makers in that process prompted a return to discussing whether or not there was something particular to films made by women in terms of aesthetics or production strategies. In 2001 at the São Paulo Short Film Festival, a diverse group of women directors gathered to discuss questions of aesthetics and production. When asked about how they understood the idea of 'women's cinema', the vast majority of women directors rejected the idea that because they are women that their films bear a particular, female imprint. The majority of the directors present at the event in São Paulo and in individual interviews expressed their belief that it is exceedingly difficult to prove objectively that a female director has been at the helm of a film. In short, these film-makers were wary

of arguments about women's film-making that drifted towards essentialism and, thus, proved to be philosophically unfruitful.

But, the category remains an important one. For the majority of women directors interviewed—but certainly not all—what is at stake are the topics selected to be treated and how issues are developed. If we heed the comments made by a number of women film-makers in Brazil, film scholars should focus their attention on the representation of diverse life experiences and larger questions of access and equity in participation in a field of mass communication and artistic production.

Eunice Gutman (2005) most clearly explains her position on this matter. She supports the idea of women's cinema but denies the idea of a particularly female way of representing. Instead, she maintains there is one cinematic language that is used differently by different film-makers depending on his or her background:

> A linguagem cinematográfica é uma, que é uma técnica... como é que você usa um plano geral, como é que você usa um *close*, como é que você usa um plano médio. Essa linguagem é única, é universal. Existe o filme de autor, existem várias tendências—mas dentro dessa linguagem. Agora, logicamente, se você vai interpretar uma história, você vai interpretar de acordo com a educação que você recebeu. Então tudo vem daí.

> [Cinematographic language is one, it is a technique... how you use an establishing shot, how you use a close-up, how you use a medium shot. This language is one, it's universal. There's auteur film-making, there are several tendencies, but within this language. Now, logically, if you are going to interpret a story, you are going to interpret it according to your background. So everything comes from there.] (Gutman 2005, interview with author)

What matters fundamentally, according to Gutman, are the experiences a person has had and how this person has been shaped as an individual. Magalhães (2001) adds that, as a director, you have to develop a complex vision of the world. She warns against '*uma visão compartimentada*' [a compartmentalized point of view] and stresses that you have to move beyond yourself when directing.

Film production: access and financing

When women began producing and directing films in the 1970s and 1980s, they were entering a context where their visions of society found an outlet in independent films.[3] Historically speaking, women have benefitted from contexts that have fostered

independent film production (Marsh 2008: 94–5). Women film-makers who produced and directed their first films during the existence of Embrafilme credit the agency for helping them start their careers. Gutman (2005), for example, describes a number of services Embrafilme offered to film-makers that she found highly beneficial which the current film-making context lacks. First, there were projection rooms for 16 and 35mm film when a director needed to show his or her film. Parties interested in helping fund film would sometimes like to view a work in progress. At that time, it was impossible for directors to screen their work without access to a 16 or 35mm projector. A press service would spread news about a film's release. Assistance was available to mail films abroad to festivals without cost to the producers and directors. If a film was accepted in a film festival, Embrafilme would pay for part of the travel expenses for the director to attend the festival. Gutman also underscores the importance of Embrafilme's physical existence. Because Embrafilme was a public facility, the average person had the right to go there to see films made by fellow Brazilians. With the vast majority of Brazilians living in poverty and unable to afford movie tickets in commercial cinemas, this made access to cultural works more democratic. Lastly, Embrafilme established a supportive environment for film-makers. She further explains that the agency's physical existence benefited film-makers as a community. Although situated in Rio de Janeiro, Embrafilme was a location where people could meet, talk about their projects, and perhaps find work. That is to say, the existence of Embrafilme led to a greater degree of dialogue and opportunities among film-makers in Brazil.[4] Moreover, Gutman emphasizes the importance of being able to meet with other members of the profession to solidify their professional demands vis-à-vis the state and in conjunction with state-sponsored agencies such as Embrafilme and Concine. In contrast, she finds today's context to be much less organized and fragmented:

> …a gente estava muito mais em contato do que hoje. A classe cinematográfica hoje está toda dispersa. O grande golpe, um dos grandes golpes no cinema, foi o desaparecimento da Embrafilme… Então a gente tinha uma vida muito ativa, a classe cinematográfica, porque a gente tinha uma representação nos congressos. Eu não estou dizendo que essa representação hoje não existe. Existe, mas não da mesma forma.

> […people were much more in touch with one another then. The film sector is scattered today. The great blow, one of the big blows to cinema, was the disappearance of Embrafilme… Back then we were very active, the film sector, because we had representation in conferences. I am not saying that this representation does not exist today. It does exist but not in the same way.] (Gutman 2005, interview with author)

Similarly, Sandra Werneck (2002) holds some praise for the past and critique of the current situation. Active in short film production and documentaries during Embrafilme's existence, Werneck comments the ways in which selection committees assisted new film-makers. As a film-maker just starting her career, she says she would submit her project proposals to a selection committee that would then provide her with an evaluation. Werneck asserts that this process was really democratic and greatly contributed to her learning the craft. Unfortunately, she does not believe the current landscape provides this form of support for novice film-makers. This description stands in contrast to what has occurred during the years of the *Retomada* when committees composed of trained film professionals were replaced by marketing executives of companies that transferred a portion of their tax income to the State for cultural production. When asked to reflect on past and current funding, Werneck feels there are now fewer film awards so that most people work on others' projects and gain experience this way rather than develop their own projects at an earlier stage in their careers. For those starting out now, she has two words: 'Puxa vida!' [Gosh!] (Werneck 2002, interview with author).

A significant shift found in the current film-making context is the disappearance of cooperative film practices. Indeed, cooperative film practice was both common and central to the development of the careers of most women who began directing films in the 1980s. Tatá Amaral (2001) explains that she learned to make films in the 1980s by collaborating with an informal group of people in São Paulo and assisting her husband at the time, who was involved in film-making. Tatá Amaral's experience resembles that of Murat who was dating a man involved in cinema and journalism. Murat notes that, as an experienced journalist, her involvement in cinema came about organically since the two were closely linked in the 1960s and 1970s.[5] Werneck (2002) reflects on her own experience selling a family cow to get supplies to make her first film and working in a context where, lacking a commercial structure, 'tudo era cooperativado' [everything was cooperative]. She notes that her daughter, who is trying to break into the field now, has to come up with a lot more money to complete her first film. Werneck believes that the collaborative environment she experienced in the past no longer exists in the current context. Collaborative film practice was heralded in the 1960s as a way for inexperienced film-makers to produce and direct their films with limited financial resources. Less collaborative environments in the current context, as described by these film-makers, could potentially impede inexperienced film-makers' entry in the field.

Attending film school was another option for learning the skills of film-making and subsequently entering the profession. While most women directors learned the craft in a cooperative manner described above, Ana Carolina Soares (2005) and Yamasaki (2005) are unique in that both attended film schools in the 1970s. Indeed, both were among very few other women in their respective cohorts. Coinciding with the *Retomada* of film production, a number of new programmes have begun, including programmes in other regions outside the Southeast. While it is more likely in the current era of film production

that women attend film schools, it is too early to tell if increasing professionalization will allow for more women and other historically underrepresented groups to enter film-making in greater numbers.

When they have not been producing or directing film projects, these directors have gravitated by choice or by necessity towards other areas of visual communication, including television and video. For Murat (2001), cinema has been an extension of her work in television and journalism. For others, such as Yamasaki (2005), working in television has developed parallel to their work in the film industry. Lack of funding for independent film projects as well as increasing costs of production have inspired a few directors to work with less expensive technology such as digital and traditional video formats. Gutman (2005) moved to video also because of the opportunities that became available to work in traditional video format with various social organizations. Others have distanced themselves from television and other areas of audio-visual production altogether. Camurati has worked in theatre production and Ana Carolina (2005) has chosen to work in opera when she has not been able to secure funds for her film projects. Despite the technical and financial assistance with production, distribution and, to a limited extent, exhibition, the majority of women film-makers hold ambivalent opinions of Embrafilme. Now distanced greatly from the years of Embrafilme, and in the midst of their own production difficulties, some see the absence of a centralized, state-led film agency as positive. A common critique these women launch against Embrafilme is the traffic of influence within the agency. Indeed, some women film-makers claim they enjoy a certain degree of freedom that has resulted precisely from the absence of Embrafilme. Nonetheless, a number of women film-makers see a film agency as something good and beneficial if it works effectively.

Most women film directors in Brazil have taken on the dual role as director and producer of their films. In this sense, not much has changed over the past decades. During the 1970s and 1980s, film directors had to have produced a film outside the state agency before they could request production funds from Embrafilme. The response from women film-makers was to establish their own production companies, work to produce their own projects with or without local or regional government assistance and, if possible, become eligible for production funding according to the requirements set forth by Embrafilme. This, in fact, is how Yamasaki (2005) was able to produce and direct her first feature-length film *Gaijin: Os Caminhos da Liberdade/Gaijin: Roads to Freedom* (1980).

The majority of women directors have established their own production companies but they do not necessarily do so in order to have greater oversight of their work. Magalhães (2001) does not feel that her authorship is at risk if she allows someone else to manage the production of one of her films. Suzana Amaral (2001) falls on the opposite spectrum. She reports feeling taken advantage of by the producer of her film *Uma Vida em Segredo/A Hidden Life*, an adaptation of the 1964 novel by Autran Dourado. Werneck (2002) sees the current lack of producers in Brazil as a problem and wishes there were

individuals who would take on this role. Murat (2002) stoically states that if she wants to direct her own films and continue doing so, then she has to produce her own films.

The challenge to secure production funding was one of several obstacles encountered by film-makers. Directors whose careers began during the 1970s and 1980s also faced the vagaries of state-sponsored censorship. Indeed, censorship cost many film-makers a great deal of time, money and, in some cases, their careers. Tereza Trautman (2001) whose 1973 film *Os Homens Que Eu Tive/The Men I Had* was banned until 1983, claims censorship gravely affected her ability to secure funding for future projects. Ana Carolina (2005) was forced to publicly discredit her work so that government censors would allow her to release the film *Das Tripas Coração/ Hearts and Guts* (1982).

Perhaps the most insidious factor characterizing political censorship in Brazil is the way in which it diverted attention away from the realities of economic censorship. Magalhães (2001) states they all knew political censorship would end one day but they did not have an adequate plan to address structural changes when this became reality. What is more, Magalhães asserts that the current mode of economic censorship works from within the industry and the main difference between the type of censorship people experienced under the military regime until the mid-1980s and the type of economic censorship experienced since then is that there is no light at the end of the tunnel for economic censorship. In contrast, Murat (2002) expresses a more optimistic view regarding the current system of film production financing. She asserts that independent film-making in Brazil is strong, believes the current incentive laws have allowed for new people to enter into the field and emphasizes that the new laws have spurred film-making in different regions of Brazil.

To be sure, the current incentive laws allowed for the resuscitation of Brazilian cinema in the mid-1990s and have, thus far, sustained film-making in Brazil. However, directors explain that they do have to work within certain limitations. Film-makers may have to associate with a certain company's brand or trademark. While this allows for receiving some financial support, it can also limit independent producers and directors from securing potential production funds from other sources. Speaking in general terms, Yamasaki (2005) asserts that some companies may not have wanted to get involved in the production of her 2005 film *Gaijin 2: Ama-me como sou/Gaijin 2: Love me as I am*, but, as a consecrated director, she did not have to deal with any interference on her project. She does not know what directing this film would have been like had she been a director with less experience. By admitting to this, she brings up an important point about potential encroachment upon artistic autonomy under the current system of film financing.

Several film-makers reveal a concern for the future of independent film-making. Despite her optimism, Murat (2002) stresses that there have been some significant shortcomings with the structure of the incentive laws. She explains that a number of foundations have been established that have managed to distort the incentive laws in such a way that a good part of public money are going to foundations or large corporations instead of independent film producers. Yamasaki, who needed nine years to see her

2005 film *Gaijin: Ama-me como sou* come to fruition, wonders if an organization such as Globo Filmes—with its connection to TV Globo, its know-how and cultural and political agency—could move towards becoming something like a 'Brazilian major' and eventually squeeze out independent film producers and directors.

Women's cinema: film practice and key trends

Women directors no longer work against the backdrop of the political agendas that existed in the 1970s and 1980s. Today we do not see specific political agendas leaving clear imprints on films such as those found in films from the 1970s and 1980s which were released at the height of the second-wave women's movement and during the long transition from a military regime to a newly democratic state. In other words, women films do not necessarily engage with a specific woman-centred political cause or specific women-centred social movements. As will be addressed more below, this is not to say that women films in the current context do not engage with issues of sociopolitical import. A comparison of women's film-making before and after the *Retomada* reveals a shift from focused action and political purpose to greater thematic diversity. During the period from 1990 to 2009, more than 50 feature-length films have been directed by women in Brazil. The diversity among the films makes it difficult to identify common themes or similar aesthetic strategies. Nonetheless, a constellation of concerns can be identified, including women's life experiences, women's participation in history, the contributions made by women to Brazilian culture, and broader questions surrounding citizenship, or 'the boundaries of belonging' in Brazilian society.

The second-wave women's movement in the 1970s and 1980s sought to increase women's rights and break down a number of sociopolitical barriers. However, with a few exceptions, women film-makers in Brazil explain they did not participate in feminist organizations nor did they embrace 'feminism' as an ideology. Although most women film-makers who began their careers in the 1970s and 1980s do not think of themselves as feminists, they do not reject a feminist reading of their works. By contrast, they express an interest in the pragmatic issues that affect women's lives. Yamaski (2005), for example, does not mince words when she speaks of feminism, stating that she thought it was 'uma coisa horrorosa' [a horrible thing]. But, she does state that she was concerned with 'o cotidiano da mulher que se estava tornando independente' [the day-to-day life of a woman who was becoming independent]. Tatá Amaral (2001) concurs with Yamasaki and explains that, as a woman film director, she is particularly interested in reconstructing the figure of women in society.

In the 1980s, there was a push to redefine the figure of women in history and contemporary society; a number of films from the 1980s focused attention on women's roles in history and political process in an effort to fill gaps in Brazilian history as well

as provide sought-after positive models for women who were challenging traditionally-defined social roles. Former actress Norma Bengell directed the 1987 film *Eternamente Pagu/Pagu Forever*, which depicted Patrícia Galvão (Pagu) who became an important figure in the second-wave women's movement in Brazil. Each of the first three feature-length films by Yamasaki addresses history from a woman's point of view. *Gaijin: Os Caminhos da Liberdade* discusses Japanese immigration to Brazil from a young woman's perspective while *Parahyba, Mulher Macho/Parahyba Woman* (1983) treats the iconoclastic young poet, journalist and teacher Anayde Beiriz. Yamasaki's *Patriamada* (1984) combined the politics of interpersonal romantic relationships with popular demands for direct free elections. Yamasaki's most recent film, *Gaijin: Ama-me como sou* revisits the Japanese community in Brazil as it addresses larger questions about immigration and globalization.

Nonetheless, films directed by women that have emerged out of the current context reveal a continued interest in the roles of women in history and politics. Camurati's breakthrough success *Carlota Joaquina* was lauded for its representation of history and Brazilian identity in a uniquely humorous way. Alongside feature-length fiction films, a number of documentary films by women focus on history, economics and political processes. A sequel to her 1987 documentary *Terra para Rose/Land for Rose*, Tetê Moraes released *O Sonho de Rose: 10 anos depois/Rose's Dream: 10 Years Later* in 1997 in which she revisited the women she had met in their struggle for land reform. Long-time activist and film- and video-maker Gutman, whose films have focused on gays and lesbians in Brazil, the politician Benedita da Silva and women's reproductive rights, recently completed her award-winning documentary *Nos Caminhos do Lixo/ The garbage hunters* (2009), which draws attention to a group of women living in poverty outside the city of Nova Iguaçu who established a cooperative to collect and recycle trash as a way to earn money for their survival.[6] Solberg's documentary *Carmen Miranda: Bananas is my Business* (1995) offers a personal account of the complicated relationship Carmen Miranda had with Brazil and her role as a Hollywood actress vis-à-vis United States foreign policy during WWII. Lastly, Magalhães directed the film *Lara* (2002), focusing on the Cinema Novo actress Odete Lara.

Other women film-makers are less clearly interested in reconfiguring the roles of women in society. Since the closure of Embrafilme and the start of the *Retomada*, a number of romantic comedies directed by women have been released. These films emphasize how women experience their private, affective lives. Although Werneck (2002) admits that it can be daunting to produce and direct a romantic comedy in Brazil given the competition Brazilian film-makers face from Hollywood, which she feels has perfected, if not codified, the genre, she went on to direct the successful films *Pequeno Dicionário Amoroso/Little Book of Love* (1997) and *Amores possíveis/Possible Loves* (2001). Also drawing on the romantic comedy genre, Mara Mourão (*Avassaladoras/Overwhelming Women*, 2002), Betse de Paula (*O Casamento de Louise/Louise's Wedding*, 2001; *Celeste & Estela*

2005), and Rosane Svartman (*Como Ser Solteiro/How to be Single*, 1998; *Mais Uma Vez Amor/Love Once More*, 2005) explore women's experiences in amorous relationships. These films tend to view intimate relationships from different angles and, in so doing, bridge social differences while breaking away from stereotypical gender roles.

Tatá Amaral sees the overall shift to greater diversity to be a salutary opening up of film-making by women, asserting that there are women who are interested in the reconstruction of the figure of the female in their films and there are women who are not—they just simply make their films under no pressures to conform to a specific ideological platform. Amaral's standpoint can be seen in her own work. In her debut feature-length fiction film *Um Céu de Estrelas* and *Através da Janela/Through the Window* (2000), Amaral focalizes the narratives through the eyes of a female protagonist and restructures the figure of women in contemporary society. In her most recent film *Antonia—O Filme/Antonia: The Movie* (2006), Amaral draws on the documentaries she worked on during the 1980s and combines her interest in Brazilian music with a focus on women's participation in the Brazilian music industry.

Although Amaral made a return to documentary film-making, a number of women film-makers who began their careers in the 1970s and 1980s left the mode to produce and direct feature-length fiction films. Because they tend to require smaller budgets, documentary films were, for many women directors, their first foray into the field. When asked why they shifted into feature-length fiction film-making, directors offer a variety of reasons. For Ana Carolina Soares (2005) it was a natural progression. Werneck (2002), who produced and directed many short documentary films, decided that documentary film was not an effective tool for her. But despite her move into fiction film-making, Murat (2001) believes that documentary film-making was and still can be an effective tool for intervening in social and political issues. Documentary films have never held a significant share of the market but Werneck hopes that the current context of film-making, which she sees characterized by big budgets and being 'more glamorous', will not put the squeeze on this outlet of expression.

It is important to note that, while the overall number of films directed or co-directed by women is slowly increasing, there is a noticeable decline in the number of short, medium and feature-length documentary films by women. This should concern those interested in women's film-making. First, documentary films serve multiple functions, ranging from training ground for novice film-makers to serving as a vital outlet to represent those sectors and issues of society that are often overlooked in mainstream media. Second, this trend may represent lost opportunities for women film-makers in a current context characterized by synergies taking place between documentary and feature-length fiction films. Specifically, films such as *Cidade de Deus/City of God* (2002), *Ônibus 174/Bus 174* (2003), *Cidade dos Homens/City of Men* (2003), and *Última parada 174/Last Stop* (2008) all have documentary precursors. In terms of women's participation, the film *Cidade de Deus* (2002), co-directed by Kátia Lund and Fernando Meirelles, developed out of the

eponymous novel by Paulo Lins as much as it did from the documentary *Notícias de uma guerra particular/News of a Private War* (1999), produced and directed by Lund and João Moreira Salles. Insofar as taking on multiple roles in multiple productions, it is to be hoped that the experience of Lund will be repeated in the future by other women directors. As stated above, the increasing number of women film-makers makes it more difficult to identify common concerns. That said, one significant trend in women's film-making does emerge, and it is a concern for cross-cultural dialogue. Although more apparent now, this current trend has its roots in 1980 with the release of Yamasaki's debut film, *Gaijin: os caminhos da liberdade*. Yamasaki (2005) asserts that she has a long-standing interest in the 'intercomunicação entre diversas culturas' [communication among diverse cultures] that has formed the Brazilian populace. Driven by her own desire to be recognized as Brazilian, Yamasaki's first feature-length film *Gaijin* not only retrieved the overlooked history of Japanese immigration to Brazil in the early twentieth century but also set the stage for a number of other women's films that took up the question of political rights and the boundaries of belonging in Brazil.

Murat shares with Yamasaki an interest in cross-cultural dialogue and allowing other experiences to come forth on screen. Since producing and directing her debut feature-length documentary film *Que Bom Te Ver Viva/Good to See You Alive* (1989) in which she denounces the practice of torture against political dissidents during the military regime, Murat has gone on to produce films concerned with Brazilian cultural identity with a strong political valence. Her 1996 film *Doces Poderes/Sweet Power* focuses on the role of the media and democratic accountability in a society renewing its democratic processes. In *Brava Gente Brasileira/Brave New Land* (2000), Murat draws on historical data to address the Portuguese colonization of Brazil while managing to not impose a patriarchal or Western understanding of history. Her film *Quase Dois Irmãos/Almost Brothers* (2004) focuses on questions of class and race, an important contribution to ongoing re-evaluations of Brazil's long-heralded racial democracy. Lastly, veteran film-maker Ana Carolina takes the historic visit of French actress Sarah Bernhardt to Brazil in 1905 as a departure point to reflect on class, ethnic and cross-cultural tensions in the film *Amélia* (2000). Despite the fact that women's film practice is currently less tied to specific social movements, a number of recent films by women reveal an ongoing concern for justice and democratic processes. Tetê Moraes' documentary *O Sol—Caminhando Contra o Vento/O Sol—Going Against the Wind* (2006) draws on her own experiences as a journalist and discusses the history and importance of *O Sol*, a short-lived alternative newspaper that first circulated during the most repressive years of the military dictatorship. Laís Bodansky's debut film *Bicho de Sete Cabeças/Brainstorm* (2001) reveals the corruption inside mental health institutions. Lastly, Maria Ramos' documentary film *Justiça/Justice* (2004) portrays the process of seeking justice in the Brazilian court system.

Conclusion

In her assessment of the current state of Brazilian Cinema, Brazilian film scholar Lúcia Nagib notes that the changes that were implemented in the early 1990s allowed for the increased production of films in Brazil and brought about a great deal of variety (Nagib 2003: xviii–xix). The range of cinematic languages, themes, and modes that Nagib observes in the early years of the *Retomada* can be attributed in part to an open selection process implemented by the Audio-visual Law. On the one hand, former Secretary for Audio-visual Affairs (1999–2002) José Álvaro Moisés applauds this measure outlined by the Audio-visual Law for allowing new talent to develop 'new languages and trends in cinematic expression' and for leading to a significant number of new women film directors (Moisés 2003: 4–5, 11). On the other hand, Moisés explains that the Audio-visual Law 'fell short' but has since been amended to take into account the experience and background of the director and production crew (Ibid: 15). Taking into consideration a director or production company's past performance can be understood in light of financial inefficiencies but support of newcomers is vital for Brazilian Cinema to continue to evolve.

The variety of films and gradual increase in the number of women directing feature-length films during the *Retomada* should certainly be celebrated. The richness of Brazilian film is closely linked to the diversity of participants involved in film production. In other words, cinematic expression will continue to evolve in different directions in the current Brazilian film-making context if the diversity of people involved in all facets of film production continues to increase. However, historical trends have shown that as film-making in Brazil has become more market-oriented with larger production budgets, it has been more difficult for new film directors and producers to establish themselves. In the past, short and documentary film-making have been important departure points for women seeking entrance as feature-length film-makers. Current data indicate, however, that few women film-makers who have directed a short film (fiction or nonfiction) within the past ten years have been able to parlay this experience into directing a feature-length fiction or documentary film. What is vital to women's continued and increasing participation as directors of feature-length fiction and documentary films in Brazil is focused support of newcomers and independent film production.

Notes

1. The extinction of Embrafilme meant that a total of three films were released in 1992, compared to an average of 80 during Embrafilme's existence. Many films that had been completed did not find distribution (Denise Costa Lopes 2001: 31–2).

2. This percentage, intended to be used for illustrative purposes, is arrived at by consulting print published and online resources, noting the number of films directed or co-directed by a Brazilian woman and dividing by the total estimated number of films produced in Brazil during the defined time period. This number does not include films in pre-production or post-production in 2009 and extends only to June of that year.

3. Indeed, independent, state-sponsored production was central to launching the careers of women entering the field during the mid 1970s. For more information on the women film-makers' negotiations with the State in the 1970s and 1980s, see Leslie L. Marsh, 'Embodying Citizenship in Brazilian Women's Film, Video, and Literature, 1971 to 1988' (Ph.D. diss., University of Michigan, 2008).

4. Clearly this advantage was limited to those who lived and or worked in the southern regions of the country. Those who lived and worked in the northern regions were at a disadvantage. Needless to say, film-making was concentrated in the South.

5. For example, at this time, the news segment *Globo Repórter* was filmed on 35mm film stock and then edited to show on television.

6. For this film, Gutman was awarded the Prêmio Margarida de Prata by the Conferência Nacional dos Bispos do Brasil in June of 2009.

References

Amaral, S. (2001) Interview by author, November 13 and 14, São Paulo, Brazil. Tape recording.

Gutman, E. (2005) Interview by author, August 27-28, Rio de Janeiro, Brazil. Tape recording.

Lopes, D. C. (2001) 'O Cinema Pós-Collor', MA Thesis. Universidade Federal Fluminense.

Magalhães, A. M. (2001) Interview by author, November 28, Rio de Janeiro, Brazil. Tape recording.

Marsh, L. L. (2008) 'Embodying Citizenship in Brazilian Women's Film, Video, and Literature, 1971 to 1988', Ph.D. diss., University of Michigan.

Moisés, J. A. (2003) 'A new policy for Brazilian Cinema' in L. Nagib (ed.) *The New Brazilian Cinema*, New York: I. B. Tauris, pp. 3–22.

Moraes, T. (2002) Interview by the author, July 11, Rio de Janeiro, Brazil. Tape recording.

Murat, L. (2002) Interview by the author, July 10, Rio de Janeiro, Brazil. Tape recording.

Murat, L. (2001) Interview by the author, November 27, Rio de Janeiro, Brazil. Tape recording.

Nagib, L. (ed.) (2003) *The New Brazilian Cinema*, New York: I. B. Tauris.

Schild, S. (1998) 'Um gênero em transição.' *Cinemais* 9:123–28.

Soares, A. C. T. (2005) Interview by the author, August 26, Rio de Janeiro, Brazil. Tape recording.

Solberg, H. (2001) Interview by the author, November 27, Rio de Janeiro, Brazil. Tape recording.

Trautman, T. (2001) Interview by the author, November 29, Rio de Janeiro, Brazil. Tape recording.

Werneck, S. (2002) Interview by the author, July 16, Rio de Janeiro, Brazil. Tape recording.

Yamasaki, T. (2005) Interview by the author, August 21, São Paulo, Brazil. Tape recording.

Notes on Contributors

Piers Armstrong is an Australian-born Brazilianist with interests in literature, film, cultural studies, ethnic studies and translation. His PhD is in Romance Linguistics and Literature from UCLA. He has taught at UCLA, USC, Dartmouth, Universidade Federal da Bahia and Universidade Estadual de Feira de Santana. He currently teaches Romance languages at California State University, Los Angeles.

Courtney Brannon Donoghue is a Doctoral Candidate and Assistant Instructor in the Radio-Television-Film Department at the University of Texas, Austin. Her research interests include global media, trans/national cinema, media industry studies, Latino/a race and representation, American film and television narratives, and Brazilian media. She is currently working on a dissertation that examines Sony's contemporary local production practices, partnership, and position in the Brazilian and Spanish industries.

Jack A. Draper III is Assistant Professor of Latin American Cultural Studies at the Univeristy of Missouri, Columbia and specializes in Brazilian literature, music, film and popular culture. His book, *Forró and Redemptive Regionalism from the Brazilian Northeast: Popular Music in a Culture of Migration* (Lang, 2010) has recently appeared. He has published in the *Journal of Latin American Cultural Studies*.

Tamara L. Falicov is Associate Professor and Chair of the Department of Film and Media Studies at the University of Kansas. Professor Falicov's specialty is the study of Latin American film industries, with particular focus on the cinemas of Argentina and Cuba. She is the author of *The Cinematic Tango: Contemporary Argentine Film* and is currently working on a book about Latin American film industries to be published with BFI/Palgrave. Her work also examines the role of Hollywood in Latin America, Spanish-Latin American co-productions, and Roger Corman's co-productions in Argentina.

Vanessa Fitzgibbon is Assistant Professor of Portuguese at Brigham Young University. She received her PhD in 2006 at the University of Wisconsin, Madison. Her research and teaching interests primarily focus on contemporary Brazilian literature and film with an emphasis in racial discrimination and resentment in the establishment of the Brazilian identity. She also mentored the 2009 documentary *Sou da Bahia* and some of her upcoming articles examine the novel *City of God* by Paulo Lins as well as the literary works of Machado de Assis adapted to film.

Charlotte Glenhorn is a postdoctoral researcher at Royal Holloway, University of London, where she is currently researching indigenous film-making as part of a project funded by the European Research Council, 'Indigeneity in the Contemporary World: Performance, Politics, Belonging'. Prior to joining Royal Holloway, she was awarded her doctorate in Hispanic Studies at the University of Liverpool and completed a Master's degree in World Cinemas at the University of Leeds. Her research expertise is in Latin American cinemas, with a particular emphasis on race, gender and memory in film.

Amanda Holmes is Associate Professor and Chair of the Department of Hispanic Studies at McGill University. She studies contemporary literature and film of Latin America, and has published on urban topics such as the circulation of metropolitan figures, political violence and the city, and the urban uncanny. She is author of *City Fictions: Language, Body and Spanish-American Urban Space* (Bucknell University Press, 2007), and co-editor of *Cultures of the City: Mediating Identities in Urban Latin/o America* (University of Pittsburgh Press, 2010).

Ana Laura Lusnich is an adjunct researcher of CONICET and professor at the University of Buenos Aires. She is the Director of CIyNE (Center of Research and New Cinema Studies) and the secretary of the AECA (Association of Studies of Cinema and Audio-visual), Argentina. She has co-edited *Civilización y barbarie en el cine argentino y latinoamericano* (2005).

Leslie L. Marsh is Assistant Professor in the Department of Modern and Classical Languages at Georgia State University, where she teaches courses on Hispanic and Lusophone Cinemas. Her research focuses on women's film-making, citizenship and representations of violence in contemporary Latin American Film.

Marina Moguillansky is Assistant Professor in Sociology at the University of Buenos Aires. She holds a Master of Arts in Sociology of Culture by the National University of San Martín (Argentina) and is a PhD candidate in Social Sciences at the University of Buenos Aires. Her research focuses on the effects of regional integration on cinematographic industries at the Mercosur.

Ana Peluffo is Associate Professor of Latin American Literature and Culture at the University of California, Davis. She is the author of *Lágrimas Andinas: Sentimentalismo, género y virtud republicana en Clorinda Matto de Turner* (Pittsburgh: ILLI, 2005), editor of *Pensar el Siglo XIX desde el siglo XXI: Nuevas miradas y lecturas (A contracorriente,* special dossier, 2009*)*; and co-editor (with Ignacio Sánchez Prado) of *Masculinidades del siglo XIX en América Latina* (Iberoamericana-Vervuert, 2010). She writes on gender, ethnicity and sentimentality in Latin America. Her essays have appeared in journals such as *The Latin American Literary Review, A contracorriente, Revista Iberoamericana,* among others.

Cacilda Rêgo is Associate Professor in the Department of Languages, Philosophy and Speech Communication, Utah State University. She received her PhD in Latin American Studies from the University of Texas at Austin. Her research interests are Brazilian film and television, with a special focus on telenovelas. Her articles have appeared in *Intercom: Revista Brasileira de Comunicação, Studies in Latin American Popular Culture, Journal of International Communication* and *New Cinemas* among others.

Carolina Rocha is Assistant Professor at Southern Illinois University, Edwardsville. She specializes in Southern Cone literature and film. She co-edited with Hugo Hortiguera *Argentinean Cultural Production During the Neoliberal Years (1989–2001)* and *Representations of Violence in Contemporary Argentine Literature and Film* with Elizabeth Montes Garces (University of Calgary Press). Her articles on cinema have appeared in *Bulletin of Spanish Studies, Revista de estudios hispánicos, Ciberletras and Letras hispanas* among others.

Ana Ros is Assistant Professor of Latin American Literature and Culture at the Department of Romance Languages and Literatures at Binghamton University (State University of New York).

James Scorer is Lecturer in Latin American Cultural Studies at the University of Manchester. His research falls broadly into the area of the Latin American city. To date his work has focused on contemporary urban imaginaries of Buenos Aires, including film, literature, art, photography and music, looking at their relationship to the construction of political communities. He is also working on the political, social and cultural struggles over the Latin American lost city.

Beatriz Urraca is Associate Professor of Spanish at Widener University in Chester, Pennsylvania (USA). A native of Madrid, Spain, she has a Licenciatura in English Philology from the Universidad Complutense de Madrid, and an MA and PhD in

Comparative Literature from the University of Michigan in Ann Arbor. She has taught at several Philadelphia-area colleges and universities, and has published a number of articles on Argentine literature and cinema. She is currently working on a monograph on social change in recent Argentine cinema.

New Trends In Argentine
and Brazilian Cinema